Artistic Judgement

PHILOSOPHICAL STUDIES SERIES

VOLUME 115

For further volumes:
http://www.springer.com/series/6459

Graham McFee

Artistic Judgement

A Framework for Philosophical Aesthetics

 Springer

Graham McFee
Vicarage Road 19
Eastbourne BN20 8AS
United Kingdom
gmcfee@graham-mcfee.co.uk

ISBN 978-94-007-0030-7 e-ISBN 978-94-007-0031-4
DOI 10.1007/978-94-007-0031-4
Springer Dordrecht Heidelberg London New York

Printed on acid-free paper

Springer is part of Springer Science+Business Media (www.springer.com)

Preface

Preamble

Asked by a colleague, some time ago, to set out my account of philosophical aesthetics (and, associatedly, of art), my first response was that I had no such account: that any of my views was also held by someone else! But my colleague insisted that, on the contrary, my views both of aesthetics and of the nature of art were distinctive. So did that distinctiveness reside in the combination of these views on the various topics, rather than in any particular view of mine? To understand, I identified and explored each of these 'distinctivenesses' in turn. This exercise, first, prompted small-scale elaborations of specific issues: how did my institutional theory differ from those standardly offered? Did it succumb to the same objections? And so on. Second, it produced larger-scale explorations of the extent to which this account of philosophical aesthetics was illuminating (and perhaps even accurate). Issues here included the nature of truth, of rationality or of philosophy as much as aesthetic matters. So I planned a book to take all these topics further. And, dear reader, you are now looking at the outcome.

This text presents a position both distinctive and powerful. At its heart, the pervasiveness of the artistic/aesthetic contrast combines with my 'take' on it. In this way, a framework for philosophical aesthetics is offered: that is, one for making sense of our appreciation and judgement of artworks of all kinds, and our appreciation and judgement of other objects in which we take an interest expressed in terms of grace, or line, or beauty—or their opposites. This is a *framework* partly in offering a fairly abstract picture, which would need application to, say, one's concerns with the aesthetics of dance (a special favourite of mine). Further, illustrative examples are offered where they seem to occur naturally.

This picture of philosophical aesthetics rests on five main concerns, roughly reflected by the chapters here:

(a) it insists on the importance of contrasting our judgement and appreciation of artworks with all our other aesthetic judgements;
(b) it recognizes the connection of artistic value to human life, and explains why no comprehensive abstract account is possible on this topic;

(c) it gives an account of art which permits critical commentary on artworks to be *true*, partly be giving due weight to the intentions of artists;

(d) it treats those truths as mutable under forces in history in general and especially in the history of art (what I call "the historical character of art");

(e) it stresses the role of practices of recognizing and appreciating art within a wider community and of presenting artworks to that community, as well as other associated practices such as the restoring of art: that is, it offers a broadly institutional account of art.

In addition, it draws on a context-sensitive account of understanding and meaning: although this is sketched in broad terms in Chapter 2, its impact is felt throughout the text. Even further back, a distinctive view of the nature of the philosophical enterprise is both exemplified and (occasionally) discussed here: that view has the writings of Wittgenstein as its remote source and those of Gordon Baker as its proximate one.

Readers may have three misplaced reactions to this text, each of which is nevertheless not without justification. Since they lead to 'taking one's eye off the ball', these objections should be forestalled here. The first is that this is all rather familiar, just lining-up 'the usual suspects'. This objection derives from the fact (noted above) that, in one way, my view is compounded out of positions shared with others. But that fails to recognize its fundamental distinctiveness(es). Central among these is my radical version of the artistic/aesthetic contrast which, I insist, is (or should be) fundamental to thinking in philosophical aesthetics.

Second, and related, the claim that this is just a collection of views—that is, not a single position but a mélange—warrants the same reply. For my view is rooted in the artistic/aesthetic contrast (and, if more is needed, in the conception of meaning and understanding that sustains it); and, correspondingly, in my views of both the historical character and institutional nature of *art*.

Third, some chapters might seem to bicker, having a structure based on "X said, Y said" (or, worse, "X said, *I* said"). Again, this objection cannot be fundamental here, not least because my focus involves addressing perplexities, meeting objections. Of course, there is some contrasting of views (and especially of my view with others) and some responding to what might seem like obvious objections—especially where these were explicitly raised. Yet this is never simply the contraposition of views: what sustains the presentation is that it moves the discussion forward by meeting fundamental objections—again, this project should be obvious in the relevant passages.

In one way, this text is a product of my thinking on *aesthetics in general* from the time I entered the profession (if not before). Since I have been thinking about this topic, in different ways, for the past 35 years, not all I would want to say is here; but, where possible, I have offered cross-references to other works—often works of mine—where the picture is elaborated.

Further, I have refrained from proliferating examples, preferring instead to see how a smallish number of examples fare in the different contexts constituted by the various discussions in this text. Having this small set of cases at the argumentative

heart of the work is an advantage, as long as it is recognized that—far from representing "an unbalanced diet", in which "one nourishes one's thinking with only one kind of example" (PI §593)—the thinking derives for a generous consideration of cases, with any (apparent) narrowness concerning clarity of presentation only.

The selection of examples poses an further difficulty. For instance, I take the *Alexandria Quartet* to be one of the greatest books ever written in English (and, actually, one of the greatest *punkt*). And reference to Durrell occurs in my other works (for instance, UD: 182–183; 189–190) as well as here. Moreover, points are clearer *to me* when I believe in the examples. But *my* judgement of the *Alexandria Quartet*, say, can cloud the discussion: my considerations in philosophical aesthetics cannot depend on my being *right* about particular artworks. Of course, that discussion always needs exemplification with concrete cases: hence, conclusions concerning particular artworks must inevitably occur. One strategy, used to good effect in McFee, 1992a (UD), involves relying for exemplifications on the judgement of critics. Another strategy (from the last chapter of McFee, 1978) is writing as a critic oneself. But then my own 'take' on the artworks can seem either underrated or over-rated respectively. Yet nothing turns on the examples as such, at least if readers who dispute them can (nevertheless) supply examples of their own to make similar points.

Finally, it is a commitment of this work that its assertions answer perplexities (questions), and that a different perplexity (question) can be raised in the same form of words (see Section 2.4). So no author can hope to address *all* the possible perplexities in an area in *all* the detail the 'perplexed' might require. Hence, I have done my best, focusing on those questions raised in the literature or in discussion; and I have offered something to those differently 'perplexed', occasionally including reference to other works (especially other works of mine) where either a similar position put in a different way might be found or a fuller version in roughly the same way.

This work is self-contained, although drawing on arguments sketched elsewhere, and operating at a level of considerable generality in (typically) talking globally about *the arts*—while recognizing differences among the arts. But, in my thinking, this is also the first volume of a two-volume project, which (following the good advice of my wife Myrene) I call *The Muscular Aesthetic*. The second volume, should it appear, will be more concrete and—consonant with my interests—will have a clearer focus on the performing arts, and especially dance.

This, then, is the culmination of much of my thinking both in philosophical aesthetics and in philosophy more generally. In that sense, it is the PhD thesis I *should* have written, if I had seen matters that clearly then! Some of the ideas here were central to my actual PhD thesis, others were prefigured in early publications or (unpublished) presentations to conferences. In particular, my admiration for John Wisdom's version of (broadly) Wittgensteinian thought made me advocate a case-by-case answer to very many difficulties, especially those in philosophical aesthetics. It is consoling to find others whose work I admire (for example, Danto, 2000: 132–133) now responding in this way. But it makes me wish that some of the details of my ideas had become more widely known at the time I formulated them.

Some are in McFee (1978): others, which I have been asserting for 20 years, have no obvious and definitive published home.

Textual Acknowledgements

Much of the material here had an 'earlier life' in conference presentations and articles: I welcome the opportunity to integrate these materials, not all previously published (and, if so, fully revised). The major published pieces are:

- 1985: "Wollheim and the Institutional Theory of Art", *Philosophical Quarterly*, 35, 139: 179–185 (mainly in Chapter 6)
- 1989: "The Logic of Appreciation in the Republic of Art", *British Journal of Aesthetics*, 29: 230–238 (in Chapter 6)
- 1992b: "The Historical Character of Art: A Re-Appraisal" *British Journal of Aesthetics*, 32, 4: 307–319 (mainly in Chapter 5)
- 1995: "Back to the Future: A Reply to Sharpe" *British Journal of Aesthetics*, 35, 3: 278–283 (in Chapter 5)
- 2001a: "Wittgenstein, Performing Art and Action" in R. Allen & M. Turvey (eds.) *Wittgenstein, Theory and the Arts*. London: Routledge: 92–117 (mainly in Chapter 2)
- 2004c: "Wittgenstein and the Arts: Understanding and Performing", in P. Lewis (ed.) *Wittgenstein, Aesthetics and Philosophy*, Aldershot: Ashgate: 109–136 (in Chapters 2 and 4)
- 2005b: "Art, Understanding and Historical Character: A Contribution to Analytic Aesthetics" in K. Mey (ed.) *Art in the Making: Aesthetics, Historicity and Practice*. New York: Peter Lang: 71–93 (in Chapter 5)
- 2005a: "The Artistic and the Aesthetic" *British Journal of Aesthetics*, 45: 368–387 (Chapter 1 is a revised and expanded version, incorporating, in particular, material presented at Oxford University, May 2005)
- 2008: "The Friends of Jones' Paintings: A Case of Explanation in the Republic of Art" *Contemporary Aesthetics*, 6 (in Chapter 6)

Further, Chapter 2 mines material from SRV: 47–52.

Other Acknowledgements

There are too many debts (over too long a time) to mention everyone who, through discussion or correspondence, has contributed to my thinking here: to stand for all the rest (hereby thanked), I will mention the following special contributions:

- among aestheticians, Terry Diffey and Nick McAdoo, both of whom commented in detail on an earlier draft, as well as the late Richard Wollheim (who supervised the PhD thesis I *did* write);

- among philosophers more generally, the late Gordon Baker, David Best, Katherine Morris, Charles Travis, the late John Wisdom; and also Brian Smart, who taught me first;
- my wife, Myrene: who fulfils for me all the tasks Lawrence Durrell also required of a woman ("lover, intellectual companion, nurse, mother, cook, hostess, manager, critic, typist, proofreader ...": MacNiven, 1998: 555) and many more.

I should also acknowledge the University of Brighton, for giving me time to write a substantial first draft of these ideas (particularly to Paul McNaught-Davis and Alan Tomlinson); and especially to those colleagues in the Chelsea School who covered my teaching and administration. Further, I would mention the less tangible but still fundamental support of my colleagues at California State University Fullerton. And, once again, the village of Joncelets, France.

Abbreviations

(a) for my own works:
 McFee (1992a—"UD")
 McFee (2000—"FW")
 McFee (2004a—"SRV")
 McFee ([1994], 2004b—"CDE")
 McFee (2010a—"EKT")
(b) standard abbreviations for the works of Wittgenstein:
 Wittgenstein (1953—"PI")
 Wittgenstein (1958—"BB")
 Wittgenstein (1967—"Z")
 Wittgenstein (1975—"PR")
 Wittgenstein (1979—"WWK") (based on the German title)
 Wittgenstein (1980—"CV")
 Wittgenstein (1993—"PO")
 Wittgenstein (2005—"BT")

[Other references to Wittgenstein use the standard enumeration of items from the *Nachlass*: see PO: 480–510]

Permissions

Thanks to Henry Holt and Company LLC for permission to include the poem "Fire and Ice" by Robert Frost, which appears in Chapter 4, from *The Poetry of Rober Frost* edited by Edward Connery Latham. Published by Henry Holt and Company, LLC. 1969.

Contents

Chapter 1
The Artistic and the Aesthetic: A Distinction Considered

Aesthetic interest, or aesthetic judgement broadly conceived, is a widespread phenomenon: people respond positively to the elegance of the Ferrari, the glorious colour of the sunset, the grace of a Fred Astaire dance sequence. This is a mixed bag: elaborating such examples would include cases where judgements, although rightly classified as *aesthetic*, were negative: the ugliness of the new skyscraper, say, or the terrifying aspect of the cliff face. In addition, for many of us, there is *art* in all its forms: that is to say, what is sometimes called *fine art*—painting, poetry, music, dance, novels, and much more. How might this puzzling diversity be brought together (where it should) by philosophical aesthetics? From what kind of framework should the investigation begin?

The literature of philosophical aesthetics contains texts whose primary focus is on artworks, texts with a similar focus on (non-art) aesthetic objects, and a number of texts which attempt to combine these foci. In developing a framework for my own account of philosophical aesthetics, I am especially concerned about *art*: that is, about the nature of artworks and of our responses to them; and, in particular, artworks' distinctive (non-monetary) value. Further, for me, understanding the nature of art centrally involves contrasting art, and artistic judgement, with other (non-art) aesthetic judgements and their objects. For one characteristic shared by many of the cases of the aesthetic noted above is that they are *not art*. As we will see, that thought is crucial for my framework as it develops here.

Actually, the beginnings of philosophical aesthetics as we understand it broadly coincides with the articulation of a distinctive concept of *art* (as 'fine art'), and with a distinctive *valuing* of both such a concept and the objects to which it applies—a valuing distinct from their beauty, monetary worth, and so on. For instance, Roger Scruton (1990: 98) writes that:

> ... aesthetics, conceived as a systematic branch of philosophy [what I call 'philosophical aesthetics'], is an invention of the eighteenth century. It owes its life to Shaftesbury, its name to Baumgarten, its subject-matter to Burke and Batteux, and its intellectual eminence to Kant.

On such a view, then, philosophical aesthetics begins in the period where concern with a distinctive conception of the artistic (roughly as I shall draw it) makes sense: then, the appreciation of nature and of craft-work is implicitly contrasted with that

of *art*. Not, of course, that philosophical aesthetics was (always) primarily interested in art—Kant, for instance, certainly was not! But his interest in, say, natural beauty must be understood against a back-drop provided by art: the contrast between free and dependent beauty is, in effect, one tool here (see McAdoo, 2002). Further, arguing that the philosophy of art has enough problems of its own, and can therefore be treated independently of the philosophy of natural beauty (as perhaps Hegel did), also marks such a contrast between judgements *of art* and others.

The thought, then, is that one understands what *art* is partly by contrast. And that understanding the nature of *art* requires endorsing that contrast, thereby stressing the centrality of this distinction between two kinds of interest, two kinds of judgement, two kinds of appreciation: that is, between the interest, judgement and appreciation appropriate to artworks and that interest, judgement and appreciation appropriate to all the *other* (non-art) things in which we take an aesthetic interest—between what I call *the artistic* and *the aesthetic*.[1] This is the single most important contrast, or distinction, within philosophical aesthetics, implicit (when not explicit) in *all* discussions of artworks—or, at least, one which should be: a distinction regularly drawn in practice, but not (typically) marked in theory, at least in this form. This contrast or distinction is fundamental to the framework for philosophical aesthetics developed here. It is addressed throughout this work, and especially in this chapter.

1.1 A Crucial Distinction

We can begin with an example. Our appreciation of a great painting and of the wallpaper on the wall on which it hangs are very different, although both are concerned with line, grace, etc. and in neither case is the object considered solely as a means to an otherwise-specifiable end: that is, purposively. Recognizing that there is, for instance, *something different to say* about the painting, and especially about the *value* of the painting, is contrasting the artistic with the ("merely") aesthetic. For the judgement of *art* needs, in this way, to be treated or regarded differently from the other: failing to do so is ignoring what is distinctive about art.

Having roughed-out the distinction for *one* artform, it should be applied quite generally: to recognize, say, the artform *dance* is to contrast the grace of the dancer with that of the roadsweeper (or the gymnast). To this degree at least, art-status should be seen as *transfigurational* (Danto, 1981; UD: 51–52): the pattern of movement was graceful in the gymnast, but incorporating that pattern into our dance requires that 'the' grace be regarded differently—as it were, like that of the painting rather than the wallpaper. Further, its recognition as *dance* (the artform) allows a different account of 'the' grace. For artistic appreciation, artistic judgement (etc.) locates the artwork in question in the history and traditions of artmaking and art-appreciating in that artform (and, perhaps, that *genre*, etc.). So that one's failure to know or understand counts against one's possibilities of making (genuine) artistic judgements—judgements *true* of the artworks before one.

Such a contrast is needed to explain *artistic value*, in contrast to the 'value' of the wallpaper—an explanation especially required in, say, 'aesthetic' education. For were there nothing distinctive about *art*, and especially no distinctive value, aesthetic education need not concern itself with art, but could instead simply treat natural beauty or decorative design. Then granting that this would be a defective view of aesthetic education is granting that there *is* a distinctiveness here, a distinctiveness characteristic of *art*. And without such a concession, there can be no distinctive art—or so I urge. Hence this is, as was said above, the single most important distinction within any philosophical aesthetics which takes art seriously.

Notice, first, that the artistic/aesthetic distinction is *technical*—standard English usage employs each word on both sides of the distinction; second, that both are within the "larger aesthetic" (UD: 39–42), so that both kinds of interest are contrasted with purposive interest, and both might be characterized as 'a concern with grace, line, etc.—or their opposites'.

Now consider in this light the misperception of artworks: the Messiaen misperceived as birdsong (where an artwork is taken for aesthetic object) and the birdsong mistaken for music (aesthetic object misperceived as art). Another crucial misperception occurs when a work (recognized as art) is nonetheless mistaken because inappropriate assumptions about art are imported—taking the atonal music for discordant tonal music, the Cubist painting for a poorly executed one in another style. So the concepts mobilized in one's perception of the artwork must be appropriate ones. These thoughts illuminate the role and importance of what, following Kendall Walton (2008), are called *categories of art*. Two points are fundamental. First, in learning about (say) Cubist painting, one learns what features are characteristic of such paintings (Walton, 2008: 199 [all citations] calls these "standard"), such that lacking these features makes one doubt that this was indeed a Cubist painting; further, what features tend to disqualify the work as Cubist ("contra-standard"); and what features do neither of these things ("variable"). What is contra-standard for Cubism might be either standard or variable for some other category (as here, categories tend to be genres, styles, types . . .). So, taking such-and-such to be standard features, and finding them only poorly exhibited (or not exhibited at all), one will tend to think ill of this work—it is not a very *good* Cubist painting. But, of course, it might not be one at all: then the features taken as contra-standard might be standard for some other category, and vice versa.

In this way, any artwork will be appropriately perceived only if located in its category; for only then might it be appropriately understood. That is our second insight from Walton: reference to *categories of art* imports the implication that (in artistic judgement) the artwork in question is located in its appropriate history or tradition; as part of what Noël Carroll calls a "narrative", since there might be competing ones. Thus an artform must be understood as part of a complex tradition of art-making and art-understanding.

In illustration, consider confronting someone who denies that Isadora Duncan's "barefoot prancing and posing" (Carroll, 2001: 91) is art. In reply, Carroll (2001: 91) suggests the beginnings of a *narrative* to show that:

... Duncan was able to solve the problem of the stagnation of theatrical dance by repudiating the central features of the dominant ballet and by reimagining an earlier ideal of dance.

Such a narrative still draws heavily on the established feature of past works. In this sense, it takes for granted both some art-status and some value to those past works. Yet, as Carroll illustrates, that narrative also shows what advantages Duncan saw in (and hence what values she brought to) this revitalized dance: both her pronouncements and her actions constitute an 'argument' for a modification of practices of art-making and art-understanding. That this 'argument' succeeded in changing taste (to the degree that it did) also reflects the state of the art-minded community at the time: in that artworld, Isadora's strategies were appropriate—we know that because we know they worked. But one can infer that other strategies would not have been successful although, typically, examples cannot readily be given here, since the net effect of a counter-argument would be the disappearance of Isadora's work from the tradition of art-making and art-understanding: it would *then* have had no place in the narrative. So accounting for the artist's activities (rendering them intelligible) is in part looking at the values challenged, in part considering what Carroll (2001: 91) called "the lay of the artworld".

Or consider Alphonse Allais' joke painting, *Anaemic Young Girls go to their First Communion in a Snowstorm*—which is all white! Because others had made *art* that was single-colour, or something similar, and because these other works were recognizably part of the narrative of art at the time, Allais could offer his joke-work. Thus its joke depends on the tradition of valuing, the 'lay of the artworld' at that time. Further, one can only *intend* to do such-and-such at certain times and in certain places: thus, Allais' intentions only made sense given 'the lay of the artworld' at that time. So artistic properties are connected to tradition, through what (in a strict sense) one can intend: Cubist intentions only make sense after a certain point in the early twentieth century, reflecting both what could and what could not be intended or attempted. Without that tradition, attempting a Cubist painting could neither be successful nor fail. Just as one cannot *attempt* to score tries without the background of the rules of rugby, one's artistic efforts cannot succeed (nor fail) without the background of tradition embedded in the artworld. But this also concerns what would be intelligible *if* attempted. In these ways, the 'lay of the artworld' constrains what I can try or intend; also what you (as audience) can understand.

That artworks can be misperceived as merely aesthetic or in an inappropriate category identifies a quite general constraint here: that the object before us is (or is not) an *artwork* is crucial for its appreciation. As Arthur Danto (1994: 384) puts it, "[t]he aesthetic difference presupposed the ontological difference": an object's being (or not being) an artwork makes a difference because art-status permits us to see the *object* (especially when a physical object, such as a painting) as embodying meaning, an idea that only makes sense for artworks (not for the [merely] aesthetic).

What we take from Danto here includes the *transformative* effect of art-status: that the artwork acquires *artistic* properties—this distinguishes it from its 'non-art' cousins. In a similar way, a graceful action might simply be my walking (to work),

or part of my gymnastic floorwork, or part of my dance: but these are not equivalent actions. That it is dance (when it is) *transforms*, or transfigures, that action. Moreover, when (say) the action of the roadsweeper is transfigured, there is a clear sense in which it is changed—a set of properties is acquired—and a sense in which it is not: the patterns of muscular movement, say, might be the same. This illustrates something about the nature of the new properties, by stressing their connection to the audience for them. For instance, the transfiguration of sounds into music (the creation of tones, rather than mere sounds) means that they are heard differently—and this is what their being different consists in. As Scruton (1997: 18) puts it, "[t]o hear a sound in music is not merely to hear it, but also to order it.... The order of music is a perceived order". Similarly, to say that a movement pattern becomes *transfigured* into a part of a dance is to say that we can (and should) now see the movement pattern that way.

So far, I have just articulated this contrast *in practice*, and explored how it must work, if one is to give it the importance it obviously requires. In that way, the argument is hypothetical: 'suppose there were such-and-such a distinction' Only when one sees how powerful and attractive picture this is, and how it deals with apparent difficulties, can it really be appraised. That said, we can return to the main thread.

1.2 Transfiguration and Artistic Properties

As an 'intuition pump' for the *transfiguration* into art, consider Danto's "gallery of indiscernibles", where objects indistinguishable to (say) visual inspection turn out to be a number of different *things*.[2] Elements from the gallery, each comprised of a canvas with a painted square of red pigment, include:

(a) "a minimalist exemplar of geometrical art ... [entitled] ... 'Red Square'" (Danto, 1981: 1);
(b) "a still-life executed by an embittered disciple of Matisse, called 'Red Table Cloth'" (Danto, 1981: 1);
(c) "a canvas grounded in red lead, upon which, had he lived to execute it, Giorgione would have painted his unrealized masterpiece 'Conversazione Sacra'" (Danto, 1981: 1): here, I imagine the preparation done by workers in the studio—this *would have* become an artwork, although presently it is not;
(d) "a surface painted ... in red lead" (Danto, 1981: 1): although Danto does not explain this, I imagine its being a kind of window blind, the red pigment being especially suitable in a certain climate. As with (c) above, Danto would call this a 'real thing': we can adopt this terminology.

And, of course, any of these objects ('real' or artwork) might be mistaken for any other ('real' or artwork).

These cases suggest (and surely correctly) two points: first, that these objects are different—different things can (truly) be said of each. Hence, one can misperceive any of the objects by (mis)taking it for another one, or treating one as though it were another (if these are different modes of misperception).

A lot of ink has been expended contesting the conditions of indiscernibility at issue here (see Wieand, 1994; Wollheim, 1993b). Yet the simplest version (you don't know which one you are looking at) is probably enough to get the cases going, once it is conceded that they *are* distinct in ways that bear on their proper appreciation. Further, it is *relative* indiscernibility: as Danto (2000: 132) notes, "a photograph ... [of Warhol's *Brillo Box*] would be indiscernible from one taken of the commonplace containers in which the soap pads were shipped to supermarkets". So objects with differences whose significance is either not transparent until the art-status issue is resolved or within limits of, say, mechanically produced 'versions' should count as indistinguishable—the concern is always with *relevant* differences.

The second point (rightly) drawn from Danto's gallery of indiscernibles is that the 'transfiguration' into artwork is important just because it brings with it a critical vocabulary of the kind appropriate to art—the kind of *artistic valuing* (of painting but not wallpaper) from which the previous section began. That is precisely what both the artworks have, and the 'real things' lack, even when, as in case (c) above, the 'real thing' has some connection to the world of art. That it is not (yet) transfigured into art means that the requisite critical vocabulary for art (of that type) is inapplicable to it. Further, this clearly articulates how the artworks—cases (a) and (b) above—differ: a *different* critical vocabulary is appropriate to each, since each has a place in a different 'narrative' of art-history, or in a different tradition; a different *category of art* applies to each, and a different critical discourse follows.

For example, Danto correctly identifies a crucial categorial difference between a neck-tie 'decorated' with blue paint by a child and an indistinguishable tie painted by Picasso:

> I would hesitate to predict a glorious artistic future for the child merely on the ground that he had produced an entity indiscernible from one turned out by the greatest master of modern time. ... what the child has effected is not an artwork; something prevents it from entering the confederation of franchised artworks into which Picasso's tie is accepted easily, if without immense enthusiasm. (Danto, 1981: 40)

The outcome of the categorial difference is that remarks truly appropriate to Picasso's blue tie, the reasons employed in interpreting it (say, in respect of its absence of visible brushstrokes), are simply not available for comment on the child's effort.

What exactly counts against the child's blue tie? Certainly, the child's object has no fixed place in the traditions of art-making and art-understanding, while Picasso's achieves that place effortlessly. In the language introduced earlier, the child's tie lacks the place in the *narrative* of art-making and art-understanding. In fact, the argument here might be the converse of one regularly raised about forgeries.[3] Just as taking (say) a Van Meegeren forgery of Vermeer *as a Vermeer* expands our view of what Vermeers are like, and hence opens the door for further forgeries, and the

rejection of *one* such work as a forgery has implications for others, so accepting that child's tie as art could have major implications for the nature of art-understanding. And one cannot just *expect* such changes. Yet that simply repeats the initial question: *why* was the child's tie excluded?

First, that tie is simply excluded *ex hypothesi* to begin the argument, without thereby attempting to prescribe any particular history of art, nor concluding that the child's tie *could not* become art, however much one might think that unlikely. But should the tie became regarded as art, *other* changes required by a coherent history for art must also be accommodated, with the change in critical assessment that implied. So it is sufficient that—focusing on the *meaning* here—we know how to regard artworks (namely, as amenable to critical discussion), even if we do not (yet) know what else to say about art-status.

This point draws on the history of art, on one reading of that history. For only certain actions are possible at any moment in that history. As Stephen Davies (2000: 173) summarizes:

> Picasso could make an artwork by painting his tie, but Cézanne would not have succeeded in creating an artwork had he produced an identical object.

Of course, recognizing the point, the example need not be disputed. More importantly, just as accepting *this* example involves adopting one picture (or story) in the history of art, so questioning it would involve positing another (conflictual?) one, in this genre, and so on. That particular example might not survive adoption of *another* narrative of the later history; but, of course, each history may be equally disputable for some such examples. Thus, if Cézanne—with the huge weight of artistic clout we take him to have—were to have offered a painted tie ... well, what could be made of it? Prior to the event, we cannot know (see Austin, 1970: 88).

Now consider someone who cannot join in the debate just envisaged: the person who does not know dominant narratives of art history cannot see or judge works as part of those narratives. But there are many different ways of knowing the narratives, typified by different ways of learning them: for example, as artist, art historian, theorist of aesthetics (and so on). There may be something that all who know these narratives can *do* (or some overlapping set of things sufficient to credit the same knowledge to all) but certainly there can be no expectation that all can say, or be able to say, the same things. On the contrary, the person who learned the narrative of contemporary portrait painting only as a painter (from a teacher of portraiture, say), might not be able to *articulate* (in words) much of that narrative—perhaps none of it. And finding someone who *appeared* to be in this position, yet could articulate such a narrative, might well be evidence that there were other sources of knowledge at work.

So what exactly does recognizing the transformative effect of art-status involve for specific properties of the relevant objects? Viewed one way, a painting (for instance) that *is* and one that *is not* a work of art might share visual properties in common—as Danto's gallery indicates. What exactly should one say of the properties mis-ascribed to the artwork when it is mistaken for a merely aesthetic object (see Section 1.5 below)? Clearly, the fact that a square in the bottom corner is *red* will be

true independently of whether or not the object is an artwork or a merely aesthetic object (see Section 1.4 below). Yet what of the claim that the painting is gaudy (or beautiful)—partly, perhaps, because of this red element? Concluding that its *gaudiness* (or *beauty*) is independent of the object's art-status involves taking it for gaudy (or beautiful) independently of whether or not it is an artwork. But, were that so, its being (say) gaudy could not depend on the genre (and so on)—this begins to deny the whole *categories of art* thesis, sketched earlier. Hence we could not follow this line. Whether or not a piece of music is really *discordant* must involve recognizing whether the musical work was in an atonal category (or style): if it were, a kind of discordance would be the norm. Then it would be odd to regard "discordant" as a useful descriptive term for it, since this feature is category-standard for such music, while "discordant" seems a negative term. Again, that a painting was *Cubist* would mean that one kind of accusation of lack of realism was inappropriate: a Cubist depiction of people (such as *Les Demoiselles D'Avignon*: see McFee, 1994) must be judged differently from other kinds of depiction. But that must suggest that these terms ("discordant"; "realism") amount to something different in the context of (differing) *categories of art*. And that restates our thesis.

1.3 Some Corollaries of the Distinction

What follows from granting this artistic/aesthetic contrast? One corollary of the contrast (to which we must return) is that one's calling a painting, say, *gaudy* amounts to something different when one recognizes that the painting *is* an artwork from what it amounts to when one mistakes the gaudy object for, say, wallpaper.

The key case here, of course, concerns the term "beauty": if I (mis)take something for an artwork, and find it beautiful, my now coming to recognize that it is *not* an artwork will *not* leave that judgement unaffected—rather, it will affect the judgement "not by raising or lowering that judgement, but by knocking it sideways" (Wollheim, 1993a: 174): even if I continue to regard the object as beautiful, its beauty amounts to something different. My finding *beautiful* (or otherwise *artistically* valuable) what turns out to be my child's painting amounts to my attributing to the object features it lacks (and vice versa). Thus one cannot *just* say, 'Well, OK, it is not art but I still find it beautiful'; for what one meant by the term "beauty" is implicated—hence the "still" ('I *still* find it beautiful') is unjustified.

Consider beauty in (roughly) a case of *trompe l'oeil* and a kind of reverse *trompe l'oeil*. First, I take for a curtain covering a painting what is actually the painting itself. Now the beauty I 'see' is clearly rooted in my misperception: it is the beauty of, say, a rich velvet curtain. This is (merely) aesthetic appreciation—the 'curtain' is not an artwork. When I come to recognize it for the artwork it is, my appreciation of it as beautiful now connects *its* beauty to beauty in other arts, to traditions, genres and the like: calling the object "beautiful" now depends on such connections, and hence amounts to something different. Second, and in reverse, I take *for a painting* what is actually a small window onto a static scene. Now, the beauty I 'appreciate'

has a connection to, say, *composition* (and, again, traditions, conventions, genres of art) that is actually inappropriate. Again, I am *misperceiving* the object. Once the misperception is identified, the scene may still count as "beautiful": but (in this example) it is aesthetic beauty only.

The *gaudiness* of (say) the painting is centrally the gaudiness of art (of a certain sort): to deny that involves applying the term "gaudy" across the artistic/aesthetic contrast, thereby treating the object's being gaudy as independent of whether it was an artwork or not. That is precisely what deploying the artistic/aesthetic contrast must deny: if objects would be gaudy whether or not they were artworks, and if gaudiness is a property relevant to art-status, advocates of the artistic/aesthetic contrast would arrive at a contradictory position—whether the object was gaudy both would and would not depend on its art-status. Of course, one might deny that the term "gaudy" picks-out an artistically-relevant property. Yet this seems both to dispute the example not the principle and to be just wrong: for example, some criticisms of Diego Rivera accuse his work of being *gaudy*, as though it is an artistic criticism (here). Then accepting the artistic/aesthetic contrast must involve taking the property of *gaudiness* as amounting to something different insofar as, or in those cases where, it is an artistic property from what it amounts to in (merely) aesthetic contexts, without assuming this to be unitary. This might be regarded as a nettle to be grasped (see Section 1.6 below) or a feature to be celebrated. But it must be granted—and then explained—by all who take seriously the artistic/aesthetic contrast.

A second corollary is that taking an artwork for a (merely) aesthetic object is *mis*taking it, misperceiving it. Birdsong mistaken for music, perhaps as a result of listening to a surfeit of Messiaen, is one classic case of such misperception, where a proper object of aesthetic interest is misperceived as art. Such objects are granted a structure they *could not* have—as though a crack in a wall *seemed* to spell a loved one's name: it not only *did not* do so, it *could not* do so. In another case, the Messiaen is misperceived as birdsong (artwork taken for aesthetic object). And we have mentioned the misperception implicit in taking the atonal music for discordant tonal music, the Cubist painting for a poorly executed one in another style—failures to employ the appropriate *category of art* in one's perception illustrate, of course, this kind of failure of artistic appreciation, not readily shared with aesthetic appreciation.

A third corollary grows from these two: that artworks have a value, of a non-monetary kind, not (in principle) shareable with (mere) aesthetic objects. This kind of value is not easy to characterize: but, as a first shot, one might talk of the kind of *meaning* appropriate to artworks. To see the object (say, the dance) as an art-object (not a mere aesthetic object) *just is* to ascribe this sort of meaning. Thus, Danto (1997: 195) acknowledges both this cognitive dimension and its importance when he writes: "To be a work of art is to be (i) *about* something and (ii) to *embody its meaning*". That is, Danto rightly stresses, as two features characteristic of artworks, what he calls their *aboutness* and their *embodiment*.

To be clear: my aim here is not to limit the realm of what is (or could be) art—much less to impose some narrow limit on it (*pace* Korsmeyer, 1977; Shusterman, 1992: 18–21). But I am urging that someone who argues that such-and-such is *art*

is thereby committed to finding such-and-such *valuable* in ways typical of art: that is why the person insists on the term "art". And thereby committed to contrasting the (appropriate) perception of such-and-such *as art* with the misperception of it as merely aesthetic—that is, as being graceful, and so on (or the opposites) but only in the manner of the wallpaper in our earlier example, not of the painting.

Further, an object or practice might be mistaken for art; its grace, etc., might lead people to take it for art when they were wrong to do so—although, in any particular case, whether or not this were so might be at best arguable. Suppose the description of American Indian Ghost Dances quoted elsewhere (UD: 286) were correct; namely, as having "... the very specific ... purpose of restoring lost lands and traditions" (Spencer, 1985: 2). Well, this might be a suitable aim for magic. But, whatever the purpose of (art) dance, it cannot be *this*. So accepting this characterization of the Ghost Dances is accepting the (negative) conclusion: these are not artworks. Hence, someone urging that these *were* indeed artworks must be contesting some aspects of that description.

1.4 Contrasting Views of the Aesthetic

Drawing the artistic/aesthetic distinction in this way contrasts my view with two others: first, with the (widely assumed) 'unity of the aesthetic' thesis, where *one* set of properties, aesthetic properties (with *beauty* a prime candidate), is shared by artworks *and* other things. Thus, for example, Antony Savile (1982: 181) writes of the need for "univocality" in any analysis of *beauty*, commenting:

> Unless the analysis I have offered [of beauty in art] can be extended to cover natural cases
> of beauty as well, and extended in such a way as not to import ambiguity into the concept,
> my proposal will have to be judged a failure. (Savile, 1982: 176)

Second, my view contrasts with the idea of artworks having artistic *and* aesthetic properties—consistent application of the distinction as we have elaborated it shows this idea to be *false*: for to attribute (merely) aesthetic properties to artworks is to *misperceive* them. But why? On this reading, the strictly sensuous properties of artworks—such as their gaudiness—would really be *aesthetic* properties. Then artworks would share these properties with (mere) aesthetic objects, while differing in others. So, on this view, one needs, first, to explain an aesthetic contribution (of the artwork)—that might be pretty easy: artworks would be like everything else in having aesthetic properties. Then, second, to go on to discuss their further artistic contribution. But then the art-status of the works would be detached from our appreciation of them—we would not really be appreciating what made them *art*.

Frank Sibley certainly assumes that the properties of artworks are shared by other aesthetic objects; in fact drawing *no* distinction here, by concerning himself with *aesthetic* concepts. As Colin Lyas (2000: 132) points out, Sibley's insight began from the fact that, while "anyone with normal vision" could see that there was a red patch in the corner of the painting, not everyone could see that the red mass in the

corner was what made the picture balanced. So that *balance* (and similar concepts) were emergent. So far, so Sibley: for us too, artistic concepts will be emergent.

But Sibley simply assumed that the *balance* here was typical of the concepts that should concern us, his "aesthetics concepts". In doing so, he equated artistic concepts with (merely) aesthetic ones. In his example (as I imagine it), the balance of the picture was planned, intended, organized balance. If, instead, someone looking through a window 'sees' that the view is balanced by the red farmhouse in the corner of the field of vision, this seems quite a different kind of case—as we have seen. In using one model to explain all cases, Sibley ignores a feature central to the idea of emergence here. For artistic judgements typically imply that, say, the *balance* in question is selected, is part of an artistic tradition, and so on.

Sibley (2001: 18) characterizes a painting and an evening landscape in the same terms, speaking of "the same serenity, peace and quality of light of those summer evenings in Norfolk": what does this show? Certainly we would not at the other extreme—with Oscar Wilde (1966a: 987)—dismiss a sunset as an inferior Turner. But that does not commit us to the very same concepts being available to both. Certainly these are *like* one another (thereby explaining my use of the same term) without conceding that only one concept is deployed. In Sibley's actual example, the right thing to say involves the artist having captured the serenity, peace and quality of light—hence of these being, respectively, captured serenity (or meant serenity), captured peace, and a captured quality of light. And here the capturing of the quality of light might be pretty far from capturing the visual appearance, thought of in terms of the distribution and wavelength of the light—for the painting might be, say, Pointillist.

In explaining his position, Sibley (2001: 258) speaks of "a 'visual appearance', or, for short, an 'appearance', in the sense in which identical twins and their waxwork effigies may all share the same appearance". Then generating the same appreciation requires re-instantiating that *appearance*—and *mutatis mutandis* for other artforms and sensory modalities—since, when appreciating works of visual art, "only literal visual properties matter" (Sibley, 2001: 263). So that, in addition, this view accepts that the only properties that "matter" for our appreciation of art could be instantiated in many objects, not just this one.[4]

We must ask, 'Matter to what?' Or, 'Matter for what?'. For Sibley, the answers lie in the aesthetic properties picked-out in judgements of the work of visual art. Yet, because he denies (or ignores) the artistic/aesthetic contrast, he aims to put aside "non-exhibited properties, background history, or tradition" (Sibley, 2001: 263) since—as he rightly notes—these do not matter to appearance in one sense: hence, trading on that notion of appearance, they do not matter to the merely aesthetic. Indeed, our (contrary) position might be put by urging that, since these things obviously do matter (getting them wrong will lead to misperception of the artwork), the distinction is crucial, at least for philosophical aesthetics.

Note that *meaning* features are essentially intended ('meant'): that is, not naturally occurring. As before, the cracks in the wall cannot spell-out my loved one's name, but only appear to do so. In contrast, the same *appearance* could be instantiated by chance, or accident:

- *by chance*: say, a naturally occurring object—the patination of a particular surface or, more plausibly, the cracking of a particular stone to constitute an 'appearance' of sculpture; but only its *appearance*, for this is precisely *not* sculpture.
- *by accident*: I mean to do something else, but end up with an 'indistinguishable'. Clearly, common sense distinguishes the work from a copy: so this is *not* just a copy.[5] The residual question is whether one has thereby made another instantiation of the original object. Such a case reflects an element of the conception of art operative here. For discovering (how?) that two art-objects (say) did have completely the same meaning, such that one could claim, correctly, 'if you cannot get one, get the other—they amount to *exactly* the same thing',[6] offers us a basis for regarding them as instantiating one artwork, rather than being separable works. And the argument for this conclusion would begin from reflection on authorship: if the first work is by Smith, and she has embodied the relevant 'aboutness', the second work (by Jones) might simply be a copy of Smith's—but then, as above, it is not the very same work. Or it might be another instantiation of that work, if the second is (otherwise) indistinguishable from the first. That is, this will be Smith's artwork: another performance of her symphony, perhaps. Hence, if the 'other instantiation' is to count as by Jones, it cannot be that very same work. At best, it is a related work. And, of course, way works with obvious relations one with another are treated in this: thus aspects of Picasso's painting 'inspire' Wallace Stevens to write his poem "The Man with the Blue Guitar", which in turn prompts a David Hockney volume of illustrations. But the Stevens and Hockney are clearly different works of art, amounting to something different, as is guaranteed by their different embodiments. Yet, in turn, that guarantees a different 'aboutness' (or meaning) for each.

That neither chance nor accident really work to produce a relevantly similar 'appearance' suggests a way to deal with (say) forgeries—that they may reproduce the appearances in a *limited* sense (the one favoured by Sibley) but not in the sense relevant to artistic appreciation.

1.5 The Artistic as Sensuous?

In some moods, Danto too seems to urge that *sensuous* properties (as I call them) are artistically irrelevant, since two objects indistinguishable in purely sensuous terms might still be, say, one artwork and one 'real thing'. Hence "the eye is of no value whatever in distinguishing art from non-art" (Danto, 1994: 7). But the properties of artworks—although transfigured—do not fail to be sensuous merely by being crucially the properties *of artworks*. And these properties are central to art-status. Suppose, for example, that Picasso had rolled up a canvas immediately after painting it: we would know that it was an important *historical* object (having a certain social significance, etc.). But, unless we thought that any Picasso was automatically art, its art-status would be entirely unclear because the features of which we would then be

ignorant (roughly, 'what it looked like') must be crucial in resolving both art-status and artistic value. We cannot consider it until we consider *it*.

Rather, the artistic/aesthetic contrast works against a crude view of sensuousness by emphasizing the cognitive dimension in artistic (and some aesthetic) appreciations.[7] In fact, even (for instance) *seeing red* might be thought of in conceptual terms: it must be learned, for instance—and be contrasted with similar perceptual claims. Thus a child's mastery of the concept *red* would require his/her recognizing the contrast with, say, *orange*. Then (some) failures of perception here might be explained in terms of the lacking of concepts, as with the appropriate *category of art* for artistic cases.

Danto (1999) has imagined a case which clarifies (at least) what I take from his position. Returning to the gallery, he imagines that one of the 'red square' canvases is stolen. To conceal the loss, gallery administration displays (as the missing work) one of the others in the series. So now spectators take as, say, *Red Square* ([a] above) what is actually *Red Table Cloth* ([b] above)[8]. Here, the spectators *misperceive* one work—see it as though it were the other. And, of course, what is true of the one work (what its artistic properties are, or what 'aboutness' it embodies) will typically not be true of the other—as the descriptions of each sketched above illustrate.

Those who think that this misperception need not matter might argue that, somehow, the one work might be 'seen' by or through seeing the other (compare Eddy, 2001: 219). But we have recognized the problematic nature of thus identifying 'what we see' independently of what we are actually looking at: namely, *this* work, not *that* one.

Support for a suggestion of this sort might seem to come from pointing out that looking at a slide or photograph of *Guernica* (or perhaps even a bad copy) sometimes counts as looking at *Guernica*. Well, we *might* so count it; and might even do so in a discussion in philosophical aesthetics. But, in just those cases, our concern would only be with some of the work's artistic properties (indeed, at the crudest, the reproduction of *Guernica* on the wall of my office is a radically different size from the artwork). Looking at the work itself should certainly not be confused with looking at any of these 'avatars': one can only *really* see a particular painting when one looks at that painting. That is Danto's point in the gallery of indiscernibles: his innovation here is (correctly) transferring this recognition applied to reproductions (such as slides) and to forgeries onto the more profound case of other (different) artworks—even if/when we cannot tell them apart just by looking.

Suppose I use Danto's gallery as a teaching tool—moreover, being a cheap-skate, I decide to use just one slide to illustrate all four of the objects (the two artworks and two others). Given my usual fumbling with the slide projector, the students do not notice: hence, they take each new *image* to be of a new *object*. Looking across at the kinds of misperception available even in my slide-show (where one was never going to actually see the object under discussion) can be revealing. As with misperception of art, misperception here is at the level of 'what we see'—and can happen even when (as here) we do not actually see the objects.

Ex hypothesi, the students do not notice my using only one slide: and, after all, as I go along I read the title and/or description for each of these objects given above

(and, where appropriate, the critical comments)—I simply *misascribe* them so that three-quarters of the remarks are false of the object of which the slide *is* a slide. Of course, most of the remarks are (typically) false *of the slide*. Yet this small price is regularly paid in using slides in classes in philosophical aesthetics, and elsewhere: they offer the best I can bring to the classroom (typically), but without being the object itself. Moreover and relatedly, the object of which this *is* a slide has many (important?) properties not shared by the slide; for the artworks, at least, these properties will be important since they will be part of the *embodiment* of the work—of how the work's specific contribution is instantiated in just this object.

The students are mistaken in thinking they have seen slides of all the objects in Danto's gallery: hence they misperceive the slide as of (a) above, *Red Square*, when in fact it is a slide of (b) above, *Red Table Cloth*. And they misperceive it again (although differently) when—later in the class—they take it to be a slide of object (c), the prepared canvas, and object (d), the window blind. Of course, and to repeat, their misperceiving of it is of a piece with the (various) misperceptions of art, although what they misperceive is, itself, not an artwork. And the context 'instructs' them to invoke this art-context, at least in respect of (a) and (b).

So, in (mis-)taking just one slide for a depiction of all these objects, the students do not notice that the objects depicted differ in important ways—in particular, in having different *histories of production* and different places in the *history and traditions of art*, including no place. We have already commented briefly on the role of such history and traditions in our discussion of categories; the emphasis on a work's history of production is fairly obvious (Wollheim, 1978: 36–38; McFee, 2010b)— that, if you make one object (and hence are responsible for it) and I make another (with the same implication), different things will be true of each. This is just a fact about the idea of authorship.

Yet this case illustrates how mistakes about the various features of a *particular* artwork might be understood: when mistaking **X** for **Y**, I apply my understanding of **X** to **Y**—this is (typically) to misapply it. For what is true of the one is not true of the other. But this difficulty can often apply—as here—just as much to *representations* of the objects (such as our slide) as to the objects themselves. The students view the slide as exemplifying key features of the object, without mistaking the slide for the object. The possibility of confusion here leads some theorists to 'invent' a shared object, a 'look of the thing' in which all the objects participate; and hence is equally replicated by the slide. Or, at least, to write as though they believed in such a thing.[9] Then this seems to explain why slides of all four objects in Danto's gallery resemble one another so closely that I might trick my students by using one for all (were I not so scrupulous): they share this 'look of the thing'—they share what I have been calling "sensuous properties". Yet, in fact, this idea highlights exactly our problem: that objects (and especially artworks) not appreciably differing in these ways may none-the-less differ very substantially. This is why our general emphasis on the possibility of misperception, and on its implications, are so important for considering the nature of art: failing to grant this point is missing what is fundamental for our contrast.

But it does suggest that taking an artistic interest does not preclude giving due weight to the sensuous properties of artworks. For, as Peter Kivy (1975: 210[10]) once put the point:

> To describe something in artistic terms *is* to *describe it*; but it is to savour it at the same time: to run it over your tongue and lick your lips; to 'investigate' its pleasurable possibilities.

Moreover, the contrast operates perceptually. Recognition that, say, the painting was not one of "the paintings of a painter" (Wollheim, 1993a: 173) inflects our appreciation of it. Finding that a painting is by a chimpanzee, or one of our children, or even a famous politician[11] does bear on how the painting is regarded—and rightly so. For then one had been ascribing to the work either a meaning it could not have (natural object/'real thing') or one it lacked (mistaken category ascription). Further, our interest in the picture was other than artistic interest. Yet when the work was thought a Picasso, we were taking just such an artistic interest in it—or, at least, trying to: our interest could not be genuine artistic interest (since what we had before us was not an artwork *ex hypothesi*), any more than one can, say, genuinely remember what did not happen. Rather, our experience was of mistaking the painting for a Picasso; that fact is crucial for correctly grasping the experience it was.

Relatedly, on the view under discussion, ceasing to regard the work as, say, a Vermeer had no bearing on our appreciation of the work: at best, that would make a purely cognitive contribution to our knowledge *about* the work, even though it required re-writing of the history of art (since one might have to re-think the nature and extent of Vermeer's oeuvre and influence). This, too, both is false in practice and should be in theory—as our discussion of *categories of art*, among others, illustrated.

We can now explore briefly the trivializing consequences for the artistic/aesthetic contrast of (genuinely) ascribing aesthetic properties to artworks. For how would one urge this position? At the centre of its defence is that what is shared are treated simply as sensuous properties. Yet then the argument closely resembles Sibley's, concerning what is relevant here (namely, 'appearance'). This equivalence to Sibley's view shows that such a position does not really endorse the artistic/aesthetic contrast.

Notice that one might continue to find an object beautiful, say, even after discovering either that it was not the artwork one took it for (when one did) or that it was not the 'real thing' for which one took it. And of course one might value an art-object (say, a painting) as one valued wallpaper: both are attractive wall-coverings. But doing that for the artwork is not continuing to regard it as an artwork, since this is not consistent with so regarding it.

1.6 The Ambiguity of Artistic Properties

Thus advocates of a serious artistic/aesthetic contrast must reject these visions of the aesthetic, despite any initial attractiveness. But what must replace them? And how might it be explicated (and justified)?

At its most provocative (see Section 1.3 above), my thesis is that (Sibley-esque) "aesthetic predicates", such as "gaudy", are *systematically ambiguous*: that their uses applied to artworks amount to something very different from those uses applied outside art. Indeed, my claim is that respecting the artistic/aesthetic contrast requires just such a move.

Suppose (as our 'intuition pump') a meteorite that just happens to be indistinguishable from a Henry Moore[12]: which are candidate predicates (from a list supplied) for each? Well, clearly the predicate "witty", and any others that imply *intention*, are candidates for the Moore only. (Of course, they might be false of it: yet they *could* apply.) Then, when we come to, say, "graceful", it seems implausible that the *grace* of each is not somehow different: one is *intended* grace, for instance; or grace *within* (or *against*) a tradition. So that calling each *graceful* does not amount to 'saying the same thing' of each: the one recognizes, as the other could not, the impact of *art-status*.

For why is the concern with *art*? What question is being addressed when artistic judgement is invoked? Our answer rests on recognizing the contribution to understanding, in this context, of *artistic* concepts, especially given their relation to *categories of art*. Such features will be stressed by drawing our distinction: within some *category of art*, certain properties will be standard- and others contra-standard; the object will have (non-monetary) value in ways similar to, and of kinds similar to, other artworks; and so on. Then these are, as it were, predicted by us in characterizing the work as art: they are our expectations here, and their fulfillment must lie in *artistic* appreciation—acting otherwise is breaking the connection between what we *mean* (in saying something) and what we *do*. Then, we are here applying artistic concepts. So what are the key features for applying (or misapplying) the relevant concepts? For these features will be important in drawing our distinction. This insight should refer back to our earlier discussion of *gaudy* as ascribed differentially to artworks and to aesthetic objects.

So that, roughly, the property ascribed to the painting is not best understood as "gaudy" *tout court*, but rather—drawing on the appropriate *category of art*—amounts to "gaudy for a Fauve"; and here one might continue, "... but not gaudy for a Vlaminck", and so on. That is, artistic judgements are implicitly comparative, sometimes within a narrow range. Thus, "[a] failure and a success in the manner of Degas may be more generally alike ... than either is like a successful Fragonard" Sibley (2001: 7). So there is "an intentional connection to preceding art, however provisionally identified" (Levinson, 1996: 151). Here, the appropriate *category of art* supplies the specific understanding of, say, the term "gaudy" in this context.

When that category is implicit (or explicit), one knows what *gaudy* here amounts to—and when *this* (before one) is acknowledged as an artwork, but the appropriate category not known, one will draw on concepts already mastered: indeed, this is precisely how an atonal work might be misperceived as tonal. One will, say, "adapt a group of expectations and assumptions, formed in considering one group of works [of art], to consider another group" (Podro, 1982: xv). If done explicitly, this might be 'contextual criticism': if I do not notice, or if I do it because I have no other resources, it is likely to result in category-confusions. So here 'the appropriate

sense' should be (a) context- or question-specific: what kind of issue is this? and (b) a feature of this category—that is, as standard, non-standard or variable for this category.

More exactly, of course, the terms shared by artistic and aesthetic judgements are not 'systematically ambiguous' at all: talking that way puts exactly the wrong weight on language. Rather, two points (one general, one specific) should be recognized. First, the general thesis: that these terms make various contributions to the judgements in which they occur, answering different questions (which roughly means having different *uses*), exhibiting *occasion-sensitivity*.[13] The effect, then might be mistaken for systematic ambiguity since, applied to our case, it highlights the different contributions of "gaudy" (or "beautiful") on different occasions. To see this idea in operation, consider the contribution of colour-shades, stains, holes, fading and such like that would permit correctly asserting on one occasion that a particular curtain was *red*; but where, on another occasion, that same combination would make it false that the curtain was red, given who now was asking, or the interest in redness on that occasion. So these different occasions set different constraints on the redness of the curtains. As Austin (1970: 130) noted:

> The statements fit the facts always more or less loosely, in different ways on different occasions for different intents and purposes. . . . And even the most adroit of languages may fail to 'work' in an abnormal situation.

So one cannot explain 'what was said' divorced from some context or utterance, or some occasion of speaking.

But also, second, the specific thesis: that there will be a 'lining up' of uses, such that these are concerns characteristic (either) of art or of aesthetic interest. For the artistic, this 'lining up' is organized by/around the *categories of art*; for the aesthetic, it will be more complex, since there are far more uses to consider.

Is such a position defensible? Certainly, it must explain how the same word occurs in both artistic and aesthetic judgements, without amounting to the same thing. This may not be easy. But such a conclusion should be sustainable in a philosophy of understanding where *occasion-sensitivity* plays a crucial role (see Chapter 2).

1.7 An Example: The Case of Marla

In October, 2004, the *Observer Review* published an account of what it claimed was the "latest phenomenon to hit the New York art scene" (Wood, 2004: 1). Although phrased as a comment on the art scene, not the real world of art, we are soon squarely into the artworld: the work under discussion has "already been compared to Pollock, Miró, Klee and Kandinsky" (Wood, 2004: 1)—and, as the article implies, these comparisons take place in the sphere of art. These "large-scale abstract works" (Wood, 2004: 1) are of interest to us because they were produced by Marla Olmstead, then a 4-year old. What might be made of this?

Three points must be granted immediately. First, as presented, this is not a case of objects *mistaken* for artworks. That Marla has "shown her work in an art gallery" (Wood, 2004: 2) is not decisive, since sometimes objects other than artworks are displayed in such galleries. But the article tells of a collector of Monets and Renoirs—hence, someone with some understanding of art, perhaps—who, asked what he saw in the Marla he bought, remarked "her soul" (quoted Wood, 2004: 2). That sounds like what one might say in relation to art, but not in relation to, say, a work by a chimpanzee which one *mistakes* for art. Second, the possibility of artistic prodigies should not be rejected out of hand: such cases are familiar for music (say, Mozart) even if "in . . . [painting] you don't have prodigies. There is no such thing as a Mozart" (quoted Wood, 2004: 2). Perhaps, at the least, one should not foreclose on that possibility absolutely, but explore its likelihood. Then, third, the article discusses how Picasso thought that a childlike naive quality was central to Matisse's work, and how for Rothko (as for Ruskin) an "innocence of eye" one might associate with children was important for artists. Even supposing these claims are true, they actually provide support in the other direction: in (adult) artists, preserving a childlike innocence may be commendable, but it cannot be so *in a child*! Or, better, if this is all that is being said, it is not after all an artistic matter. Rather Marla's painting would have roughly the same logical status as the African masks which inspired Picasso: something there connected to art, once seen by an artist, although the objects themselves were *not* artworks.

At least arguably, this concrete case is the real-life counterpart of one Danto envisaged (see Section 1.2 above): the tie painted blue by the child. Of course, the paintings of Marla do not replicate visually those of extant artists. Nevertheless, they are taken as the work of a "world-famous Abstract Expressionist" (quoted Wood, 2004: 1). But any apparent difficulties this case might cause for one's account of art can be put aside, by deploying the artistic/aesthetic contrast: one could urge that, however attractive Marla's paintings were, their interest was not (and could not be) artistic interest. One *could* say that: but why *should* one?

Three (related) factors weigh heavily with me. First, considerations from Danto's gallery of indiscernibles show the irrelevance of the contrary position. Imagine an opponent asking, "What is so good about these daubs?". We know this is the wrong question, for the look of the paintings cannot absolutely decide their art-status. So urging, "Well, Marla's paintings look like masterpieces of Abstract Expressionism" (even supposing this to be true) is beside the point: we know enough about these paintings to raise doubts that they were *intended* as art, having a place in the *narrative* appropriate to Abstract Expressionism, understood in terms of its *categories of art*. The substance of our argument would be that a 4-year old could have mastered neither those narratives, nor that set of categories. Moreover, any counter-argument urging that Marla has this mastery just says that she is (after all) a prodigy, since then her claims to artist-status would be exactly those of other candidates. And one might need a fair bit of convincing that this was so.

Second, how might Marla's work be accommodated into the contemporary "lay of the artworld" (Carroll, 2001: 91), since it cannot be achieved simply via their 'look'? Given the differences between this case and more standard cases (noted

above), the burden of proof here lies with those who claim that Marla's work actually fits into some contemporary narrative of art-history. Of course, at best its advocates might show this to be arguable—yet that is enough. But what might that argument be? Well, parallel arguments for other candidate artists are not made out in *one* form only. So we should not expect that. Rather, one might, say, explain that the painter *chose* to paint in this style, from mastery of others (Picasso' Cubism); or that the artist had a conventional training in art, despite his current preoccupations (Damien Hirst and the shark); or that the artistic vision was in marked contrast to that current, and hence explicable in terms of it (Turner, on one reading). Of course, arguments of this kind cannot deal with all cases: in particular, naive artists seem problematic— Henri Rousseau, for instance, for whom none of these explanations seems plausible. But there at least one has the distinctiveness of the vision, together with the thought that Rousseau *chose* when to call the paintings finished (that he was clearly an *agent* in respect of them). Yet such an argument for distinctiveness is weakened when combined with the idea that Marla's works are Abstract Expressionist: that already supports a counter-charge of derivativeness, of the kind that (say) might be made of a copy. Moreover, it is clearly much more difficult to see a 4-year old as an *agent* in respect of important choices—a fact our legal system reflects. Of course, the possibility of answering these challenges cannot be ruled out in principle. But we see how difficult it might be in Marla's case.

The third factor clarifies a feature of artworks plausibly lacking in this case, although one difficult to express exactly. Roughly, it is that emotional content or engagement of the kind that the work *would* have—were it an artwork—is not plausibly among the emotional responses of a 4-year old. (And, of course, prodigy-status could again be granted just in case these demands were met.) For example, it makes sense to think of Rothko as exploring just what Wollheim (1973: 128) finds in one of his works: "a form of suffering and of sorrow, and somehow barely or fragilely contained". For this is a mature, adult emotional response. Is this plausible for Marla? We are not, of course, asking if these ideas *could* (much less if they *did*) go 'though her head'. Instead, the question is whether ascription of them *to her* makes sense. And my answer is that it does not.

Another Abstract Expressionist-manqué might generate less enthusiasm, but her work would be easily accommodated as constructed under the concept *art* and as in the *category* "Abstract Expressionist". Locating *this* body of work in the context of the rest of contemporary art might be the best way to make sense of her achievements. To use such an account for Marla, though, at best treats her simply as a prodigy; and, given the giants of Abstract Expressionism (starting with Pollock and Rothko, perhaps), a pretty minor one. So, on this understanding, the level of praise for Marla recorded in our source-article seems odd.

Further, that text does not make out the argument for Marla in terms of her distinctiveness or originality. Instead, she is presented as ploughing a well-worn furrow, a practitioner in an established 'craft'. Again, there seems no special basis here for any claims to artistic value. Then the only distinctiveness would lie in her youth (were her mastery of the craft at that age established). Yet that highlights again problematic areas already noted: can the relevant emotional engagement be granted

to these works (supposing them to have one) while conceding that their author is a 4-year old?

Moreover, it is not irrelevant that the style the critics ascribe to Marla, Abstract Expressionism, is both a style from the (now fairly distant) past and one where, all along, critics urged, "a 4-year old could do this". A sceptical viewpoint here might suggest that the claim to art-status of Marla's works remains as yet unarticulated: how could a convincing case be made out? We have already highlighted how few of the standard resources are available—one cannot readily and uncontentiously cite originality, nor mastery of the history and traditions of that artform/genre, nor the profundity of the insight (since this would be highly contentious for a 4-year old), and so on. We cannot, of course, cite the sensuous or material properties of the works, such as their combinations of colours, or textures, or pigments. For, at one level, these could all be shared by non-art objects (as Danto's gallery shows us); at the other, their whole nature as *artistic* properties (when this is granted) depends precisely on what is at issue: namely, on whether these are indeed artworks.

Hence the interest of Marla's work (such as it is) is not artistic interest. That idea, if granted, is at best arguable—it might still be contested, however much I doubt that. And such contest is the life blood of a vibrant artworld. Further, the judgement is institutional: the current judgement of the artworld (as I have reconstructed it) might be overturned (see Chapter 6). Then that fact reflects the historical character of art for, if it were to be overturned, the outcome would then be that Marla's work was *always* art—hence that it is now.[14]

1.8 Exploring the Contrast: Methodology

This chapter aims partly to explain, partly to motivate the artistic/aesthetic contrast as I see it—in this way, to persuade the reader of the wisdom of marking such a distinction here. Acknowledging the artistic/aesthetic contrast in this way means that one's account of *artistic* experience has a connection to the cognitive and to human value different from that for *aesthetic* experience. This will typically be true even when the same form of words expresses both artistic judgements and aesthetic ones: our example was the term "gaudy". Indeed, my argument has been that, for the distinction to be maintained, key terms (for instance, "beauty") *must* amount to something different in these two cases. Further, *occasion-sensitivity* was offered as my explanatory tool. Can one say more, in the abstract, to identify the contrast more exactly? One might think not: that any comments would always be more specific, relating to *this* artwork in *this* context.

Consider the issue of generality for such a contrast between the artistic and the aesthetic: even if what is urged is true for some artworks, is it true for all? In answer, one might look for (or hope for) a technique which, on a parallel with mathematical induction, allows one to move from one case to successive cases; and hence to all cases. Such a hope is vain, at least for those of us who grant the impossibility of

conditions for arthood individually necessary and jointly sufficient: first, no discussion *could* deal with *all* cases, since there was/is no finite totality of such cases to consider—the historical future of art ensures that; second, no transcendental argument *could* be produced because its possibility *assumes* just that finite totality of cases (or kinds of cases).

That tells us something about the possible form of any 'solution' here. For *that* assumption of a possible 'neat' answer was an error of a kind common throughout philosophy: the 'hope' for something concise yet comprehensive reflected a "craving for generality" (BB: 17) inconsistent with my more general philosophical commitments. Instead, as John Wisdom (1965: 102) remarked, "at the bar of reason, always the final appeal is to cases". In recognizing the philosophically *fundamental* character of such cases, this comment rejects the "contemptuous attitude to the particular case" (BB: 18) sometimes taken in philosophy. In effect, there are two connected points here. The first emphasizes the practical role of examples or cases: they are all we have to turn to—and they prime our 'intuition pumps'. But does this suggest that appealing to cases or examples is second-best; that some general claim would be preferred "if it could be got" (Bradley, 1969: 506)? On the contrary, Wisdom's second point recognizes that cases provide the strongest 'arguments'—in fact, they are what our formalized arguments are answerable to.[15] So the cases are not deployed in *default* of something better but because, logically, *there could not be* anything better.

In effect, then, one must attempt, ultimately, to resolve any issues by giving (and discussing) examples; in particular, showing how apparent counter-examples could (and should) be treated. But four general difficulties for this use of particular examples should be noted:

- any example is just an example: it can be contested without contesting the point (especially when the example is merely sketched);
- if examples are located in the writings of critics (an obvious strategy), which critics are selected? (The worry here is that one gets the result *just because* one uses certain critics);
- such examples seem to imply the *unitary* character of artistic meaning, even when denials of any such commitment to the idea of *the* meaning have been issued (UD: 115; CDE: 97);
- since examples of the ascription of meaning or value typically relate to the work as a whole, they are too long to give fully. So those in philosophy texts can only be "a fragment of" or "features towards" such an account: but anything less than a fully-worked example must seem less compelling.

In addition to *general* problems about identifying suitable examples, a further problem follows from (at least) my view of the project of philosophical aesthetics. For, on that view, accounts of the meaning of artworks must always be *strategic* (to answer a particular person's perplexity, perhaps in a particular context), and *complete* if the account does so (Baker and Hacker, 1980: 79–81). Hence, a *complete*

account in *this* context, satisfactory for me, might fail to be convincing for you—might fail to address your perplexity (especially puzzling when both perplexities are expressed in the same form of words). Thus the difficulty of giving *specimen* examples of such explanations is really the difficulty of giving explanations of artworks *in the abstract*, where this means 'abstracted from actual perplexities'.

The pervasiveness of the influence of the artistic/aesthetic contrast is not widely appreciated. Recognizing that contrast bears on what one can (and, more especially, what one cannot) say about the nature of both artistic properties and artistic value. For drawing the contrast involves (typically) saying something different about *art* from what one would have said about (other) objects of aesthetic appreciation. In any case where this is true, drawing the contrast involves a difference from those who fail to draw it (or neglect to draw it, or deny it [implicitly or explicitly]). Further, drawing the distinction admits the possibility of distinguishing cases that, without the contrast, would probably be treated in the same way.

1.9 Outline of This Work

In beginning to sketch my framework for philosophical aesthetics, I have aimed both to explain and to motivate the artistic/aesthetic contrast, and to insist on its centrality within philosophical aesthetics. In doing so, I invoked *occasion-sensitivity* to explain how to dodge one apparently deadly 'bullet': that notion is expanded in Chapter 2, which also illustrates that artistic understanding is the province of *competent judges*, with such understanding the sort of thing can be learnt without necessarily being able to say (other than truistically) what one thereby learns.

I have also urged that artworks are *transfigured* objects, with artistic properties generated in the transfiguration. Chapter 3 then explores the distinctive kinds of meaning that follow from an object's being transfigured into art, since this meaning (or, better, understanding) is what artworks have and 'real things' lack. In particular, the chapter investigates the connection to human life and valuing which offer art the possibility of having the distinctive (non-monetary) value characteristic of artworks (again, in contrast to 'real things'). Here, the aim is to defend an account that applies to *all* art, using some (necessarily more partial) contemporary accounts of art—especially moderate moralism or ethicism—to reduce the sting of implausibility. This chapter also defends our case-by-case response to apparent counter-examples.

Since artworks (as something *meant*) are centrally the products of human intentions, Chapter 4 aims to better understand artistic properties. Hence it turns to the topic of such properties' *reality*, acknowledging its connection to the intentions of artists operating in contexts. Given the importance (in these ways) of artistic meaning, how does such meaning relate to particular artworks? In particular, is it a fixed property of those works, unchanging over time? The argument of Chapter 5 defends a "no" answer against some of its critics, exploring and elaborating what (following Levinson, 1990: 197) is called *forward retroactivism*, on which later changes can alter artworks' meanings.

Then Chapter 6 stresses the connection of artistic meaning both to the artist and to the artworld which acknowledges his or her achievements: in this sense, it offers a (weak) *institutional* account of art, contrasting the place of artworks—within this institutional framework—with that of the 'real things', necessarily outside it. Further, a real, if limited, explanatory benefit of such an account is urged: that the artworld is a pre-condition for art. And our discussion of Marla Olmstead (Section 1.7 above) has already illustrated (if briefly) the recurrence of the topics of Chapters 5 and 6 in a real case.

So, on one hand, the account the nature of artistic properties should flow from acceptance of the artistic/aesthetic contrast (in my version): hence, each chapter should explore some aspect or theme there. On the other, our engagement with these properties should elucidate that very contrast, so as to produce a coherent (as well as attractive) view of the nature of art.

1.10 On Not Defining Art

Given this plan, it may seem odd that this work contains no explicit discussion of the definition of *art*. But I am sceptical of the possibility of such a definition. For suppose (which I doubt) that an account of art concisely and comprehensively characterized *extant* artworks: could it be *guaranteed* to deal with future candidate artworks? Now, the context of the discussion of the artistic properties of extant artworks is given by the present history of art: if you like, by our current *narrative* of art. Since we cannot know the impact of these (hypothetical) *future* works on that history, we cannot guarantee their consistency with it. But just this would be required of our (candidate) definition.

More importantly, the absence of a definition here is not obviously a deficiency. An interesting illustration might come from the putative definition of "game" offered by Bernard Suits (1978: see SRV: 17–31). Suppose (what is false) that Suits' view offers an accurate definition of "game": where would that leave those of us who did not know it? Surely we cannot have remained ignorant of *what games are* until Suits (or whomsoever) told us? Certainly, the philosophical investigation of games and gamesplaying cannot require making explicit what, in fact (prior to Suits, say), *no-one* knew. So the project of *philosophy* cannot involve the articulation of hidden definitions, discoverable only through (logical) analysis of some kind—at least, it cannot do so if that definition of (say) *art* is supposed to connect to our actual practice of discussing and appreciating art, for (*ex hypothesi*) we do not know, and have not done, that analysis. As Wittgenstein had long insisted (WWK: 129f.), we understand our sentences without being able to give a (logical) analysis of them—so logical analysis cannot tell us what (if anything) we mean by our sentences. Indeed, philosophers do not automatically understand a particular English sentence better than (other) native speakers (PR: 118).

Further, there is a solid reason for this 'omission' of a definition of *art*. To bring it out, one could look to general reasons for philosophy's not wanting definitions,

either in general or for art (see McFee, 2003a). One difficulty for such a proce-
dure is that no properties or features seem shared by all artworks. But the need for
a broadly 'exceptionless' account might still be urged. Further, attempts to gener-
ate such an account take many forms. It is unrealistic to hope to address them all.
So, here, some points are extracted from one such candidate for a comprehensive
account of art. Berys Gaut considers ten 'criteria' each of which, he notes, is shared
by some artworks but not by all. His solution is to urge—in contrast to what he
calls a "resemblance-to-paradigms" account of art's character—that *art* is a cluster-
concept, with these features (or some like them) instantiated in typical artworks.
The list of 'criteria' is:

> (1) possessing positive aesthetic properties . . .; (2) being expressive of emotion; (3) being
> intellectually challenging . . .; (4) being formally complex and coherent; (5) having a capac-
> ity to convey complex meanings; (6) exhibiting an individual point of view; (7) being an
> exercise of creative imagination . . .; (8) being an artifact or performance which is the prod-
> uct of a high degree of skill; (9) belonging to an established artistic form; (10) and being
> the product of the intention to make a work of art. (Gaut, 2000b: 28)

Once condition (1) is modified so as not to prioritize aesthetic features in ways *prima
facie* inconsistent with the artistic/aesthetic contrast, I grant that putative artworks
all meet at least one of these ten candidate conditions, as Gaut lists them. But might
some general condition (say, *aboutness* in Danto's sense) be articulated in a number
of these ways? For instance, 'criterion' (4) stresses *coherence* (that is, a normative
condition) as well as complexity: that might be made sense of against a background
of the work's *aboutness*. Then is Gaut like the learner driver who insists that there
are a great many occasions in which one might use one's mirror when driving (say,
when pulling out from the kerb, when slowing down, when changing lanes, and so
on) and Danto perhaps like the driving instructor who insists that there is only one
such occasion; namely, when changing speed or direction? (Although I shall not
pursue this line of argument directly, it suggests another problem for any *obvious*
attempt to enumerate 'criteria'—one must show, additionally, that one's account is
economical, in not 'double counting' conditions or 'criteria': that is far from easy.)

 Next, is Gaut's list of ten candidates complete? For Gaut (2000b: 29), these are
only "good prima facie candidates", conceding that others "may wish to dispute
these particular criteria, or add others". That these are just "some properties the
presence of which ordinary judgement counts towards something's being a work
of art" (Gaut, 2000b: 28) implies that *some* candidates might not have made this
list. But, in that case, what exact force attaches to Gaut's claim for a *single* cluster
account of art? He could instead simply say that, for some works on some occasions,
features of these sorts may/will be important. For it is very difficult to know whether
conditions (1) to (10) are a *cluster* uniquely identifying artworks (assuming that the
aim is the *unique* identification of artworks) without being sure what is, or is not,
in *the* list of conditions or 'criteria'; and especially difficult to comment on the
inter-relations (if any) among the candidate 'criteria'.

 In explanation, Gaut (2000b: 27) highlights three conditions which (he urges) a
cluster-concept must satisfy: the properties must be jointly sufficient; no properties
must be individually necessary and jointly sufficient (except perhaps the whole list);

and the properties must be disjunctively sufficient. But how can one know, in this case, if these conditions are met? For we are sure neither of all the 'criteria' nor of all the cases to be addressed (as candidates for arthood). Further, do these conditions offer some reason to be glad that, say, art *is* a cluster-concept, as opposed (for instance) to lacking any general analysis of this sort?

In reply, Gaut exploits three methodologically-motivated considerations: he urges that the account of the concept "should be *adequate to intuition*" (Gaut, 2000b: 30, his italics); that it "must be *normatively adequate*" (Gaut, 2000b: 30), in the sense that, where our intuitions differ from others', there should be some form of explanation of (roughly) the others' mistakes; and it "should have *heuristic utility*" (Gaut, 2000b: 31), so that it figures "in true or at least promising theories about the concept to which it applies" (Gaut, 2000b: 31).

A version of each condition might be met without the assumption of some under-lying unity for the concept, especially since the full candidate list of 'criteria' is lacking.[16] For concrete cases would accord with our 'intuitions' about them if, as is obviously true, some of these 'criteria' or properties were shared by all the artworks one initially thought of—although not, of course, by *all* artworks. Also, counter-cases to any 'criterion' are findable—Gaut (2000b: 31–32) himself offers plausible candidates for such counter-cases here, at least for most 'criteria'. And, in addition, we cannot readily add to the list, since no basis for generating new members is provided. Moreover, the same conditions support the *normative adequacy* here: roughly, those who disagree have over-stated one or other of the 'criteria'. In particular, we should recall that, for Gaut (2000b: 29), these are "preeminently" for artifacts constructed under the concept *art*—hence opponents might mistakenly offer non-art objects as putative counter-cases. (Of course, adherents of the artistic/aesthetic contrast are familiar with this kind of misunderstanding.) Further, one can imag-ine claiming the *heuristic utility* of the account if one believes, with Gaut (2000b: 40–41), in "the attractions a cluster account possesses as a guide for philosophical aesthetics", taking this to exemplify "how analytical philosophy of art can still be fruitful". (Clearly, showing that as genuine fruitfulness, rather than a placebo, would be a huge task—but one equally problematic for other accounts of philosophy, such as mine.)

Given, then, that the conditions Gaut draws up can (apparently) be satisfied in this way, is he correct in taking *art* to be a cluster-concept? Our answer should be "no", for three reasons. First, the power of cluster-concepts to provide *heuristic utility* is less than Gaut imagines. Instead the idea raises once again fundamental questions about the place and useful of definitions, or some such, within philosophy. In particular, it seems to assume that the individual items comprising the cluster are clear, and clearly bounded (as well as clearly differentiated). But how is this to be achieved? A broad commitment to definability and definiteness might lead one to expect some account of this—the question cannot simply be ignored. Yet, if each individual element in the cluster absolutely requires a (traditional) necessary-and-sufficient-conditions definition for its integrity (in line with the demands of definiteness), it will be odd if the whole 'cluster' does not. Or, if the 'cluster' does not require such a definition, it seems odd to insist that the elements do. In this way,

the internal stability of this conception is undermined. For what unites the cluster? For this reason, the idea of a 'cluster concept' is indeed as mysterious as its critics find it.

Second, the forms of argument Gaut mentions can never conclude that art is a cluster-concept, as opposed to highlighting that one has no need to address the question to which the cluster-concept account offers an answer. Or, to put that another way, there is no need (in philosophical aesthetics) for a unified account of art of *this* type. Of course, one part of our argument involves acknowledging that, for all the concessions above, one might be doing no more than listing a bunch of individual-sounding conditions: some clearly apply to some artworks, others clearly apply to others. To show that this is indeed a cluster-concept, Gaut must show how one could be sure that all (and only) the crucial 'criteria' are in our list; and *then* that they met his requirements. But, doing this requires showing that *all* possible art-objects meet at least one of his set of 'criteria' (expressed in the most concise fashion); further, that any future work that failed to do so (on any future 'reading' of the history of art) would *for that reason* not be an artwork; moreover, that any future work which met some (and especially all) of these 'criteria' was therefore bound to be a work of art. All of these seem (to me at the least) impossible. But the last requires special comment. For Gaut (2000b: 28) rightly notes that circularity as such is not damning, provided such accounts "are informative". Now, what is the point of using the language of *definition* (of conditions individually necessary and jointly sufficient) if one wants to tolerate circularity (see also Section 6.4)? Be that as it may, the condition under discussion can, of course, be made true simply by reading "artistic" (in parentheses) into the text at an appropriate place in each condition—so it would be, say, "(2) ... (artistically) expressive of emotion", or "(9) belonging (artistically) to an established artform". For us, this will be crucial: once these conditions are 'read' as transfigured then each will indeed be (individually) sufficient for art-status; but only because (on our account) the transfiguration involves the applicability of artistic properties. So it would be made correct by fiat. Yet, again, this cannot be Gaut's position.

Then, third and relatedly, the path to Gaut's conclusion requires considering in detail one's reason for wanting such a unified account (say, reasons in one's conception of philosophy). To begin, as Gaut (2000b: 25) does, from those (like Weitz, 1977: 26) who argue that the concept *art* lacks such a definition seems just to dispute 'the facts of the matter' of the public deployment of the concept: are there in fact conditions constraining (or 'closing') the concept *art*? With just what justification is Weitz (say) operating? This remains unclear. Then others (such as Kamber, 1998) can be forgiven for hoping to explore the topic empirically. If Weitz offers a thesis about how the concept functions (like Waismann's talk of the *open texture* of some concepts[17]), one might still wonder how this is determined.

Of course, Weitz (1977: 31–34) famously appeals to Wittgenstein's discussion of the concept *game* (PI §§65–67[18]). But his account misunderstands Wittgenstein. As Brand (2000: 175) rightly points out, and I argued elsewhere (McFee, 2003a), Wittgenstein's primary achievement was not just to show that certain terms (the term "art" among them) were not amenable to definition, where definition is understood

as the giving of conditions individually necessary and jointly sufficient—although he did show this too (compare UD: 16–21). As Gordon Baker (2003: xxxiv) accurately recognizes, the arguments in "*Philosophical Investigations* §§65–142 are concerned with the prejudice that there *must* be a general form of the proposition": that is, not with the question of whether, as a matter of fact, there was one (or not). Rather, Wittgenstein's main point was that the search for such definitions, and the conception of definiteness in language that underlies that search, is neither the centre, nor a major part, of the project of philosophy. Understood this way, one can see why a text on philosophical aesthetics (such as this) should give no space to the issue of how to define the terms "art" and "artwork".

Notes

1. Following David Best's technical use of these expressions: Best (1978: 113–116, 1985: 153–154, 1992: 166–172).
2. Danto's version of his key question (Danto, 2000: 131):

 > Given two things which resemble one another to any chosen degree, but one of which is a work of art and the other an ordinary object, what accounts for this difference in status?

 Notice (a) "to any chosen degree"—complete indistinguishability is not required; (b) the assumption (shared here) that this possibility is unproblematic.
3. The locus classicus is Goodman (1968: esp. p. 111).
4. The contrast between kinds of art that are particular and kinds that are multiple is dismissed as merely a "practical limitation" in Strawson (1974: 183–184).
5. Borges' literary fantasy "Pierre Menard, author of Don Quixote" (Borges, 1962: 42–51) instantiates the relevant case. As Borges imagined the case, difference in authorship (in 'history of production') between two artworks makes them distinguishable for artistic purposes: for instance, the later work is mannered in a way the earlier could not be.
6. Compare Beardsmore (1971: 17–18): of course, Dickens' novels (say) might be sufficiently similar for two of them to share *something* of the same 'aboutness'.
7. Danto cannot take this line, given his conception of role of any conditions he identifies: finding that X is sometimes not relevant is taken to show it never is.
8. Danto's example is different; but the differences are not germane.
9. Such a thought might begin from a remark by Lyas (1997: 18):

 > It is because we are struck by rainbows, entranced by fictions, moved by rhythms, unsettled by certain colour combinations, that we developed the words and behaviour that articulate aesthetic responses.

10. Rectified for the artistic/aesthetic contrast: see also McFee (1997: 31–46).
11. Examples from Wollheim (1993a: 173).
12. This is the 'Moore than a meteorite' discussion in Ground (1989: 26).
13. See Chapter 2: and Travis (1997, 2008: 94–108; 109–129). Also SRV: 48–52. (The phenomenon is also called "speaking-variability".)
14. This only seems counter-intuitive if one lacks a robust sense of "forward retroactivism": see Chapter 5.
15. As Lewis Carroll ([1894] 1973) argues, purely formal constraints must be *seen* as compelling; and even recognizing contradictions is not, typically, a matter of simply finding certain syntactic structures.

16. There can be no finite totality here, of the kind that might (say) be listed (see Section 2.2; FW: 121): hence, Gaut's ten 'criteria' cannot be thought *part* of the full list—there is no *full* list!

17. The use of an open-textured concept "was *always* corrigible or emendable" (Waismann, 1968: 42)

18. Although the fourth edition of PI (Wittgenstein, 2009) differs from some others in its translation of remarks, it has not been used here: however, its treatment of (the former) Part Two as a separate work is respected when relevant.

Chapter 2
Art, Meaning and Occasion-Sensitivity

In Chapter 1, the contrast between the artistic and the aesthetic was assumed, while trying to motivate it. But could that contrast plausibly be denied? To be clear, my argument (repeated in various forms throughout this work) is that denying the contrast must involve denying the concept *art* (at least, on more than a sociological understanding of that concept), because the artistic/aesthetic contrast brings out the distinctiveness of the concept *art*. At the least, philosophical aesthetics can reject neither the concept *art* tout court nor the distinctiveness of artworks (compared with other objects of aesthetic interest), although it is granted on all sides that objects other than artworks can be beautiful, can reflect their authors' ideas, can be expressive in some sense (see Lyas, 1997: 103–105), and so on. That is, at first sight no list of properties seems uniquely applicable to artworks. But this conflicts with our sense of the distinctiveness of the artwork (compared with, say, wallpaper: see Section 1.1); in particular, with our sense of the artwork as valuable (in a non-monetary fashion) in ways not available to, for instance, that wallpaper.

How can this kind of distinctiveness be made out? As we saw (Section 1.2), a typical appeal is to the concept of (artistic) *meaning*: that is, to a conception of artworks as meaning-bearing in a distinctive fashion. This involves endorsing the most extreme corollary of the artistic/aesthetic contrast in my version (namely, that artistic uses of a term amount to something different than aesthetic uses of the same term). At the centre of the explanation here is our *occasion-sensitive* picture of understanding, and hence of meaning, sketched below—a key methodological insight for the whole text.

In this vein, Danto (1997: 195) offers *aboutness* and *embodiment* as two features characteristic (indeed, as necessary and sufficient conditions) of art-hood: "[t]o be a work of art is to be (i) *about* something and (ii) to *embody its meaning*". Since his account of meaning (or of *aboutness*, as he calls it) at least parallels that developed here, let us sketch it briefly. First, (familiarly) with "confusable counterparts" like those from his gallery, "at least one of the counterparts is *about* something, or has a content, or a subject, or a meaning" (Danto, 1981: 139): this one is the artwork, "'aboutness' being the crucial differentiating property" for artworks (Danto, 1981: 3, 81). Another object from the gallery is not *about* anything "but *that* is because it

is a thing, and things, as a class, lack aboutness just because they are things" (Danto, 1981: 3). As Danto (1992: 46) puts it:

> The artworld is the discourse of reasons institutionalized, and to be a member of the artworld is, accordingly, to have learned what it means to participate in the discourse of reasons for one's culture.

Thus one learns this, roughly, in learning 'how to go on' (PI §151, §179) in art. And one learns mastery of this contrast.

Second, Danto (1993: 200) made clear that artistic meanings are "of *that* particular object". Of course, recognizing differences among the 'aboutnesses' of those "confusable counterparts" (Danto, 1981: 139) can be acknowledging that 'aboutness' differentially embodied: that is why the 'aboutnesses' differ (for objects having them) even when they are confusable counterparts. In addition, Danto (1986: 9) sees criticism, as he practices it, as "finding out how the ideas expressed in the works I discuss are embodied in them". Further, "central to the identity of works of art was their historical location" (Danto, 1986: xi): such a historical location yields a unique *embodiment*. Moreover, stressing the particular instantiation of that meaning in artworks (hence, their *embodiment*) recognizes that these artworks amount to something other than any recapitulation of them (say, in words).

We part company with Danto in three related ways. First, Danto is searching for conditions individually necessary and jointly sufficient: that is, for a definition. His project begins:

> ... the task of framing a definition of art, ... [laying out] a few conditions for such a definition which aim to be universal, addressing art as art, whatever its provenance or situation. (Danto, 1999: 5)

Now his book at best "ekes out two conditions", since he "was (and am) insufficiently convinced that they were jointly sufficient to have believed the job done" (Danto, 1997: 195). But he is convinced that this was the job! By contrast, here the conception of philosophy that requires (or values) such definitions has been put aside. Second, more must be said about the relation of 'aboutness' to artistic *value*. Third, Danto does not recognize *occasion-sensitivity* (or speaking-variability): for us, it is crucial for any understanding of the project of philosophy, as well as having a role in our account of the distinctively *artistic* uses of terms such as "gaudy" or "beautiful" (see Section 1.5).

2.1 Meaning *Meaning*

However, before arriving there, some other matters are usefully clarified. The first concerns the notion of *meaning* applied in artistic contexts. For the vision of art offered here builds-in a connection between the artwork and its meaning: that whatever was not a property *of it* could not be its meaning (on a parallel with words). Moreover, whatever lacked meaning of this kind would not be an artwork. My point,

of course, is to insist on the distinctiveness of what I called *meaning* (without being prescriptive about the use of words).

Meaning in the appropriate sense is connected with a certain kind of intending. So that, negatively, finding that such-and-such was not intended shows (absolutely) that such-and-such was not meant (although one needs carefully to consider what is *evidence* for not intending). As Best (1978: 139–140: UD: 243–244) has shown, the idea of *meaning* is (essentially) related to that of *communication*. For instance, my boss learns from my yawning that I am bored by/at the meeting—the very last thing I'd hoped for! There is no (genuine) communication here, and no meaning, just because my behaviour lacks both the required kind of *intention* and (therefore?) anything specific to communicate—in contrast to, say, a case where (catching your eye) I yawn extravagantly. These fit together: there cannot be anything to communicate in the first case (since nothing was intended) and from the lack of intention can be inferred that there is no 'message' to be communicated (or to fail to be communicated, or to misfire in communication, etc.). Further, a crucial requirement here is the *intelligibility* of what I do or say: my work can have no *audience* if that work cannot communicate. So the commitment to meaning or communication cannot really be distinguished from the commitment to intention.

Such a commitment might be lacking. When one *mistakes* a meteorite for a Henry Moore sculpture—perhaps (as earlier) they are indistinguishable (Ground, 1989: 25–26)—one takes as meaningful, intended, and so on, the wholly *natural* properties of the meteorite. (One sees *design* where there is none.) If all one says of the object is compatible with its being naturally occurring (the meteorite), none of *those* features can be artistically-relevant features; and hence none are candidates for "aboutness"-type properties. Certainly, they cannot be intended or meant: hence, cannot be involved in what I earlier called "genuine communication". Treating the meteorite as an artwork mis-ascribes artistic concepts to it, thereby saying what is necessarily *false* of it: such concepts cannot possibly have application in this case. Even were the features designed (as in a polished rock), that they are the features of *this particular* rock, and that the designing was by *this particular* individual (or group), operates differently from the features of our sculpture. Here again, treating it as an artwork involves mis-ascribing artistic concepts to it. So different things will be true of each (even when we cannot tell them apart purely visually). Or suppose a work of decoration, such as some wallpaper, is confused with a decorative artwork, clearly fine art (the Matisse *Red Interior*, say). Although the wallpaper is both *designed*, and designed *with beauty* (or something similar) in mind, treating it as an artwork involves mis-ascribing artistic concepts to it.

But the term "meaning" has other uses in English[1]: for instance, what I call "association". That we met beneath a particular painting, for example, tells us nothing about artistic merit, one way or another. Or, suppose, for example:

Meaning is that which is presented by a text; it is what the author meant by his use of a particular sign sequence, it is what the signs represent. *Significance*, on the other hand, names a relationship between that meaning and a person, or a conception, or a situation, or indeed anything imaginable. (Hirsch, 1966: 8 [quoted Levinson, 1990: 189])

Whatever one makes of the detail of Hirsch's account (in particular, its equation of work-meaning with author-meaning), the contrast with *significance* seems right. Roughly, the meaning is the fixed content of, say, the poem. Thus Blake's use of the expression "dark Satanic Mills" means something in the context of the poem (something about the condition of religion) but may acquire a significance about textile factories of a century later "from the triangulation of the poem's meaning and economic developments a century down the road" (Levinson, 1990: 191).

In a similar vein, Picasso's *Guernica*, say, has a social 'meaning' by virtue of being planned for *that* wall, in *that* pavilion, as part of the Republican exhibition at *that* event. But such 'meaning' (or rather *significance*) is independent of the painting's *specific* features; for instance, of whether or not it is a good painting—a bad painting could have that same social *significance*. Indeed, one could conclude (correctly) about the painting's *significance* while it was still rolled up! Thus what, say, that painting tells us about twentieth century capitalism is not part of its *meaning* here, unless that is part of the painting's topic.

Again, Bob Sharpe (2000: 38) uses experiences from his Non-conformist childhood in rural Gloucestershire, during the Second World War, to explain his response to the hymn, "Will there be any stars in my crown":

> ... [although] the hymn itself is undoubtedly mawkish, trite and false ... I value the experience, and I see no reason to deny that it is an aesthetic experience. But it does not lead me to value the hymn.

All this might be expected, with regard for the hymn *not* artistic appreciation: indeed, Sharpe's formulation here seems exact—that he does not value *the hymn*, does not take pleasure or delight in its features. As it were, his valuing of the experience would be spoilt were he required to pay close attention to the hymn itself, with all its mawkishness. So, although this is an object *with* meaning, its meaning is not relevant to Sharpe's regard for it. This too counts as *association*, rather than meaning in the sense under consideration.

This formulation offers another approach to the meaning/significance (or meaning/association) contrast: the search for meaning focuses *on the object itself* (say, on the poem, picture or dance), while the search for significance looks at what the poem (etc.) tells us about, say, the society of the time, using the poem as a tool for sociology, or some such. It involves looking *outwards* from the poem. Of course, what is part of the poem (or whatever) may differ from what is usually thought part of it: such distinctions are not made out easily. Thus one may need persuading that a certain aspect is a matter of meaning rather than of significance. One cannot specify in advance of critical practice what are and what are not meaning-features of the works, what are (and what are not) significance-features.[2]

In practice, we can typically distinguish accurately these judgements of, say, association from those concerning artistic meaning, but what about in theory? While this line cannot be drawn exceptionlessly, a rough account of the kinds of reason-relations required can be supplied: that they are internal (or criterial) reasons, rather than those indicating symptoms (PI §354; see SRV: 43–44), such that they provide good reasons for the ascriptions they support, but do so defeasibly.

2.2 Exceptions (a): Dealing with Defeasibility

Then a second topic for clarification highlights a feature of our logical armoury (*defeasibility*) which—for all its pervasiveness—does not take us far enough. In introducing the methodological framework for this text concessively, neither details nor notions need be developed beyond what is needed. That will show both the power of defeasibility and the need for something yet more powerful.

A quite general objection to my strategy suggests that logical relations of the kinds central to philosophy are all-or-nothing: *entailment* offers a good example of the kind of relation meant—that it is all-or-nothing is visible in its susceptibility to counter-cases. Hence whatever concerns *philosophy* will be exceptionless. But, in this text, logical relations are viewed differently: some are seen as *defeasible*. Nor is the possibility of such logical relations especially contentious. Since (legal) *contract* is defeasible notion (UD: 61–63; Dancy, 2004:111–113), the law offers a model for such *defeasibility*. Once certain conditions are satisfied (signed and witnessed, for instance), there *is* a contract between us. But there so being a contract may be defeated if a recognized 'head of exception' is satisfied (Baker, 1977: 52–53). Although 'heads of exception' are normally expressed as positive-sounding conditions (that the contract be 'true, full and free'), this is just shorthand for objections of various kinds to be raised by someone denying such a contract, having granted satisfaction of the contract's major conditions (for example, the signed and witnessed document, etc.). Thus, the signatory must not be a minor, nor coerced—these pick out ways of failing to be *full* or *free*. Moreover, for defeasible notions, the 'burden of proof' is on the objector, the one who denies the usual 'run of things' once the initial conditions are satisfied. So any 'counter-possibilities' are considered only insofar as they apply *in this case*, rather than simply as abstract possibilities. When sceptics require that *all* counter-possibilities be ruled out (Stroud, 2000: 43), we cannot know precisely *what* things were to be considered. In contrast, someone wishing to object to a contract (or the application of any other defeasible notion) knows fairly precisely what considerations are relevant, for these considerations are the "recognized heads of exception" (UD: 62). In our case, satisfaction of one of these 'heads of exception' explains why this particular work *is* art, in spite of lacking (say) the meaning-connection, without thereby undermining our general commitment to that connection.

In practice, then, possible exceptions are built-into such defeasible relations but without this counting as a flaw. Further, the kinds of exceptions are recognized from the beginning; and such a exception is not a flaw because it operates *by contrast* to what is denied (and is only intelligible as such). As Cavell (1969: 253) urges in respect of intention:

> I do not wish to claim that everything we find in a work of art is something we have to be prepared to say that the artist intended to put there. But I am claiming that our not being so prepared must be exceptional.

Moreover, it operates "at the same level as intention, a qualification of human action" (Cavell, 1969: 235 note). Applied more widely, this sort of counter-case,

where there is explicit reference to what is being contested, is a *modification* of what was being asserted—rather than a denial!

The inclusion of defeasibility into our logical armoury, although important, is not unproblematic. Its introduction may strike critics as ad hoc or gratuitous—how is it to be justified? As yet, we have not said. Further, the dependence on 'recognized heads of exception' (even interpreted generously) seems too restrictive: often, it remains unclear just what candidate counter-cases might be offered. Explanation here requires further elaboration of both the place of exceptionlessness, and of generality.

In illustration, Paul Ziff (1972: 127–141; see EKT: 177–193) grants that it is true that a cheetah can outrun a man. Further, counter-cases to what was claimed (that a cheetah can out run a man) cannot be found by considering cheetahs encumbered by weights, cheetahs with broken legs, sprint champions, or any such—these cases are beside the point (they do not dispute what was asserted). Moreover, no additional details will deal with *all* the apparent counter-cases, as there is no finite totality of them (FW: 118–123). Hence no modified version (for instance, talking of "some cheetahs") will be equivalent to the original claim. Thus, even if the slow, horned cheetah, the cheetah not motivated to run, and the broken-legged cheetah were explicitly excluded, more cases could always be raised: the otherwise-disabled cheetah, the baby cheetah matched against a sprint champion, and so on. For none of these was explicitly included (nor excluded ... nor even considered) when claiming that a cheetah can outrun a man. Nor do they lead us to give up the truth of the original claim. So there are no *conditions* here (for instance, no conditions for the truth of an assertion) such that one could conclude *absolutely*, and abstracted from the detail of this case on this occasion, that they had (or had not) been satisfied.

Of course, in a particular context, the assertion would be (determinately) true or false. For a remark of this generality, the context shows the features relevant on a particular occasion: we are not required to consider just any (apparent) counter-cases. As Ziff (1984: 39) puts it, "[t]here are always all kinds of special conditions": but they are not *really* special. Rather, the conditions were simply not an explicit part of what was asserted or claimed: they were not something (somehow) *left out*, or assumed. So they cannot just be filled in. Moreover, there is no way to fill in them *all* since, as we will see, there is no *all* here. However, the difficulty of giving *specimen* examples of such explanations is the difficulty of giving *explanations* of artworks *in the abstract*, where this means 'abstracted from actual perplexities'.

2.3 Exceptions (b): Disambiguation?

The case of the cheetahs, say, might *seem* easily dealt with.[3] For instance, faced with a description of an event which left open or ambiguous *whether* (if at all) a certain description applied, it might seem that a disambiguation of the additional description could *always* be produced to clarify the matter—as when, eating the Indian meal, one offers an (apparent) 'disambiguation', contrasting spice with temperature: "But that is another kind of hot". Yet this is *not* always possible.

Disambiguation seems to offer some *natural* or *obvious* way to distinguish cases. Thus, when buying alligator shoes, only rarely must I add, "Yes, *of course*, for my alligator" (Ziff, 1972: 63). But is this really always so? Consider an example from Charles Travis (2008: 112): "the leaves are green", said of painted leaves. Now, is this just plain true or plain false? Part of the difficulty is that we cannot decide *which*, since it seems natural (on a particular occasion) to say one and, on another occasion, to say the other. And if we cannot decide which is (obviously) right, then neither can be *obviously* right.

Faced with the disambiguation option, then, our attention turns to one of the (apparently) disambiguated pair: if occasion-sensitivity can be generated in respect of it, then the disambiguation strategy looks unhelpful. For such a case suggests that, however good we are at 'plugging the gap' we started from, yet other gaps might arise. Thus talk of, say, "painted-green leaves" too might become problematic: for instance, some (otherwise) green leaves might be painted green. These would then be, as it were, double-green.

So our strategy involves finding *each* of the different 'senses' of the term "green" proposed *after* disambiguation still amenable to occasion-sensitivity. Of course, one cannot prove that such still-contentious cases can always be found, but it looks promising. Travis (2008: 276) rightly notes the wide variety of cases here, including the sense "green" to mean inexperienced ("But that is a different *kind* of green!"). Still, even sticking to some version of (roughly—but much turns on *how* rough) *green-coloured* and *leaves*, there are green leaves painted green as well as brown leaves painted green; we also have leaves dyed; and 'naturally occurring' green leaves. In this last camp, there are those uncontentiously green, and those contentiously green ("Isn't this one a little yellow?"; "Hasn't that one started to turn red?"). And many more. What I am happy, for some purposes, to call "a green leaf"—and right so to do—will not count for you: you needed an example for your biology class, and neither my painted leaf nor my yellowing (but still green) leaf fits the bill. And you have no truck at all with my jade leaves!

Suppose someone hoped to deal with our problems by legislation: so that a new term, "flurg", says of a leaf precisely what you said in saying (on a particular occasion) "The leaf is green" (compare Travis, 1997: 119[4]). But this "is a dead end" (Travis, 1997: 119), because even flurg-saying must now be confronted with "novel cases, which it may count as describing correctly or not" (Travis, 1997: 119). So this kind of stipulation cannot escape occasion-sensitivity.[5]

Even when disambiguation sorts out *a particular* case, one cannot guarantee that it will resolve *all* such cases. For any level of 'grid', a yet finer mesh might be needed to avoid unclarity or ambiguity. But then the idea of an ultimately fine mesh is needed—we lack any basis for such a conception. Further, if disambiguation works for these purposes or in this context, it could be viewed as dealing ('completely') with the issue in this context: our puzzle is the one *now*, the one in this context. But that makes the puzzle, and the relevant 'disambiguation', occasion-sensitive.

The point of disambiguation, recall, was to find a *single* description of 'what happened' to apply exactly to this situation. If the description of a situation cannot be successfully disambiguated, one cannot find a *single* reading of the description

(in our case, of the artwork): without it, the description cannot pick-out uniquely one situation; and hence one cannot hope to formulate descriptions dealing with *all* possible cases. For no description would uniquely identify a range of cases within which no problematic instances could arise. Rather, any answer would reflect the question asked, or the occasion of its asking. Our examples show how exceptions might arise—clearly, such 'loopholes' might then be covered by disambiguation. But doing so just exposes us to other, different loopholes or exceptions. Such exception-inducing cases may not be likely in practice: their logical possibility alone precludes (say) all-encompassing determinacy, or exceptionlessness, of the kind sometimes assumed (see SRV: 102–105).

2.4 An Occasion-Sensitive View of Meaning and Understanding

Although this *occasion-sensitivity* (or "speaking-sensitive view of words": Travis, 2008: 70) draws on considerations in the philosophy of language, the primary point here has nothing to do with *words* as such. For when we both truly say the world to be such-and-such, we both speak the truth—independent of the words we use! Given the debt to Travis, as well as the complexity of the issues, we will largely continue with his examples, and fair amount of quotation. (At the least, the puzzled reader is offered a clear location for alternative sources of discussion.[6])

One example (already mentioned: Section 1.6) concerns the colour of curtains. Of course, "[t]o state something is to aim at truth" (Travis, 2008: 3). And then "[i]f we know that someone said such and such to be thus and so, we do, in some sense, know what he said (to be so)" (Travis, 2008: 300). Although a suitable beginning place, as Travis (2008: 300) recognizes, this slogan must be understood in terms of what precisely saying *that* in this context commits one to. Suppose I purchase some emerald-coloured velvet curtains: at the time of purchase, then, they are uncontentiously green (although taking anything as "uncontentious" may be hubristic). At a later date, I need a new Robin Hood suit, which calls for Lincoln green. My wife suggests that one of the old green curtains will suffice—not Lincoln green perhaps, but green surely. Despite rips and stains, the curtain is certainly green: well, it is not any other colour. Moreover, the Merry Men are slightly colour-blind. I say (correctly) that the curtain is green. Later yet my wife wants a green covering for a part of a stage set: but now she declines the (rest of the) curtain as just too faded, an indeterminate pale colour—it would not contrast sufficiently with the blue of the sky. Certainly, she says (correctly), this curtain is not green. Thus, between us, we have said both that it is and is not green; and each has spoken the truth—given the question each was then addressing. This is more obvious if, mistakenly, I had said the curtain was *not* green, for my 'Robin Hood' purposes: for then what I said would have been *false*.

In fact, the utterance *amounts to* something different on the two speakings just presented: to say "This is not green" is to say something true in one but not the other. And nothing else has changed: the word "green" still means *green*, the indexical ("this") is not the problem. In these cases, the word "green" makes "any of an

indefinite variety of distinct contributions to what is said in speaking it, and, specifically, to the truth condition for that" (Travis, 2008: 71). So, more generally, the contribution of colour-shades, stains, holes, fading and such like that would permit correctly asserting on one occasion that a particular curtain was green must be recognized—but where, on another occasion, that same combination would make it false that the curtain was green, given who now was asking, or the interest in greenness on that occasion. These different occasions set different constraints on the greenness (or otherwise) of the curtains. That is why, as Austin (1970 130: quoted Section 1.6) noted, "[t]he statements fit the facts always more or less loosely, in different ways on different occasions for different intents and purposes." There is a definite result as to *truth* only when the circumstances of the describing somehow make one standard or another the *right* one for the purpose in hand: so truth essentially depends on the context in this way. This means *both* that there is no *abstract* resolution here, divorced from context, *and* that there typically *will* be such a resolution once the details of the context are taken into account—or, at least, there is room for debate towards such a resolution.

Moreover, what is true here is true more generally: however carefully one builds-in details of this situation *only*, other 'readings' of it—and hence other ways of treating it—are always possible (Travis, 2008: 97–101). Hence, in another example:

> Suppose someone says the toast to be blackened; it is perfectly determinate that *that* is what he said. For all that, there may be a multitude of standards by which toast may be counted as blackened or not, a multitude of ways of deciding whether the given toast is precisely *that* way. For all those standards, it is whether the toast is blackened that would have to be decided. ... The point is: whether *that* is so depends not merely on the fact that it is *this* that is to be so or not, and on the way things are, but also on what one is to count as things being that way ...

Thus, in our simple example:

> Just how black does toast need to be to count as blackened? If it is covered with Marmite,[7] is it blackened? The concepts expressed in the words used to call the toast black do not answer such questions univocally. There is not just one thing that might count as toast being blackened. And so it is in general. (Travis, 2008: 301)

As a result, no formula covers *all* cases: as we have seen (and said before), there is no *all*, no finite totality of cases to master. So our model must involve our mastery in the situation—often our learned mastery, no doubt—allowing us to dealt with the new context if we can, bearing in mind the warning that "even the most adroit of languages may fail to 'work' in an abnormal situation" (Austin, 1970: 130).

Here, three points are important. First, although utterances may *mislead*, they are not in general *misleading*: the hearer may not know how to take an utterance, although it *is* in fact clear once the context is taken into account. Once the question about my curtains related clearly to their Robin-Hood-suit suitability, a question about their green-ness can be answered truly; but perhaps not before. Although I might end up confused (I don't know what question is being addressed), the question asked is not itself *confusing*.

Second, these issues are not simply amenable to solution through *disambiguation*—which may have been a first thought. If we could just speak more exactly of "Robin-Hood suit green", that thought might go, the occasion-sensitivity disappears: what I *hear* determines whether the curtain is green, with no need to explore the details of the occasion or the speaking. But a number of reasons why this answer is inadequate have been sketched:

(a) *What is said* was always clear in these cases: once we know what occasion this is, or what 'world' we are in, the claim becomes clear (and clearly truth/false). So there is really no *ambiguity* to be remedied.

(b) There is no natural or obvious way to distinguish cases. In trying to simplify the case, my 'green curtain' story might seem to support the misunderstanding, because I *indicated* how the differences for the term "green" might be taken (with, seemingly, only two outcomes possible). But that is a red herring: in general, there is no precise number of possibilities here—for this reason, my artificial case, while inducing recognition of occasion-sensitivity, may cloud our understanding of it.

(c) If there really were just two options here, we should be able to say *which* is the correct one on a particular occasion, which we cannot. As Travis (2008: 112) puts it, this amounts to urging that, say, both utterances concerning the curtain have a *consistent* truth-value: both are true (or both are false). Thus, for example, suppose someone urges that I was speaking the *truth* when I said the curtain was green, so my wife must be saying what is false in denying it. But why is *this* the preferred outcome, rather than taking what my wife said as true? Each reading seems to reflect what, on that occasion, was said: so why select one *this* as true? On the view under discussion, "one must choose in a principled way. What the words mean must make one or other disjunct plainly, or at least demonstrably, true" (Travis, 2008: 112). And there seems little hope of this.

(d) If some term in English is ambiguous (and therefore amenable to disambiguation), "there must be a way of saying just what these ambiguities are: so a fact as to *how many* ways ambiguous they are" (Travis, 2008: 112: my emphasis). Again, there seems no hope of finding some *fixed* number here.

(e) Further, the 'new' terms, now suitably disambiguated, are still amenable to occasion-sensitivity—as when my wife contrasts "the really green, green curtain" she wants with the 'green curtain' she gets. For that **really** *green, green curtain* might only suffice on some such occasion: then she might further contrast the **really** *green, green curtain with stains*, from the one *without stains*. Disambiguating the expression "green curtain" once, still leaves her with two occasions, with different satisfaction-conditions, where she wants a green curtain, and the one she has (while uncontentiously green for some purposes) is not green for hers; but on which the word "green" means *green*, and so on. The artificiality of this case should not disguise its power. For one cannot in general *predict* how certain expressions might be used; moreover, one cannot *predict* which of the many understandings of a particular situation is the appropriate one for a particular occasion—although (consonant with earlier points) one typically understands that statement when encountering it!

Third, by highlighting one set of contextual features, this position seems merely to demonstrate the inadequacy of the concepts presently deployed—so that, say, an ideal language might do better. But such an 'ideal language' is a fiction, because no finite totality of conditions must be met in describing a particular scene. Relatedly, the problem simply recurs even were a particular issue accommodated by, say, modifying what was urged (so that it covered exclusively *some* of the cases originally envisaged: for instance, by specifying *which* kind of green, in context). There is no *basic* level of description or explanation here (see FW: 130–131); so that we cannot simply 'disambiguate' [see (c) above] *down*—or *up*—to that level: a possible use of, say, the term "green" may always escape such disambiguation.

These points have a parallel bearing on the application of general terms to, say, artworks; and, in particular, the application of terms that explain the value of *this* work on *this* occasion—how do they stand with other works or other occasions? Again, there is no suggestion that, having once identified the detail of this case (and our perplexity in respect of it), what we say is not true. Or, better, no reason in principle why this should not be so. And no amount of disambiguation will guarantee to identify just what is, say, valuable about *this* work, such that we might try to apply it seamlessly to *that* one. Moreover, we cannot look for the application of some technical expression to *all* cases—say, all works of Abstract Expressionism or of Martha Graham's dance. For, while there may be a finite totality of artworks (at least for Graham dances), there is no finite totality of 'readings' of such works; or, if this is different, no finite totality of (artistic) perplexities in respect of them.

Another way to make the points here draws (again: Section 1.8) on the idea of *completeness* for an account or description: for, in one sense, these are *perfectly* complete—namely, in dealing with the actual case, in an actual context. Any 'incompleteness' arises only in their failing to deal with *all* cases, actual and possible. But this cannot be a deficiency in the description here, since no complete list of such problem cases is possible, in principle. For there is no absolute standard of completeness since completeness is always explained by contrast with what is incomplete (Baker and Hacker, 1980: 79–80): further, *incomplete* "wears the trousers" (Austin, 1962: 70–71), since incompleteness must be understood as relative to some purpose.

At its heart, a *slogan* for the insight here might be that different questions or issues require different answers. Yet (as visible especially for the case of the green curtains, above) the very same form of words ("Are the curtains green?") can amount to a different question, or raise a different issue, in different contexts. Hence this conception of the philosophy of language does not place a premium on the details of linguistic usage. Rather, to repeat, it stresses what is *said* (in that context or on that occasion) in *using* those words. Then obviously one might be *saying* something different in using the very same form of words on different occasions; or, as we might say, in two contexts. Since (as here) that form of words answers two different questions, or addresses two different issues, the same form of words amounts to something different in the two cases. That is just what was urged in contrasting, say, *beauty* in artistic contexts with (merely) aesthetic ones. But there is no independent way to articulate contexts: indeed, such-and-such may

only be recognized as constituting another context *because* that same form of words amounts to something different.

It may seem (from Chapter 1) that my position yields an artistic sense of the term *gaudy* and one (or more) aesthetic sense of the same term. As Terry Diffey pointed out,[8] that seems to infringe against Occam's razor. But, as I made clear (Section 1.5), my plan treated different contextual uses of the term, rather than invoking different senses (or ambiguous expressions); such disambiguation is never, in principle, an ultimate solution to problems or issues about meaning (compare SRV: 52). Rather *occasion-sensitivity* should be recognized as a general feature of understanding, and a similar strategy adopted for artistic meaning.

Contextualism of this sort works against the 'one right answer' view of meaning in general (compare Grice, 1989: 21–34; Travis, 1989: 208). Consider a simple-sounding question: "How many book are there on the shelf?". Suppose the shelf contains:

- 13 volumes of the English translation of Proust's novel (as published by Chatto & Windus);
- 3 volumes of the Pléiades edition of Proust's novel.

Candidate answers include:

(a) one book (Proust's novel), but in two versions;
(b) two books (Proust's novel, and an English translation of it);
(c) sixteen books—because sixteen volumes.

This need not be at all puzzling in a concrete case: if I end up puzzled, it is because I misunderstood what interest in the books prompted your asking the question. So a *right* answer can even be imagined, in a particular context—*of course* I simply wanted to know if the volumes I had loaned to a friend had been returned ... (and so on).

This occasion-sensitive conception of meaning and understanding offers a radical perspective on truth, such that "there is a definite result as to truth only if the circumstances of the describing, or those of its evaluation as to truth, somehow make one standard or another the right one for the purposes in hand" (Travis, 2004a: 265–266). Further, it seems right to recognize key properties as *parochial*, in the sense that a person:

> ... may know all there is to know as to what being coloured red would be as such—and for all that, ... not yet be in a position to see whether a given judging, or stating, say, that the drapes were red is to count as having answered to the way things are. (Travis, 2004a: 266)

Then what is *there*—whether the drapes are red, in Travis's example—may require taking or noting or recognizing things to be a certain way. Hence, what is *there* may admit that, given their stains, these drapes do count as red on some occasions—one would speak truly in calling them red—but do not count as red on others. And others may be unable to notice these features on those occasions. So "[p]arochial

human responsiveness" (Travis, 2004a: 269) must be recognized to understand the application of, say, colour concepts[9] But granting such *parochial* properties requires adopting a particular view of truth, meaning and understanding (and their inter-relation): unsurprisingly, this is occasion-sensitive.

This view would be radically revisionary of many of the questions or issues or assumptions of much philosophy of language (at least, in the Anglo-American ana-lytic tradition). Rather than exploring such topics further, the point *here* is simply to suggest that the literature of the philosophy of understanding (or meaning) contains a fairly fully articulated defence of a conception of understanding both plausible *for us* and independently defensible (see also Travis, 2006: 4–5).

So granting that meaning in general is occasion-sensitive, and therefore *what is true* (as in, "What my wife said is true") is also occasion-sensitive, undermines the assumption that so-and-so being true is easily characterized as some 'fact' time-lessly true, or non-perspectivally true; thereby showing the fundamental nature of difficulties for such characterization. For it may be impossible, now, to assert what my wife asserted, when she (correctly) said that so-and-so was true: certainly, doing so will be complex. Yet a currently fashionable view (treating meaning in terms of truth-conditions) finds such 'translation' unproblematic. Others take the use of the same words to guarantee either that the same idea is deployed or that any dif-ferences are susceptible to disambiguation. Both *these* views have implicitly been rejected. For, once occasion-sensitivity allows rejection of the disjunctive disam-biguation strategy, the same form of words might amount to something different in two cases in ways disambiguation could not, in principle, rectify. Hence, *what was said* would be different.

Our contrary view, applied in philosophical aesthetics, is best seen by comment-ing on a familiar example. For, if one ignores or forgets its art-status, the object (qua aesthetic object) is *gaudy* because of its bright, vivid colouration. Perhaps, recog-nized as an artwork, it is still *gaudy*—but now the term "gaudy" amounts to, say, *gaudy for an Impressionist*: that is, it imports ascription to a particular *category of art*. The occasion-sensitive character of understanding justifies these differences, explained by the impact of categorial ascription.

2.5 Contextualism in Philosophical Aesthetics

The idea of *occasion-sensitivity* was initially introduced because key terms (with "gaudy" our example) amount to something different used in making *artistic* judge-ments than they would in making aesthetic judgements (without assuming either kind to be unitary). Elaborating this conception of meaning and understanding shows it to be much more powerful.

• Contextualism grants that an ordinary book (for example, the report of a road accident) may be read in many different ways; but prioritizes the ways that treat it as informative about the accident. One grants *that* in granting that it (genuinely)

is a report of a road accident. While only part of the truth, this points in the right direction.

- A novel is *like* another book, with the added constraint that avoiding misperception of it (that is, regarding it as an artwork) requires deploying artistic concepts. That means, in context, that only a limited range from among the ways the text might be read *count* as reading a novel (although those ways may change over time: Sections 5.3 and 5.4). For only some of those ways count as reading it in the appropriate category of art; as having the artistic features it does, when so read (and so on).
- Other artworks are similarly 'contextualized': they must be treated *as artworks*, since failing to do so involves both misperceiving the objects (they *are* artworks) and an inability to attribute to them the artistic features they possess as an inability to see an object's colour prevents one from ascribing any particular colour to that object (were that one's only basis).

Contextualism here gives due weight to the kinds of 'issue-related' or 'question-related' approaches to artworks endorsed throughout this text.

The question, "what context are we presently in?", must also be occasion-sensitive: why is it being asked? Different agendas here might amount to different issues being raised or different perplexities being addressed. But these matters can only be approached case-by-case. At the very least, philosophical aesthetics has nothing to fear from occasion-sensitivity just because the *occasion* (of appropriate artistic judgement, concomitant with art-status) is already acknowledged as potentially transformative. That is what we could/should say for artworks; although this would be inappropriate for other objects (otherwise indistinguishable): as it were, as an occasion of a *different* kind. Consider here the suggestion that "a photograph ... [of Warhol's *Brillo Box*] would be indiscernible from one taken of the commonplace containers in which the soap pads were shipped to supermarkets" (Danto, 2000: 132: quoted Section 1.2). Are such boxes indistinguishable or not? Occasion-sensitivity shows why this is not the right question: the point is not whether they *could* be distinguished, but whether (in the context of the discussion) they *should* be. Here the answer is clearly "no": only artistically relevant differences should be mentioned. So, although close specification cannot be given of what the terms for artistic properties (or those terms in their artistic uses) amount to, some occasion-specific things can be said.

Of course, the contextualism advocated here as *occasion-sensitivity* is a general phenomenon, operating 'all the way up' or 'all the way down'. Nevertheless, contexts may profitably be clustered together for particular purposes—and especially if those contexts are widespread. Thus, first, our discussion of *defeasibility*, and especially of 'recognized heads of exception' (see Section 2.2), recognizes patterns within the kinds of differences between one occasion and another—in raising a recognized head of exception one in effect moves from one familiar occasion (or context) to another; in which the occurrence of that 'head of exception' dominates. Second, a more general occasion-sensitivity recognizes that, on occasion, *this context* can be regarded as importantly like *that* one. Thus one begins from the fact that

"you can only speak truly in calling something green if it *is* green on that under-
standing of a thing's so being on which you speak" (Travis, 2008: 156). Moreover,
what runs (as Travis describes) for *green* runs also for *gaudy* (see Chapter 1). So
some insight—while not *hugely* informative—accrues from spelling-out the under-
standing at issue of being gaudy; namely, that it is gaudiness in the *artistic* context
(and perhaps, say, in the *Fauve* artistic context) rather than the merely aesthetic
one. This may be informative *across* the context here, reflecting the artistic version
of what—above—were called "standards by which [say] toast may be counted as
blackened or not" (Travis, 2008: 300); and similarly for objects being *gaudy*. Only
some will be those for (artwork) paintings to be *gaudy*; and some of those for the
gaudiness of Fauvist artworks.

On an occasion-sensitive view, even my artistic uses of a particular term permit
a degree of variability; but the discussion of the *artistic* (in our sense) provides a
relatively stable context, differentiating it from parallel discussion of the aesthetic:
that is what our talk of "a contrast", "a distinction" really amounts to. Thus artistic
judgement 'fixes' one set of contexts: there, (defeasibly) artistic uses of key expres-
sions are envisaged because one sees how (defeasibly) these uses might answer the
same (or similar) questions, address the same (or similar) issues, approach the same
project. In particular, faced with a discussion of what one understands in under-
standing *that* artwork, the work is sometimes appropriately characterized without
distinguishing it from other works ("Man's inhumanity to man"), while in other
contexts such a differentiation is crucial. In this way, artistic judgement (implicat-
ing *artistic* properties or qualities) provides one occasion, or a limited set of them,
for judgement; hence broadly locating a set of truths, by locating appropriate *stan-
dards* for truth. This may not apply across the board: but, to the degree that it does,
artistic judgement can be contrasted with (mere) aesthetic judgement as involving
different contexts. So, in some contexts, some features are mentioned in discussing,
say, the gaudiness of such-and-such artwork, while in another context other features
are stressed. This explains why, as we saw (Section 1.5), terms used in both kinds
of judgement amount to something different in each. At the least, people regularly
making artistic judgements, for example art critics, know where to find themselves
in such judgements; able to understand what is asked, and to reply in kind.

Centrally, the idea of *art*—or the uses of terms dealing with (fine) art—is con-
trasted with other objects of aesthetic interest. When concerned about *art*, one must
draw this contrast (see also Section 2.9 below): as it were, a context here is pro-
vided by (or at least centrally includes) reflective discussion of (fine) artworks and
of the nature of fine art—or, to put that another way, by the characteristic activities
of (philosophical) aesthetics, together with some art-criticism, some art-history, and
the like. Thus, to see what is required for Cubism may require locating *this* (can-
didate) work into a history with places for analytic and synthetic Cubism—without
that contrast, one cannot see how this work is best understood.

More specifically, seeing the object as an artwork contextualizes it as the
bearer of artistic properties. That is why we insist on the term "art". Thus the
attribute *witty* was a (candidate) property of the sculpture, as it could not be for
the meteorite (Section 1.6; Ground, 1989: 26). And the same goes for "mature,

intelligent, sensitive, perceptive, discriminating" (Lyas, 1997: 141), and a host more. Attributing such expressive qualities (or "personal qualities": Lyas, 1997: 141) to an artwork involves recognizing these as candidate properties of lumps of rock or canvas-and-pigment; and as genuine properties (when they are). Also recognizing that what was *witty* in one work might be *tired* in another: that the nature of the tradition, and of one's place in it, plays a role in explaining how, as Greenberg (1999: 67) puts it, "mood and emotional tone" are context-specific. In a simple case, given the chronology of the expression "plastic arm" in Mark Akenside's poem "Pleasures of the Imagination" (1744), that term cannot refer to a petrochemical prosthesis. The contexts of creation and reception bear on *what* the features of the artwork are—and hence on what it would be to misperceive them.

While dependence on *categories of art* provides a background for the ascription of artistic meaning here, implicating the history of that artform, that genre, and so on, occasion-sensitivity offers a way to connect the *meaning* to the explanation that might be given of it, since that meaning is connected to the kind of question asked in enquiring about meaning. The crucial dimension here concerns the role of those who appreciate or recognize the meaning of artworks—in those cases where this happens. For, roughly, occasion-sensitivity invites substitution, for the question "What does expression or sentence X mean?", of the better question, "What does X mean on this occasion?" or ". . . in this speaking?". That shows that another substitution is possible: "How should X be *understood* (on this occasion)?". So this occasion-sensitive account of meaning makes transparent the connection to understanding.

Moreover, engaging with artworks deploys this connection in practice. For instance, the author, in being be identified as responsible for the work, may provide temporal (and spatial) locations for that work's creation—with associated genre, categories of art, language, and so on. Consonant with our contextualism here, authorship operates to identify an *occasion*: one knows how to take the object (or, at least, one begin to) through finding a way from this starting point to the appropriate concepts. Hence at least some of the *categories of art* relevant to our understanding of *this* work are located once one knows that the work is a Picasso—one starts thinking of Cubism (perhaps analytical cubism), Spanish themes, connections to death and the bullfight, or whatever. And rightly so since, as we saw (Section 1.1), some *narrative* is fundamental to appropriately perceiving the work; and these considerations are typically relevant to such a narrative.

In unusual cases, more might be asked. For example, regarding "Nocturnall upon St. Lucy's Day" as an utterance (hence, temporally specific) provides reasons to choose among various readings that might be offered for it. Given the state of Donne's life at that time, it makes more sense to read the poem as bleak; and the poem makes sense read that way. Here, facts of Donne's life combine with other elements of my reading of that poem to 'decide' that it is not ironic. So understanding the artwork (here, the poem) involves understanding it as the product of a certain period or genre, perhaps of such-and-such a place (or even of so-and-so person), in this tradition and that category: it cannot be made sense of 'standing alone' (Lyas, 1997: 140–142).

2.6 Competent Judges

Yet, paradoxically, this account of meaning allows meaning for artworks to be contrasted with *some* other occasions when, say, art critics use the term "meaning" or its cognates, or even synonyms. Asking about the meaning of a work might identify *associations*, or locate *significance*, just as asking the artwork's *value* might enquire about its monetary value. But these are not our concerns. Rather, the relevant uses are those in *making artistic judgements*: that is something we can recognize, without (necessarily) being able to say how.

Here, the philosopher's perspective should, in general, be contrasted with that of the practitioner (here, say, the art-critic).[10] For the philosopher takes a *long* view of conceptual disputes: the objections of this critic may pass by those of another critic—their views are not incompatible, but rather incommensurable (see Kuhn, 2000: 189). But the critic's 'take' is different: he is right, his opponent wrong! A useful comparison comes from the practitioner in science, who regards his predecessor's theories as wrong, as refuted by his work—and is right so to do! But a philosopher of science might take these views to be incommensurable. Similarly, the art-critic prioritizes the current judgements of the artworld, reflecting the current "lay of the artworld"; and typically contrasted with the philosopher's perspective. Since philosopher and practitioner approach different questions, occasion-sensitivity explains why—on occasion—they arrive at conflicting answers.

So our philosopher offers an account of the nature of artistic concepts; our art-critic (the practitioner) uses them in artistic judgement. In practice, these judgements identify the properties of the artwork. Of course, their applications are *disputable*; but those who contribute to such disputes should be knowledgeable, and sensitive, in respect of art of that *category*. Indeed, this follows from our recognizing (above: Section 2.4) that "there is a definite result as to truth only if the circumstances of the describing, or those of its evaluation as to truth, somehow make one standard or another the right one for the purposes in hand" (Travis, 2004a: 265–266): it means that one must master such standards.

For performing arts, the norm is some diversity among the art-objects as one engages with them: Tuesday's *Swan Lake* may differ from Thursday's; and this company's *Swan Lake* from that one's; and so on. As realized through *any* performer's interpretation, any work in a performing art (like dance) is under-determined: that work itself might always have come out differently than it did. Since performing artworks can typically exist in more than one performance, difference *as such* cannot guarantee that one addresses a different artwork—a thought central to the very idea of a work performable on more than one occasion. To illustrate, consider rehearsing on Monday and performing on Tuesday and Wednesday: for *which* performance was the Monday event a rehearsal? Answering "both" (as we must) highlights that there is just *one* artwork here (UD: 93). To list just some relevant differences, the same artwork in a performing art such as dance can (in principle) be performed by different companies; in different spaces; incorporating different movements (say, because of different company members or because of mistakes etc.—against the silly idea that every little mistake initiates a different artwork: Goodman, 1968: 186); and

with differences of music, lighting, costume—although not necessarily as great as is sometimes supposed (UD: 98). But recognition of performance A as the very same artwork as performance B (in the same performing art) is neither unconstrained—that is, this is not a case of 'anything goes'—nor constrained in easily specifiable ways: it typically is not *rule-bound* or *definable*. In practice, efforts to find the features of 'the dance itself' often draw on memory. Thus recent reconstructions of some works by Siobhan Davies were justified to me as authoritative because Davies sanctioned them, and because two of her company dancers managed the restaging process. Clearly, these two conditions are worthless! As general rules, the claims of authorities should always be disputed; and memory should never be relied on where it can be avoided.

But these practical difficulties acknowledge the theoretical constraint: one looks to those who understand, both for criticism and construction. Then some role for *learning to understand* is guaranteed:

> ... what one acquires here is not a technique: one learns correct judgement. There are also rules, but they do not form a system, and only experienced people can apply them right. (PI: 193[11])

Competent judges are required, for what one learns is not what correct judgement (in its varieties) *is* but rather how to make it. Here, too, the 'rules' for artistic appreciation (as for artistic production) "do not form a system": this is *not* a "calculus operating according to definite rules" (PI §81). Further, "only experienced people can apply them right" (PI: 193 [other editions: 227]: PPF §355). As elsewhere (see Section 4.5), one useful comparison is with colour: its redness, although a public, shareable property of the red object, requires a world with beings of suitable discriminatory powers. Thus that property relates to human powers and capacities. Similarly, the possession of the artistic properties (by artworks) relates to the powers and capacities of the audience for those works (CV §389 para. [h]), while leaving the properties as clearly properties *of* the artworks. For musical appreciation (like other art appreciation) draws on powers and capacities consequent on, roughly, *this* anatomy and physiology: a set of potentialities open to humankind, although actualisable in a variety of different ways in different contexts (including 'not at all'). Thus *competent judges* have a conceptual role in the *understanding* of art. Moreover, that art is meaning-bearing (or has a 'cognitive dimension') depends on the *possibility* of creatures able to recognize such meaning—just as the possibility of persons following them transforms posts by a roadside into *signposts* (Baker, 1981, esp. 55). The possibility of competent judges, therefore, is a conceptual requirement for any artistic judgement at all.[12]

But, while general powers and capacities may be guaranteed (in a typical case) by anatomy and physiology, Wittgenstein rightly stresses (CV §389 para. [f]) that the capacity to actually *make* artistic judgements, or to engage in artistic appreciation, is not. Rather, it must be learned, if it can. Even *that* is not guaranteed. For *having* the concepts (demonstrated one way) is not equivalent to being able to *mobilize* those concepts—itself characterizable in terms of one's sensitivity to *art* and, then, to works in *this* form, (perhaps) *this* genre, etc. (see also Section 4.8).

One might mistakenly think that a fairly small amount of collateral knowledge here could turn tyro into connoisseur—perhaps that knowledge could even be described! But this is mistaken in two ways. First, in reality, the required background is fairly extensive in typical cases; and not specifiable in the abstract. Thus, as Wittgenstein urges, "[a]ppreciating music is a manifestation of the life of mankind" (CV §389 para. [h]). Then describing that appreciation to someone would involve describing *music* to him, as well as saying "how human beings react to it". For, again, the powers and capacities of humans are crucial: making appropriate artistic judgements (that is, judging artworks as artworks) involves recognizing both the art-status of those works and their artistic value.

Equally, and second, no *explicit* contribution from knowledge is required here: there are many ways to acquire the requisite knowledge and understanding, other than through (say) art-history classes—most dancers, for instance, may acquire them *en passant*, in training and performing. But they *do* know: and, *if pressed*, they might even explain what they knew (although this ability is not required). Still, such dancers can perhaps then draw on the knowledge and understanding, perhaps as choreographers. (And granting this possibility works against those who insist that, if one knows something, one must be able to *elaborate* it.)

Wittgenstein's insight is that the idea of a *competent judge* does not require itemizing the knowledge and understanding required of such judges. So that, when the powers and capacities of such judges operate smoothly, there is nothing *more* to be said: they are marked out as *competent judges* (in respect of art, in that form, etc.) by this role in the explanation of art (in that form, etc.). Then we do not say *how* they do it; nor (exactly) *what* they do: these questions do not typically arise. Instead, failures of judgement are explained as, say, failures to recognize or failures to value. Thus, nothing separable that can be stated here would be both comprehensive and true of all. Instead, the thought is that one does not do something *else* in order to do artistic appreciation: that is, to understand (in this case) a musical work.[13]

2.7 Meaning, Explaining, and Artistic Properties

As common sense suggests, the meaning of an artwork depends on the features or properties of that artwork. And, given the *transfigured* nature of art (Chapter 1), our description of an object (and hence of its features) *as art* will not be equivalent to any non-artistic description of it.

Yet what are the properties of *this* artwork? A danger here is that, on our account, what can (correctly) be said of an artwork becomes arbitrary, or unconstrained by the work's features. But our position does not lead to that conclusion. Here, the idea of a *narrative* or "story"[14] comes into its own, in ways comparison with, say, discussion of the duck-rabbit design (PI: 166 [other editions p. 194]: PPF §118 ff.) may bring out. For whatever one says about that design ("picture of a duck"; "picture of a rabbit"; "picture of a clock, at 8.45"; UD: 28[15]) must be 'answerable' to the design's

perceptible features. That means, roughly, that they are explicable by pointing to the design, saying "this is a beak", and so on. Similarly, any account of the artistic features of the artwork must be 'answerable to its perceptible features' and (at least in the artistic case) drawing on what we know of the history and traditions of art, of the art form, of this genre, of this artist, and so on. (This second condition follows from the judgement here being *artistic judgement*.) This can be modelled as explaining the artwork to some (potentially imaginary) 'other'—someone who asks about the work, for whom one acts as a kind of (informal) art critic.

Moreover, some consensus around judgements follows from being competent to discuss a certain topic. Conversations on classical music become difficult if your list of composers of classical music does not include *any* of Mozart, Beethoven, Bach, Mahler, Stravinsky, Schöenberg, and so on—your taste is just too eclectic (see Cavell, 1969: 193). So the public dimension of such competent judgement is clear, rooted in roughly what have been called "interpretive communities" (Fish, 1980: 167–173): (imagined) communities of *competent judges*. So the question of arbitrariness only remains an issue for those who reject the notion of *truth* entirely (compare McFee, 1998: 84–88).

Thus, whatever one says must be *arguable*. Yet, as with the duck-rabbit, being 'answerable to the perceptible features of the object' simply invites further questions: for instance, *perceptible* on the basis of what *cognitive stock* (see Section 4.9)? In reality, one simply characterizes the work a certain way. In effect, doing so offers a explanation and attempts to meet objections to it: as when one's claim to make sense of a particular dancework in such-and-such a way is contested. In a real example, a student disputed my account of a particular dance—and, in support of his reading of it, produced the programme notes. Unfortunately, his programme was not the revised one detailing the works we had actually seen. He managed to see the dance *as though* it were built around a mournful desert wind, *Khamsin*. But, in this case, he was wrong so to see it. And our discussion brought out why features he took found *problematic* in that dance were actually straightforward features of a very different dance. Yet the case exemplifies how one's view of a work may be contested, and the objections met.

Discussion here concerns, simultaneously, what the *features* (properties) of the artwork are and what its *meaning* is. Consider distinguishing between cases of *difference* in (ascribed) artistic meaning: what might, less rigorously, be called *different interpretations* of the artwork. Of course, in cases where something different is claimed or urged, one is obviously saying something different *about* the work (about its features or properties) *and* ascribing a different meaning to it. For instance, seeing *Alice in Wonderland* as a 'version of pastoral' *rather than* as a Freudian psychodrama (Empson, 1935: 203), or vice versa, involves thinking differently about what *exactly* goes on in the novel, what its *exact* features are. But this is really one discussion, since a work's meaning connects to its properties/features. When a difference in focus offers different features or properties of the artwork, that permits (or, perhaps, requires) ascribing a different meaning to that work. Equally, taking the work's *meaning* to be different can only be justified by ascribing different features or properties to that work.

But, as our general contextualism grants, the same *form of words* might amount to different things: so that, here, different meaning might be ascribed to a particular artwork. In a simplified example (re-used Section 5.3), two spectators describe Picasso's *Guernica* in exactly the same (judgemental) terms, thereby offering what might be thought exactly the same interpretations of that work. For example, both identify elements of man's inhumanity to man, of a crushing of the human spirit, and the like. But one explains the judgement as the symbolizing of events in Spanish history, and the other in terms of purely formal features of the work (perhaps drawing on the comparison of central triangles in *Guernica* and da Vinci's *Last Supper* etc.). These are pretty clearly not the same judgements since, in such a case, different circumstances would make each judgement *false*. Despite employing the same form of words, they can hardly be equivalent.

So, to repeat, when a difference in how the work is seen—a difference in focus—offers a different account of the work's features, a different meaning is being ascribed, even if in the same words. So the meaning of artworks should be regarded in terms of explanations of those meanings: this allows differences in meaning one might otherwise miss to be picked-up; and, then, recognition of differences in explanations or reasons as indicative of difference in meaning. But is my explanation complete? Do I give *all* my reasons? That is part of the narrative aspect mentioned above: suppose, in giving your reasons, your mentioning something I accept—that might best be thought part of *my* reasons (part of my explanation), at least where consistent with (and, perhaps, of the same kind as) my other remarks.

Further, as Baker (2004: 193) notes, "it is to be *expected* that explanations are local and purpose-specific; hence variable . . . [rather than] uniform and invariant". For an occasion-sensitive account of explanation, offering variability and contextualization, is "everywhere evident in Wittgenstein's work" (Baker, 2004: 193). So what we anyway thought—that is, thought independently about art—turns out to be a generalization, to artistic meaning, of one of Wittgenstein's most powerful slogans for meaning quite generally: namely that *meaning is what explanation of meaning explains* (BT: 29e; see UD: 113–114; CDE: 95–96). This coheres well with our scrupulousness about the term "meaning".

Wittgenstein's slogan is designed primarily to deal with meaning in respect of language. So that, perplexed by the word "evanescent", you ask what it means. If my explanation takes away your perplexity, then I have given you the meaning of that word. Such explanations occur *in response to perplexities*: I explain the meaning because you ask for it, or because you need to understand it (even if you have not yet asked). And the standard for adequacy (one might even say *completeness*: Cavell, 1981: 37) is that I deal with *your* perplexity. There is no suggestion that I must say *all* that I could say—far less *all* that could be said. For there is no *all*, no finite totality. So, adapting this Wittgensteinian slogan to meaning for artworks, we (negatively) no longer ascribe to the artwork some *complete* meaning, which a greater elaboration might identify. Then, positively, we ask how *meaning* here is made sense of. Thus Wittgenstein asks how "explaining a musical phrase" (CV §389 para. [a]) is related to understanding that phrase. For then we look not to fixed objects, *meanings*: we cease to search for something hidden or arcane. Rather, we

look to our practice of *explanation of meaning* when asked, and concentrate on what is before us: that is, an artwork and various discussions of it. This is the sense, then, in which "[u]nderstanding correlates with explanation" (BT: 9e).

Applied to art, Wittgenstein's slogan takes the meaning of artworks as what is explained in the explanation of their meaning. But who explains artworks to us? Well, explanation in this sense is one job of critics. So the meanings of artworks can be looked for in the works of critics, both formal and informal. But, when wishing for particular enlightenment, perhaps the works of the formal or professional critics might be preferred.

In directing our attention to something public and tangible (the explanation of meaning), this Wittgensteinian slogan acknowledges meaning as something made by human beings: hence something which human beings *know* in typical cases, and moreover must know. The idea of forever and in principle inaccessible meanings for artworks is obviously excluded. That point is easily misunderstood. For, often, nothing can be *said*. But, while critics' work *typically* consists of strings of words in sentences, our explanations of meaning need not *solely* take this form—they could also include, for example, gestures, demonstrations and so on.

In this way, then, our account of meaning for artworks connects with human practices, making artworks inherently the kinds of thing possible in principle to understand: again, at least negatively—such that my being (in principle) unable to understand the work counts against its art-status. For unless I am simply untypical (say, badly informed), the fact that (*ex hypothesi*) *I* cannot understand it *in principle* means that humans cannot understand it. Art-status builds-in certain constraints concerning intelligibility, as a *logical* or *in principle* requirement: it says nothing about the extent, or otherwise, of the audience in question. For instance, my choreography might be thought *safe* if I draw extensively on the forms etc. of the past, or *radical but intelligible* if I challenge the past aesthetic in clear ways, or *powerfully challenging* if, say, a whole genre is contested. All are ways of my making intelligible danceworks, works that have (or acquire) an audience. So these are ways of making art. Yet they also highlight a way of *failing* to make art; namely, by lacking an audience. For a work not art in anybody's eyes—one permanently lacking an audience—is not art. In this case, too, it lacks meaning (of the kind discussed here). Further, that salutary possibility relates to the properties of my works, or what is *true* of them. As this implicitly acknowledges, changes in the 'understanding conditions' for particular artworks should be seen as changes in the *meanings* of those works (the topic of Chapter 5). Of course, that requirement for an *in principle* understanding does not take us very far: skills and sensitivities must still be developed in order to *actually* instantiate the relevant understanding.

This offers a practical way to make sense of the idea of *meaning* here: a 'picture' of meaning, with an injunction to recognize key *differences* in use, and not to worry about meaning, except in this way. But, as it stands, this does not seem good advice for philosophical aesthetics: as we have seen, the notion of *meaning* can be useful (if we are scrupulous about it)—but partly just because it articulates some 'uses' of that term to *contrast* with the meaning/value use, some places where the word "meaning" might get used in respect of artworks without talking about *artistic* meaning!

2.8 Meaning, Explanation and Content

So the emphasis on explanation offers an account of *content*, or what is understood. Hence it might seem problematic that (usually) the meaning of (especially) abstract artworks cannot be put into words. But it is not. Structurally, nothing here is especially distinctive about, say, abstract painting—or even about painting more generally. As Greenberg (1999: 67) urges:

> ... [t]hat the content or "meaning" of the Mondrian can't be put into words is not something that should give us pause. The content of the *Divine Comedy* can't be put into words either, nor the content of any Shakespearean play, nor that of a Schubert song.

Greenberg means, of course, that the content of the Mondrian, say, cannot be put into words so as to be equivalent to the Mondrian. For, at least in some circumstances, some revealing things may be said about it: for instance, when Meyer Schapiro (1995: 68) writes, of *Broadway Boogie-Woogie* (1942–1943):

> The notes have been shuffled throughout to yield a maximum randomness, while keeping their likeness and coherence as oblong or square units of the same width and family of four colours. Their confinement to the parallel tracks of the grid is a means of order as well as movement.

Of course, in one way, the content of the *Divine Comedy* or the Shakespeare play *can* be put completely into words—but only into the words that they are already in! But these very same words might be arranged in that order—and therefore with the same 'music' when read aloud—without being that artwork; but rather a report, or a proof-reading exercise, or a theological text mistaken for art (as reports of traffic accidents in French have a music for me, when read aloud—that does not make them art). To get art, one must read the appropriate texts; and read them appropriately! And then explanations of their meanings can be offered.

But that suggests a substantial objection to the Wittgensteinian slogan as applied the arts: might one's *explanation* of meaning be incomplete, leaving something out? The thought (granted earlier) that no 'reformulation' completely captures an artwork's meaning, without remainder, seems just to generate this seemingly damning general problem. For how can the meaning be what is explained by an explanation if that explanation always (and necessarily) *leaves out* aspects of the meaning?

In fact, care here clarifies the insight in three ways. First, as already noted (Section 2.4 above), the question of meaning in general is a *contextual* question: if my explanation of meaning addresses *your* perplexity (perhaps, in this context), it *is* complete (Baker and Hacker, 1980: 79). Of course, something else might be said to someone else, further, I can typically say yet more if my first attempt does not address—or does not fully address—your problem or perplexity. So something can *seem* to be missing: these *somethings* are not provided initially. But this is a confusion. As our commitment to occasion-sensitivity highlights, the fact that more might be said in response to a *different* question (even though asked in the same form of words) shows us nothing about the adequacy (or otherwise) of what was said in answer to *this* question. And then my 'saying more' is not simply additive (see FW: 119–120).

Second, the general point does not make the explanation *equivalent* to the meaning; nor does it deny this. It says only that when the work is explained *to you* (so as to dissolve your perplexity in respect of it), the *meaning* has been explained to you. Its target is the thought of some inaccessible Platonic object—'the' meaning—beyond our human practices of explaining, discussing and the like. For this is one place where the idea of *the* meaning is most suspect: different explanations of meaning might be offered in different contexts, to different audiences. As for the duck-rabbit design, an *acceptable* 'reading' is answerable to the features of the 'design'. It does not follow that only one such reading is possible. Indeed, our discussions of art have emphasized just this diversity.

Third, and now in relation to art, the thesis about the *embodiment* of artistic meaning, and its consequent *uniqueness* to that embodiment, implies that no explanation *could* be equivalent to 'the' meaning. That need not be disputed. Of course, in other circumstances, one might want to say other things. But those would be *other circumstances*! And the work itself might be seen (and hence explained) in more than one way. For example, however impressive a Freudian reading of *Alice in Wonderland* (see Section 2.8 above) might seem, *other* readings might still be defended—perhaps on other occasions. And doing so will stress other features of the book.

This follows from identified features of the nature of artistic judgements, since our account of meaning gives weight to the *context* of 'utterance', or to the (implicit) question addressed, in line with occasion-sensitivity. The required context is (at least) one of *artistic* judgement. For both the features and meanings of our artwork must be recognized (by knowledgeable persons); and that recognition is tied to the work itself, rather than 'imposed' on it by the spectator. Then identification of the meaning will be either via the work itself (pointing to it), or via explanations or narratives articulating that meaning. These come together: for ascribing the meaning to the work involves acknowledgement of the work's *artistic* features or properties—and this *is* (implicitly) "telling the story" in respect of the work, articulating what its artistic features are. So that, while artistic meaning is embodied in the work, *investigation* of it often focuses on how that meaning is explained.

Yet my engagement cannot be solely with explanations which do not induce *perceptual* or *experiential* confrontation with that work: hence the embodied nature of artistic meaning plays a role, but without significantly limiting the forms of explanation here. In particular, ostentations (say) cannot be precluded, in principle, when discussing an artwork's meaning: clarifying the structure of the opening of Christopher Bruce's *Ghost Dances* (1981) for you might involve pointing out this and that pattern (especially repeating pattern) of movement. Similar 'pointing' might take place when I highlight the canon structuring the beginning of the Webern *Symphonie* (Opus 21).

Moreover, someone[16] who objected to talk of *explanation* here might also have reservations about whether music was really a suitable subject for *understanding*.[17] In response, the negative case is clearly the most compelling. The idea of *understanding* music (say) makes sense by looking at cases of *not* understanding music: the person who understands is just one who does not *fail* to understand. I say, "I do

not understand such-and-such a dancework" ("I can make nothing of it")—with the implicit contrast to the previous piece in tonight's programme. In *not* noting any failure to understand (nor manifesting any), I might with justice be taken as implicitly claiming to have understood. And here typical 'indicators' (the rapt expression, say) are just what you need to confirm your diagnosis of my understanding. For instance, Wittgenstein suggests demonstrating one's understanding of such-and-such a piece of music via a dance step (CV §389 para. [a]): he stresses the step or gesture as a way of explaining the work, or of teaching it to someone. Since one cannot say (non-trivially) what one understands, that will throw the weight back onto cases of *failure* to understand (which is grist to my mill): the person who does understand does not fail in these ways—and we know (defeasibly) that he or she does not fail to understand from their dance steps, etc. In this sense, this is 'what I understand': since it might help you to understand, this is a contribution to *content*.

While there typically *is* an explanation here, often it cannot be readily stated: there may be nothing to say in explanation of what I understand (PI §527), except to say that I understand the music. Part of the topic, of course, is that—unlike, say, some cases of understanding novels or poems—for music, one cannot say *what* one understands, except to repeat that one understands the music.[18] And *that* I understand may be apparent in ways sketched above. So that recognizing a work's *unity*, for instance, might be important. And, for music, such recognition must typically be aural (one must *hear* it); but this can be problematic. Indeed, Alban Berg ([1924] 1965: 189) specifically identified, as an issue for Schöenberg's music,[19] the need:

> ... to recognize the beginning, course and ending of all melodies, to hear the sounding-together of the voices not as a chance phenomenon but as harmonies and harmonic progressions, to trace smaller and larger relationships and contrasts as what they are—to put it briefly: to follow a piece of music as one follows the words of a poem in a language that one has mastered through and through means the same—for one who possesses the gift of thinking musically—as understanding the work itself.

Further, my understanding (or lack of it) relates directly to *this specific* artwork. Of course, sometimes *something* can be said, in explaining what one understands in understanding this work—for instance, highlighting a musical work's expressive properties: say, the desolation of the sixth of Schöenberg's *Six Little Piano Pieces* Opus 19 (see McFee, 1997: 36–38). But such remarks would not relate uniquely to *this* musical work; although that is equally true of critical remarks about, say, paintings—as Wittgenstein's use of the example of painting (PI §523) assumes. So these comments would not articulate *all* that one understands. The thought, roughly characterized as 'the heresy of paraphrase',[20] is that what a particular work 'says' cannot be *completely* explained in words, without remainder—this typically follows from the impact of its *sensuous* properties on the artwork's 'meaning'. For any 'translation' lacks just *that* sensuous embodiment.

With these points on board, this objection has effectively disappeared: there is no reason (in principle) why the meaning might not be studied—and hence the work studied—by looking at *explanations* of that meaning, once those explanations are treated in an appropriately generous fashion. And, lest this seem like a kind of trick

(building-in the disputed features), note that the required emphasis both on the variety within explanation and the (essential) embodiment of artistic meaning were in place before the question of the explanation of meaning was raised; hence were not 'cooked-up' simply to meet a difficulty.

2.9 The Context of Philosophical Aesthetics

The contextualization of questions or issues might seem to conflict with the centrality of the artistic/aesthetic contrast: why is that contrast not drawn only in an *occasion-sensitive* fashion? But, of course, that contrast *is* drawn contextually; yet the context, provided by central questions of philosophical aesthetics, almost always requires contrasting the *art* case with others. For instance, a discussion of *beauty* (*punkt*) requires that the beauty of art (at least) be differentiated from that of other cases—that (say) the beauty of art must be grasped through recognition of the appropriate *category of art* (otherwise this will be misperception), an idea not informing other cases of beauty. Moreover, similar points apply to discussions of any other concept (apparently) shared by artworks and (mere) aesthetic objects. As this case illustrates, artistic *meaning* almost always has a bearing in any discussions in philosophical aesthetics—of the kind this example displays. So that context requires that attention be paid to the artistic/aesthetic contrast.

As a second example, notice that some concepts (for example, *representation*, in the sense of "depiction": see McFee, 1994) apply only or primarily to artworks. Here too the context of philosophical aesthetics requires recognizing the *distinctiveness* of art; and hence respecting the artistic/aesthetic contrast. Of course, are there concepts (on a parallel with this second case) which apply only to mere aesthetic objects, and not to artworks? If there were, approaching them still deploys the artistic/aesthetic contrast. Moreover, artworks can be misperceived as merely aesthetic. In doing so, one mis-ascribes aesthetic properties, in contrast to the artistic properties of the work: that is, the artistic/aesthetic contrast is re-imported.

Thus some contexts fall typically within philosophical aesthetics, while others are outside it. Many remarks about an artwork, or about the nature of art, have nothing to do with the work's art-status or our appreciation of it, or (again) its value: for example, discussing its monetary value, or (for a painting) the blue fluff on the back of the canvas, or some *associations* of the painting (such as my meeting so-and-so beneath it: see Section 2.1 above), or the fact that one of my grandchildren painted it. In typical cases at least, discussions of these sorts have no place within philosophical aesthetics, except to be put aside.

Of course, the *content* of the context for philosophical aesthetics is set by that for philosophy—it is the sub-set of that context that applies to the consideration of (among other things) art. So philosophical aesthetics should be exploring the perplexities to which consideration of art can lead. Of course, some of these are just *art-critical* perplexities, and so on. What remains is what follows from the way the concept *art* intersects with other concepts: in particular, with concepts

of *meaning*, of *value*, of *expression*, and of *life* (or importance)—among others. For these conceptual connections would disappear were there no art-objects in the world, but only (say) beautiful objects. And, unsurprisingly, commitment to the artistic/aesthetic contrast is precisely a commitment both to the existence of these conceptual connections and to their importance.

Not all perplexities will be philosophical. But, as with many issues here, the right way to resolve this one is case-by-case: with a good reason to put such-and-such perplexity aside as not philosophical (say, as just a product of the particular agent's peculiar psychology), putting aside a corresponding concern with the art-related dimension of that perplexity will be equally dependable. And so on.

This direction to contexts is important, of course, because the reservation about the occasion-sensitivity of a particular remark (if repeated constantly) would raise a question over every claim one made: in particular, over *every* assertion in this text—is there a context in which just that form of words (true here, on a certain contextual understanding) might be false? Since our commitment to occasion-sensitivity requires answering such an 'in principle' question in the affirmative, there might be nothing left worth saying. That obligation is removed because, although the string of words might (on *some* occasion) be correctly taken this way, this is not that occasion. And the mere possibility does not undermine what one says in *this* occasion (rather than *that* one). But the proof that we are not in that occasion lies in how the text is to be taken. Just as the author of a science fiction novel cannot absolutely prevent his work being taken as a bunch of false assertions about our world (and only point out that this is to *mis*-take it), one cannot absolutely guarantee that this text will not be read as, say, a contribution to the genre *heroic saga* (albeit a failed contribution) or some other sort of poem: indeed, some postmodernist theorists might insist on its location within the *poem* genre. But you and I (dear reader) know this is philosophy. And what that means.

Notes

1. Indeed, Danto's preferred term, "aboutness", has the virtue of being, from the beginning, a technical expression.
2. For instance, Levinson (1990: 191 note) urged that I attempt "to dissolve the distinction between meaning and significance", because I disagreed about where it falls.
3. This section and the next draw heavily on SRV: 47–52. See also EKT: 183–187.
4. The example here is modified; but the point remains the same.
5. As Travis (2008: 99 note) says, although of a different example (roundness), "I will not pause to argue against the heroic view that that just means that no one can ever speak truth in calling something round."
6. Other cases: for the Pia/Hugo "milk" example, see Travis (1989: 18–19); for the red fish example, see UD: 121; Travis (2008: 189–190).
7. In the UK, Marmite is an almost-black spread, often applied to toast.
8. In comments on an earlier draft of this text, for which I am grateful.
9. This grounds our response to the argument from illusion: see Travis (2004a *passim*).
10. For this contrast between the views of practitioner and philosopher, see Feyerabend (1987: 272; UD: 307).

11. First and second editions p. 227: fourth edition (Wittgenstein, 2009: 239 as §355) of *Philosophy of Psychology—A Fragment* (PPF).

12. My discussion draws on Wittgenstein's notebook for 15th February, 1948 (Ms 137: 20 ff.)— his one comment of the day—ostensibly about understanding music, using the enumeration from Pichler (1991) (see McFee, 2001; 2004c—giving its subsequent publishing history, partly in Z and partly in CV).
 NB translations of 1st edition of CV is used throughout.

13. There remain different explanatory structures, considerations to be met (say, through education) in different ways. So becoming a *competent judge* might be characterized as *learning to see* and *learning to value* (compare Section 4.6).

14. As the policeman might ask (for your explanation or excuse), "What is your story this time?": this idea loomed large in my "The Historical Character of Art", unpublished PhD thesis, University College London, 1982.

15. The use of this example here does *not* invoke aspect-perception: see McFee (1999).

16. Thus Hanfling (2004) argued that Wittgenstein was wrong to talk about understanding here; and, reflecting his general non-cognitivism about artistic appreciation, Hanfling would be even less happy about talk of *meaning*.

17. Interestingly, Wittgenstein's illustrates his discussion of understanding with, first, understanding a musical theme: the sentences are no more interchangeable "than one musical theme can be replaced by another" (PI §531), which it cannot, without loss; second, "[u]nderstanding a poem" (PI §531). So, for Wittgenstein, *these* art cases were transparent, clarifying the case for language.

18. See here Wittgenstein's discussion of an "intransitive use" (BB: 174–177) of certain expressions—clearly "expressive", and other terms descriptive of music, would have such an intransitive use (and see Wittgenstein, 2009: 260). See also Wollheim (1980: 93–96).

19. A similar picture of the difficulty of meeting this requirement was identified in correspondence by Michael Finnissy (quoted McFee, 1978: 25 note). See also Adorno (2002: 133 note), which recognizes that Berg's chosen example was an early *tonal* work of Schöenberg's (1st String Quartet in D minor, opus 7).

20. Compare UD: 118; 318 note 5.

Chapter 3
Art and Life-Issues: Meeting Counter-Cases

3.1 Artistic Value and Life-Issues

Thus far, exploring the implications of adherence to the artistic/aesthetic contrast stresses the distinctive value of artworks. The connection between *artistic meaning* and value is easily seen from the artist's viewpoint. For why would artists *offer* to their public, the audience for that category of art, works lacking all distinctiveness? After all, this audience is (to some degree) knowledgeable about art (*ex hypothesi*: they are the audience for art!). Too, our typical artist will not offer (to such a public) works that *simply* repeat the familiar, or offer nothing new, or If some artists do offer such works, this may be deliberate, part of the artistic gesture. Similarly, when our typical artist takes a work to be neither suitable for nor worthy of appreciation, he/she will not present the work to its public—with the same provisos as above. Thus artists put forward as art only works they consider worthy of appreciation and not time-wasting for the audience for art (of this type).[1] So the making of (artistic) meaning is also be the making of (artistic) value.[2]

Hence *artistic meaning* is value-involving from the beginning (defeasibly); but such meaning is also human-world-involving *from* (at least) near the beginning. Negatively, the concern with artworks cannot be simply with *pleasure* or with *beauty*, because these would be aesthetic concerns *ex hypothesi*; positively, the possession of this kind of meaning is the outcome of transfiguration distinctive of the arts. Given art's relation to *valuing*, part of a slogan to characterize the artistic draws its connection to life-issues or life situations: as David Best (1978: 115) urges:

> It is distinctive of any art form that its conventions allow for the possibility of the expression of a conception of life situations.

And again:

> [I]t is intrinsic to an artform that there should be the possibility of the expression of a conception of life issues. (Best, 1985: 159, 1992: 173)

In this chapter, I shall both articulate and defend these slogans. Yet one way to put aside candidate artworks involves dismissing the objects as 'merely propaganda' or 'merely pornographic': those cases might seem simply to reflect a (negative) connection to the realm of life-issues. Instead, they reflect specific ways for such a

G. McFee, *Artistic Judgement*, Philosophical Studies Series 115,
DOI 10.1007/978-94-007-0031-4_3, © Springer Science+Business Media B.V. 2011

connection to fail. So is some defeasible 'world related' connection for artworks obviously untenable? To show that it is not, some arguments around cases are explored. The upshot is that the life-issues connection, in offering a fundamental contrast with (say) decoration or sport, militates against formalist misconception of art.

Can such a connection avoid instrumentalism about art? In reply, the perspective of those sympathetic to *some* connection of the moral to art, in *some* cases, is considered. This view, prominent in the contemporary literature of philosophical aesthetics, should soften-up opponents by suggesting both how *some* art-morality link might be urged, and how such valuing differs from instrumentalism about art. If this connection *sometimes* applies, for *some* artworks, no argument can conclude that it is beyond the pale of artworks as such.

This discussion provides a background to explore the chapter's central thesis: that, while the life-issue connection in general explain cannot be explained fully nor its place in respect of all artworks demonstrated, we have the intellectual resources to meet typical counter-examples raised against such claims.

3.2 Life-Issues Connection to Artworks?

My account of art could be aligned with that of John Gardner (1978): "that art is essentially and primarily moral... moral in its process of creation and moral in what it says" (Gardner, 1978: 15). But this is no bar to forms of art-practice of which Gardner disapproves—for instance, "the music of John Cage" (Gardner, 1978: 9) or "an empty but well-made husk like John Barth's *Giles Goat-boy*" (Gardner, 1978: 17): it can (and does) fit all art, at least once properly understood. Hence cannot count against the art-status of those (disapproved of) works. I also differ from Gardner in the treatment of (apparent) counter-cases provided both by works uncontentiously art that seem not to fit this account, and by those works Gardner dismisses as *not* art.

On the point of scholarship, Gardner and I may not differ. After all, he says, "I do not deny that art, like criticism, may legitimately celebrate the trifling. It may joke, or mock, or while away the time" (Gardner, 1978: 5). He discusses *trivial art*: the cases to which he alludes in this way are, for us, legitimate art-objects, making a contribution to Gardner's bigger project; namely, that art "seeks to improve life, not debase it. It seeks to hold off, at least for a while, the twilight of the gods and us" (Gardner, 1978: 5). These aims are not essentially incompatible with joking or mockery; indeed, joking or mockery is just what is needed in some cases—perhaps to stop art (and the artist) taking itself too seriously. There is no *in principle* argument from, say, humour to the conclusion that artworks are not serious: that they lack a 'life-issues' connection. These parallels allow a clearer statement of just what is involved in my version. Gardner is making a polemical point about what should count as art (that is, against the artworks of which he disapproves); I am discussing features regularly, and with justice, ascribable to artworks.

What is the account's scope? Both of Best's formulations (quoted above) refer to *artforms*, and canvass a possibility only. That position would be sharpened by a clear sense of what were the artforms (say, a list of them). On this view, for any artform, one work that *does* express a conception of life-issues demonstrates the art-status of the *form*—thus, one poem (say, one of Wilfred Owen's war poems) with an explicit life-issues connection makes the point for *all* poems (were poetry the relevant form). This loose constraint becomes yet looser in requiring only the *possibility* of a life-issue connection for that form (hence for one work in that form). Assume, what I take to be false, that no musical work to date had such a connection: even that would prove nothing—the question is whether music has this possibility, even if presently unactualized. Nothing so far would show this impossible (as opposed to, say, very unlikely).

For that reason, I propose a stronger version (UD: 180–182): that all *artworks* should have this connection to life-issues—although defeasibly (see Section 2.2); so being made in explicit contradiction of this requirement would count as a way to satisfy it! Thus my view is more powerful, in facing more opportunities for refutation. Then apparent cases where the artwork has no such explicit or obvious connection to life-issues must be explained (see Section 3.6 below). But the question of a life-issues connection would be raised only in some circumstances: one typically invokes it, for instance, to demonstrate why certain ice-dance performances were not artworks (Best, 1978: 121).

To what exactly do the terms "life-issues", "life situations" above refer? These terms simply point in a useful direction by emphasizing the connection between art and both our values and (the rest of) our lives. In other places (UD: 174–179), I have followed Best (1978: 115), writing of "contemporary moral, social, political and emotional issues". Of course, this does not really characterize the *life-issues* connection uniquely. For Best (1992: 180 note 1), reference to life-issues "gives only a vague indication of the characteristic" he had in mind, a vagueness which "is unavoidable, since . . . the arts can take as their subject matter almost, if not quite, *every* aspect of the human condition". As I understand him, though, Best (correctly) holds that such comments represent all that can be offered at this level of generality. So that nothing beyond some platitudes *can* be said in the abstract. This is (defeasibly) a case of human valuing: thus it reflects what humans value, to be contrasted with other value-involving notions (and, in particular, with pornography and propaganda). But our contrast here is also with valuing-involving aspects of aesthetic objects—what, above, were put aside as either extrinsic matters (such as economic interest) or *mere* aesthetic ones.

Any response here is necessarily case-by-case. First, we cannot assume any abstract generality which runs across cases—any general view or (exceptionless) principle at work here. Hence remarks informative about this work have no *automatic* applications to other works. Second, the occasion-sensitivity (to some question) of the critical commentary means that even what can be said about *this* case is a response to some enquiry; hence, to some perplexity—not to all! Thus, John Gardner (1978: 17) regards, say, *Giles Goat-boy*, as "an empty but well-made husk". To address his perplexity concerning the work, our comments could grant

the formal success of the work ("well-made"), while denying its emptiness. We might focus on its manipulation of novelistic conventions—especially on who its precise 'author' is: is it one computer, or many, or . . . (and so on). In that sense, the work comments on the nature of literature, a second-order value matter. But its central character's position might also be compared to one from Kafka: how does one deal with bureaucracies one does not understand? Either (or both) lines here might make Gardner revise his judgement. Yet this need no represent our 'take' on *Giles Goat-boy*, our last word. So we would offer different comments if, say, T. S. Eliot asked about *Giles Goat-boy*. Then the vision of the human soul portrayed might be stressed, drawing a connection to philosophy "in the sense in which we can speak of Lucretius, Dante and Goethe as philosophical" (Eliot, 1993: 252): that might reflect what we took Eliot to be asking! Both critics might be satisfied; and both comments sketched connect to life-issues.

So, is such a thesis urging the life-issues connection for all artworks *defensible*? My answer is "yes'. But no straightforward style of argument will generate it, consonant with my claims throughout. No exceptionless justification can be offered, since the mere fact of a (vague) connection to life-issues does not manifest itself in one way only. Clearly, at best, we are considering typical cases. As Cavell (1979b: 26) recognizes, morality is not designed "to evaluate the behaviour of monsters". But one way forward might consider some cases in certain circumstances. For my picture contains the intellectual resources to respond satisfactorily to any putative counter-examples. Some kinds of example will be mentioned here, to give a backdrop for our later argumentative strategy (see Section 3.6). First, some cases have an explicit a life-issues connection (say, Picasso's *Guernica*; the war poems of Wilfred Owen); second, in some cases lacking *explicit* connection to life-issues, such a connection is easily argued (for example, the Grand Canyon paintings of David Hockney which, with their variable viewpoints, might reflect the inter-relation of human and natural); third, something can be said for some objects apparently lacking any such connection (for instance treating the Tracy Emin unmade bed as a *representation* of a bed, and then seeing the life and personality both portrayed and commented upon); fourth, and in the opposite direction, cases of art so (apparently) abstract that no life-issues connection seems plausible may still exhibit one (here I'd cite the painting of a personal favourite, Rothko, understood in terms of "a form of suffering and sorrow, and somehow barely or fragilely contained": Wollheim, 1973: 128); and, finally, some cases are understood as *in explicit contradiction* to such a life-issues connection—and here we recognize either the way that revolutionary ideas are understood by contrast with those against which they rebel (and hence in terms of them) or the force of recognized heads of exception, central to defeasibility (see Section 2.2), or both. Here, then, responses highlighting a life-issues connection have been drafted to cases from the superficially more promising to the less; in this way, sketching *some* defences for the general claim that artworks manifest a life-issues connection.

This answer concerning the *nature of art*—in terms of the embodiment of life-issues (or life situations)—can *sound* lame because its critics assume something more specific, and more detailed, should be forthcoming. Instead, I am simply

explaining why that is impossible (because searching for such a resolution is employs, or assumes, the *metaphysical* uses of terms: compare PI §106); then using my methodological insights to elaborate that reply in the face of apparent counter-cases. Since I recognize that the account cannot be exceptionless,[3] my defence of it assumes that fact.

Opponents of some such conception must meet a two-fold question: *why is this object valuable?* and *why is this art?* If answering the first aspect (about value) involves reference to artistic meaning, the answer to the second becomes obvious. Finding a work *artistic* (finding that it is an artwork) and finding it *meaning-bearing* is one finding, with apparent counter-cases dealt with in one of a small number of recognizable ways, and for familiar reasons. Artistic endeavour is the making of meaningful objects, objects with a 'bite' on human concerns and values: anything not so valued would not be art—would be the wallpaper rather than the painting, say. Talk of a 'life-issues' connection is just a way to articulate that relation to human valuing. Alternative explanations fail to identify both the distinctive value of the object and its status as an artwork as opposed to an aesthetic object.

Thus the case of art here has two dimensions. For *the life-issues connection*, the question concerns the nature of the "issues" invoked, and the generality of the connection—does it hold for *all* artworks? (A "yes" answer to this question was already sponsored, to be made good below.) Then, for the *morally-positive connection* (where art is contrasted with, say, pornography): if artworks necessarily have a meaning/message which bears on human life, could it not be a malign meaning/message? Our reply in this second aspect, with Danto (2000: 132–133), involves looking case-by-case, drawing on the uncontentious past of art: such artworks contrast at least prima facie with propaganda or with the pornographic. First we adopt, from that past, the conception of artworks as making the *morally positive connection*. Further, our account regards any connection "at the same level" (see Section 2.2) as constituting a positive connection, once its defeasibility is recognized.

The contours of the concept *art* here can become visible in how its ascription is contested. Then a few typical strategies are open to someone making artifacts that (somehow) challenge *art*, strategies indicative of various facets of typical artworks. First, one can attempt to make objects lacking 'aesthetic' (that is, sensuous) interest, as Duchamp said he was attempting with the snowshovel, and other Readymades. But such sensuous interest was never crucial to art, even given the embodiment of artworks (see Sections 1.3 and 1.4). For, in one way, *a* sensuousness could be shared with a non-art 'real thing', as Danto illustrates. Second, one can attempt artifacts that lack meaning—as, say, Merce Cunningham (1984: 105) saw himself attempting with *Winterbranch* (1964):

> We did the piece [*Winterbranch*] . . . some years ago in many countries. In Sweden they said it was about race riots, in Germany they thought of concentration camps, in London they spoke of bombed cities, in Tokyo they said it was the atom bomb. . . . I simply made a piece which was involved with *falls*, the idea of bodies falling.

Yet meaning is not thereby avoided. The mere fact of *Winterbranch* being, say, a *dance*, in a particular style, genre, and so on, gives a critical vocabulary for both

understanding and valuing it. Even a dance challenging the traditions or conventions of dance in its form is still understood by reference to those traditions or conventions—made sense of as in opposition to those traditions or conventions. In drawing on the history of art, such works are part of a meaning-bearing tradition. Since those traditions and conventions take artworks as meaning-bearing (in this sense), our revolutionary dance also shares such meaning—even if not necessarily some otherwise-stateable meaning.

As a third case, imagine an assault on the connection of an artwork to human valuing, to "life-issues"; for instance, by stressing simply our enjoyment, or the formal features of the work. Again, what is the *occasion* here? Why does one take such objects to be artworks? Or how might the artist (or critic) argue for the art-status of such an object? Such an argument is implicit in taking the object as *art*. Recognizing the connection to the past of art (for instance) is recognizing a connection to the (artistically) valuable. And so on for any such arguments.

Consider, in this light, Man Ray's Dada work *Object to be Destroyed* (exhibited in 1922) consisting of a metronome with a photograph of an eye attached. Such a work might be treated like the cases just mentioned; and understood in ways they suggest: its subsequent 'history' offers another insight. For an irate 'art-lover' destroyed the work, perhaps taking the title too seriously. Man Ray's response deployed another photograph of an eye, and another metronome, exhibiting the work under the title *Indestructible Object*. In doing so, he emphasized that a place in the history of art (which this work subsequently achieved—if a minor place) ensures the value of the art-object: here, a comment on the ephemeral status of art is clearly involved. The meaning-bearing character and value of the artwork endure, while its embodiment is more ephemeral. Of course, although Man Ray was not attempting to make a value-free art-object, that was how the destructive 'artlover' regarded it—he thought it *lacked* the value, and hence was not an artwork (or, perhaps, *vice versa*). Events proved him wrong! So here too the connection of art-status and (artistic) value is explicit.

3.3 The Importance of Life-Issues

Is this talk of a 'life-issues connection' really worthless? Am I not simply calling *whatever* grounds the valuing of artworks by humans a "life-issue"? Further, how might one establish *conceptual* or *internal* connections here (of the kind of interest to philosophy)? Certainly, the 'life-issues' connection cannot be an *empirical* thesis, discovered by investigating artworks or 'what we say' about them. The issue is not what we *say* (since the term "art" is used in many different ways) but what contrasts are drawn. So, noticing the connection of value to the artistic, we look for illuminating ways to characterize that connection!

Further, this 'life-issues' connection for artistic meaning is independent of the term "life-issues": for example, for Danto (1981: 3), "artworks are ... typically about something". Then the addressing of the *specific* perplexities of particular individuals ("shewing particular flies the way of specific fly-bottles": see PI §309)

may implicate that "something". But it still takes place within a framework suggested by the idea of 'life-issues': that is, in the context of human thought and feeling. Indeed, it is hard to understand how else to explain the valuing of some objects as art is valued. So insisting on a 'life-issues' connection is insisting on art's connection to human thought and feeling. Of course, a work might 'satisfy' this 'requirement' by being in *explicit* contravention of it (UD: 181). Such a work might be important in the 'construction' of a history of art (in that form), shaping the kinds of connection to human thoughts and feelings characteristic of art: it seems churlish (or pedantic) to deny it some connection to human thought and feeling.

The model of human valuing here is not, for example, one of 'exchange value' in which, say, gold is valuable. Rather, it is a non-extrinsic value like friendship: that is, not that which regards one's friends just as potential baby-sitters. The intrinsic character of such value is clear: as Rhees (1969: 3–4) pointed out, insofar as I value such-and-such a person for what he/she can give me or do for me, to what degree I am not valuing him/her as a friend. Nor is there is a single, unified explanation of such value—no single way we value friends; certainly no way to describe or characterize such value. Similarly, the artwork itself is valuable; I am not valuing it as wall-covering nor a door stop. Were some function here divorced from the work itself, it could not ground *artistic* interest, since that function could in principle be fulfilled by something other than the work itself. And hence could not be the value that artwork embodies.

3.4 Learning from Art?

One difficulty in saying more returns us to the need for an appropriate audience, for *competent judges*. As Scruton (1998/2000: 21) writes, "in the nature of things, the arguments of a critic are only addressed to those who have sufficient reverence for literature; for only they will see the point of detailed study and moral investigation". And *mutatis mutandis* for the other arts. Thus the *real* audience values grappling with the moral concerns, a recognition that the 'life-issues' connection. But how? Since each work raises its own difficulties, an exceptionless general picture cannot be offered.

Further, any cognitivist account of artistic experience, like mine (or Nussbaum's: see Section 3.8 below), must connect its explanation of the *value* of art to art's meaning-bearing character. Here too a general, exceptionless account cannot be expected. As a slogan, we can claim (say) that the artwork is "revealing anew the familiar from life" (Wisdom, 1953: 224; UD: 185). But the revelation begins from *this* work. Peter Lamarque (1996: 102) suggests a recipe, where "good art reveals the particular". One model here, reflecting this particularity, might be that person who:

> ...picks up a novel or a poem. Absorbed by what he reads he goes on, reads it again, possibly many times. And afterwards he is no longer inclined to think or speak of the world in the same way. The significance which events have has changed for him...(Beardsmore, 1973a: 31)

Wisdom (1953: 223) highlights one way such an idea might be exemplified: namely, that an art-critical remark "need not be directed towards showing that a work is good or bad. It may be directed simply towards showing it to us for what it is". One of Wisdom's favourite examples[4] here was the prophet Nathan's response to King David's treatment of Uriah the Hittite, who David had put in the front line of battle (where he duly died), allowing David to make off with his wife. Nathan tells a story (*Samuel* Book Two) about a rich man who kills the only lamb of his poor neighbour, although he has many sheep of his own. David gets angry:

> ... and he said to Nathan, As the Lord liveth, the man who has done this shall surely die: And he shall restore the lamb four-fold, because he did this thing, and because he had no pity.
> And Nathan said unto David, Thou art the man ...

Then David's eyes are opened: he recognizes what he has done—this is, to use a revealing expression from Wittgenstein, *the revealing word*.[5] What is said is literally false: David has not actually done the things described. But the revelation is not thereby undermined, a fact important when looking across from art. For part of the intention (potentially) embodied in artmaking is a revelation of 'the logic of the soul' (Lear, 1998: 8) from, say, literary cases.

As one example of such revelation, confrontation with (fictional) cases highlights the contours of a concept in ways consideration of our own situation might never achieve—we cannot all have (say) shallow lovers, as Anna has Vronsky in *Anna Karenina*. (Interestingly, Vronsky's shallowness is itself displayed through art: see Beardsmore, 1971: 45–46.) But her case can show us some aspects of such shallowness here. If we do not find ourselves in this context, we recognize that human beings easily could. The author leads us to regard the case a certain way—it is not simply described to us neutrally. Instead, there is a point 'behind' the characterization of the events, if a complex one. And cases like these will be the ones we first think of; perhaps best typified by the 'fate' of tragic heroes. Such cases reveal choices which (with luck, for the tragic ones) one never has to make. In this sense, they 'describe' contexts other than our own. But these cases also show that making any decision here has implications for the rest of our lives. In this way, an artwork both presents to us a set of life-issues or life situations, and reveals to us aspects of the situation of which (left to ourselves) we might have remained ignorant. By involving us in thinking through its ramifications, it equips us both to confront this case if something similar (enough) presents itself in our lives and to explore what would constitute the recurrence of this case. For instance, there are fewer Russian counts than there were: does that introduce irrelevance? Or does it militate against such irrelevance? (Importantly, such questions might be occasions for art-critical debate about the meaning of our artworks—as we have seen, this is also debate about artistic value.)

In a second example, the upshot of confronting the artwork is (roughly) that the contours of the concepts are exposed, through confrontation with cases which present the concept *love* (say) in ways beyond what one would initially consider. Jesus's remark that looking lustfully at a woman is committing adultery in one's

heart might be one such, for the concept *adultery* is not usually understood in this way (Wisdom, 1991: 70–71). Moreover, Jesus's remark—which simply poses a question for us—is both discussed and embodied in Richard Wollheim's *A Family Romance* (Wollheim, 1969: esp. 53–54). Here the revealing aspect is directly integrated into a novel. But, equally, part of the power of Lawrence Durrell's *Alexandria Quartet* should be seen in exactly these ways, for the concept *love*.

Not all such insight is, neutrally, discovery: traditional conceptions of love may be shattered by Christ's remark that to look lustfully at a woman is to commit adultery; while, from Justine's love for Pursewarden and Darley (in Lawrence Durrell's *Alexandria Quartet*), we may come to think of our conceptions of love as flawed, sentimentalized. And that may amount to *conceptual change* of the kind sketched earlier.

One way of describing such a case is in terms of the possibilities or alternatives this person now recognizes. Then it may be:

> ...important to notice *what he considers the alternatives to be* and ... what are the reasons he considers relevant in deciding between them. ... [Sometimes two men] ... cannot even agree in their description of the situation and in their account of the issues raised by it. (Winch, 1972: 178 original emphasis)

Perhaps an artwork—more specifically, a novel—can help us through this tangle. This is why Iris Murdoch (1997: 353) writes of the vision implicit in a (typical?) artwork in terms of "a clarity that does not belong to the self-centred rush of ordinary life". But such clarity can come about through 'real life' as well as through art, although one might be less certain in calling it "ordinary life". For instance, consider a case where one comes to see the world differently (although not always in ways one could describe):

> The Belgian had been broadcasting throughout the war for the European services of the BBC and, like nearly all Frenchmen or Belgians, he had a very much tougher attitude to 'the Bosch' than an Englishman or an American would have. All the main bridges of the town had been blown up, and we had to enter by a small footbridge which the Germans had evidently made efforts to defend. A dead German soldier was lying supine at the foot of the bridge. His face was a waxy yellow. On his breast someone had laid a bunch of lilac which was blooming everywhere.
>
> The Belgian averted his face as we passed. When we were well over the bridge he confided that this was the first time he had seen a dead man. ... For several days after this, his attitude was quite different from what it had been earlier ... His feelings, he told me, had undergone a change at the sight of 'ce pauvre mort' beside the bridge. It brought home to him the meaning of war. (Orwell, 1968: 3–6; also Beardsmore, 1973b: 351–352; UD: 188)

Perhaps this Belgian could not characterize the transformation in his view: what did he then *know* that he had not known before? All he could do, perhaps, is repeat that the world looks different. And artworks might bring about a similar transformation. Then the "fine-tuned *concreteness*" (Nussbaum, 1990: 38 original emphasis) of a particular case may allow us to distinguish situations otherwise thought equivalent (even if not to *say* how): just as the novels are different (in particular, different in the meanings they embody), what we learn from each is different. Or, at least, they will be when the occasion requires us to press that far. For, as Lamarque and Olsen

(1994: 387–388) note, on this conception, literature "involves the reader in a process of discrimination and perception which develops his moral awareness".

But why should all the insight be moral? If it relates to human valuing, it might be thought moral *for that reason*. But, in fact, whatever is of inter-personal, human interest might be revealed. Is this "what its extremities of beauty are in service of" (Cavell, 1979a: xiv)? Well, there seems some reason to answer, "yes", and thence to acknowledge the intrinsic interest of such value-concerns (for these are "*its* extremities of beauty" [my emphasis]).

As a slogan to characterize such changes in understanding, think of them as conceptual changes that permit finer discriminations (UD: 168–170), which might be advantageous in making sense of one's life.[6] Then the narrative thrust of literature (and especially novels) can have a role in the revelation. If literary works can be revealing in these ways, through offering alternative perspectives, the argument might be extended (*mutatis mutandis*) to other artworks. For there are other narrative artforms; even (some) danceworks are narrative. Moreover, since the revelatory role is not exhausted in this way, other artworks might (at least arguably) fulfill a similar role. Thus, while most readily articulated for the narrative, no *in principle* reason precludes a similar rationale for artistic revelation more generally; hence for locating the value of the artistic (at least partly) in such revelation.

Of course, sometimes such revelation might be discernible, or discerned, from the work itself. This can be hard to illustrate since, often, the change in understanding can only be characterized in banal ways ("I realized war was a bad thing", said by Orwell's Belgian: see earlier) or by repeating, with new emphasis, what one was already saying. No doubt Picasso's bull's head/bicycle parts makes me think (slightly) differently about bulls, and perhaps about bikes, yet how could I describe that difference? Yet the inability to say does not dispute the phenomenon of my seeing (slightly) differently.

But, whatever we might come to understand for ourselves from an artwork, critical discussion of that work might also bring us to—if we then experience the work as the critic suggested! First, the result here affects our appreciation (our experience) of that artwork; second, it might involve *conceptual change*, in respect of the concepts through which we then appreciate that work (UD: 168–170), since those concepts now apply to this 'new' work—or apply differently to this work. Suppose that a work by Rothko were readily taken for one by, say, a follower of Chagall— this might fit some of Rothko's earlier works. How should this work be taken or seen? How should it be 'read' in terms of art, and (once we know the artist) especially in terms of Rothko's art? Now seeing something in Rothko (in this work, and perhaps in others) that we had not seen before, we still 'tell the tale' in terms of our understanding of Rothko. The same words might even be used for the new case as for the old—that is why the term "conceptual change" seemed appropriate.

Now imagine that another account is offered: some critic suggests that the work is ironic (hence our background understanding need not be modified). Then, say, the work draws on features of the category *X*, but so as to make (through ironic comment) a work in category *Y*—as it might be surmised that Swift's "modest proposal" (with its plan to solve both famine and over-population problems by breeding

children "for the table") does not seriously make that proposal. But how can such cases be resolved? First, it must always be case-by-case, rather than *absolutely*; second, the consideration of a particular case can draw on a variety of factors, including:

- the history and traditions of the artform;
- the *oeuvre* (and perhaps the biography) of the artist—part of our confidence is that we are sure *Swift* would not make such a proposal;
- the detail of the object offered—is there really no clue?;
- the "lay of the artworld" (Carroll, 2001: 91; see Section 1.1): at some times, irony (or similar) may be impossible.

It will not be easy to identify cases best cast as *conceptual change*: that is no more than a timely warning.

Of course, some cases resemble all of these, while in others the impact of art (although granted to be revelatory) is not well-captured in any of these ways. All this is acknowledged: these cases offer only *some* "objects of comparison" (PI §130) for the revelatory aspect of art. The emphasis, then, has been on revelation and perceptiveness: on 'learning from fiction' where this is "cannot be understood as either the knowledge of facts or the grasp of principles" (see Beardsmore, 1973a: 29). Granting that aspect also shows both that it only applies clearly in some contexts and that it does so to different degrees. This is ensured by our commitment to *occasion-sensitivity*; and integrated through our acknowledgement that (in the final analysis) art-critical understanding will be case-by-case.

A 'down side' is that exceptionless characterizations of (say) the revelatory aspect of artworks cannot be offered. The contextualism central to the conception of philosophy (hence, of philosophical aesthetics) deployed here not only rejects such exceptionlessness, but constitutes a powerful denial that the alternatives make sense, highlighting mistaken assumptions from alternative conceptions of the projects of philosophy. Hence, it is not a weak position on these topics. No doubt the exact nature of the revelation, for (defeasibly) revelatory artworks, is indeed best caught case-by-case: but, for philosophical purposes, such talk of 'revelation of the familiar' at least offers a slogan to articulate aspects of our confrontations with artworks.

3.5 Art and Moral Value: Moderate Moralism, Ethicism

There might seem, though, that what is being urged here faces some quite general objections: would it not turn artistic value into a kind of instrumental value? Of course, "artistic values are not instrumental values" (Scruton, 1997: 375, transposed to the artistic/aesthetic contrast). Like the value of friendship itself (Rhees, 1969: 4–5, 149; Scruton, 1997: 375), the value of art *qua art* is missed if it is thought of instrumentally. But might artworks nevertheless be valuable in bearing on the

moral lives of persons? The most thorough debate (in recent years) on this issue has been in respect of literature. So, as a methodological dimension here, we begin from there. For drawing extensively on the writings of others, in giving exposition of (and exemplifying) this *world-connection* for art (here, literature), emphasizes that others too pursue theses in this general direction.

One of the conflicting positions debating the instrumentality, or otherwise, of art is *autonomism*, the view that "[a]rtistic activities cannot be explained as a means to any non-artistic ends" (Beardsmore, 1971: 3)—with the "Art for Art's sake" slogan of Oscar Wilde as an example. The other, *moralism*, locates "the importance of art in some moral purpose which it serves" (Beardsmore, 1971: 6): Tolstoy's views provide the example. Given the full-bloodedness of these positions, they are rightly taken as "radical autonomism" (see Carroll, 2001: 295; Carroll, 1998a) and "radical moralism". Then *any* formalistic elements in one's account of art might seem to point towards (radical) autonomism while *any* concern with human values points to (radical) moralism. Here, I simply assume that these radical versions are untenable (a conclusion I take Beardsmore to have demonstrated: and, given our strategic purpose in mentioning them, one we can adopt).

More recently, defences have been offered for more limited versions. First, *moderate autonomism*, which:

> . . . though it allows that the moral discussion and evaluation of . . . at least some artworks is coherent and appropriate, . . . the aesthetic dimension of the artwork is autonomous from other dimensions, such as the moral dimension. (Carroll, 2001: 301)

One difficulty lies in identifying the precise thesis denied here. Suppose we assert that:

> . . . a work's moral flaws never count as artistic flaws . . . [and] a work's moral merits never count as artistic merits. (Anderson and Dean, 1998: 154, rectified for the artistic/aesthetic contrast)

Now consider works otherwise the same, one of which had a moral flaw or moral merit which the other lacked: for instance, Carroll (2001: 305) imagines a version of Jane Austen's *Emma* which did not engage "our moral understanding". His position (surely correct) is that this would not be *Emma*—in *our* world, those words in this order (seen as part of that genre, history and so on) could not fail to engage our moral understanding. If artistic concepts lacked a cognitive dimension, perhaps artistic merits would differ in kind from moral ones. (Defenders of a certain conception of the aesthetic certainly urge this.) But properly artistic concepts have cognitive dimensions, as well as affective ones—insofar as the contrast makes sense, for analytical purposes: they imply *categories of art*, at least. So there can be no hard-and-fast line here.

Of course, not all kinds of cognitive merit are artistically relevant: one can learn about, say, the plight of the poor or the conditions of (some) schools in Dickens' England from artworks. Yet these are not really artistic features of the works, as our concern with the embodiment of artistic meaning helps recognize. Imagine two cases (drawing on Borges, 1962 story, "Pierre Menard . . ."): first, a story written in the sixteenth century from which we can learn certain facts about life at that

time. In this case (*ex hypothesi*), this 'information' was not something the 'implied author' (and perhaps the real author) meant us to take from the work. After all, these were simply facts of sixteenth century England that the author (a sixteenth century Englishman) took for granted; facts one could *learn* from the story, but of no artistic relevance. In the second case, a twentieth century text is written *as though* by a sixteenth century Englishman. (Let the two be orthographically indistinguishable, if it helps.) For the second, the 'facts' are heavily researched, to provide just this sense of authenticity (let us imagine)—to find these supposed facts wrong or misleading will be a criticism of the work, if a minor one. For they are 'part of the construction': roughly, the work *aims* to tell us these things.

Faced with these cases, how should the proposal for an autonomous "aesthetic dimension" be regarded? If by "aesthetic dimension" is meant something *not* part of the artistic understanding and artistic value of the work, it is false in virtue of denying (or ignoring) the artistic/aesthetic contrast, especially were the "aesthetic dimension" taken as somehow purely sensuous (again, for familiar reasons: see Sections 1.3 and 1.4). Grant the artistic/aesthetic contrast, thereby locating our (legitimate) interest in artworks as *artistic* interest, and questions about how art is intrinsically valuable to humans are simply posed again. In particular, some account of artistic *value* is owing. Such a position readily acknowledges a 'life-issues' connection, especially once the coherence and appropriateness of at least *some* moral evaluation of *some* artworks is recognized. But now its claims to distinct artistic and moral dimensions look decidedly suspect: these discussions and evaluations will all be of artworks viewed as artworks.

More interesting for us, though, is *moderate moralism* (also called "ethicism"), explained as the view that:

> ... for certain [narrative] genres, moral comment, along with formal comment, is natural and appropriate ... [since] ... moral evaluation may figure in our evaluations of some artworks. ... That is, some artworks may [legitimately] be evaluated in terms of the contribution they make to moral education. (Carroll, 2001: 299)

This is because:

> [m]any artworks, such as narrative artworks, address the moral understanding. When that address is defective, ... the work is morally defective. And ... that moral defect may count as a moral blemish. (Carroll, 2001: 304)

In a similar vein,[7] and summarizing:

> Ethicism is the thesis that the ethical assessment of attitudes manifested by works of art is a legitimate aspect of the aesthetic evaluation of those works, such that, if a work manifests ethically reprehensible attitudes, it is to that extent aesthetically defective ... (Gaut, 1998: 182[8])

These theses are limited partly in only being about *some* artworks, at best.

Notice that 'moderate moralism' is *moralism* neither in Beardsmore's (1971: 6; also 14) sense—where it would be a species of instrumentalism—nor in the sense that implies *moralizing*! Rather, the thesis is just that, for *some* artworks, their moral

failings are (also?) artistic failings, and vice versa: hence, for these at least, the distinction between moral interest and artistic interest is not as absolute as is sometimes urged. Of course, there is no suggestion here that moral interest is not separable from artistic interest—works might be morally praiseworthy but artistically poor, for example; nor any suggestion (as there would be with *moralizing*) that particular moral positions must be endorsed. Instead, the point is that these works embody moral concerns or preoccupations; hence, for them, being morally *suspect* (as, say, propaganda or pornography) would be an artistic flaw. So perhaps what is good about—or, more likely, wrong with—certain artworks is just what (some) moderate moralists or ethicists say.

Certainly Carroll's *moderate moralism* and Gaut's *ethicism* move in a congenial direction. Like me, these authors are partly motivated towards appropriate *negative* conclusions: that, for instance, being propaganda or pornography are (in general) two ways of *not* being art; or, in some intermediate case, provide a basis for criticizing artworks; namely, as tending towards propaganda or pornography (Robinson, 1973: 160–166; UD: 175–177). Their tendency, then, is towards a recognition of the intrinsic human value of art. For artworks must be interesting as more than mere "social documents" (Gaut, 1998: 192). Those with only social interest of this kind would be interchangeable with other, artistically inferior works with the same 'content' (or with reports that were not even artworks): "if you can't find X, then get Y". Our commitment to the embodiment of artistic meaning (see Section 2.3) ensures that all the features of artworks viewed as artworks are artistically relevant— at least, any irrelevant features will be artistic flaws.[9] And such irrelevant features might, say, be a moral message (or its converse) not embodied in the artwork. For artworks cannot have meaning-irrelevant features without this being a criticism of them.[10]

Yet the quite general (if defeasible) connection of art to "life-issues", or "life situations", makes my thesis at once stronger and weaker than that normally discussed in connection with ethicism. Against those who wish simply to discuss moral cases, I urge wider application for a life-issues-connection for art, showing clearly the nature of artistic value in general. Such claims are strengthened once the connections are treated defeasibly, ceasing to regard them in terms of the all-or-nothing of entailment. Against those who take at least some artworks to be non-moral (or moral-indifferent), I urge that they are never (except defeasibly) life-issues-indifferent. For instance, Eaton (2001: 148) agrees that "[m]usic certainly can connect with . . . [life situations], and life situations are certainly often moral". For her, though, a strictly *moral* dimension is urged: so this is a feature that concerns some artworks only—Eaton (2001: 136) writes: "some works of art (and I emphasize *some*) . . .". Further, as promised (Section 3.2 above), my claim here is defended case-by-case, against putative counter-examples (see Section 3.6 below).

Moreover, these other writers may need to show that "aesthetic failures lead to moral failures" (Eaton, 2001: 149). By contrast, I need only concern myself with cases where *artistic* failures lead to moral failures (or vice versa). For our artistic/aesthetic distinction illustrates how at least some candidate counter-cases should be deal with here: say, aesthetically-powerful (but non-art) propaganda, such as

Riefenstahl's film *The Triumph of the Will*. For example, Anderson and Dean (1998: 164) urge:

> Leni Riefenstahl's *Triumph of the Will* provides what is doubtless a classic case of moral and aesthetic value going their separate ways...

In a similar way, Gaut (2000a: 344) discusses *Triumph of the Will* as "a glowingly enthusiastic account of the 1934 Nuremberg Nazi Party rally", commenting:

> It has frequently been denounced as bad art because of its message. Or is its immoral stance simply an irrelevance to its merit as a work of art?

And earlier, elaborating that "some works of art are ethically deeply flawed" (Gaut, 2000a: 343), he instances *Triumph of the Will*. But this case is only relevant if *Triumph* ... is an artwork: that might be contested (McFee and Tomlinson, 1999: 90–95). Then the right response is that *Triumph* ... is merely an aesthetic object (at best), not an artwork (compare Eaton, 2001: 137). If the contrast is simply with the *aesthetic*, as the passage above from Anderson and Dean suggests, there may be no dispute.

In another way, the targets of 'ethicism' or 'moderate moralism' are not mine. On my view, something similar (but *only* similar) applies in all cases—if only defeasibly. I have characterized (and discussed) a life-issues connection, holding (defeasibly) for *all* artworks, to explain the (human) value of such works. It would be preferable if the connection of artistic meaning to human valuing were clearer, so as to argue against (say) pornography; and for the outcome to relate directly to the artistic meaning (or message) of the work. For such connections would strengthen my position—or *appear* to! Yet we have urged that no single unified account of that kind could be offered here. Still, since moral concerns are uncontentiously a species of life-issue, any artworks having a moral connection in line with ethicism has a life-issues connection a fortiori: some generality is implied. And at least one basis for denying the moral connection to an artwork cannot count against recognizing a life-issues connection. Thus, when Emily Brady (2003: 249) writes that "[n]arrative art often has moral content", she implicitly contrasts *that* art with another kind, lacking such content. Since the context of her discussion is the appreciation of nature, reference to *art* here is plausibly a comment on, say, landscape painting. But perhaps such painting lacks "moral content" because it is, say, a celebration of nature—that too is an aspect of human valuing! So, whatever its relation to the moral,[11] this is no reason to reject a life-issues connection.

Moreover, some failings of artworks, while not strictly moral failings, nevertheless explain (some of) the artwork's flaws by reference to defective life-issues connections. Thus, having an inappropriate connection to emotion, "emotion had on the cheap" (see Tanner, 1976: 128[12]), say, provides a reason to *criticize* a work as sentimental, although sentimentality is not (exactly) a *moral* failing. But it is (at least) a human, value-related failing: a failing in terms of the life-issues connection. Equally, if kinds of support and balance in a dancework reflect more general human support for others (what might be called a kind of *metaphor* for that relation), there may be nothing centrally *moral* in all this. Yet there seems no reason to limit one's

'life-issues' concerns in this way to the strictly *moral*, unless one concludes that all human values are, at base, moral (to some degree or other).

Such a view of action, morality and art has been defended by Rob Van Gerwen (2004): for him, art is open to moral criticism, broadly understood, because art is (the outcome of) human action. Or, as Andrew Wright (1953: 24) puts it, "all art is necessarily concerned with morality . . . because all art must deal with man's actions in the world". And hence *all* human action is amenable to such moral criticism in principle (see Eaton, 2001: 137). Even supposing all action being open to such criticism, the point is not strong. Saying, "You ought not to have made it" (for some artwork) seems too mild a criticism here. Better to say, "You did something bad in making it"—where that *something* is a readily foreseeable outcome; or, anyway, one that thoughtful and careful attention should have foreseen. Yet this seems just an objection to any extrinsic condition: that is, to a *use* of the artwork by someone; and certainly not one which obviously continues to treat it as an artwork.

In *moderate moralism*, then, a moral connection is claimed for *some* artworks: further, art's connection to human valuing was only to *moral* value. Our concern was to articulate a satisfactory account of our own, rather than to enter (or study) that debate. Those who acknowledge the connection to value implicit in *moderate moralism* grant, first, what such a connection might mean in those cases where moral appraisal of artworks is appropriate; and, second, how some of the insightfulness of art (which grounds its value) might be justified as insightfulness into (roughly) the human condition. The interest resides in highlighting shared commitments, thereby suggesting that my position is not bizarre—although the 'life-issues' connection is urged quite generally.

3.6 A Seven-Part Strategy

None of this is actually an argument for the life-issues connection; instead, as noted above, it is designed show why no argument of *that* degree of generality was possible, although the ethicist position suggests taking a connection of art to human valuing as a kind of default. That throws us back onto our resources of offering examples and meeting counter-cases. To provide context for such examples, I initially sketch a seven-part strategy highlighting features of arguments here, before turning briefly to the structure of some apparent counter-examples.

First, to illustrate the 'life-issues' connection, consider how art can enrich and enliven our understanding of the world, just as personal relationships can. Knowing, for example, all the suicide statistics of England may still leave one feeling that the 'nature' of suicide has escaped one. Now reading John Donne's *Biathanatos* and his "Nocturnall upon St Lucy's Day" might give this kind of apprehension (compare Alvarez, 1971: 138). If it did, some aspect of the world becomes clearer to that person. Of course, change of this kind might be hard to express without sounding trite: saying that the world of the potential suicide is black, pointless, and unfriendly may be stating the obvious, but that may be the best one can do. As Al Alvarez (1971: 263; UD: 188–189) remarks, after coming to value life through

attempting suicide, "[i]t seems ludicrous now to have learned something so obvi-
ous in such a hard way". Here (as commonly with life-issues) one cannot say just
what is learned—except, perhaps, truistically. Refining one's conceptual grasp may
not generate radically new judgements: of course, such judgements may have some-
thing new about them—they might, for instance, inflect the world differently for
one. When Mats Ek's *Swan Lake* (1987) avoids a 'happy ever after' ending, that
might bring before one the shallowness of one's understanding of human relation-
ships. In Ek's world, "even with swans, everything is not black or white" (CDE: 80).
In recognizing the complexity of adult relationships, one sees the world differently.
These cases show artworks bearing, in different fashions, on 'life-issues': that is, on
what is important in human life.[13]

A second strategic point comes from considering less obvious connections to
'life-issues': for example, a Constable landscape might (say) celebrate aspects of
the natural world; or the variable viewpoints of Hockney's *Grand Canyon* paintings
(mentioned above) might reflect the inter-relation of human and natural. By con-
trast, viewing the Grand Canyon itself may make one aware of the small scale of
human history. But this would be an inference one draws, not one the landscape
prescribes (see Gaut, 1998: 192). The lack of intentionality for the *real* landscape
here precludes its having *direction* of this sort. In comparison, (say) the *landscape
painting* is more than merely a (literal) 'window on to the world': rather, the trans-
formative effect of art-status is recognized. So this might present a perspective onto
a world, literally or metaphorically. Since such things as *these* count as 'life-issues',
the necessity of a 'life-issues' connection poses less of a threat to the integrity of
art: there is nothing directly instrumental here.

Now consider (as point three) a response to abstract cases where there seems
no such connection. In *some* such cases, there *is* a life-issues connection, despite
appearances to the contrary. So many works thought obviously to have no life-issues
connection in fact *do*—as illustrated when Wollheim (1973: 128) characterizes a
painting of Rothko's in terms of "a form of suffering and sorrow, and somehow
barely or fragilely contained". The (apparent) abstractness of an artwork need not
automatically run counter to that work's claimed connection to what humans value.
In yet other cases, the *rejection* itself indirectly acknowledges such a connection—
say, where the denial of the life-issues connection is itself polemical (as with
Merce Cunningham's dance: see Section 3.2 above; compare Cavell, 1969: 221).
Further, those rebelling against, say, an artistic tradition, implicitly acknowledge
that tradition, against which background their actions are intelligible: such apparent
counter-cases are still 'in relation to' the tradition (UD: 246).

A fourth point extends the third by reiterating the *defeasibility* of the relation (see
Section 2.2; UD: 61–63): highlighting the *logic* of the move away from the 'all-or-
nothing' of entailment deals with apparent counter-cases. For defeasible notions, an
objector can raise recognized 'heads of exception' (Baker, 1977: 52–53) only inso-
far as they apply *in this case*, not simply as abstract possibilities. Then the art-status
of this particular work is explained, despite its lacking the life-issues connection
(since one of the "recognized heads of exception" is satisfied), without thereby
undermining our general commitment to that connection—just as explicitly denying

a connection of one's work to artistic meaning is, after all, to be understood "at the same level" (Cavell, 1969: 253) as any other meaning-connection.

Fifth, the idea of *life-issues* here contains no implication of high seriousness, or of the earth-shattering character of such claims. Rather, they are *life*-issues only in the sense of bearing on human life; hence on what humans value. Also—and sixth—these cannot be issues for me only: art viewed as art cannot find a response in purely personal concerns. As Kant ([1790] 1987: 54) put it, "it must contain a ground of delight for everyone". So, for instance, taking an artwork as pornography is definitely misperception (rather than, say, another legitimate way to perceive the object) because it cannot sustain the (relative) universality of artistic interest. So it would focus, at best, on *my* issues, rather than on *life*-issues. To see an object that way is not to see an *artwork*. Rather, with art (as Bradley, 1934: 623 puts it[14]), "[w]e have everywhere . . . the impersonal direction and set of interest. We are absorbed not in ourselves but by an object before our minds".

As a seventh point (and finally in its place), the argumentative force behind the 'life-issues' connection is recognized (UD: 17): would we accept as art something with *no* connection with human thought and feeling? Surely not. For doing so could not explain artistic value.

Raising examples here sketches lines of response to particular problems or perplexities that might be brought against my general thesis, treating each strategically. In this way, it illustrates how candidate objections might be met or defused. Further, as occasion-sensitivity suggests, the topic (or question) of a life-issues connection will likely arise only in certain circumstances: in particular, in respect of problematic, or even improbable, cases (and we have suggested how they might be dealt with: see also Section 3.2 above) or, by contrast, when elaborating the specifics of the connection—say, in respect of a particular literary work. So here one returns to some uncontentious cases—artworks clearly meaningful (in the relevant sense) and clearly connected with life-issues, with the war poems of Wilfred Owen as our example.

But, yet again, could one show that *all* such cases may be treated in this fashion? One cannot; but the challenge here is precisely that our resources, in their diversity, seem adequate both to deal with typical or candidate cases, and to explain why atypical cases count as exceptional.

Finding a counter-case here cannot be a matter of simply scrutinizing artworks: rather, the implications of the object's being (or not being) an artwork must be considered. Certainly the matter is not an empirical one, such that one might discover an artwork not valued in (broadly) these ways. Then any argument to show that the object in question *was indeed* an artwork (say, appearance to the contrary not withstanding) would simultaneously be an argument for its being (appropriately) *valued*. And any argument against the object's being (appropriately) valued would count against its art-status—at least, once the points above about rebellion and defeasibility are accepted. Then the choreographer who *sets out* to produce a dance avoiding these conditions (as Merce Cunningham claimed to: compare Section 3.2 above; UD: 253–254) merely invents a new way of meeting them!

Am I saying more than that art must make a connection to our lives? Yes, both because my claim was not supposed to be exceptionless (although it will usually be

contradicted only when something 'at the same level' replaces it) and because, on my view, the connection must be a positive one. Clearly, this is a recipe for disputes about what *should* be meritable in a humanly-sensitive world. But, as our examples show, the conception of the value of art developed here is centrally concerned with raising issues or questions, with disturbing the un-thought-through assumptions; and not with finding (general or generalisable) answers. Further, just those debates are *within* the human world: if artworks make issues vivid for us, they may help us to articulate a view of the matter, or to come to one. It is hard to require that my 'life-issues connection' deliver more than that.

This reiterates (in slightly different language) some ideas concerning *categories of art* and about *embodiment* from earlier in this text. For the appropriate (appreciative) response to a particular artwork depends on how it *should* be seen— misperception is the evil to be avoided. And making senses of this "should" requires locating the work in its history and the history of art-making and art-understanding in which it participates. Gaut (1998: 195) is keen to emphasize that artworks "can teach us new ideals, can import new concepts and new discriminatory skills". Again, there is nothing necessarily ethical about this, although this alone may take us quite some way towards a new view of our lives; hence to a change in what are 'life-issues' for us (UD: 173–190).

3.7 Literary Value and Moral Understanding: Nussbaum

We have, in effect, two different *contexts* or *occasions* for this discussion:

- to make out the *importance* of art: here, that 'answer' should be broadly in terms of art's revelatory capacities;
- to make out the detail of the 'life-issues' connection, as best as we can, in line with what is said in relation to the other point.

Any answers will be occasion-sensitive; hence, not exceptionless. A model here would be useful. But what form should any account generally revealing here take, one typically of use in explaining how to respond to an opponent? Such an account would be (i) at least weakly ethicist, in seeing some moral connection to some artworks in some favoured category (such as literature), whereby the moral successes are literary successes and where moral failures count as literary failures; (ii) revelatory (see Section 3.4 above); (iii) perceptual, in stressing that artistic value is seen or noticed; and (iv) particularist, in the sense that the explaining of artistic value for *this* work need not offer anything generalisable. Further, (v) its primary focus would probably be on literature, as the easiest case for a life-issues connection.

Mirabile dictu, the literature contains (in Martha Nussbaum's writing about literature) a discussion of art's value which, in addition to meeting these five constraints, offers a plausible response in respect of the first issue (above) combined with the beginning of an answer to the second—or, better, a model from which an answer to the second issue might be developed, since Nussbaum writes only about the

moral impact of (some) art. So, for many cases, my responses should resemble Nussbaum's.

Nussbaum grants, and rightly, the 'fact' that novels (in particular) are regularly recognized as offering insight into, roughly, the human condition. How can this be? In particular, why should any (supposed) insights not simply be *stated*? As Nussbaum (1990: 138) asks, through her discussion of a novel by Henry James:

> Why ... do we need a text like this one for our work on these issues? Why, as people with an interest in understanding and self-understanding, couldn't we derive everything we require from a text that simply stated and argued for these conclusions about human beings plainly and simply, without the complexities of character and conversation, without the stylistic complexities of the literary ...?

What does this *form* offer that is somehow unavailable (or, anyhow, problematic) elsewhere? Beginning her answer, Nussbaum rightly distinguishes "the claim of this particular novel ... [from] ... the philosophical importance of literary works generally" (Nussbaum, 1990: 138), where the best that could be said about "the philosophical importance of literary works generally" is really a kind of abstraction from what could be said about this novel by Henry James, that play by Shakespeare, and so on. Hence the only fully satisfactory answer to Nussbaum's second question must be assembled from the various answers to her first. This is one reason why there is no wholly general way literature relates to human lives. Instead, the stress is on "the ultimate and particular" (Nussbaum, 1990: 74, quoting Aristotle: NE 1142a23[15]).

Moreover, even the substance of a particular literary work cannot be portrayed divorced from its literary 'incarnation':

> ... a paraphrase ..., even when reasonably accurate, does not ever succeed in displacing the original prose; for it is, not being a work of high literary art, devoid of a richness of feeling and a rightness of tone and rhythm that characterize the original ... (Nussbaum, 1990: 154).

For it will be a criticism of an artwork if its artistic features can be changed 'without loss', since then these features were not, after all, crucial to the work's *meaning* what it does (to its having the *artistic* meaning it does), and hence to its *being* the artwork it is. The work cannot, in this fashion, be exhausted by paraphrase. As Nussbaum notes, works of high (literary) art will be especially resistant here.

Further, one cannot infer from the fact that such-and-such was a reason for so-and-so judgement in *this* case that it will generate a similar judgement in *that* case. The reasons here presently do not necessarily combine with each other in any simply additive way. At the least, that cannot be guaranteed in advance of investigation. So that a reason for a positive appreciation of one work might have no such implication, or even a negative one, for another work. To recall an example (Section 2.8), a critic explaining the virtues of the relevant artworks would certainly mention the canon-style structure at the opening of the Webern *Symphonie* Opus 21 and at the opening of Bruce's *Ghost Dances* (1981): in both cases, this canon is one reason to think well of each work, one good thing about it. But, to repeat, it does not follow that possession of a canon-type structure is always and everywhere a virtue: on some occasions, it is beside the point—for instance, a camp-fire song sung in canon is not

thereby transformed. Moreover, in some works, this would be a flaw: "Not another canon!" is a complaint familiar among those who view student dance-compositions. There, perhaps, the feature has been over-used; or used thoughtlessly—then these are reasons to criticize the choreography. So, although a positive feature in the works by Bruce and Webern, canon is not always positive: its possession is not always a reason for (mild) praise. Further, it does not bear in the same way on both our cases: its contribution to the excellence of these artworks is not uniform.

Hence, one cannot articulate reliable general principles ("fixed in advance of the particular case": Nussbaum, 1990: 38) since such principles should be exceptionless, but new features of the situation can always arise, or unexpected kinds of action or response. That would pose the question of how (if at all) the supposed principle applied. For art, some novelty to *this* work (compared with the works preceding it) is at least the norm. Without knowing what circumstances may be confronted, such an exceptionless principle cannot be formulated; and one cannot know the range of such circumstances.

Embracing these as features of reasoning or appreciation may be easier for artworks than for (say) moral action: after all, artworks have a minimal uniqueness—faced with two artworks, exactly the same things may not apply to each; offer the same reasons explanatory of their virtues, say. For "[h]ere, particularity is not contrasted with universality but rather with generality or theory" (Lamarque, 1996: 102). And Nussbaum offers considerations against generality,[16] commenting on "the need for fine-tuned *concreteness* in ethical attention and judgement" (Nussbaum, 1990: 38). The same might be said for artistic judgement, stressing "the priority of the particular" (Nussbaum, 1990: 37).

In fact, two (slightly different) particularities occur here: first, the particularity of the artwork—that *its* meaning is uniquely embodied in this form; second, the particularity of its concerns also seems a further particularity of content—that it portrays aspects of the life of so-and-so (for example): of Pursewarden (*Alexandria Quartet*), or Maggie Verver (*Golden Bowl*) or Newland Archer (*Age of Innocence*). But how exactly does insight into the life of, say, Pursewarden bear on my life; or on human life-issues more generally? But how might such "fine-tuned *concreteness*" be revelatory?

The insight (recognizing the difficulty) is that observing the workings-out of the lives of others can amount to 'revealing anew the familiar from life' (see Wisdom, 1953: 224) for *one's own* life. Anything less than a thorough investigation might provide little more than the offering of slogans, beloved of some talk-show hosts (and some psychologists), which *then* need to be integrated into lives; and into one's own life. Part of Nussbaum's concern is with "the sheer *difficulty* of moral choice" (Nussbaum, 1990: 141 original emphasis). Insight here requires:

> ... views whose plausibility and importance are difficult to assess without the sustained exploration of particular lives that a text such as ... [James'] makes possible. (Nussbaum, 1990: 139)

So that literature *is* well-placed to "yield insights into moral reality of a depth and precision that no other cultural form is well placed to match" (Gaut, 1998: 191).

In this vein, Nussbaum (1990: 148) writes of a "conception of moral attention and moral vision [that] finds in novels its most appropriate articulation". This "most" might be denied without disputing that novels articulate, or embody, such attention and such vision; that, when true, this contributes to explaining the (artistic) value of these novels. Again, it is assumed here—and surely correctly—that really understanding a moral question (as might result, for Nussbaum, from careful and thoughtful reading of James' *The Golden Bowl*) is progress in itself: one can learn, in a personal way, *about the problems*—that will be a gain, whether or not one moves further in resolving them.

Nussbaum's position rests on her account of "the ability to discern, accurately and responsively, the salient features of one's particular situation" (Nussbaum, 1990: 37)—what she calls *perception*. Here, the *perception* operates both as sensory and as perceptive. For "discernment rests with perception" (Nussbaum, 1990: 66, quoting Aristotle: NE 1109b23). Thus the artwork (at least, the typical novel) "instructs us in how to view the world" (Lamarque, 1996: 105); and does so because "[a] novel . . . places us in a moral position that is favourable to perception and it shows us what it would be like to take up that position in life" (Nussbaum, 1990: 162). Nussbaum (1990: 162) comments that the novel does this "just *because* it is not our life" (my emphasis). That it is not my life allows me to work through its issue without the usual risks. This explains an important connection between art and fiction—between art's revealing character and its fictionality. Equally, *fiction* here does not mean exactly 'contrary to facts', for the "life" at issue might turn out to be someone's life (even someone called "Maggie Verver" or "Newland Archer"): we simply do not care. As Lamarque (1996: 105) puts it, "[w]hether the particulars are factual or fictional is, in this context, of subsidiary importance to the seeing itself." For example, in considering the question, "does real love exist?", Wisdom (1965: 144) praises Stendhal because his novel *De L'Amour* "does much to bring in order before the mind the many forms of love and their relation to what is not love". Nothing here turns on the fictionality (or otherwise) of the case: instead, like a good parable, it offers an insight into conceptual connection—here, we see the revelatory aspect of artistic judgement; and see it in relation to revelations about persons, their inter-relations, and our understanding (and so on) of them.

Of course, as Lamarque and Olsen (1994: 389) recognize, "not all literary works present situations of moral conflict and choice". So Nussbaum's account cannot be a model for either a general account of artistic value, or an account of all literature. But *our* target, in showing some contours with respect to moral implications for artworks, lies in illustrating one way artistic value (and artistic meaning) might be discussed and defended when these issues arise.

3.8 A Conflict Between Morality and Art?

Can a moral dimension conflict with an artistic one? While, of course, such a conflict is not necessary, a particular work's moral commitments (especially when viewed negatively) can run counter to viewing it as an artwork. For example, one *might*

argue that Eliot[17] could regard Ezra Pound's *Cantos* as simply "an inexhaustible reference book of verse forms" only because the *Cantos* instantiate Pound's fascist leanings so poorly. For perhaps a more powerful exposition of the repugnant fascism would have rules out *Cantos* as art. At the least, Eliot sets that issue aside—thereby highlighting its potential for conflict if *not* set aside. Of course, this is not what Eliot says; but we are used to disagreeing with the pronouncements of artists and critics! Equally, criticizing some Socialist Realist works from the (former) Soviet Union for "their happy images of communist society at work and play" (Lynton, 1989: 161) might actually be to stress that these painters "were insisting on the primacy of meaning . . . in the old sense of discursive content partly or largely paraphrasable into words . . . over artistic interest" (Lynton, 1989: 182 [my order, rectified for the artistic/aesthetic contrast]). That is, the commitment to the 'message' in these cases was so strong that it interfered with the embodiment—partly explaining why they are badly painted. Even granting these two cases, there is no implication here that something similar (what could *that* be?) could be said of other cases—it might, or it might not.

As we saw, the artistic/aesthetic contrast allows the putting aside of cases that are not artworks (for instance, Riefenstahl's *Triumph of the Will*). Parallel problem cases for my account come from artistic successes that are moral failures. Since my reply will be case-by-case, consider (for instance) D. W. Griffiths *Birth of a Nation* (1915). As accurately characterized in the *LA Times* (Braxton, 2004: E1), this film "still evokes such volatile reaction that it is rarely shown publicly"; then explaining some of the reasons. For instance:

> Blacks are depicted as buffoons and rapists. White actors in blackface pose as congressmen, eating fried chicken and watermelon on the floor of the House. The hooded riders of the Ku Klux Klan are portrayed as heroes of the Reconstruction era. (Braxton, 2004: E1)

But *Birth* . . . was uncontentiously meant as an artwork, and is reported as "experiencing a mini-renaissance among artists, scholars and film lovers who deplore its racism but applaud its cinematic achievements" (Braxton, 2004: E1). At least in the minds of those supporters, then, it succeeds as (flawed) art, as "a very effective and well-made movie" (Braxton, 2004: E4). For all that, it clear incorporates morally unacceptable 'messages': for instance, when the "Ku Klux Klan are portrayed as heroes". In fact, this work, as typically, is flawed in both dimensions: to the degree that it succeeds in embodying its (disgusting) message, it is failing morally; but to that degree too it cannot *deserve* any audience for artistic appreciation that it attracts.

So adopting the artistic/aesthetic contrast (on my version) is clarifying here: it draws contrasts between art and pornography, or art and propaganda, where we pretheoretically wanted them. But it also opposes that aestheticism (what Beardsmore [1971: 3] calls "autonomism") which claims that art has no connection at all to life (or politics). If *Birth of a Nation* is honestly a challenging case—as its history suggests—confirmation might even be found in the fact that my account too finds it challenging!

When confronting a problematic cases, one should always turn to the *occasion*: here, consider what is being asserted in calling this object (say, Pound's *Cantos*

or Griffiths *Birth*...) *art*. Different points one might be made in different contexts. For that assertion is complex: it amounts to more than simply that the objects are well-crafted, or that they are beautiful—both of these claims are compatible with the objects *not* being artworks, but only (mere) aesthetic objects. Our line (above) was that Pound's *Cantos* constitute a flawed artwork, with positive artistic features as well as (powerful) negative features derived from the ethical stance the work embodies. And beautiful (and well-crafted) objects, such as Riefenstahl's *Triumph*..., remain unproblematic if they are not artworks. In some cases, moral repugnance may be sufficient to rule-out an object's claim to art-status. So when is the object rightly regarded as a flawed artwork rather than a failed (and hence non-art) candidate artwork? Perhaps, despite appearances to the contrary, *Birth of a Nation* is not an artwork. Another strategy treats it as a flawed artwork, after the fashion of Pound's *Cantos*. These are our two hard-line responses. But a third response to *Birth of a Nation* might conclude that there is no one right thing to say: perhaps, for a group of film students attending to craft and its ability to embody meaning, the film might be taken (exceptionally) as genuinely being an artwork *and* morally reprehensible. Yet, with a group discussing art-status, one might decline to take *Birth*... as a suitable topic for discussion. After all, it would be too far from the norm of a morally positive life-issues connection for artworks.

So, in different contexts, *Birth*... might count either as an artwork (albeit a flawed one) or as not art, because the moral stance it embodied was incompatible with art-status; or perhaps that work was so far from typical cases of art that one could not know what to say. There need be no any hard-and-fast distinction here—agreement as to the work's properties (in this case) might generate consideration of how those relate to art-status: that is part of the case-by-case debate here.

Resolved in any of a number of ways, this case is defused as a potential counter-example to my view of a *positive life-issues connection* for art. Other theorists might assume that a sharp contrast is required (in *all* circumstances) in order to do justice to the facts of the situation—otherwise these would not be *facts*. But the *occasion-sensitivity* of what is meant or asked should be recognized (see Sections 2.3 and 2.4) and, more specifically, the case-by-case character of debate about the value of artworks. What one needs to say (truly) in these different contexts depends on the questions asked: there need be no firm contrasts that one *must* draw here—although the artistic/aesthetic contrast will be firm for any discussions turning on *art*-status.

As the moderate moralist or ethicist grants, artistic value can conflict with moral value, although it does not do so in principle; then morally-flawed works are art 'on balance', or some such. Further, in some cases, moral evaluation has artistic force. Our view is at once more concessive and more powerful. For instance, were this topic raised by some critic (formal or informal), it could not simply be dismissed out of hand, as is acknowledged by finding a relevance on some occasions—reference to, say, monetary value *could* be so dismissed (at least in typical cases). Then, if raised, the specific relevance in *this* case must be shown and argued (which may result in its being rejected); further, the ensuing debate is joined by 'understanders' of art (in that genre, and so on). Given that logical relations here are *defeasible*, there is no reason why artistic judgements might not involve an ethical dimension:

certainly, this possibility cannot be defused with counter-examples. Hence, all artistic judgements have this as a possibility: *moralistic* and *interested* judgements are (rightly) precluded, but not other kinds of other-involving and world-involving judgements.

3.9 Conclusion

Noticing how finer perceptual discrimination might be humanly beneficial offers a connection to human valuing of the kind the moderate moralists (etc.) urge. But Nussbaum's position (like mine) is rather badly described as concerned with *morality* at all—except in the widest of sense, that in which all human activities (at least interpersonal ones) have a moral component. Certainly the 'issues' considered "are typically not front-page news" (Cavell, 2004: 38): they need not be of the 'earth-shattering' kind.

One should not, of course, conclude that art *must* be revelatory in ways Nussbaum suggests: that conclusion has not been argued. But if the account here shows how art might be taken in that way (or what it would mean to do so), it advances our argument by suggesting where the value of art resides. Or, better, how *sometimes* (perhaps often, in the context of philosophical aesthetics) questions about art's intrinsic value might be answered. On those occasions, that would be the right answer.

Similarly, the soundness of the argument for moderate moralism was not assessed. That argument simply indicated a direction to thought—that seeing a moral dimension to art was not obviously crazy, and nor did it require viewing art *instrumentally*. Given this possibility, our considerations suggest both how rejection of instrumentalism combines with insistence on a life-issues connection; and how a connection to value more generally conceived is actually more plausible than the restriction to (just) *moral* value.

This discussion turns on its head a point raised earlier. If accounts of the meaning of artworks (articulating those works' life-issues connections) must always be *strategic*—to answer a particular person's perplexity, perhaps in a particular context—an account satisfactory for me might fail to convince you, since it might fail to address *your* perplexity. This insight into the project of philosophical aesthetics renders difficult *explanation* of artworks *in the abstract* (where this means 'abstracted from actual perplexities'). Thus giving *specimen* examples of such explanations becomes difficult: what exactly do they exemplify? Yet my earlier strategy amounted to presenting examples. This apparent tension need not be a problem. Since these examples are (always and necessarily) directed at *specific* perplexities, we have a further explanation of why there can be no *totality* of cases to consider: there is no totality of perplexities.

Finally, it should now become clear what problems my artistic/aesthetic contrast dissolves. Without this contrast, ideas central to philosophical aesthetics cannot consistently be maintained: first, that artistic value is distinctive[18]—I do not see how an aesthetician could deny that; second, that the philosophy of art has enough problems

of its own, without getting embroiled in the kinds of 'philosophy of beauty' that (merely) aesthetic judgement subtends. Either adoption or rejection of these ideas will transform one's view of the project of philosophical aesthetics.

Notes

1. As we shall see (Section 6.4), this is the AM (revised version).
2. Compare McFee (1997) where the distinctiveness of artistic meaning (and its application in *apparent* problem cases) is aligned with artistic value.
3. On exceptionlessness, see also EKT: 177–193.
4. Wisdom (1991: 112–113); see also McFee (1978: 40–41).
5. This is the *erlösende Wort*: PO: 165.
6. See Eaton (2001: 162) re moral lessons.
7. Carroll (1998a: 419) takes Gaut's project to be "much more ambitious".
8. Since this was written, Gaut (2007) has produced a more worked-through version of his ethicism. In general, the points of relevance simply replicate those made in the works cited here. But Gaut also wants to put aside another possibility: what he calls "immoralism", explained as the thesis "...that ethical defects of works can contribute to the aesthetic value of works, and that...ethical merit can also contribute to the aesthetic demerit of works" (Gaut, 2007: 11). By contrast, Gaut's own view emphasized merited responses, such that *Jane Eyre* "prescribes us to admire Jane's fortitude, to want things to turn out well for her, to be moved by her plight" (Gaut, 2007: 230). On this position, the artwork "presents a point of view...that the reader is prescribed to have towards the merely imagined events" (Gaut, 2007: 231). Four responses are germane. First, in contrasting the artistic with the aesthetic, our reworking gives a cognitive 'edge' to our account of art, congenial to various cognitive relations playing a role here. Second, and relatedly, this position is best called "contextualism", as Gaut (2007: 13) notes. Such *contextualism* is obviously very congenial. Third, as particularists, we need not worry about immoralism, once the connection of art to morality is granted—for we accept that there can be such changes of "valance" (that "a reason in one case may be no reason at all, or an opposite reason, in another": Dancy, 2004: 73; or "that each single feature can change its polarity", from *reason for* to *reason against*: Dancy, 2004: 94). And these are further discussed in Chapter 5. But, fourth, the specific examples now offered—from de Sade (Gaut, 2007: 230)—do not in fact support the case. For such examples are not correctly understood as simply endorsing the pleasure in the objects—it is conditional ('in this corrupt world': compare Gaut, 2007: 101–102 on de Beauvoir). Moreover, some of these works (in particular, the one most cited, *120 Days...*) were written with a further (non-artistic) intention: as masturbation fantasies for de Sade's time in the Bastille. So this suggests treating them as 'the lesser of two evils' (as artworks *pro tanto* at best).
9. This differs from even (say) the elaborate "S" written by Mr. Johnson (in Joyce Cary's novel of that title: quoted and discussed Beardsmore, 1971: 9–12). There, although Johnson's primary concern is with aesthetic flourish, considerations of legibility impinge. There is no justification for blue ink rather than black (if both flow equally smoothly), but none is needed: so this is not a criticism.
10. A special case here: performances (musical works, dances), which are under-determined by the artworks themselves (UD: 96–97): but the *works* have no meaning-irrelevant features.
11. On the supposed conflict between the ethical and the aesthetic concerning nature, see Brady (2003: 246–250).
12. Oscar Wilde (1966b: 946) referred to a sentimentalist as one who "desires to have the luxury of an emotion without paying for it...Indeed, sentimentality is merely the bank holiday of cynicism" (to Lord Alfred Douglas, 1897).

13. In elaboration, a mechanism for this change in understanding, emotional education, might be sketched (UD: 168–170).
14. UD: 175–177 urges a powerful argument for this conclusion, from Bradley (1934).
15. Standard citations to Aristotle are used, rather than a specific edition.
16. In relation to universality, the discussion turns, for Nussbaum as for Winch (1972: 151–170), into a dispute against a certain kind of *universalisability*—and a discussion of Bradley (UD: 175–177) might suggest what is universal (ish) here.
17. T. S. Eliot, quoted in Leavis (1950: 114 note).
18. Contrast Bennett (1979: 11) who cites scholars who feel that the concept *literature*, "artificially separates the study of 'literary' texts from adjacent areas of cultural practice"; and is unhelpful for that reason—'literature is just text'. But this is just to deny literary value (and, *mutatis mutandis*, artistic value)—surely not a move open to an aesthetician.

Chapter 4
Intention, Authorship and Artistic Realism

This chapter explores three overlapping topics concerning artistic properties: their intentional character, and the role of their histories of production, and of their response-reliance, in our understanding of them. For, as we saw (Section 2.1), *meaning* has conceptual connections to *intending*. And artistic properties bring with them (artistic) meaning. This enquiry grants methodological points made previously. In particular, the *defeasible* character of any claims made is recognized, and that they are not exceptionless, and cohere with our *occasion-sensitive* account of meaning and truth, in applying to *this* work, in *this* context, with *this* question asked or at issue.

The problems here might be conceptualized as arising from scepticism concerning the relation of artworks to humans. Thus, sceptically, the intention of the artist can be put aside, as Wimsatt and Beardsley (1962) did, as at best causally connected to the work itself—pursuing it would commit 'the intentional fallacy', looking to the artist rather than the work. Our sceptic makes a similar point about each work's history of production: looking there commits a causal fallacy. Finally, artistic properties might be rejected (on a parallel with the colours of things) as dependent on human judgement in a dismissive way: as subjective (roughly).

Clearly, aestheticians should reject, as misplaced, these sceptical tendencies. One strand here disentangles such sceptical threads by discussing features of the concept of *authorship*, in the sense in which artists are the authors of their works. Of course, central to (artistic) authorship is the making of *meaning*. For artistic properties might be roughly characterized as the properties that artworks have in virtue of being artworks: that is, (following Danto) their transfigured properties. And finding art-status (or artistic meaning) is also finding artistic value.

4.1 The Intention of the Artist

Stressing artistic *meaning* gives a place to an intentional concept: for only what is meant in that way can be meaningful. This is why the cracks in the wall not only do not spell-out my loved-one's name, they could not do so. A naturally-occurring process (such as the wall's cracking) lacks the intentional force. Further, artworks are

not Rorschach Tests, 'blanks' for interpretation: one cannot just make whatever one wants of them. Neither are their features *accidental* (unless someone decides they shall be). So (roughly) an artist's intelligence must be seen behind the artwork. Thus, when a perceptible property of an artwork makes it (say) expressive, "the property is due to the intentions of the artist" (Wollheim, 1993a: 155). Moreover, artworks can be made sense of; and hence are objects of understanding, with the possibility of an audience. Applying these points reiterates two features of artistic meaning. First, a cognitivist thrust to artistic properties follows from the role of *categories of art* in connecting particular artworks to the history and traditions of art-making and art-appreciating: for instance, a knowledge of the appropriate *category of art* is required to avoid misperception (compare Sharpe, 2000: vii). Second, what is intentional in this sense need not be what common sense calls "intended": one need not have thought about it specifically. Thus, my walking is an intentional activity (it is not an accident; I am responsible for any damage I do); but I do not, usually, *think* about walking—one way or the other.

Clearly the concept *intention* must be found a place in any plausible analysis of artworks, given the connection between meaning and intention. To speak, when discussing a play, of "What Shakespeare intended . . ." (say, in this scene) is to grant that its features are not accidental; that the work here was intended. Of course, a number of problems with assigning a role to intention in understanding art have been identified (at least since Wimsatt and Beardsley, 1962): in particular, how is intention correctly ascribed? And what about intentions not fulfilled? Here:

> [I]t no more counts towards the success or failure of a work of art that the artist intended something other than is *there*, than it counts, when a referee is counting over a boxer, that the boxer intended to duck. (Cavell, 1969: 181 original emphasis)

The real problem arises when asking about intention (or about 'what is intended') directs attention away from the work of art, towards the artist—and especially if our view of intention makes us (try to) look 'inside the artist's head'. Indeed, the standard opposition between Intentionalists (such as Hirsch, 1966) and Anti-intentionalists (such as Wimsatt and Beardsley, 1962) is built both on a shared conception of *relevance*, on which artistic intention is either always of relevance or never is—and hence can be explored by hunting for counter-examples—and on a shared *picture of intention* on which "[i]ntention is design or plan in the author's mind" (Wimsatt and Beardsley, 1962: 92), at best causally connected to the artwork produced. Neither of these is very plausible.[1] First, our contextualist conception of philosophy does not support such a view of relevance as exceptionless (see also EKT: 177–193): certainly there seems no reason to assume it. Second, that psychologised view of intention cannot long survive a consideration of how intention is ascribed in practice (UD: 232). At the least, the logical connection between intention and action intended should be acknowledged. Then reflection on patterns of *explaining* intention can begin from simple cases. Thus, the ascription of intention is public (in principle)—at least defeasibly, that I am digging is 'evidence' that I intended to dig; and so is my complaining that the bad weather stopped me digging, and so on.

Further, I do not (typically) study my intentions to find out what I will do—the relation is *not* (or, anyway, not straightforwardly) causal. So saying, "I am putting on my coat, so plainly I intend to go home", is not reporting a discovery of a causal structure. In the opposite direction, my explicitly intending such-and-such does not, by itself, bring that thing about—as we know, since what I explicitly intended may yet not occur. Moreover, the ascription of intention involving a kind of interpretation: making sense of what I do, in terms of my intentions, may require reconsidering my past behaviour. Perhaps my past intentions were not what you thought they were; perhaps they were not what I thought they were. Discovering that my action of pumping water to the town poisoned the inhabitants, one might think I made a mistake; or one may re-examine my attitude to those townspeople (compare Lyas, 1992: 142). In summary, intention-ascription can be revealing about human action, but not (typically) in virtue of revealing what went on 'in the head' of agents.

A similar pattern of explanation should apply to art-making. As Wollheim (1987: 37) puts it:

> ... the burden of proof would seem to fall upon those who think that the perspective of the artist, which in effect means seeing the art and the artist's activity in the light of his intentions, is not the proper starting point in any attempt to understand painting [or any other artform]. For it is they who break with the standard pattern of explanation in which understanding is preserved.

So one has a right to expect the artist's intentions to cohere with the understanding of his/her work; the case where it does not will be an exception (and itself open to explanation). This is (presented as) a "starting point"; and at its centre is the idea of not separating artist and work. (Thus, for example, Wollheim, 1980: 185: the creative process as ". . . not stopping short of, but terminating on, the work of art itself".) Applied here, then, we need instead (roughly) 'the intention embodied in the work' (whether or not it was the artist's): as a slogan, this will be "intentionalism constructed out of anti-intentionalist materials" (as I called it elsewhere; UD: 230).

Here, materials need only be provided sufficient to meet objections that might arise, or questions that might be asked, about the place of the artist's intention in the understanding of her work. These typically relate to decisions about how best to make sense of that work: or, if this is different, what properties are best ascribed to it. Then a very complex area with a large literature can be sketched in three ideas.[2] First, as above, this cannot be *actual* intentionalism, if *intending* something is thereby reduced to, say, what so-and-so person actually thought. For instance, although I certainly intended to go home this evening, this is the first time I have considered it, one way or another. So ascribing intention is often a matter of making sense of action by seeing it as, say, not accidental. The "framer's intentions" for the US Constitution provide a rough parallel: properly understood, the "framer's intentions" are determined by a mixture of history, (constitutional) integrity and practice (see Dworkin, 1996: 10; Dworkin, 1986: 176–224)—precisely the sorts of considerations which apply, *mutatis mutandis*, to artist's intentions! For determining such legal intentions is a matter of making the best 'fit': as with determining the appropriate reading of philosophical texts (Baker and Morris, 1996: 5–6), few considerations

could be absolutely decisive here. Rather, such-and-such a 'reading' arguably preserves integrity better than its competitors (Dworkin, 1986: 217). Such an account of the US Constitution, which Dworkin (1996; see SRV: 108–110) calls a *moral* reading, grants that thoughts which did not enter the heads of the actual people are nevertheless rightly regarded as part of the intention of the Constitution. So the difficulty is not unique to *intention* in respect of artworks, but is an issue resolved in the legal case (in roughly the way suggested here for art).

Since our topic is not what so-and-so artist *did* think or consider, our account is not necessarily refuted by evidence that the person did not think about such-and-such for himself. For example, Dr. Johnson might correct Goldsmith's account of what he intended by the word "slow" in first line of his poem, "The Traveller":

> Goldsmith said it meant 'tardiness of locomotion' until contradicted by Johnson. 'No, sir. You do not mean tardiness of locomotion. You mean that sluggishness of mind that comes upon a man in solitude.' (Cioffi, 1965: 175–176)

Here, Johnson is offering a stronger 'reading' of the passage. And what is resolved is the meaning of that passage. So, rather than being about (say) what makers or audience thought, reference to "the artist's intention" here, as typically, amounts to commentary on the artworks themselves: hence, is true or false of them.[3] This accords with our general commitment to artistic properties as properties *of the artworks*.

Second, our concern is with intentions ascribable to this artist, given the time of construction of the work. In the simplest case, a person from a society lacking the concept *art* could not intend to make art, and hence could not succeed (nor fail) in making art. These conditions are primarily used negatively: *this* 'reading' of a work can be dismissed as conflicting with the artist's intentions. In the strongest case, we know that so-and-so could not have *intended* such-and-such, because the concepts were not available at that time. So reference to *intentions* here is also a way to talk about the state of the artworld at that time (say, the time of composition).

Third, one begins by simply ascribing meaning to a particular work, and then explaining that meaning. So there need be no explicit concern with *intention*, or such like. But misperception must be avoided; and the context of creation and reception has some bearing on what the features of the artwork are—and hence on what it would be to misperceive them. And artworks are intentional: hence, artistic meaning is *intended* (which is why, concerned about the best 'reading', we can speak about Shakespeare's *intentions*). In reality, then, the discussion is not usually about what the artist intended, except to recognize (where appropriate) laudable but failed intentions or to point out that a certain 'reading' of the artwork in inconsistent with what could have been intended.

One strategy of art critics rightly consists in looking for the best reading of the work, the one giving maximum weight to the details of its features when 'read' in that way. Some constraints on our reading are to be found in the features of the work (as with, say, the duck-rabbit) and in the 'lay of the artworld', which may (sometimes) include facts about the artist. Thus, facts of Donne's life at the time of

composition of "Nocturnall upon St Lucy's Day" (Alvarez, 1971: 138) might decide against an ironic reading of that poem.

Or suppose an account of Matthew Bourne's *Swan Lake* (1995), with its "radical gender twist ... [in which] ... Odette became a male Swan and Odile a louche freebooter" (Mackrell, 1997: 32), stresses Bourne's use of Freudian ideas: such an account should not be rejected *simply* because Bourne tells us that he did not think of it nor, even, that he has never read Freud! He might have forgotten, or have picked up Freudian ideas in other ways. But a similar account of the Ivanov and Petipa *Swan Lake* (1895) must be *rejected* (or at least modified extensively—in terms of 'precursors', perhaps). Since Ivanov and Petipa *predate* Freud, they cannot be seen as drawing on his *ideas*—at best, there might be Freudian *themes* at work. Roughly, that they could not *intend* to refer to Freud's ideas guarantees that they *do* not. That Bourne did not explicitly plan to draw on Freud cannot have the same implication.

Two more general constraints are mirrored here; *mere* intending is not enough ('wishing cannot make it so'), since what is intended must be achieved, to some degree. And just because a certain account of an object could be justified by reference to public features claimed for that object does not make that account *true*: one is not thereby justified in so understanding it! Moreover, as we saw (Section 2.2), the relation to intention is defeasible, such that:

> I do not wish to claim that everything we find in a work of art is something we have to be prepared to say that the artist intended to put there. But I am claiming that our not being so prepared must be exceptional. (Cavell, 1969: 253)

Hence any other account is "at the same level as intention, a qualification of human action" (Cavell, 1969: 235 note). And this will be one tool to deal with apparent counter-cases.

Given these considerations, the most concessive version achieves all we need; this is a version of *hypothetical intentionalism*.[4] On it (for a painting), understanding that work, or grasping the meaning embodied in it, is conceived in terms of what would be most justifiably ascribed to the artist:

> ... on the basis of the perceptible features of the painting, a complete grasp of its context of production, and a full knowledge of the artist's intentions as to how the work was to be taken, approached, or viewed ... (Levinson, 1996: 218[5])

Accounts for other artforms might be drawn up *mutatis mutandis*. Once *intention* is no longer taken as implying some private, prior planning on the part of the artist, we are no longer claiming to know what such-and-such an artist *thought* on so-and-so day. As a result, our claims cannot be defeated in that way. Rather, and more plausibly, we are commenting on how the work should be 'read', given what is known about it (both locally and more generally—to pick up "history, practice and integrity" [Dworkin, 1996: 11]). And meaning/intending of *this* sort has a *history*, such that what can be meant depends both on the history of the artform up to the point of one's so meaning (including being in revolt against that history) and on the 'narrative' appropriately given in explaining what the work meant.

Can such hypothetical intentionalism deal with, say, the ironic? Is not the actual intention required there? Our answer is, that actual intentionalism is not required:

as above, the hypothetical intentionalist can consider the facts of the author's life—they too offer a basis for generating readings of works. But, on our view, we are not obliged to use such facts; and neither are they always decisive.

Indeed, a strength of my hypothetical intentionalism is precisely that it does *not* assume that the meaning of the artwork (say, the poem) is exhausted by what the author would *say* if asked, both because the claims of authors cannot be decisive and because authors can be capricious here. For instance, faced with his mother's angry request, about *La Saison en Enfer*, "What does it mean?", Rimbaud responded, "It means exactly what it says" (see Durrell, 1952: 4). However, my view *does* grant both that the work must be intentional *as art*, and that 'readings' of it in terms of authorship cannot justifiably deploy concepts unavailable in principle to the artworld at the time of the work's construction.[6] Moreover, it offers a principled rejection of the claim of any 'reading' to be *complete*, if that implies some finite totality of features of the poem *all* accommodated in this reading. For here—as elsewhere (FW: 116)—there is no such finite totality. Instead, a key idea here concerns *the incomplete*: so that calling a 'reading' *incomplete* need not presuppose the possibility of the finite totality of an exceptionless (or counter-example-free) *complete* reading. Instead, its completeness (or otherwise) is occasion-sensitive. Thus, consider Robert Frost's poem "Fire and Ice":

> Some say the world will end in fire,
> Some say in ice.
> From what I've tasted of desire
> I hold with those who favour fire.
> But if it had to perish twice,
> I think I know enough of hate
> To say that for destruction ice
> Is also great
> And would suffice.

Now, any appropriate reading of this poem should be answerable to, say, the *fact* that the first lines are:

> Some say the world will end in fire,
> Some say in ice.

Then, a 'reading' which did not deploy the fact that the word "fire" is first rhymed (with "desire") and then repeated would be neglecting uncontentious features of the poem. Such a reading would be incomplete in a *clear sense*: it fails to mention something it *could* reasonably have mentioned. So we can imagine its being augmented by comments on this rhyme (and perhaps on others). Then this revised 'reading' would not be *incomplete* in the way the other was. But that revised reading will not be *the last word* here—even when it is the last word *I* care to say! For, in principle, other readings of the poem could always be offered, not conjoinable (FW: 118–120) with either our original or revised 'reading': our poem is amenable to 'readings' not (previously) thought-of—although (of course) we cannot *now* say what they are!

But, finding one, our new account would be *incomplete* in respect of it. And this feature should differentiate our hypothetical intentionalism from Levinson (quoted above) with its talk of "*complete* grasp", "*full* knowledge"—as we have seen, such notions make no sense in this context.

There might seem obvious counter-examples to my intentionalist theses. For instance, John Cage and Merce Cunningham each set out to 'avoid intention' both by using aleatory (chance) compositional procedures, so that each did not *decide* what happened when, and by explicitly denying that the works they made had *meanings* (for which intention would be implied). But chance compositional techniques still involve the composer or choreographer in making a *choice* of a kind, although a 'second-order' choice—the choice to use this compositional technique; and to select the elements over which the procedure then operates. Moreover, taking seriously both the denial of intention and the denial of meaning grants that these denials operate at the same 'level' as what is denied, occupying the same 'logical space'. Further, such denials are intelligible as aspirations only by contrast with what is denied (as we understand the revolutionary by contrast). So these are not ways of extracting oneself from the consideration of meaning or intention. Thus neither strategy *could* be successful, as long as Cage and Cunningham were engaged in making art.

So artistic meaning requires a context in which it is possible to *intend* to make art. Then, since *art* is a central interpretive category for the activity here, it limits what could count as *artistic* intention. Thus one cannot genuinely be indifferent either to whether or not one's work is art, or to whether or not art *as such* is (at least typically) valuable, in non-monetary ways. For such value is typical of *art*. At the least, these indifferences are not open to artists. Of course, the artists should not *just* be taken at their word[7]: often, their point is argumentative or polemical (Cavell, 1969: 221). Yet that at least gives a place to start: that they made the works *as art*.

Does my view here entail that a hypothetical intentionalist can never be wrong? Clearly, this is a crucial question since our rejection of the subjectivist "anything goes" will be based precisely on the capacity of *some* judgements of artworks to be *wrong* (modelled on, say, the diverse but not open 'readings' of the duck-rabbit design). But here the three conditions Levinson implicitly set out (quote above) offer guidance. For he rightly urges that appreciative remarks be based on:

- *perceptible features of the artwork*—as with the duck-rabbit, there is *answerability* here; and hence the possibility of being wrong;
- *a grasp of the context of production*—not a *full* grasp, of course, but still enough that (finding one had 'the wrong end of the stick' about a artwork's history of production or reception) one might be led to revise one's view of that artwork;
- *the intention of the artist* as to how the work is to be taken, approached or viewed. The simplest case here is that above concerning the title of a work: approaching the artwork with a mistaken general conception (of the sort a title might provide), one is likely to misperceive or mis-value.

The problem, of course, is that there is no *general* or *abstract* way of explaining one's being wrong here: but that hope when was given up we agreed that exceptionless relations were not required.

4.2 Excursus: Hypothetical Intentionalism and Its Discontents

Given the interest in intentionalism, it is worth clarifying that, in a sense, our hypo-thetical intentionalist is trying to determine the author's intentions: but doing so in a world where what the author *says* of his intentions is not always conclusive; and where, since there need be no 'prior planning' on the artist's part, our account cannot try to match any such planning. As we saw, Dr. Johnson could contradict Goldsmith when the latter asserted what he had meant (or intended). When trying to determine what our author actually intended, we must concede that, in at least some cases (like this one), asking that author is not a guaranteed way forward. It might *seem* a crit-icism that my hypothetical intentionalist chooses a certain 'reading' of a work as "the best interpretation, even if we know the author's actual intention was otherwise (say, through personal communication)" (Carroll, 2001: 209). For this might seem to 'read in' that interpretation, in the face of the artist's denial. Yet that assumes that the author's "personal communication" here is *authoritative*: that it tells us his/her "*actual* intentions" (my emphasis). But, at least sometimes, faced with a conflict between what the author *claims* to have intended and how best to 'read' the work, we should go with our version: 'his intentions were not what he thought they were'. This possibility follows from our account of intention; and might sometimes be justified by appeal to consistency.

Still, in a sense, our target is to determine what our author intended. Thus Noël Carroll (2009: 144 note) rightly imagines our author protesting, "Don't put words in my mouth". That is, the moral imperative here is to ascribe only the intentions (genuinely) embodied in the work; not to 'read in' intentions in respect of the artist's actions. But, of course, the author may not have avowed these intentions; and may not be able to do so. So there may be literally *nothing* in his mouth (or equally, in his mind—since we have rejected a 'prior planning' model of intention). Yet that does not make that author's actions accidental: hence a story can be told. For we aim to *make sense* of our author's doings.

Here, my version of hypothetical intentionalism approaches Carroll's moder-ate actual intentionalism, since the 'hypotheses' of hypothetical intentionalism are "hypotheses about *actual* intentions" (Carroll, 2001: 205: my emphasis). But, actual intentions (in this context) are not necessarily ones the author or artist might avow. So in what sense are they *actual*? The intentions 'at work' here need not reflect what the artist did say; nor even what he/she would say, if asked; nor yet what he/she could say (given his/her knowledge of, for instance, psychology— and this might even extend, in *some* cases, to the knowledge of psychology current in his/her time). For all these depend on taking intention as the kind of prior planning that might be reported; then locating the actual intention would be (somehow) matching that 'prior plan'. And this account of intention had been rejected.

Equally, the claims of the author can be crucial in some contexts. Then, one may rule-out ironic readings, say, by reference to the facts of the author's biography; as earlier, in my reading of Donne's "Nocturnall Upon St. Lucy's Day" (*pace* Carroll, 2001: 209).

Carroll (2001: 205)—discussing Levinson—urges that "[r]eading in accordance with hypothetical intentionalism is simply reading for actual intentions". Here, agreeing does not make me an *actual* intentionalist (as opposed to a *hypothetical* one) since I reserve the right, in any particular case, to reach an understanding of the work, and hence of the intention it embodies, by using whatever materials strike me (in that context) as the appropriate ones[8]; hence, to put aside (say) author's diaries if they are inconsistent with what is otherwise taken as certain. So this sometimes involves rejecting what the author claims, in favour of making better sense of his/her doings, in the context. And some species of actual intentionalist would never do that.

So Carroll (2001: 205) draws a false contrast in saying that "if we come upon the author's actual intention, even if it departs from our best theory of it, then that is what we should prefer." For, if we "come upon" the author's actual intention, it will play a key role in our thinking. There are two main cases to consider. In one, discovering the intention is the result of our "best theory of it"; and hence they cannot come apart (in the way Carroll imagines). For if [a] the artist fulfilled his/her intention in this work *and* [b] this intention is relevant to our understanding here (that is, the work embodies that intention), our best account of the relevant intention will be the one 'discovered'. But the main work here is done by the condition [b]. For the artist's intention may not, after all, be relevant in this example. This becomes our second case, where that author failed to embody the intention in the work. As Wollheim (1987: 86) rightly notes, the only intentions of interest to us are those successfully embodied in the work: the artist's *fulfilled intentions*, in this sense. If the author's intentions are not embodied in the work, then—while that fact may be revealing about the author—it cannot be revealing about *the work*. In such a case, to understand the work, we should look to what *it* means, while granting the force of a human being 'behind' the work: that the work did not come about by accident.

Of course, the work so understood might be a triumph. Here, one might conclude that the artist's actual intention does not do justice to the achievement. In this way, this version might, after all, be granted to reflect the artist's intention, just not one he/she could or would avow. So one sets aside what, up until now, was taken as his/her actual intention. This returns us, indirectly, to the case of Goldsmith and Dr. Johnson (above): in the real case, Goldsmith accepts Johnson's account of his meaning/intention. There, Goldsmith's actual intention (on mature reflection) included those elements Johnson ascribed. Yet suppose we had discovered ("come upon") Goldsmith's actual (better, *avowed*) intention prior to this event (say, as a private communication from Goldsmith to this effect): it would be different. But the later event shows us we were wrong. And, notice, intention is invoked precisely because it allows us to *modify* our reading of—in this case—the poem.

On my version, hypothetical intentionalism offers an explanation here just because it accepts, as the work's embodied intention, our best account of what the artist intended—given what we know; but grants the possibility of failure of intention (the failure to embody that intention in the work). And grants such cases even where, sometimes, the resulting work is still highly regarded. But, in such cases, it will always be possible to urge that the artist's intentions were not what he/she

thought they were; and thus to treat this as the success of a different intention, rather than as the failure of that we first considered.

Our earlier point about Levinson's mistaken assumption of a *complete* account of the artist's position, and such like—which distinguishes this version of *hypothetical intentionalism* from Levinson's—could be augmented by a recognition of the expansiveness of our conception: Levinson (1996: 178 note 11) presents as more limited the range of epistemological resources open to the hypothetical intentionalist.[9] Initially, Levinson (1996: 207) asks what might realistically be required of the reader; and comments that it "mustn't ... require of the reader 'inside' knowledge ... which may be in the possession of family members, private secretaries or clairvoyants" It might seem that Levinson wishes to set aside only these rather arcane 'sources' (for no-one trusts the clairvoyants in such matters). But he aims to limit what 'information' is relevant to our making sense of the literary text. For instance, Levinson seems to preclude the use of "interviews, private correspondence, the author's unpublished journals, diaries, and so on" (Carroll, 2001: 210–211) as not being strictly in 'the public domain'; as lacking "public contextual factors" (Levinson, 1996: 207). This is, in effect, the inheritor of Beardsley's conception of 'bringing nothing' *external* to the work. Thus literary works (and other artworks) are supposed to stand on their own feet: to be objects for interpretation, in context, rather than needing the *artist's* explanation. That is why "we are ... implicitly enjoined from allowing an author's proclamations of meaning from having an evidential role" (Levinson, 1996: 208). And *this* explains Levinson's reservations about the use of diaries or interviews—they are not part of the work.

Moreover, *some* limitation here is not out of place. Insofar as Levinson (2006: 311) sees the reader's task as to "set about to interpret ...[the text] *as literature*" (my emphasis), he rightly recognizes it as "one governed by different ground rules of interpretation than are ordinary utterances" (Levinson, 2006: 310)—in the sense that these will begin from the fact of our *artistic* interest in the works: that is, our *artistic* rather than, at best, aesthetic interests. Thus the English teacher who (in *Mrs Dalloway*) returns Septimus Waren Smith's love poems, corrected for grammar in green ink, misses exactly this point. For a literary work is not, say, just *words* (however beautiful), but a beautiful *poem*: its appreciation must be artistic appreciation. Yet, of course, a restriction of that sort will not turn on the kinds of evidence, or 'information', that could be relevant to understanding the artwork.

Still, diaries (or some such) can sometimes clarify the *categorial ascription* of the work: where an ironic reading is specifically endorsed, say. Why is this (supposed to be) forbidden? Certainly, critics do use such material; and we (as contextualists) can have no global basis for banning it. Such general restrictions are not needed. Of course, what is appropriate *here* may always be a matter for debate, in any case: resolution may be sought *in that case*, rather than more generally. The idea of general 'underlying rules' here must be rejected since there seems no one way to make sense of all literary work (or other artworks); nor one set of obligations as to what could be relevant.

Now, clearly, at issue is the meaning *of the work*—in line with a slogan from Beardsley (1970: 33), we do not aim to be mind-readers. And Levinson's term, "hypothetical intentionalist", is used precisely to recognize that an idealized spectator's point of view is needed (with the artist one such spectator). As a result, one should look first to 'the public domain' of the general context to understand this or that work: to the relevant categories of art, for instance. For the contrast between the work's meaning and the author's meaning must be maintained (in principle). But, when 'the public domain' proves insufficient, or when its insufficiency is raised as a 'recognized head of exception' to our defeasible relations, we can certainly look elsewhere. In at least *some* cases, it may be a criticism of an artwork that our understanding of it requires particular associations or relations to its author: perhaps Eliot's notes on *The Waste Land* were an attempt to avoid such a criticism; and certainly Pound's *Pisan Cantos* have been criticized as "not wholly a public poem ... [since] their logic is the drift of his most intimate associations; it is fully available only to Pound himself" (Alvarez, 1963: 69). Whatever the justice of such a criticism *in these cases*, the general point has weight as a *critical* tool: the work is flawed precisely in being too personal to permit the reader access. Yet to understand the poem (and to understand that about it) requires access to that material in respect of the artist—say, to some of the names in Pound's *Pisan Cantos* as "presumably soldiers at the camp" (Alvarez, 1963: 70). So this ("personal") material must be *deployed*, even if only to make the criticism. Thus it cannot ground the limitation of the resources available to the justified interpreter of literature (or art more generally).

Moreover, this distinction between (roughly) the acceptably and the unacceptably private seems unworkable—especially for contextualists, not looking for a 'once-and-for-all' resolution. As Carroll (2001: 212) notes, what is or is not in the public domain seems, in general, quite arbitrary: some artists tell us a lot—and do so in contexts relevant to the *intentions* within which their work is understood.[10] Other artists offer nothing; or nothing but mystification. Similarly, facts of the artist's biography—in clarifying his/her place in the history of the art, and (perhaps) his/her conception of the artform (say, in terms of *categories of art*)—can bear on how to understand the work before us. I instanced the facts of Donne's life, as well as his poem about his marriage (Alvarez, 1971: 137–138). But sometimes nothing is known of the artist's life (or nothing that seems to bear). As we saw initially, there seems no need for an 'all-or-nothing' resolution here.

Of course, in summary, my claim is simply that all intentional ascription of action follows this pattern—that so-called "hypothetical intentionalism" is just *intentionalism*. And it is distinguished from actual intentionalism, first, by its weaker commitment to realism about intentions (to have intended such-and-such is not necessarily a matter of prior planning; and hence not amenable to the retrieval of such planning) and, second, by being less inclined to take the author (or artist) at his word. For, to repeat, given our contextualism, this much weaker version will do all we need: it allows for the *human intelligence* characteristically embodied in artworks.

4.3 The Embodiment of Artistic Meaning

Artworks have some specific 'embodiment' (whether in pigment on canvas, or a block of marble, or words on a page, or sounds from an orchestra, or the movements of bodies, or some such) in which, as Urmson (1976: 243) puts it, "the witnessable work consists". Of course, identifying that embodiment exactly, or recognizing its relation to the artwork, may be a complex matter. For instance, danceworks are (arguably: UD: 88–90) *multiple* 'objects', existing through many *performances*: so any account of their embodiment must respect these facts.

It might be argued that embodiment is not crucial for various artworks—say, Conceptual art, or various Readymades. But, first, for *some* works, such as Carl André's *Equivalent VIII* (the bricks in the Tate Modern Gallery, London), the specific details of embodiment may not be fixed by the artist—in this case, he just ordered the bricks. Yet the work *is* embodied in those bricks: without them, it is an idea (or joke). And if that embodiment permits other bricks to be substituted under certain, specified circumstances, the point is unaffected. Second, the place of the sensuous properties of the embodied object can be over-rated: to *just* enjoy the sensuous surface of artworks *is* treating the music as birdsong. Third, it seems too glib to dismiss forms X, Y, and Z (say, Conceptual art or Readymades) as art just because our legitimate or appropriate concern with them is not obviously with sensuous appearances. Such a concern, even were it typically true of artworks, would be so only *defeasibly*!

So stressing embodiment at best draws two contrasts. First, the artwork, though meaning-bearing, differs from (say) the report of a road accident: the precise details of the artwork have an importance, bearing on that work's meaning. Other accident reports could be different-but-equally-good. But to say, "Well, you can't get that Dickens novel, so try another one" is not to do full justice to the artwork (see Beardsmore, 1971: 17–18[11]). For the meaning of that artwork is made concrete in the work itself, where only that concretization counts as bearing that meaning.[12] Second, the emphasis on embodiment allows due weight to an artwork's sensuous features, by stressing the need for direct confrontation with artworks (via the appropriate perceptual modality): the contrast might be with the gallery-goer who never takes his nose from the catalogue—he sees no art!

Then the conclusion that artworks are not 'paraphrasable' is not an empirical discovery, based on considering lots of cases and trying hard to render them into another form, either art or non-art. Instead, it reflects a commitment on our part, an element of the conception of art at work here. For, suppose two art-objects (say) did have *completely* the same meaning, such that we could say, correctly, "if you cannot get one, get the other—they amount to *exactly* the same thing". That would offer us a basis for regarding these as instantiating one artwork, rather than as separable works. Our argument begins from reflection on authorship: if the first work is by Smith, and she has embodied the relevant "aboutness", the second work (by Jones) will simply be a copy of Smith's—or another instantiation of it—if that second work is (otherwise) indistinguishable, for artistic purposes, from the first.[13] A different 'aboutness' is required for a different work. And, of course, this reflects our

treatment of works with obvious relations with one another. So, although Wallace Stevens's poem "The Man with the Blue Guitar" prompts a David Hockney volume of illustrations, these are clearly different works of art, amounting to something different—and that is *guaranteed* by their being different embodiments.

Indeed, Danto's requirements for *embodiment* and '*aboutness*' (see Section 2.1) are more revealingly viewed as negative conditions—two ways of explaining failures of artistic endeavour (or properties of non-art objects): such-and-such report is *not* an artwork because, although it is certainly *about* something (namely, the road accident), that aboutness is not *embodied* in the object. Equally, a piece of road-sweeping (or an Olympic ice-dance performance[14]) would consist of something—it would be embodied, in that sense. But it would not embody *meaning*: necessarily lacking "aboutness", it cannot be an artwork.

4.4 Making Meaning: The Concept "Art"

To see this account in operation, we can consider how questions of authorship might arise in practice, in respect of the concept *art*, by looking at some limitations on what artists can intend.

Considering the variety of objects on display in galleries of contemporary art, or the variety of objects that have won the Turner prize recently, one is struck by ... well, the absence of traditional kinds of artwork—typified by, for instance, sculptures and easel paintings. The intentions embodied in typical works are not easily recognizable artistic intentions. Not only is there Conceptual art, in all its varieties, to consider: one must plug-in the various methods of composition deployed, especially those which separate the *work* part from the *art* part (Wollheim, 1973: 107–108[15]). That is, where the selection of the sensuous surface of the work was at best *arguably* the artist's. It is no longer easy, if it ever was, to list the (fine) arts: no doubt painting, sculpture, literature, music, dance are included. But each of these in its contemporary incarnation is likely both to conceal a diversity and to be contentious. Further, the extent of the list is problematic. Perhaps the scope of art could once be circumscribed by enumeration,[16] but presently the hope for such enumeration seems vain. And what are the *categories of art*? Ron Mueck's *Dead Dad* (1996–1997: from the *Sensations* exhibition) shares features with (say) traditional sculpture, but differs from the past of sculpture sufficiently radically to make that category-ascription for it unhappy—although Laura Cumming (2003b: 10) settles for that. Then defending a version of artistic *value* no longer seems an aspiration of some self-styled contemporary artists, given their different agendas. And, especially, not an aspiration they avow. Of course, as recognized earlier, artists' claims are often argumentative or polemical; and so not *just* to be taken at face-value.

Yet giving up artistic value gives up the notion of *art*: this would be a loss—not least the loss of an occupation for any self-styled artists! This in turn limits what counts as *artistic* intention. For *art* is a central interpretive category for the activity here, which cannot be given up *without loss* by artists. So one cannot genuinely

be indifferent to whether or not one's work is *art*; moreover, one cannot genuinely be indifferent to whether or not art *as such* is (at least typically) valuable, in nonmonetary ways. At the least, as before, these indifferences are not open to artists.

Even were similar points also true of other (fine) arts—if one were never really sure what kinds of objects can *constitute* artworks—this seems especially true of visual art. Danto regards painting as somehow the primary art, with its vicissitudes reflecting (and perhaps anticipating) the vicissitudes of art generally: as Danto (1987: 216[17]) puts it, "painting had become the avant-garde art just because no art sustained the trauma it did with the advent of cinema". At the least, visual art provides the examples here.

Our case should not be overstated: art's *avant-garde* 'edge' has probably always been challenging to the audience for established art of a certain period. Think of the shock (even among his friends) that greeted Picasso's *Les Demoiselles D'Avignon*, or of the critical rejection of the early dances of Martha Graham (they were dismissed as angular—in contrast both to ballet and to the rococo elegance of Orientalist dances of, say, Ruth St. Denis). So, even when putting the objection at the level of *technique* or *style*, its centre is a familiar plaint: that these objects *cannot* be art. Yet these works were still *claimed* to be art by their makers: in this way, the makers *argued* (if only implicitly) that they had made artworks. Further, of course, this 'argument' was ultimately recognized; these works acquired a centrality for later art-making. So nothing follows from the fact that the contemporary audience (then) *took a time* to acknowledge these works. Hence nothing turns on the *actual* or *extant* audience for art.

Even apologists for the artworks under discussion recognize a work's (implicit?) connection to the past of art: thus, for instance, claiming that Damien Hirst's *The Physical Impossibility of Death in the Mind of Someone Living* (1991):

> ... examines aspects of our relationship to death, both through its metaphorical implications, given by the title, and through the very fact that it presents us immediately with a real dead animal. The subject is traditional. The medium is not. (Warberton, 2003: 87)

Its traditional subject-matter suggests that, after all, this object is 'working the same street' as more traditional art. Further, this connection is made through the sensuous medium, thereby reiterating our stress on embodiment (Section 4.3 above).

Yet not just *any* connection between the past of art and a sensuous medium is sufficient. Thus, commenting dismissively on this very work, Damien Hirst's shark, Craig Raine (1998: 21) urges that its:

> ... gabby title (*The Physical Impossibility of Death in the Mind of Someone Living*) asserts ... that the living can't get their heads around the idea of death, you know what I mean.

On this account, the work is flawed because "Damien Hirst offers an illustrated *aide-mémoire* to his dog-eared proposition—that shark" (Raine, 1998: 21). At root, this criticism takes Hirst's 'work' as a proposition, divorced from the sensuous properties of the object, suggesting that the shark both makes a hackneyed point and does not embody (even) that point. These comments, if true, would explain a negative evaluation of the shark. Whatever their truth, applied to this example, both are

relevant criticisms because, once granted, they undermine at least two fundamental features of art, thereby highlighting such features for us. First, accurately describing a work as 'hackneyed' is highlighting flaws—in the most extreme case, explaining why it is not art after all. Hence, ideally, artworks should be profound—at least some art is, although there are many ways of being profound; for example, in jokes. And profoundness should not be confused with innovation. Second, art *embodies* its meaning: such meaning cannot be accurately captured distinct from its embodiment in *this* artwork. Hence, no two artworks can come to *exactly* the same thing (or there would only be one artwork[18]). So even were the *aboutness* of the Hirst shark granted, it might still not succeed as *art* if it fails to *embody* that aboutness.

One difficult point here concerns the place of language. Clearly, even a painting can include words. But the meaning of such words should not be detached from their artistic context. As the artistic/aesthetic contrast implies, even beautiful combinations of words (beautiful *language*) should be contrasted with literature (say, with a poem). And one basis for such a contrast must be the issue of 'other words'. As we saw, even the most evocative report on a road-traffic accident could be put into other words without loss—at least, without loss *qua* accident report. But this cannot be true for the poem. As this case suggests, even words *in art* acquire artistic properties. Another case makes that point graphically (in two senses!). In Jenny Saville's painting *Propped* (1992), a number of words appear inscribed (in reverse) into the torso of the woman who is its (apparent) subject. But, in order that these words be understood, their context must be recognised as the artistic one: their point is missed if they are simply regarded as assertions by the artist. That means, of course, that these words are ill-fitted for deployment in arguments, where the concern is with clarity, not evocation.

The comment on Hirst (above) comes from Raine's discussion of Ron Mueck, contrasting Mueck's work with Hirst's. To understand Mueck's project, we are directed to ideas from (and works by) Holbein and Rembrandt (Raine, 1998: 21, 22 respectively[19]). Thus, as theory predicted, one attends to the past of art to make sense of the artistic properties of these works: that is, their *meant* or intentional properties, although without discussing Mueck's *intentions* as such. For us, then, Mueck's work illustrates the scope of artistic intentions by recognizing their relation to the concept *art* and the past of art.

Of course, my selection of Mueck here is contentious: his work already resembles sculpture—perhaps that grants too much to the traditionalist (or old fogey). Further, Mueck's work involves high levels of craft, visible in, for instance, his decision to construct the body of a figure from fibreglass *because*, unlike silicone, "any seams still visible after the casting process can be filed away" (Wiggins, 2003: 26). But, he realizes, this renders problematic the detail of the face: in particular, "glued-on eyebrows and eyelashes can never look completely authentic" (Wiggins, 2003: 26). Recognizing continuity between craft-traditions and Mueck's art acknowledges his deployment of the material as a sensuous and expressive medium. But these were not the craft-issues that perplexed Michelangelo! Still, putting aside the question of materials, Wiggins (2003: 21) regards Mueck's methods as "exactly the same as that of Donatello, Rodin or the ancient Greeks when casting in bronze." By contrast,

arguments from Raine and Cumming, as well as Greeves (2003: 54), suggest the possibilities of connecting Mueck's work more strongly to traditions in painting, rather than to those of sculpture.

But one need not decide: the innovations, both technical and expressive, represented by these 'hyper-real' figures (see Greeves, 2003: 43) were intelligible to the artistic community. For instance, visitors at Paula Rego's exhibition at the Hayward Gallery in 1996 "were surprised to find a small figure of a young boy, naked but for a pair of white Y-fronts and a mischievous expression" (Greeves, 2003: 43). Yet that object (Mueck's *Pinocchio*, 1996) was found both expressive, and valuable as art was valuable: that is, not time-wasting of the audience for artworks. So, although "the traditional subjects from the art of the past are capable of radical re-interpretation" (Smith, 2003: 9) in Mueck's work, such re-interpretation retains connections to the goal of artistic value. That Mueck succeeds here is argued—as theory predicts—by connecting his work to that past. Thus if Van Eyck's *Adam and Eve* (1432) "are real people, minutely observed and reproduced with dispassionate accuracy" (Greeves, 2003: 51), just the same might be said of, for instance, *Dead Dad*, "the perfect and unsettling scaled-down waxwork of the artist's dead father" (Adams, 2003: 2)—although no waxwork was ever so lifelike; or, perhaps better given the context, so death-like.

In this work, "Mueck sets out to examine, without mystification, the mystery of death" (Raine, 1998: 21). This is a familiar project. Thus both Raine (1998: 21) and Greeves (2003: 53–54) use Holbein's *The Dead Christ in his Tomb* (1521) to aid understanding of *Dead Dad*,[20] aligning the expressiveness of each project. But the specificity and acuteness of Mueck's gaze is one reason why "Mueck's hyper-realism is not 'simply' the flawless technical imitation of reality, but requires another definition" (Greeves, 2003: 44). For, as Greeves (2003: 59) notes, "[e]ven the hyper-real descriptive art of the last few decades is driven by impersonal observation and an unsparing factuality." Yet this is not Mueck's way: rather, his is "an evocation of reality, summoned out of this minute perfectionism" (Greeves, 2003: 62). As Raine (1998: 22) comments, "the skill is enigmatic"—a remark directed first at Holbein (for painting a scar) but applied, at least by implication, to Mueck. And this close attention to detail raises a question which these works press on us: "what distinguishes animate from inanimate matter; what is the essence that animates, the spark that constitutes life?" (Greeves, 2003: 47). But the outcome is a set of unsentimental views: "they are awkward, flawed, mortal flesh" (Greeves, 2003: 51)—a point seen clearly in both *Dead Dad* and *Ghost* (1998).

We have already recognized *Dead Dad* as "a little naked corpse, much smaller than life, over which a huge soul seems to hover" (Cumming, 2003b: 10). So that even if in this work "Mueck convinces us not of the presence, but of the absence of life" (Greeves, 2003: 47), it remains part of the project to explore human life and—via the hovering soul?[21]—its distinctiveness. The other work mentioned, *Ghost*, is:

> ... a gigantified schoolgirl in an unflattering swimming costume ... Here the scale is exaggerated to record, perfectly, another intense emotion ... acute self-consciousness.
>
> (Raine, 1998: 21)

This work captures brilliantly "a stage at which our bodies become suddenly large and strange and acutely embarrassing to us" (Greeves, 2003: 59). That familiar sense that our bodies have become "suddenly large" is again reinforced here, by the scale of the work: as Greeves (2003: 59) records, "[s]cale is one of the most powerful tools Mueck employs". *Ghost* is literally large, as *Dead Dad*—portraying the father once the animating spirit has left—is smaller than life, shrunk "to the consequence a life requires".[22] As Greeves (2003: 59) accurately records, of *Ghost*: "[t]wo metres tall, rawboned, slightly pimply, she hunches against the wall as if wishing her regulation swimsuit could conceal her." Moreover, the minute detail of the observation reinforces the overall impression:

> The skin of the adolescent is perfectly rendered ...—not pimples, but the pink patches of *healing* pimples, and some dark hairs sleeving her forearms, as well as the awkward eloquence of her angular pose, her monumental feet and hands. (Raine, 1998: 21)

Of course, the size of the hands has the exact opposite effect of their enlarged size in some of Rodin's sculpture: there, it depicts the confident mastery implicit in his hands; here, their gawkiness. Thus, this discussion of Mueck's intentions, seen through his achievements, need not speculate on his thought-processes. Instead, the power of these works is explicitly theorized as connecting them both to the past of art and to what is of importance for humans.

4.5 Making Sense: 'History of Production'

So the past of art has a connection to the 'lay of the artworld', and hence circumscribes artistic intention: what can be done or said differs at different times and places because what is intelligible (that is, can be made sense of) at one time may not be intelligible at another time. This is easy for the earlier unintelligibility of later ideas—although I urge it equally in both directions. But we can reach the minimal conclusion (which is all we need) on the minimal thesis! That is easily described by recording how, say, the work of Picasso and Braque changed the landscape of art (at least in Paris) around 1910: certain actions became possible, and certain intentions became intelligible, in ways they previously had not.[23]

This easy case, if granted, implicitly concedes that, discovering an authentic Mozart autograph score indistinguishable from Schöenberg's opus 19, we could not automatically conclude that Mozart explored atonalism or prefigured 12-tone technique. For that cannot *automatically* be a realistic way to view *Mozart's* writing such a score. Instead, we must consider whether, were this to have occurred, it would have been intelligible to the audience of such work; and how such intelligibility might have been explained. This means, roughly, that we would need evidence of atonal intentions in Mozart: and those could only be found in the context of the musical world he inhabited.[24] Thus it also constrains what could be achieved.

Further, working out what is intended or meant in a particular context is often complicated. In a familiar example, one must recognize the irony in Swift's *Modest Proposal*, which suggests solving (at a stroke) the contemporary food shortage and

the over-population of Ireland—otherwise Swift would be branded a monster for suggesting "breeding children for the table".[25] Moreover, what I achieve relates to what I intend: failing in my art-making intention, I may still produce something worthwhile (say, a decorative object); equally, I may not, despite my best efforts— what I make is not art *and* not (merely) aesthetic. In this way, merely wishing or wanting is not sufficient to count as intending, at least as far as art-making is concerned. For one's intention must be intelligible, and worthy of attention, although this alone will not secure artistic meaning. At its simplest, it must be seen—by the audience for art—as meaningful in roughly the way past art was; although this may include rebelling against the tradition. Thus the artworld constrains what can be *attempted* and what can be *recognized* or acknowledged.

One feature, powerful in distinguishing artworks from each other and from 'real things', will be the distinctive histories of production of each. If the chair I was sitting on yesterday was made in Spain and the one I am sitting on today was made in France, it follows they are different chairs—or if one was made yesterday and the other the day before, or ... (and so on). Applied to the authorship of artworks, this idea (already intuitively plausible) gains further impetus. Suppose what I do or make is genuinely *mine*, so that I am responsible for it—as I would not be for, say, a copy (where all the 'thinking' were ascribable to the artist I copy): then the difference between this work's history of production and others will be relevant just when my claim to authorship is. Of course, art-objects are *specific* in just this way. If a painting of mine is compared with one of yours (the art-status of both being granted), it follows that they will be different artworks.[26] Hence, as Danto's gallery of indiscernibles (see Section 1.2) predicts, a differentiated history of production is an artistically-relevant fact even for two (otherwise indistinguishable) works. In this vein, the Walter Matthau character in the film *Kotch* (1971), asked "Do you like *Alice in Wonderland* by Lewis Carroll?", appropriately responds, "I wouldn't like it by anyone else": if it were by someone else (therefore with a different history of production), it would not be the work he admires.

This challenge is posed by the story of Pierre Menard, as Borges (1962) imagines it.[27] Here, a twentieth-century Frenchman 'writes' Cervantes masterpiece *Don Quixote* in isolation from Cervantes' text, thereby drawing on his own ideas, experiences, and so on, to produce a text indistinguishable from Cervantes'. Borges (1962: 49) then urges that, given their different locations in the history of art, "[t]he text of Cervantes and that of Menard are verbally identical, but the second is almost infinitely richer". For example, writing sixteenth-century Spanish is mannered for Menard, as it could never be for Cervantes; and so on. The connection here, through the *choices* made, reflects who is *responsible* for what: that each work has a different author permits differences in what each is responsible for—because, as Wollheim (1978: 37) notes, neither is responsible for the words as such. Rather, each is responsible for his novel, which is not a "macro-grammatical" concept (compare McFee, 2010b).

This both explains why Menard's word's work would not be a forgery, and illustrates that forgeries cannot be works of art. There are, of course, two sorts of forgeries: first, cases which purport to be extant works by a particular artist—say,

I produce something indistinguishable (in the extreme case) from a particular Monet and pass it off as that Monet. Second, forgeries 'in the style of' where—although my painting resembles Monet—there is no particular extant work by Monet it resembles. Here again, I attempt to pass my work off as Monet's (or allow others to do so). This masquerading as Monet's marks the case off from, say, the realization of Pierre Menard's project: he wrote a Cervantes-indistinguishable text without reference to Cervantes' work, while I drew on Monet directly (either his specific work or his style). Thus (roughly) a forgery necessarily lacks the artist's insight or creativity in whatever sense, at a pre-theoretical level, that this is manifest in *his/her* work. Then neither kind of forgery counts as an artwork, if that means its counting (in this case) as a *Monet*.

In explanation, recall Van Meegeren's attempts to forge Vermeers. While a particular painting, for instance *Christ with his disciples at Emmaus*, is thought a Vermeer, discussion of its art-status includes consideration (even if indirectly) of its place in Vermeer's oeuvre. Then its forged status is discovered. To insist that it is an artwork after all concedes (at most) its art-status as a Van Meegeren: as such, no longer a *forgery* at all—it is a genuine Van Meegeren! But now any argument for its art-status can no longer draw, as previously, on the history of Vermeer's works—it lacks that connection to the hand (or brush) of Vermeer. The object cannot simultaneously be a forgery and an artwork. Here, it does not matter which version of forgery is under consideration. For one cannot, with justice, simply ascribe the artistic properties of a Monet to a work by someone else: doing so makes a mistake, at least as far as artistic properties go. In this sense *intention*—or, perhaps better, the hand of the artist—is crucial to art-status.

Suppose, then, some ingenious artist aims to confer artistic status on one of my paintings (described above). This so-called artist is attempting to get accepted as *his own* artwork my 'version' of the Monet. *Perhaps* my work could be regarded as artistic out-put of mine. Of course, it must then be explained how this work managed to 'say' anything distinctive; but that might possibly happen, perhaps by stressing its ironic differences from Monet! Yet success there makes this an artwork *of mine*, not of this other person. Or, more exactly, he must then explain why the work is indeed *his*. Should he succeed, he will have provided a good reason why that painting is neither a forged Monet nor even a McFee! This would (somehow) involve his having *meant* the painting: that is, give him a place in its history of (artistic) production.

4.6 Response-Reliance and Artistic Properties

Meaning in our sense always requires a potential audience able to recognize meaning of that kind: and this involves recognizing the 'inscriptions' as *meant*. A peculiarity of typical artworks is that their artistic properties and artistic value, which follow from their art-status (or artistic meaning), require an audience of persons able to recognize and value such features. So any property ascribed requires both the characteristics of the object and the powers and capacities of the audience:

these properties are *response-reliant*. As Thomas Reid ([1815] 2002: 574) puts it, "This excellence [of an air in music] is not in me; it is in the music. But the pleasure it gives is not in the music; it is in me." Yet how can these be genuine properties, when not everyone can recognize them?

As one obvious parallel, colours too seem response-reliant properties of objects. For someone with "normal intelligence and good eyesight" (Sibley, 2001: 1) who stands before the UK postbox, in normal lighting conditions,[28] will see its redness (as the use of "normal", and so on, ensures). And the postbox's being red is compatible both with its not always *appearing* red, and with *some* people being unable to recognize its redness. In laying out what he takes as the 'common person's' view, Reid, 1997: 86) identifies that believing in the colour of objects is compatible with denying that they will always look the same:

> The common language of mankind shows evidently, that we ought to distinguish between the colour of a body, which is conceived to be a fixed and permanent quality in the body, and the appearance of that colour to the eye, which may be varied a thousand ways, by a variation of the light, of the medium, or of the light itself.

How does one recognize this? Well, first one recognizes that colours persist:

> The scarlet-rose, which is before me, is still a scarlet-rose when I shut my eyes, and was so at midnight when no eye saw it. The colour remains when the appearance ceases . . .
> (Reid, 1997: 85)

But that persistence may not always be obvious: for instance, "when I view this scarlet-rose through a pair of green spectacles, the appearance is changed, but I do not conceive of the colour of the rose changed" (Reid, 1997: 85). In part, changes in my situation do not seem mechanisms of the kind appropriate to bring about changes in the rose, although they might explain changes in how I took the rose. Reid also mentions that, when one has jaundice, one might mistake the colour of our rose. Indeed, as Reid, 1997: 85) continues:

> Every different degree of light makes it [the rose] have a different appearance, and total darkness takes away all appearance, but makes not the least change in the colour of . . . [the rose].

Any argument which raised doubts about this should cast doubt (instead) back onto that argument itself. As Austin (1962: 29) acknowledges, "[i]f something is straight, then [does] it jolly well have to *look* straight at all times and in all circumstances? Obviously no one seriously supposes this" (original emphasis). In elaboration, Austin (1962: 40–41) notes that footballers look one way seen from pitch-level but another ("like ants") from high in the stadium. Indeed, this point exemplifies a familiar theme:

> Which ways things looked on an occasion, and what they then looked like, is, in general, an occasion-sensitive matter: these are questions whose (true) answers vary with the occasion for posing them. For whether X looks like Y is very likely to depend on how comparisons are made. (Travis, 2004b: 71)

Further, as Reid, 1997: 86) insists, confronting colours is confronting their appearance: but "it is to the quality, not the [Lockean] idea that we give the name colour".

Hence, "[such] ideas do not make any of the operations of the mind to be better understood" (Reid, 2002: 184): that is, one should reject any 'representative perception' view, on which what one really sees are (for instance) ideas or images or sense-data or qualia[29] Reid's conclusion is that, if there were no creatures capable of recognizing *colour*, it would be odd to *call* the world coloured; and difficult to see how one might conclude that it was. But, given those powers and capacities, it *is* coloured: that is, there are coloured objects, not merely coloured appearances. In this way, he recognizes clearly the response-reliant character of such properties.[30]

Yet, as Reid (1997: 87) is keen to insist, response-reliant properties are familiar outside the realm of appearance: "Medicine alone might furnish us with a hundred instances of this kind". His examples, which include "astringent", "narcotic", are powerful, since these seem genuine properties nonetheless understood in terms, roughly, of some effect that have. But they do not seem response-reliant in quite the same fashion, since (say) the *recognition* of narcotic properties is unrelated to the having of those properties—I may not recognize the mushroom as a narcotic, but (having ingested it) still suffer its effects.

At the least, then, response-reliant properties have been acknowledged. As was said, someone with "normal intelligence and good eyesight" (Sibley, 2001: 1) who stands before the UK postbox, in normal lighting conditions, will see its redness. On some occasions, these facts alone should be sufficient to meet the sceptic. But the comparison with artistic properties cannot be sustained at this point. Despite my normal (or "good") eyesight, the normal lighting conditions, and so on, I might fail to recognize an artistic property instantiated by the artwork before me. For the operation of *taste* (in its artistic sense) has, in this way, a stronger cognitive aspect: not knowing one was encountering art would preclude one's encounter being with *art*. So there is a stronger 'learned' mastery in that case. Of course, there is an experiential element: "[m]usical understanding is inseparable from the experience of music—so much, at least, is obvious" (Scruton, 1997: 217). But only those who hear the sounds *transfigured* hear the music. And that will not be everyone—and one should really have talked, not about *music* (*punkt*), but about the various *categories* of music. Those who hear the sounds in the auditorium (rightly) as Mozart's music may fare less well confronted with, say, Schöenberg's *Six Little Piano Pieces* opus 19: can they hear it as music? Those who misperceive it (say, as poorly constructed, discordant music in another genre) certainly will not.

The same holds true more generally, across the arts. As Scruton (1997: 377–378) notes, "[y]ou do not 'see' that a work of art is sad, sentimental, or sincere unless you understand it. No understanding is required to see that a picture is red." Scruton is not, of course, disputing that a certain *conceptual mastery* is required to see that a picture (or even a painted surface) is red—but, despite the cognitive element this implies, it does not require (further) *understanding*; and, in particular, not understanding of this object. Nor is Scruton here denying that one 'sees' (I take the scare-quotes to highlight the variety of perceptual modality) that the work of art is sad, etc.: that these are features of the work of art, and that our access to them comes from being "perceptually sensitive to features of . . .[our] environment" (McDowell, 1994: 50). Indeed, this thought is fundamental to the artistic/aesthetic

contrast: that artistic properties of artworks are genuine features or properties of those works—even if they require an audience for their recognition (or existence), as secondary qualities do! Indeed, the connection between artistic judgement and artistic value is central here: this is the sense in which art is "that of which the very apprehension is found worthwhile" (*id cuius ipsa apprehensio placet*; Sparshott, 1982: 103[31]).

4.7 Understanding and Criticism

The kind of common sense reflected in ordinary language that *does* recognize, say, the colours of objects as features of those objects treats artistic value the same ways: "To say that there is in reality no beauty in those objects in which all men perceive beauty is to attribute to man fallacious senses" (Reid, 2002: 595). Reid's thought is that the attribution has only one possible basis (namely, a perceptual one): hence there is only one possible basis for disputing such attribution. Further, this cannot be a sufficient basis, for either it simply grants the 'fallaciousness' of the senses in *that* case (but not in others) or it becomes a general (sceptical) thesis.

As Reid suggests, the basis for ascription of beauty (although beauty is just an example) *in this case* is the only basis on which such properties might be ascribed ('for one's self'). So the person speaks truly in urging that this object is, say, beautiful—unless he/she has made a mistake! Then other cases are contrasted with these in principle favoured, 'no-mistake' cases. Further, to ascribe such beauty (etc.) for myself, I must go beyond the potentiality implicit in the property, and be actually responding to that object. Moreover, that claim about beauty cannot be false other than simply by its being not true. As a result, even if (say) *these* objects lack beauty, others do not: then the previous point generates the 'reality' of, for instance, beauty as a perceptible property. (On the counter-view, this is not the sort of thing that *could* be true of, say, physical objects or human actions—which would be a kind of error theory.[32])

A different response-reliant judgement, such as "It looks red", can also model some features of artistic judgement (UD: 33–35): especially, judgements of this kind cannot be dismissed as *merely perceptual* (that is, subjective), although they sustain neither a truth independent of (the possibility of) human perceivers nor a single, 'correct' answer (that is, objectivity—on some accounts). This position, sound as far as it goes, defuses objections to artistic judgement, by making them no more 'a matter of opinion' than, say, the fact that postboxes in the UK *look red* (and do so because, in typical cases, they *are* red). Of course, when such postboxes (which look red) do not look red *to you*, that can be explained in terms of some aberration *of yours*—for example, your colour-blindness. And a *personal* or *private* condition is required here, since your claim treats differently the way the object looks: you must be saying more than that, in this light, red objects look orange ... or some such. That is how such objects look (the "to you" would be redundant): that thought cannot sustain the kind of subjectivity urged.

However, this account misses something central to many uses of the "looks" locution. As Austin (1962: 38) recognizes, this locution sometimes has an evidential force: "that somebody looks ill may *be* the evidence on which we could also remark that he seems to be ill" (emphasis original). Yet it typically would not have this force in artistic judgement: that the painting looked like Tower Bridge might suggest somewhere to start in guessing what it depicted; but not when it *was* a painting of Tower Bridge—as, say, the title might indicate! Equally, its looking like (a painting of) Tower Bridge may ground my judgement that it was not a painting of Tower Bridge: "It looks like Tower Bridge, but . . .", where we might fill-in the lacuna differently for different artists. For example:

- ". . . but X has never been to London, never seen a picture of that bridge, and only paints what he sees. So this must be another bridge." (perhaps even, "so there must be another bridge that looks like Tower Bridge")
- ". . . but Y never paints narrative or figurative subjects. As this is (recognized as) one of his typical works, it must not be a figurative painting either."

And many, many more! More usually, though, the "looks" locution occurs, not in making our artistic judgement, but in justifying it. That it *is* a painting of Napoleon must bear *in some way* on how it looks (at least to count as "a Napoleon-painting": Goodman, 1968: 22), since the fact that it is *of* Napoleon must be embodied in the painting, at least where this is an important fact about the painting. And our connection to that painted surface is perceptual—its sensuous properties are recognized 'on the way' to acknowledging its *artistic* ones.

Recognizing artistic appreciation as thus perceptual has, in effect, two dimensions. By the second (pursued in the next section), it is perceptual rather than inferential. By the first, it is perceptual in the sense that, in learning to understand artworks, one learns to *see* their characteristics (that is, their characteristics once *transfigured* to art). Then certain ways are appropriate to doing so—not only one, but not 'anything goes'. So that, having recognized the work as balanced, we can ask on what features that balance depends—here, our reply might (with justice) be, "on that patch of red in the corner". But, as Lyas (2000: 134) notes, this is "a reason for being balanced, not a reason for believing it". That is, it does not function as a reason which might persuade someone who has not learned to see balance of that sort. So coming to understand art might be characterized as requiring *learning to see* and *learning to value* (see Chapter 2 note 13).

The first slogan ("learning to see") identifies the perceptual base of artistic understanding, recognizing the possibility of misperception: that is, failure of artistic appreciation resulting from inability to perceive an artwork in ways appropriate to it. Such appreciation minimally requires perceptual engagement with the artwork, for appreciation is demeaned if considered as a kind of elaborated day-dream merely stimulated by that work. While such day-dreaming is entirely possible, the person engaged in it is not really appreciating that artwork, because not engaging with *its* properties.

Then artistic value is *recognized* in perception. So learning to *see* the artwork in question appropriately is learning *what* to see as *valuable* in it (or how to see it as valuable); and hence learning to value it (second slogan)—although I may rebel against what I have learned! Thus someone who merely understood what a particular group valued in an artwork (without finding it valuable himself/herself) would, for that reason, fail to view the object as an artwork, or to make artistic judgements of it.

So errors in understanding artworks, explained in terms of the *misperception* of those works, can be failures to understand the work appropriately or to appreciate it appropriately. Treating music by Messiaen *as though* it were genuine birdsong (no doubt pleasing, but meaningless), one not only misperceives it by applying the wrong *category* (see Section 1.1); but also mis-values it—since the normativity that follows from recognizing it as art (rather than as *merely* aesthetic) would be inappropriate to birdsong. Treating it, instead, as tonal music, one imports *a* normativity all right. But these judgements are inappropriate *to the Messiaen*. Hence one's valuing of it will also be inappropriate. So learning to *see* the value of artworks (and to see certain features of the works as reasons for one's judgements) is engaging with the narrative of art history in respect of that artform.

Further, values learned in this way can be changed similarly. Suppose that, having learning to see Martha Graham's dance a certain way, and to value its features accordingly, I am startled when confronting a dancework by Merce Cunningham: I do not know what to make of it. Gradually, as I consider it more (and more carefully), this work—indeed, the body of work of which it is a part—seems a kind of sub-Graham: I value it as I do Graham's, but regard it less highly (since it is derivative). Yet more reflection leads me to recognize its striking differences from Graham's work, and to value those differences—as a result, to come to value it more highly than Graham's, or to value it in a different critical dimension. Such a narrative, describing my coming to understand Cunningham, involves a reassessment of Graham: it might challenge some of what I had originally 'learned'. Saying this does not, of course, minimize the importance of the original learning—as with, say, one's learning history, what one is taught as 'the facts' may not survive later investigations, new insights, scholarship, and the like. And what I do here for myself might have come from reading criticism. For "a major occupation of critics is the task of bringing people to see things for what, artistically, they are, as well as why they are" (Sibley, 2001: 38: rectified for artistic/aesthetic contrast). Or, again, "a good critic ... brings home the character of what he writes about, in such a way that one can feel and see, see and feel about that character much better than one did before" (Wisdom, 1953: 223). So these slogans highlight a contribution of *some* critics on *some* occasions.

Then the roles of teachers can be distinguished, for analytical purposes, from those of critics: the teachers are dealing with those without a formed taste, while the critics are dealing with those whose taste *has* been formed, albeit temporarily—for, as illustrated in coming to value Cunningham as against Graham, having a 'formed taste' is less an achievement than a process. On this view, both teachers and critics are saying, "Try looking at the work this way". For the teachers, this may involve asserting some feature of the work or artist under consideration. That can teach us

to see this work (or other works) that way, where the outcome is that we *do* see the work that way. As with (say) the history teacher, our teacher's claim will not be disputed—at least, not initially: a framework for any later debate must be learnt. But, on *entering* a debate with the views offered, we start treating that 'advice' as just that of (another) critic, either formal or informal.

On this view, is what the critic says *true*? If critics are primarily offering a way of seeing a particular artwork, then can critical 'judgements' ever be true or false? Clearly a *suggestion* is not in the same way truth-evaluable. If I am really only *suggesting* that you give a particular computer a try, my remark is neither true nor false, even if framed as, "Macs are better than PCs" (and even if, as is the case, Macs really are better than PCs). I have in effect only said, "Try a Mac"; and you can accept my suggestion or not. Either way, I was not wrong. Of course, this is a mistaken model for critical discourse, both because the concepts central to art are response-reliant (hence, the 'suggestion' concerns concepts to be mobilized in one's experience) and because one must learn to recognize such concepts. As above, the ultimate outcome for the critic resembles that of the teacher, but reflects different positions in the learning process—and hence different positions for raising and sustaining debate about the properties of particular artworks. The teacher presents us with this conception as the *facts* of the (appreciative) matter. But seeing it that way requires that one has learned (relevant) artistic judgement. The work as seen from the teacher's perspective *has* the properties at issue. And the critic's suggestion is that one see the artwork that way.

In one sense, then, the critic is recommending a 'take' on the work; but, in another, he/she is highlighting for us the properties of the work ('taken' that way), the properties the teacher asserted. So the critic is not merely making a suggestion: instead, he or she is implicitly claiming that this way of seeing the work is revealing, a way the work *should* be seen so that its value can be recognized. Seen that way, the work will have certain response-reliant properties that it will lack if not so seen. Then the critic's *assertions* of features or properties of artworks—a typical linguistic form of such comments—should be taken seriously: critical remarks are truth-apt, because (in rejecting a remark) we are concluding that the artwork lacks these features, since there would only *be* such features were the work seen that way! On some occasions, then, our best response to the critic will be, "But there are other (better?) ways to see that work". On yet other occasions, arguing with the critic involves denying that the work has the features or properties the critic asserts. These may seem like wholly different responses: but only because we do not take seriously enough the *occasion* of the issue's being raised, the specific response-reliant character of artistic properties, and their specific learned connection to the history of art (or the artworld).

4.8 Criticism and Inference

Artistic appreciation (or even art criticism), then, is a matter of perception, rather than of inference: "perception of the arts *is* ... the process of understanding the work of art" (Wollheim, 1993a: 142). That is, one just *sees* artistic properties or

artistic value, if one has learned to do so—say, if one is "suitably sensitive, suitably informed, and, if necessary, suitably prompted" (Wollheim, 2001: 13 original emphasis). Of course, a closely parallel claim occurs in discussion of perception: "the idea that one can see that it is raining; one is not reduced to inferring that it is probably raining from premises concerning other things" (Dancy, 2004: 102). But such a characterization of the position is "hampered by the fact that nobody has been able to produce a criterion for distinguishing the inferential form the non-inferential" (Dancy, 2004: 102). (No doubt some writers will claim to have such a criterion: at the least, life is simpler if we can do without one.)

Instead, then, I stress another feature of artistic appreciation, widely recognized if still contentious: that it does not draw on *principles* in ways that are sometimes assumed for, say, deductive reasoning. This, then, contests, that general principles of, say, artistic value serve as (roughly) the major premises in pieces of deductive reasoning, of the form: work of art X has property Y; all works with property Y are Z (where "Z" is a term for artistic value); therefore X is Z.

First, cases where a supposed principle is "true, but toothless" (Dancy, 2004: 95) must be put aside: for instance, a 'principle' to the effect that, where two cases are *relevantly* similar, what is a reason for judging or appreciating one way in one case is also a reason for such judgement or evaluation in the other. For then one must establish that the cases are indeed relevantly similar. Yet:

> ... all I can do is to show that what is a reason in the first is a reason in the second, and vice versa. But that is what is supposed to be established by our showing that the cases are relevantly similar. (Dancy, 2004: 95)

To put that another way, all the work here is achieved by the term "relevantly".

Some writers have thought that art-criticism either *sometimes* (Shusterman, 1984: 203–205) or *always* (Davies, 2007: 207–224) has such a deductive form. Thus, Shusterman (1984: 205) at one time thought it revealing to note that Aristotle seems to present the tragic unities (of place, time, and so on) as holding both of tragedies and of good tragedies. But, at least once "toothless" versions are set aside, the candidate examples offered are not genuine principles of artistic appreciation or judgement. Some seem false; most are not exceptionless. Of course, it is not obvious that what lacks such general principles must be bad reasoning, or not reasoning at all. Thus, if appreciations or criticisms of art turn out to lack such general principles, they are *not* thereby rendered beyond the pale of reason, although this is sometimes assumed.

So why (if I am correct) can there be no general principles of art-appreciation or criticism? In part, the answer is that none are necessary: that our recognitional model offers an alternative (McFee, 1990). But a central aspect of the argument against generality for art-related claims turns on the distinctiveness of particular artworks: although there may be enough in common among artworks to sustain, say, the concept of *genre*, and so on, this artwork must differ from that one—or we have one artwork, not two. For example, its deployment of the image of lovers as a pair of compasses is often mentioned as part of what is powerful about Donne's poem "Valediction: Forbidding Mourning". Then at least *some* such poems

depend for their impact on Donne's use of this image, as allusions, or homages, or ironic references, or some such. Clearly the image in such cases amounts to something different than it did in Donne's poem: we could not argue, "They all have the same image, and so they must be treated in the same way (in respect of this)". In some cases, the issue is *originality*: that these other uses are derivative on Donne's. But Donne took that image from a poem by a minor Italian poet, Guarini. Still, Guarini's poem has nothing of the power of Donne's. In part, that reflects the rest of the poem; but, in part, it is how the image itself functions in each poem.

Perhaps this example does not highlight features of the kind supposed to be in common: should we not be looking for some general feature, as Aristotle wrote of the unities for tragedy? Trivially, two artworks having unity in relevantly similar cases should be regarded similarly in respect of it—if it is a virtue in one, it will be in the other. As above, that simply exploits the term "relevantly" in an unsustainable fashion. When instead we consider similarities not modified by terms such as "relevantly", the issue is sharper. For some shared features will clearly amount to different *artistic* properties. The way Van Gogh permits the canvas to be visible in *L'Eglise D'Auvers* is a strength of the work, a feature mentioned in explaining that work's power. In other works, finding the canvas visible would explain taking a less positive view of a work: for instance, in later painting by Lucian Freud. So the very same feature (or so we might think) is a plus-feature for this work and a minus-feature for that one. The explanation here is partly that the apparently shared feature—absence of pigment—is a different *artistic* property in the different contexts provided by these works, each with its place in the artist's oeuvre and in the contemporary history of painting. So these were not, after all, the *same* feature recurring. We could conclude that there is no common feature here—and could not be, since each feature will be 'defined' by its place in a particular work. Or the features could be treated at the level of their 'underlying' structure: then they are common but amount to something different.

Thus a particular feature important for the value of artwork A may have no role, or a contrary role, for artwork B. So there are no *general* roles—hence no general principles (in this sense). This idea is of a piece with our occasion-sensitivity. For, even were exactly the same feature to be encountered in two artworks, that these were indeed *different* works already suggests a different *context* (or a different *occasion*) in each case: that in turn would ground treating that feature as amounting to something different in each case. We know that the artistic features of, say, a play (as of other artworks) are a complex amalgam of the work's physical properties and its response-reliant ones. So there is no clear way to identify how the work should be seen that is not an appeal to both:

- the history and traditions of that work ("*Hamlet* is in the Elizabethan 'revenge tragedy' tradition, so that it is crucial that Claudius not merely dies at the end, but dies *for his crime*—hence, Hamlet forces the poisoned drink on Claudius, although the poisoned sword has already killed him");

- the features of *this* work, seen this way ("Jones's staging of *Hamlet* misses its force as an Elizabethan 'revenge tragedy', in such-and-such ways: and this is among its artistic flaws").

At the least, though, such considerations illustrate how any conclusion here are at best arguable, in ways those familiar with the field know how to continue. For such response-reliant properties *of the artwork* are required in order that it *be* an artwork: to *not* see such properties is to misperceive an artwork, precisely by not seeing it under *artistic* concepts—therefore, not as an *artwork* at all! And recognition of the artistic/aesthetic contrast is precisely a commitment to its *excluding* character.

Here, I have concentrated on what *divides* artworks one from another; but the more general context recognizes that most judgements of art are *comparative*— using this interpretative category implicitly compares the artwork under discussion with a great many others, for which this *category* is appropriate, as well as with those for which it is not. Yet the precise upshot of any such comparisons or contrasts cannot be described in the abstract: rather, one must look to why just *this* point was being urged, or asked about, here—as opposed to what happened on another occasion or for another work. This just applies the insight from *occasion-sensitivity* (see Sections 2.3 and 2.4): faced with a different question, a different answer will be appropriate, even when the two question are put in the same form of words.

4.9 The 'Reality' of Artistic Properties

Throughout, I have discussed artistic properties. But do artistic properties really exist? Some philosophers might put this question by asking whether such properties are 'in the real world', having an existence independent of our own. Put *that* way, the answer is obvious: artistic properties can have no *completely* independent existence since they are both brought into being by our actions as artists and recognized by us in appreciation or as critics. In particular, they are response-reliant properties (Section 4.6 above). Yet, in a transposed version, this *easy* answer would arrive at the same result for, say, colours. However, the response-reliance characteristic of 'secondary' qualities like colour is relatively unproblematic: more specifically, it is *true* that postboxes in the UK are red. So (as a default position) response-reliance of that type amounts to existing, or being 'real'.

Artistic properties are more complex than mere 'secondary' qualities like colours: someone who could see the red patch in the corner of the painting might yet fail to see the 'balance' of the painting, even when that balance was produced primarily by the very red patch. At least three other features seem essential: first, one must have acquired or learned the relevant concepts (the *cognitive stock*: Wollheim, 1993a: 134)—here, (artistic) *balance*; second, one must be able to *mobilize* that cognitive stock in one's experience of the artwork, in contrast to the person who (although having the relevant abstract knowledge) could nor *perceive* the objects under those concepts; third, one must have acquired *taste* in respect of such works.

The first constraint is relatively unproblematic: lacking the concepts *oak, elm* (or their equivalents), one cannot discriminate among *trees* in this way. This idea was already used in noting the need to deploy the appropriate *category of art*. The second constraint, concerning *mobilization*, is more problematic: Wollheim (1986: 48) writes of "the concepts ... the spectator has and mobilizes". The phenomenon referred to (the need identified) is familiar to anyone who has been taught a critical vocabulary for poetry but, at first, cannot see that this vocabulary informs the understanding of *this* poem—and then, quite suddenly, it does: the person can now mobilize those concepts in the appreciation of the poem.

So identifying the requirement for *mobilization* basically explains misfires here: even then, it really says no more than *that* the person cannot bring the concepts to bear—it does nothing to explain why. To put that the other way round, the contributions of *cognitive stock* and *mobilizing in one's experience* as differential explanations of failures to make sense of artworks: "He lacks the requisite cognitive stock", "She has the concepts, but cannot mobilize them in her experience". More exactly, these are diagnoses of relevance to aesthetic education: "He needs to learn more about ..." (and then some filling about cognitive stock; locating the work in its appropriate tradition, for example); "She needs to be helped to see *these* artworks in ways we know she can see others", say—roughly as someone unable to see one aspect of a multiple-figure might be helped.

To elaborate the third constraint, concerning taste, consider *bad taste*: cases where a (cognitively?) inappropriate judgement founds a mistaken regard for an object. Moreover, bad taste is not taste that is bad; rather, it is lack of taste—what is in bad taste is thereby *tasteless*. Of course, what are and what are not *examples* of bad taste is genuinely arguable: one side of the argument takes itself to be recognizing as, say, kitsch (and hence as art) what the other side takes to be *mere* bad taste. As Renford Bambrough (1962: 112) perceptively put it, "it is those whose knowledge of these things ["buildings, paintings, novels"] is greatest whose taste is likely to be the best". That is, the argument relates somehow to the *knowledge* of the two parties. But what is the force of "likely" here? Certainly, such a conclusion seems a good bet because, as Bambrough (1962: 112) continues, "[n]o opinion is worth anything unless it is an informed opinion ... [even though] there are topics on which informed opinions may differ". So the very idea of bad taste, if granted, emphasizes how issues here might turn on relevant knowledge, without either requiring that all appreciators of art become art historians or guaranteeing that art historians are the *best* appreciators. Still, the point is that one's critical judgements display discrimination or discernment: it is not enough that one can mobilize certain concepts—one must select the right ones!

These conditions (the cognitive stock, its mobilization and the acquisition of taste) offer ways of explaining failures to move from the recognition of, say, 'secondary' properties to the recognition of artistic properties. Further, they are perfectly public. So, if they represented the chief ways such failure was explained, one could conclude that artistic properties are 'real' or objective or public in the sense that, say, colours are. These properties are *true of the object*—indeed, one sees the object (as *art-object*) appropriately only when seeing it in these terms: that is, mobilizing this

cognitive stock in one's experience of the object. But then how do the specific features mentioned (such as the colours on patches of the canvas) relate to the specific *artistic* properties, such as (artistic) balance?

One candidate answer makes artistic properties *supervenient* on the others. (And my specific position—that it is often clarifying to conceptualize one set as *emergent* on the others: see Section 1.3—resembles this one.) A problem for such a view, it is urged, is that two objects cannot differ simply in their supervenient properties. Marcia Eaton (2001: 33) presents this criticism:

> One can imagine two women, identical in all respects except that one is a brunette, the other a blond; one cannot imagine that one of these women is a virtuous person and the other is not, if their behaviour is identical. Nor can one imagine the two women alike in all respects except that one is beautiful and the other not.

So, to differ in the 'supervenient' property, the object must also differ in the property on which it supervenes. If accepted, this line of criticism must mean that two objects not differing in (say) perceptual properties cannot differ in value-endorsing properties, such as artistic properties.

From our perspective, this form of argument is problematic, like the conception of supervenience it assumes. First, it operates (if at all) only for *aesthetic* properties: if one of the objects is an artwork while the other is not, only one is a suitable candidate for the *artistic* properties at issue—so nothing here stands as the *two women* do in the cases Eaton sketches, as suitable bearers of both contested and uncontested properties. Yet our topic is the supervenience of *artistic* properties.[33] Second, our position developed (in Chapter 1) from Danto's gallery of indiscernibles: if such a case is at all plausible, two objects sharing at least many 'lower level' properties may differ very substantially at the artistic level. Further, this argument and the conception of supervenience it attacks both have a reductionist slant to their conceptions of the perceptual (compare Travis, 2004a: 245–250): in particular, the materials for the conclusion derive from that reductionist assumption, by treating perception of the 'lower level' properties as unproblematic.

One defender of supervenience for the properties of artworks, Nick Zangwill (2001: 47), introduces in this context the idea of "the total conjunctive set of aesthetic properties": this—he urges—is what supervenes on the set of sensory, physical and relevant extrinsic properties of the object. But his picture of the 'lower level' properties is also reductive: they are conceived as logically fundamental *atoms* derived from analysis—or they themselves might be supervenient.[34] Yet such crude empiricism conflicts with our contextualism: we have no reason to accept such ultimate properties. Further we do *not* expect the properties truly ascribable to an object (especially its artistic properties) to be conjoinable in this way; nor do we expect some finite totality of such properties, given our commitment to *occasion-sensitivity* (see Sections 2.3, 2.4 and 2.5). So there can never be a *total* set of them.

Here, Zangwill's response shows clearly the nature of the misconception inherent in the question to which "supervenient" was supposed to be the answer. There seems no reason to imagine some finite limit to the ways (say) a poem might be understood: that is, to the readings that might be offered of it, seen as an artwork. Hence no

reason to imagine a single seamless move from a fixed *base* on which such artistic properties supervene. But this is required by those who, as Eaton (2001: 44) puts it, "chafe at the claim that the intrinsic properties [of artworks] are not settled forever". We are not in that club. Eaton (2001: 43–44) makes the specific point eloquently by discussing a poem by Robert Frost: should we assume that some fixed, finite totality of properties is truly ascribable to that poem? This point might be granted at the level of letters on the page; but, as earlier, it will certainly be contested applied to the principles of structural organization of those words: what exactly is the grammar of the passage? And even granting this to be determinate (contrast FW: 117–122) offers no reason why *one* narrative only should identify the poem's artistic features. Of course, that does not mean that 'anything goes': instead, any such reading must be answerable to the features of the artwork (UD: 141–143)—here, to the words on the page.

Indeed, our earlier use of the term "emergent" was directed to this feature, answering to embodied properties. First and negatively, we cannot infer from there being a red patch in the corner that the painting is balanced; a different painting might have just such a patch and not be balanced (Sibley/Lyas example: see Section 1.3). The properties of artworks must be discussed case-by-case. With Danto (2000: 135), we admit to being unable to deal with "every historical case" viewed in the abstract; but, like him, offer instead to tackle "any historical case" actually presented. Then second and positively, some narratives can be rejected on some occasions: for instance (as above), reading the expression "plastic arm" in Akenside's poem "Pleasures of the Imagination" as identifying a petrochemical prosthesis is just wrong. But we cannot address *all* narratives, on *all* occasions: since neither is a finite totality, the term "all" has no legitimate use here.

Once we grant the transfiguration of real things or events into art, and concede that one must *learn* (and learn to *use*) artistic concepts, three points are fundamental: first, the relation of artistic properties to others, picked out in the positive and negative aspects just identified; the second extends the positive point, by noting that no narrative of the properties of an artwork is settled forever—as the case of Frost's poem illustrated, that cannot be expected; third, the properties at issue must be *of the object*. This seems to raise an issue for 'relational' properties; but does not do so (see Section 5.5). Indeed, Danto's achievement here is to show that objects can and should be seen differently on the basis of such properties.

Notes

1. Our strategy here might seem to deploy Ramsey's Maxim, on which "whenever there is a violent and persistent philosophical dispute there is likely to be a false assumption shared by both parties" (Bambrough, 1969: 10).
2. One issue not addressed: the extent to which this issue arises solely, or primarily, in respect of arts of literature. I shall assume that, while a concern with literature may introduce some specific aspects, most points can be taken to apply across the arts *mutatis mutandis*. And this assumption is typical. Thus Beardsley (1958: 20) moves seamlessly from considering the author of a literary work to "the painter with his exhibition catalogue ...", and to what "a sculptor tells us ...".

3. A view I. A. Richards (1924: 20 note) dismisses as "delusion"!

4. In addition to *actual intentionalism* (author's intentions constrain how his/her works are to be 'read') and *hypothetical intentionalism* (interpretations are justified as those most likely intended by a postulated author), the literature also contains value-maximizing theory, on which interpretations are preferred as they present works in the most artistically favourable light. But, as Stephen Davies has argued, the differences between the last option and hypothetical intentionalism are slight: that, under some conditions, "hypothetical intentionalism and the value-maximizing theory ... [are] equivalent" (Davies, 2007: 186)

5. Levinson (2002) presents and meets central objections to hypothetical intentionalism: for us, it is just a default position.

6. Of course, some concepts can only be *applied* with hindsight; for instance, *precursor of ...*

7. Otherwise, say, Deborah Hay describing her whole life as dance would have to be taken literally: see Foster (1986: 6).

8. Since they strike me that way, they are arguable!

9. To Levinson (2010: 139), it seems obvious that conceding too much to actual intentionalism might undermine the 'distinction' between *utterance-meaning* and *utterer's-meaning*. Our contextualist recognition of *occasion-sensitivity*, as sketched in Chapter 2, will require a sophisticated treatment of this distinction: *utterance-meaning* is contextualised to time and place of utterance—and hence potentially to *utterer*. (But saying that does nothing to undermine the contrast with utterer's-meaning.).

10. Levinson (1996: 188–189) distinguishes *categorial intentions* from *semantic intentions*. In fact, both are relevant here: see (McFee, 2005b: 85–87). Further, while the contrast between *semantic intentions* and *categorial intentions* (Levinson, 1996: 188: see Chapter 5) may be needed, the detail of the contrast in a specific case must be elaborated in *that* case, not generally.

11. Note that we are not denying that Dickens' novels, say, might be sufficiently similar that *something* of the same "aboutness" might be shared by two of them.

12. A full account here would accommodate, say, small changes—the missing comma in one version, for instance—where there is no doubt that this is such-and-such novel. But this degree of detail is not required here.

13. Two works different in authorship (in 'history of production') might well be *distinguishable* for artistic purposes even when otherwise indistinguishable: for instance, the later work might be mannered in a way the earlier could not, as in the case Borges (1962) imagined: see Sections 3.5 and 5.3.

14. See Best (1978: 121) on the different fates of Toller Cranston and John Curry.

15. Of course, those of Duchamp's Readymades where the theory of '*rendez-vous*' was it its purest provide the foremost examples—where Duchamp simply exhibited a found object, without (say) writing on it.

16. See Kristeller (1965: 200). Compare Reynolds (Sparshott, 1963: 108); Batteux (Sparshott, 1963: 148).

17. See also Carroll (1998b: 17–19).

18. Perhaps two tokens of a type! (See UD: 90–97).

19. My use of critical judgements of others—say, their judgements of Mueck and Van Eyck, and so on—represents a methodological commitment here: that nothing turns on the accuracy (or otherwise) of my specific artistic judgements.

20. Given that Greeves refers to Raine, this may not be coincidence or shared thought.

21. See also Cumming (2003a: 12): "that little naked corpse, so supernaturally real, over which a great soul seems to hover." There seems no question about the (apparently) hovering soul!

22. Empson "Missing Dates", in his *Collected Poems* (London: Chatto & Windus, 1969: 60). It seems to me exactly right to align *Dead Dad* with Empson's evocation of "the inevitability of defeat" (Alvarez, 1963: 84–85).

23. One key factor involves integrating the *changing* impact on our artistic judgements of what we know (that is, of our cognitive stock). For this might involve the character of artistic properties *fluctuating*. Fluctuations here, going unnoticed, might be taken as *always* symptomatic when they are only symptomatic *sometimes*, and sometimes indicative of a logical relation (Wittgenstein's point: PI §354).

24. If granted, this should already affect powerfully those who regard musical works as simply sound-sequences.

25. See Lyas (1992: 390–391): also Lyas (1997: 145).

26. Complication: the performing arts—but these difficulties can be overcome to leave the same conclusion (see Wollheim, 1978: 37; McFee, 2010b); namely, the crucial nature of history of production (*pace* Goodman, 1968: 113–121).

27. Utilized here Section 1.3 note; Section 5.4.

28. I do not assume that there are such conditions, that they might be specified, or that they play any role in the analysis of perception: as with words, there need be nothing paradigmatic about the context in which mastery of perceptual notions is learnt.

29. Reid (1997: 120–121) is rightly dismissive of "images in the brain".

30. Reid (1997: 167) is keen to put aside the issue of subjectivism: like Foot (2002: 6), he distinguishes those claims where mistakes are possible from those where one's (say) lying is possible—if I assert that an object looks red to me, then (lying aside) I am right. But this would not follow when I might be mistaken—and that might *even* be for the real colour or for the look.

31. I use Sparshott's translations of Aquinas since, as Sparshott (1982: 103) notes, "*placet* is how one registers a favourable vote in Latin". See also Mothersill (1984: 323 ff.).

32. See Mackie (1977: 15), Wright (1992: 6), McDowell (1998: 112).

33. For more general discussion of supervenience in relation to value-properties (using the response-reliance idea), see Wright (2003: 162–166).

34. A useful comparison: the problems with *facts* that led to *logical atomism* (see Dummett, 2006: 6–8).

Chapter 5
The Historical Character of Art

5.1 Precursors and the Past

In one of his many philosophically illuminating essays, Jorge Luis Borges considers
a number of writers who, he argues, are precursors of Kafka. Borges's point is
that works by these authors must be understood in terms of Kafka's ideas and
achievements. As Borges (1970: 236) puts it:

> In each of these texts we find Kafka's idiosyncrasy to a greater or lesser degree, but if Kafka
> had never written a line, we would not perceive this quality; in other words, it would not
> exist The fact is that every writer creates his own precursors. His work modifies our
> conception of the past, as it will modify the future.

The thought reflected here is of the *historical character* (or historicity[1]) of art: that,
in general, the meaning of an artwork may be different at some later time than it
was at the earlier. For example, Borges' precursors of Kafka must be understood
in terms of ideas from Kafka—only then are they seen as *precursors*. This means
bringing to bear on those works analytical concepts drawn from the study of Kafka:
in Borges' example, the very possibility of these analytical concepts depends on (a
view of) Kafka. Then understanding an artwork may require concepts not available
to the artist at the time of the work's creation. Here, Danto (1977: 34) speaks of
"this retroactive enrichment of the entities in the artworld", correctly putting a claim
about (the possibility of) changes in how we understand artworks as a thesis about
the artworks themselves. Like us, Danto recognizes the connection of meaning-
properties for artworks to the 'story' (or explanation) that might be given of them.
And conceptual changes here can modify the *occasion* (or context) of requests for
artistic meaning.

This chapter urges that a mild historicism follows automatically from the role of
traditions, genres and the like granted by many aestheticians (the *categories of art*:
see Section 1.1); and that such accounts naturally sustain *forward retroactivism*, the
stronger historicism mentioned above. As Jerrold Levinson (1990: 197) explains it:

> Adopting to these works the perspective of forward retroactivism ... involves first constru-
> ing ... [a later artwork] in the light of ... [an earlier artwork], which is just traditional
> historicism, and then projecting this understanding back onto [the earlier artwork] ...

My thesis of *historical character* is a (limited) a defence of forward retroactivism interpreted in exactly this way.

A slogan from Heinrich Wölfflin suitably introduces similarly radical historicist ideas: that 'not everything is possible in every period'. He makes the point explicitly for the understanding of art:

> False judgements enter art history if we judge from the impression which pictures of different epochs, placed side by side, make on us ... They speak a different language (Wölfflin, 1950: 228).

Similarly, Stanley Fish (1980: vii) opposes any view which takes (literary) meaning to be "an entity which always remains the same from one moment to the next" (Hirsch, 1966: 46). In line with ideas here, Fish also disputes the claim to, and necessity for, "a standard of right that exists independently of community goals and assumptions" (Fish, 1980: 174). The thesis of forward retroactivism is radical, then, both in diverging from a general consensus (at least in philosophical aesthetics in the analytical tradition) and in undermining a prevalent conception of artistic value as timeless, where criticism of the whole project of aesthetics has assumed just such a conception. Such a prize is worth striving for.

The dispute here turns *ultimately* on the account of meaning and understanding employed: that is what allows us to regard changes in (appropriate) understanding as changes in meaning. Some of the issues are highlighted as they arise. Note, though, that my view has changed substantially on this issue since my first published consideration of it (McFee, 1980): namely, on the form of an account of meaning. Russell (1919: 170) claimed "a robust sense of reality is very necessary in framing the correct analysis of propositions about unicorns, gold mountains, round squares and other pseudo-objects". Rejecting the view of meaning and understanding this imports, I now urge that philosophical aesthetics requires a *robust sense of constructivity*: that one should strenuously insist on the philosophical justification of limiting one's claims here to the realm of (possible) artistic knowledge (UD: 311–313). Could such *meaning* or, worse, *understanding* be permanently unavailable? The robust sense of constructivity guards against such reasoning. For if some artworks have these unavailable meanings, or even if they could, why not say that all art works have them?—they are admitted to our ontology. Even grasping some nettles of improbability in my view is preferable to the idea of forever unavailable meanings (that is, meanings divorced from the possibility of understanding).

5.2 Art, Change of Meaning and Standard Historicism

Is there *change* of (artistic) meaning? Is the fact that one understands an artwork *differently* at some later time reason to think that one *should* do so? That is, has the meaning of the work changed, or is something else happening?

Let us begin from cases where—at least prima facie—works are understood differently at different times. Then, do we genuinely *understand* them differently, in ways that are warranted, or have we merely invented new ways of *misunderstanding*? Consider the following mixed-bag of examples:

(a) The need to determine historical accuracy 'with hindsight': does the invention of a workable submarine turn the reference in Jules Verne from fictional to historical? Or suppose the Woody Allen film *Sleeper* (1973) was made before the Watergate scandal, and Nixon's fall from grace. In that movie, the future knows nothing of Nixon, but thinks he was a president of the USA who did something so terrible that all record of him has been removed. Might the reference to Nixon also move from fictional to historical?

(b) We understand the motivations of a character in a novel in terms of contemporary psychology: when psychological theory changes, we view that character (and hence the book as a whole) differently.

(c) There are phases of regard or popularity. Not only does the judgement of, say, Sibelius fluctuate (at some times he is judged a minor composer, at others a major one), but—at another time—he is regarded simply as a music-maker, his works not thought to have art-status. Such a revision must involve taking those works differently.

(d) Re-thinking a movement or genre: what *exactly* was the impact of, say, the Pre-Raphaelite Brotherhood? If their works are more significant than was thought (or less), the works themselves will need to be reconsidered, in order to justify that changed judgement: doing this may requiring considering the movement *as a whole*, from the standpoint of history (like [a] above). Similarly, the claim that Bach and Handel were the culmination of the High Baroque[2] requires looking back over a whole movement with concepts acquired from the high point of that movement. As such, it draws on a particular version of the history of music.

(e) 'Old' movement/'new' movement: locating, say, the first Impressionist (perhaps Monet, given the stir over his *Impression: Sunrise* [1874]) will be different once there is a school or genre within which his works can be considered and understood.

(f) *Oeuvre*: we often think of an artist's later works as constituting a kind of unity (his/her *oeuvre*), seeing later works in terms of the earlier. Might that also involve re-evaluating a work by recognizing what came next?

(g) Precursors: seeing **X** as a precursor of **Y** (say, of Kafka, above) deploys concepts developed from the understanding of the later figure in understanding the earlier. Yet these concepts were not available at the earlier time; further, had the later artist not come to prominence, these concepts might never have been used here (A good example: Franger's [1951] text on Hieronymus Bosch as a precursor of Surrealism.)

(h) Getting new insights: Picasso's *Las Meninas* series suggests new ways of looking at Velasquez's *Las Meninas*, such that ignoring the Picasso works is missing something in discussion of the Velasquez.

(i) Rewriting art history—really, a radical version of (d) above: Clement Greenberg's bold attempt to say what artists had (according to him) always been doing *really*—whatever they claimed—offers a different view of the project of a great deal of fine art. If it succeeds, a great many works will be viewed differently. But that insight is only available to us after Greenberg! So that way of viewing the art-objects is historically located.

Moreover, there may be cases requiring 'change in order to remain the same'. For example, Hanfling (1992: 92) remarks, of Gilbert and Sullivan:

> Their operettas are full of topical jokes and allusions whose meaning would have been obvious to their audience. But, for us, many of them are obscure or pointless.

As Hanfling notes, learning about "the relevant facts and personalities" will not really suffice here, unless it makes the jokes (say) *immediate* in the way they once were: "what was at the time pungent and actual is now meaningless or lifeless" (Hanfling, 1992: 92). And such *immediacy*, say, may be crucial, when artistic judgements are response-reliant. As a way forward, an attempt to recapture the *spirit* of the original might introduce modern-day material with broadly the same impact, as in (say) Jonathan Miller's staging of *The Mikado*. This conception, of course, gives up words written by Gilbert and Sullivan—part of what they "intended"—in favour of modern words. But that is changing the work!

These examples are not all the same, nor are all equally plausible. But they suggest cases where different things may (truthfully) be said about an artwork at one time than could have been said at some earlier time, where such different views connect with the concepts, narratives, traditions and so on within which the artworks in question are understood. Since we recognize that understanding artworks depends on *categories of art* (etc.), anything that makes us (appropriately) change our category-judgement (as in [e] above), or revise our view of that category (as in [d] above), will affect how we (appropriately) view the artwork. Further, talk of the *meaning* of artworks implies no commitment here to a single, unitary meaning—although (for ease of presentation) I often write as though there were.

So what will count for us as a *change of meaning* for a particular artwork, given that something could? Suppose that at a certain time, artwork **X** is rightly understood a certain way: that is its meaning (with the provisos above). Once it is granted that it is work **X** that is understood (its properties and features), and that they are *rightly* understanding work **X** later in ways that were previously impossible, this change in *understandability* is a change in *meaning*: for its *meaning* is the feature or property of the artwork that corresponds to our understanding of it.

As this sloganised account rightly emphasizes, a particular way of understanding the work makes sense, given the categories of art, traditions, the work's place in the narrative of art history, and so on—this understanding is answerable to the perceptible features of the artwork. Carrier (1991: 196) suggests:

> All we need ask . . . is whether Campanella's ideas, which were available in Poussin's world, provide a convincing way of interpreting that artist's paintings.

As this case shows, both a lot more and a lot less than this is needed: for Campanella's ideas being "available" only shows that a reading in terms of them would have been legitimate *then*, and that they therefore *may* provide a "convincing" way of interpreting Poussin. Now one must ask whether anything in the paintings conflicts with this reading. And, centrally, the understanding here takes the work to be *art*: it is artistic understanding.

Moreover, the central case of change of meaning should be contrasted with cases where, say, more is *learned* about the work—where more can be said about the work than previously just because one knows more than one did. Then, the 'more' was always *available* to human knowledge, even if one did not know it. Similarly, thinking harder about a work, immersing oneself in it, is (typically) not a change of meaning. So, for instance, the case of Greenberg ([i] above) might seem to be just that: someone thinking (harder) about the work. But Greenberg's contribution involves a new conceptualization; thus the (putative) meaning-change is rooted in this conceptual change.

Indeed, someone's *learning* more should be contrasted with at least two other cases that recognize our judgements as located historically, so that some can only be made with hindsight. Then a kind of historical percipience is needed to assert that in such-and-such a house is presently being born the greatest physicist of the twentieth century—granting both that this is Einstein's birth-place, at his birth-time, and that Einstein was the greatest physicist of the twentieth century. This judgement requires hindsight, because only the passage of time proves it true (or false). That judgement is not really available until some later time, but the difficulty seems purely practical.

On this view, events which lead us to re-conceive/re-configure the tradition can alter our understanding of (later) works in that tradition. Our understanding of art-works can legitimately be modified when, having understood a prior work by seeing it as part of a tradition, our thus revitalized view of the tradition is then applied to the present work, from which our investigation began. Such categories have a historical dimension in line with what (following Levinson, 1990: 197) I call "backwards retroactivism" but is "just traditional historicism". He comments:

> Here the present permits us to see the past more clearly, as it couldn't have seen itself, which in turn clarifies the present understanding in relation to, and as a development out of, that past (Levinson, 1990: 197).

On this view, a work created in 1985 (W2) is understood by reinterpreting a tradition leading from a work of 1885 (W1), where that reinterpretation draws on our understanding of the later work (W2). So we could not *know*, in 1885, faced with Van Gogh's *The Potato Eaters* (1885), that the artistic force of its portrayal of peasant life was as revealing as later works (including later Van Gogh's) demonstrated; although it was. But recognizing that may help understand the more recent work. Or, again, reconsidering, say, the Pre-Raphaelite Brotherhood (example [d] above) might lead us to see such-and-such a feature of a particular poem or painting a certain way: what should now be made of C. A. Collins' painting *Convent Thoughts* (1851)—which, following Ruskin, was admired partly for its delicate portrayal of the water plant *Alisma Plantago*—once Peter Fuller (1988: 234) demonstrates that

this plant is absent from the painting? That change might affect not only how one thinks of the painting, and hence of works in the tradition flowing from it, but also how *well* one thought of it. Of course, for many aestheticians (for example, those committed to "canonical interpretations": Savile, 1982: 64) this idea too is problematic. But, Levinson (1990: 196) concludes, it "is, perhaps, legitimate". Avoiding misperception of artworks requires deploying the genres (etc.) appropriate to our perception of them: hence works must be located in their history. Thus at least *backwards retroactivism* is needed to explain what gives the categories of art their power.

In contrast to the judgement (above) about the twentieth century's greatest physicist, the parallel judgement that the creator of the Theory of Relativity is presently being born in that house, said at that time, makes no sense: the expression "Theory of Relativity" requires later conceptual events even to be meaningful. More than *mere* hindsight is required to assert it, since the expression "Theory of Relativity" either made *no* sense or a very different sense (from the modern one). Here, the past could not see itself that way for a reason in *logic*: that the concepts required made no sense at that time. In this way, the judgements 'pass one another by': they are *incommensurable* in the strict sense of being unable to be put into one-to-one correspondence.[3] But what counts as possible now (and thus as true or false) depends in part on the concepts available now. Hence later events supply more than just truth-*determinants* of the property-ascription: they additionally supply the concepts for those properties. And this will be our *forward retroactivism* (see Section 5.3 below).

As we saw (Section 2.6), Paul Feyerabend (1987: 272) contrasts the perspective of the practitioner with that of the philosopher: applied to our context, a perspective on meaning for artworks which treats it centrally in terms of gaining insight is distinguished from one that treats it in terms of change of (artistic) meaning. The critic who, looking back, claims that Bosch prefigured surrealism (say, Franger, 1951) can be speaking the truth. Here, contemporary art criticism claims (and rightly) that earlier critical judgements of a particular artwork of Bosch were mistaken. But if this claim reflects instead conceptual change of this sort, aestheticians might regard it differently: that this judgement is only possible because *now* we have the concept of surrealism. Therefore, a detached perspective shows that only later conceptual changes make possible the truth (or otherwise) of what is later claimed.

5.3 Forward Retroactivism, and the Threat of Misperception

Misperception of an artwork can occur when the *transfiguration of the commonplace* has escaped notice (as we noted: Section 1.1); when the artwork's interest is taken to be *aesthetic*, rather than artistic—treating the music as though it were merely birdsong, however pleasing to the ear. A second type of misperception, more important here, occurs when we mobilize *inappropriate* concepts in our perception of an artwork: say, complaining about the lack of tonality in a certain musical work, before

realizing that it is actually atonal music. Locating the appropriate concepts identifies the *category of art*, where such categories are brought into being (roughly) through the *narratives* (Carroll, 2001: 63–99) told in explanation of *this* artwork (in particular, of the virtues of this work) in terms of previous works. So that the understanding of a particular work draws on our understanding of other works—typically works of the past—and especially other works by the same artist, or in the same genre or tradition, or ... well, connected in that narrative of art history.

Then a changed narrative of some tradition (say, of the Pre-Raphaelites) can alter the (artistic) properties of a particular work: seeing the tradition differently, thus urging something different in seeing *this* work as part of that tradition. But, as I shall argue, historicism of this *mild* sort cannot provide a stable resting place. Rather, on consistent interpretation, it must turn into *forward retroactivism*, the more radical form of historicism on which changes in the later tradition inflect understanding of earlier works (Levinson, 1990: 197, quoted above). For later events can alter how to think about earlier works, by altering the concepts *appropriate* to the perception of those works (where the term "appropriate" is doing a lot of work). My preferred example was of such-and-such an artwork as a *precursor* of some later movement.

Suppose that study of Picasso's *Las Meninas* series throws light on the Velasquez *Las Meninas*. Certainly we can say more about the Velasquez: not least that it stimulated such-and-such in the fertile imagination of Picasso. But critical insight could actually be got here. For me, the passage on the Velasquez *Las Meninas* with which Foucault (1970: 3–10) begins *The Order of Things* could not have been written without Picasso—even though Picasso's name does not appear! Then how Velasquez *Las Meninas* is (appropriately) understood involves reference both to Picasso's *Las Meninas* series and to critical insight that might be got from it. Perhaps Picasso's works allow an increased understanding of what is familiar in the Velasquez[4]—say, its formal properties or its ironic inclusion of the artist, or some such. This is certainly one way to read Hans Hess's (1975: 14–15) discussion of Velasquez's *Las Meninas*. In this example, the meanings of artworks are apparently changed, and changed by later events.

Or imagine that Borges's story of Pierre Menard were factual: a young Frenchman has written a word-perfect version of Cervantes' masterpiece (assume him to have finished it). Then, as Borges (1962: 49) urges, "[t]he text of Cervantes and that of Menard are verbally identical, but the second is almost infinitely richer". To illustrate, he then quotes a passage from Cervantes and one from Menard, commenting on the different import of the two passages, what they convey etc. (Remember, these are identical strings of words.) He continues:

> Equally vivid is the contrast in styles. The archaic style of Menard—in the last analysis a foreigner—suffers from a certain affectation. Not so that of his precursor, who handles easily the Spanish of his time. (Borges, 1962: 49–50)

But what has changed here? Not the words, of course. Rather, the meaning of the Menard differs from that of the Cervantes: we can accurately say things of the Menard which we could not say of the Cervantes—different reasons for our judgements become open to us.

This case (not yet apparently involving the historical character of art) shows vividly what is at work in others. The Menard might be misperceived, by being mistaken for the Cervantes (or vice versa). Moreover, our understanding of the Menard text might 'highlight' for us features of the Cervantes: for instance, a certain *blandness* (by comparison) might be visible in the earlier text. So different judgements can be made, since different reasons are available. And that is what Picasso's work offers to the Velasquez. Then these reasons are best thought of as *part* of one's judgement or interpretation, rather than merely what leads to the making of that judgement. Thus, two spectators of, say, Picasso's *Guernica* who describe it in exactly the same (judgemental) terms might seem automatically to be offering exactly the same 'reading'. Suppose, for example, both identify elements of man's inhumanity to man, of a crushing of the human spirit, and the like: are they in fact making the same judgement? As shown (see Section 2.7), these are clearly not the same judgements when entirely different sets of reasons were offered for each—say, one in terms of the symbolizing of events in Spanish history, and the other in terms of purely formal features of the work (perhaps drawing on the comparison of central triangles in *Guernica* and da Vinci's *Last Supper* etc.). Suppose there is no question that the judgement(s) have these bases; further, that they could not be combined or subsumed under some more embracing judgement (without that, they are not separate judgements). As with my wife and the green curtain (see Section 2.4), an occasion can be imagined where one of these judgements was false and the other true. So they cannot be equivalent. And even when each is true (in its context), different things would make each judgement false in that case. Then these are indeed different judgements. Hence judgements cannot really be separated from their reasons.

As this case exemplifies, having different reasons for judgements can amount to having different judgements, even if made in the same form of words—as the Borges' example suggested. Then the force of the other cases shows how the passage of time might make just such new reasons available to us. That may mean different (artistic) properties can be ascribed to the artworks. So one way to put the thesis of historical character is that changes in the reasons used to make a certain artistic judgement (or, anyway, in those available for that judgement[5]) imply a change in the meaning of that judgement; hence a change in the meaning of the work of art itself.

But is there only one kind of occasion for making judgemental remarks about artworks? In this one case (*art*), that assumption might well be warranted, since we have assumed the stability of a background, or context. For a 'reason' not appropriately related to the judgement of the artwork lacks the sort of internal connection between reason and judgement sketched above. For instance, *association*, where I admire a painting because we met beneath it (see Section 2.1), is not historically sensitive. To profess admiration for a painting on that basis does not really contradict someone who asserts the opposite: I do not *really* admire the painting. His judgement might change if the features of the painting were changed; mine would not—it would still be the painting under which we met. Such a contingent, associative sort of connection cannot bear on the work's meaning.

There is, however, something distinctive of the concept *art* in the *historical character* thesis—not, perhaps, unique to it, but still distinctive of it, and similar, concepts: namely, that judgements of the arts are susceptible to the authority of experts in ways some other judgements are not (compare Section 2.6). So, I read the writings of my favourite dance critic, (say) Marcia Siegel, because her judgements are more insightful than mine, and hence I can learn from her—which means both learn about the dance under consideration, and learn to be more insightful myself (at least in respect of dances). I come to see what is good, and to recognize it. In this way, my understanding art-status and artistic value might be developed by, say, theoretically-inclined critics, art-historians and the like: I learn *taste* (see Section 4.8). But what one learns may differ at different times. Of course, explanatory and justificatory methods of the sorts which allow the modification of human practices in general, and these in particular, require more than just wanting it so. At the least, they require presenting explanatory reasons, getting others to accept one's claims as genuine reasons, and also as good or compelling reasons for judgement of action (And that puts the matter unduly rationalistically!). So, for instance, such expert judgement will probably change with the passage of history. In particular, insights from other fields (say, psychology) might be expected to bring about such changes. Then the artistic standards, values and the like learned will be changeable by human means (unsurprisingly, given that art is a human practice). Thus the distinctive kind of historical character of the concept *art* goes with the placing of weight on expert opinion.

What is not eternal can be none-the-less valuable for human beings. We are compelled to see ourselves and our judgements as part of the passage of a process. Thus *our* judgements are the ones that typically concern us. And when such judgements differ from those of past theorists, those past theorists will look wrong. And will *be* wrong, from the practitioner's perspective (Section 5.2 above), since the term "wrong" here is founded on the historical character of the judgement. But saying that future generations may (or will) find our best judgements wrong is simply an expression of humility before the fact of history, rather than as taking seriously that our 'best shot' is mistaken. In particular, it should not be seen as a ground for present scepticism. For doubt needs a *specific* ground; and here there is none.

Another specifically aesthetic thesis follows from this one. For, paradoxically, accepting that art has an historical character justifies a certain kind of ahistorical judgement: what we presently say about artworks is then true of them. And it must be, because we are in the flow of history. But nothing is unalterably fixed: any aspect of taste could be changed (though not all at once).

5.4 Are These *Genuine* Properties?

Two fundamental and revealing objections might be raised here. First, that what are discussed (as changing) are not genuine *properties* of artworks; second, that they are not *meaning*-properties.

That work **X** is a precursor of work **Y** (or even that work **Y** is in a tradition that includes work **X**) might seem not to depend on *genuine* properties of the artworks, but instead on *relational properties*—as it is not a genuine property of a particular chair that it is next to the sofa, but merely a contingent fact about it. What is true of the chair in itself should be distinguished from such merely relational truths about it. Both, of course, can be truly said of the chair, both are true of it; but the relational truth is external to the chair in a way the other is not. So, the argument might run, the relation of this painting (say) to these other paintings is irrelevant to what is true *of this painting*—even when the judgement true here is an *artistic* judgement (the truths are artistic truths). In effect, the question asks how *genuine* properties can change, granting that relational ones can. Further, even if some genuine properties of artworks change over time, are they the meaning-properties of those works? Then, the connection between intending and meaning might be stressed in explanation, or the connection between the work and its creator more generally: that the meaning is fixed by the artist (without, of course, somehow assuming a unitary character to meaning).

But 'properties' must be investigated under *occasion-sensitivity*: why exactly is such-and-such treated as a relational property (that is, not a genuine property of the object) in a world which grants both the truth of ascriptions of response-reliant properties and occasion-sensitivity? Like what counts as the curtain's being *green* (in the story from Section 2.4), what is or is not *true* will itself be occasion-sensitive. Suppose that such-and-such is *true*: is it true of the object, or merely relational? Here, response-reliance provides one complexity, for (on this conception) what is *true of the object* is not true of it alone: some role must be given to those able to recognize the property (see Section 4.5). Still, the yellowness of the lemon or the redness of the UK postbox are features of those objects, if response-reliant ones. Is there an equally clear answer for a property such as *being a precursor*?

Recall the centrality, for art-status and the importance of art, of an artwork's *meaning*-properties: to *lack* this kind of 'aboutness' is to not be an artwork. Moreover, genuine meaning-features are contrasted both with *significance* and with *association* (see Section 2.1), features or properties of kinds that might be confused with artistic meaning. Then the first issue above an be used against the second. If a genuine feature or property of the artwork is one that bears on artistic judgement, it is (for that reason) straightforwardly a meaning-feature or property, or a feature which grounds such a meaning-feature or property. For changing it changes the *embodiment* of the artwork, and hence its 'aboutness'. For example, "hanging on such-and-such wall" seems an entirely *neutral* property of the work: the artwork might have the same (artistic) meaning hanging on other walls. This counts as a relational property here—in *this* example, not *all*. By contrast, the 'hanging' of a particular painting in a particular gallery might be a part of a *narrative* (offered, say, by the curator) of how the painting should be seen; what traditions it took part in, which it rejected, and so on. That is, it might attempt to write a history of art for this work. Adopting the view of this work that this narrative implies, its (artistic) properties will differ from those otherwise endorsed for it. When this new view is genuinely *arguable* (say, by *competent judges* for art of that sort: see Section 2.6),

it offers a revised understanding of the work. Where that revised understanding is credible, it might be taken as the (or a) *meaning* of the work.

Of course, this generous view of what relates to *meaning* is warranted by recognizing that one cannot be more specific here: that is precluded by the specificity of artistic meaning. Moreover, we may need to be persuaded that a certain aspect is a matter of meaning rather than, say, of significance (or vice versa); but this is not a matter on which pre-judgement is possible. In particular, events (intellectual, artistic or social) later than the composition of the works cannot simply be ruled out as candidates for a role in meaning-relations.

Granting these points brings the other issue into sharp focus: is what changes genuinely a *property* of the artwork (as opposed to something merely relational)? Once we note that, *if* such-and-such is a feature or property at all, it is a meaning-property—or, perhaps better, a property concerning how the artwork is appropriately understood—the way towards an answer becomes clear. For the kinds of connection to understanding highlighted (in terms of *categories of art* and *narratives*: see Section 1.1) appear relational by one test, yet are clearly central to how artworks should be understood. So, for artistic properties at least, the contrast between genuine properties and merely relational ones must be drawn differently from elsewhere. In this sense, reference to a particular *tradition* ("the British School of ballet choreography"), or *category of art* ("analytical cubist painting"), or *narrative* ("the 'lay of the artworld' in Isadora Duncan's day") does not amount to making a relation between this artwork and some other works or events, but to articulating a property of this particular work: the property of 'expressiveness-of-a-Fauve-type', for example, or of 'fragility-as-captured-in-Abstract-Expressionism'; or whatever—although, of course, the full complexity of such properties would not normally be *stated* (even when one could), nor should either a full or a stateable complexity be assumed. So, properly understood, these are not *relational* properties at all. Instead, they are properties of a complex sort—as we might expect, given that they are typically meaning-related, value-bearing, sensuously embodied, and tertiary (Scruton, 1983: 28), properties!

These remarks stress the connection of the properties or features of artworks to the understanding possible of those works; hence to the explanations offered of them. As we might say, the explanation given of ("my reason for") an artistic judgement is related distinctively to that judgement itself. I need not labour this point in the abstract: both the point and its implications should become clearer as we go along.

5.5 Reasons and 'New Evidence'

Someone[6] might take issue with my claims about the relation of the reasons for an artistic judgement to the meaning of a work (its "content") ascribed in that judgement: "For McFee, the content is not merely the property but also the reasons available for ascribing that property". As exemplified by the contrasting judgements

of a Picasso (Section 5.3 above), giving different reasons (where the occasion involves our stressing their difference) *will* imply different properties, by highlighting different contexts—even when the judgements might be mistaken for one another. And a reason for distinguishing them, although they were made in the same words, was that one might be true in circumstances where the other was false. This account of artistic property-concepts illustrates how my view of the relation of meaning builds on occasion-sensitivity, granting that the same form of words can amount to different claims, in contrast to other, less flexible pictures of meaning.[7]

Does this view imply "that we cannot give further reasons for an ascription or that people cannot believe the same thing, but for different reasons" (Stecker, 2003: 151 note 23[8])? The case of people believing 'the same thing' but for different reasons is complex: does someone who believes in the existence of the God described in the Bible really believe *the same* as another who believes in the existence of the God described in the Koran? In this case, the reasons for one's belief colours what the belief is. So, in at least some cases, two people who hold different reasons *do not* always believe in the same thing, despite each stating his/her belief in the same form of words.

Further, what is the *occasion* of the question? For there will clearly be cases where it makes little or no difference upon which reason a particular judgement rests—we might be happy to offer either reason, or (perhaps) a combination of them. But this will precisely be a case where nothing turns on this difference. This would not be, say, when two critics are disputing which of the two reasons best captures a particular artwork. In yet other cases, should it become important to search for this level of specificity:, that will be for some distinctive 'good reason': that despite seeming to believe 'the same things', these people actually held different positions—as the fact that they might disagree illustrates. So my willingness to accept conclusions Stecker finds so counter-intuitive is a principled willingness, based in a recognition that differences in judgement can be reflected in differences in reasons; although, of course, saying more can sometimes show that there were not, after all, differences in reasons.

My view might seem to have "the unacceptable consequence that we could never find new and further grounds for a judgement already made" (Sharpe, 1994: 170–171). Further, we "could never overturn a judgement on the basis of newly discovered evidence" (Sharpe, 1994: 171). Yet this objection is nothing like as powerful as it might seem. Of course, the scope of "grounds" here is restricted: they are internally related to that artistic judgement. Since most genuine critical commentary on art was taken in that way, the qualification is small. Then, that a reason for a judgement was not mentioned does not preclude its being a genuine reason for that judgement. For the 'reasons' at issue are not necessarily ones you, as reasoner, can articulate for yourself—you may recognize them in others' articulation, noting, "Yes, that's what I wanted to say, and why". So the *recognition* of the reasons on which a judgement stood (say, through reading a critic) might be *mistaken* for the discovery of 'new grounds': one can 'discover' something to *say* that one could not say before.

Nor have we just assumed the unavailability of new evidence; for instance, further textual material, such other folios, quartos, or manuscripts. Rather, any critical judgement operates under a 'principle of total evidence', such that the evidence before us is all the relevant evidence.[9] And it operates defeasibly. When it can be shown that this condition does not hold—say, by producing another quarto—we shall be well on our way to defeating ascriptions of concepts or judgements based on the incomplete evidence. So is appeal to 'new evidence' really precluded? Given our contrast between the perspectives of philosopher and practitioner (Section 5.2 above), the critic may think (correctly from his perspective) that a view is being overturned when it is simply being superseded, just as a scientist correctly describes the theoretical judgements of previous scientists as wrong although philosophers regard the two positions as incommensurable. Thus, the practice of art critics does not count against my position.

On my view, when one has different reasons for an artistic judgement, one has a different judgement (even if made in the same words). But when is this? 'Criteria' for sameness of judgement or of reasons were not offered, since this may often be a matter for dispute and discussion.[10] Indeed, occasion-sensitivity suggests that we may sometimes need to enquire *why* the difference in the basis for someone's judgement from one's own was under investigation.

5.6 Are These *New* Properties?

Sometimes history simply needs to be written with hindsight. But are the *facts* there, to be written about? Consider my contention (McFee, 1980: 313–314) that the contemporaries of Bach and Handel could not see them as the culmination of the High Baroque: is this "just conflating grasping an artistic fact (or its graspability) with its being so?" (Levinson, 1990: 206). For the fact that:

> ... the concepts and categories were not possessed in 1750 for making this judgement does not entail that there was no such constellational fact coming into being. (Levinson, 1990: 206)

This was actually a simplifying assumption: that the concepts needed to justify the judgement of Bach and Handel were *not* available to their contemporaries—that possibly their contemporaries might find some other culmination of the High Baroque (McFee, 1980: 314a). Still, the criticism is clear:

> ... any new perspective that purports to be an interpretation of a work's meaning cannot introduce or impose that meaning but only disclose or evince it. Valid interpretations from a perspective show us what works mean, rather than making works mean what they previously didn't; they don't create meaning out of whole cloth. (Levinson, 1990: 208 note)

Obviously, no account can tolerate critics irresponsibly *reading-in* just any 'take' on an artwork (UD: 142–145). However, this is not easy to preclude; for where does reading-in or imposing start? As already mentioned (see Sections 2.5 and 4.9), the expression "plastic arm", in Mark Akenside's poem "The Pleasures of the

Imagination", could be *mis-read* in taking it to imply that the character had a petro-chemical prosthesis (McFee, 1980: 311a). Thus permissible readings can sometimes be distinguished from non-permissible ones. In some cases, like this one, the 'exclusion' is permanent. But this sort of example must not prove too much. It shows neither that all words have some fixed and immutable meaning, nor that all artistic properties are like (linguistic) meaning.

However, could the 'fact' of the place of Bach and Handel in the High Baroque be seen as "coming into being" (Levinson, 1990: 206 quoted earlier)? Levinson is right that it *is* a fact that Bach and Handel were the culmination of the High Baroque. And I could deploy (some of) the concepts needed to argue for that claim. But if, as in my example, those concepts were not available to the contemporaries of Bach and Handel, then equally those arguments were not available to them. Indeed, that way of hearing the works of Bach and Handel was not available to them, since the concepts were not. It would rely (presumably) on some response-reliant features of works by Bach and Handel, but ones not (then) available to human response! Then if it were a *fact* (at that time) that Bach and Handel were the culmination of the High Baroque, it would be a 'fact' that no-one could know or state (even in principle). Only confusing the practitioner's perspective with the philosopher's (see Section 5.2 above) makes us *now* think that, since it is true *now*, it must have been true then.

This form of argument does not urge (as Levinson seems to think) that, because Bach and Handel could not *say* they were the culmination of the High Baroque, then it follows that they were not. I would not claim that it must be *Bach and Handel*. Moreover, the business of "saying" is misleading: the issue is not whether those words could be uttered, but whether they would be understandable if uttered. That is what I deny (at least as the case up is set up). Indeed, judgements about the culmination of the High Baroque are (typically) the province of theoretically-inclined critics. This question refers to facts about *art*—that is, to the man-made and man-appreciated—and hence not to parallel questions about, say, the existence of the planet Neptune.

Further, denying this claim about Bach and Handel involves taking a certain view of the development of eighteenth-century music (among other things): as Sharpe (1994: 171) remarks, "a failure to consent to this judgement would show a failure to understand the nature of eighteenth-century music". Here, determinations of the truth can only be 'written with hindsight'. Further, present-day critics taking such a view would be right—unless a different view of eighteenth-century music (and other things) were also taken. Hence the understandings of the works from this period that such critics presented through their criticism would, and should, reflect that fact. Moreover, critics today will think (correctly) that, in the situation imagined above, these contemporaries of Bach and Handel were *wrong*. However, as philosophers (as we have seen: Section 5.2 above), we can acknowledge a clear sense in which they were not exactly *mistaken*: that is, they didn't fail to notice, or to check, or to consider. When we learn from today's critics, our understandings of the works in question would, and should, also embody our best view of music of that period. In this light, the proffered judgement of Bach and Handel bears on how artworks should be understood, and is properly (part of) a remark about an artwork itself: hence about its meaning.

This discussion emphasizes, of course, the close connection between my view of art and my view of meaning and understanding. To dispute it, Stecker (2003: 151–152 note) claims that my view mistakenly contrasts swans and dinosaurs—that, on my view:

> We had the concept of a black swan prior to their discovery, so the applicability of the concept predates the discovery. We did not have the concept of a dinosaur prior to the discovery of dinosaurs, so . . . the applicability of the concept begins with the discovery.

Since (for Stecker, 2003: 151 note) these cases do not, in fact, differ, my view is problematic in making "essentially similar cases radically different". But, contrary to Stecker's assertion, these cases are different in kind. Imagine:

(a) although I know swans are real, I think your discussion of a black swan is a piece of fiction ("How could there be such a thing?"), although one with its roots in fact (perhaps I am even willing to grant that our white swans might occasionally have dark offspring). Here, the concepts are clear, and I am mistaken.

(b) I know there are no centaurs, so I take your discussion of them to be pure fiction. We agree on the concepts, and I am correct.

(c) I regard your talk of large saurians that walked the earth in the same way as talk of centaurs. And it is not as though the precise details of centaur-hood were clarified there. Stecker, though, encourages us to see this case as like the first. But that grants our knowledge of what dinosaurs *are*.

In the third case, if I am a child, and you know about dinosaurs, I am mistaken. But if we are both in the dark about paleontology (it is before the discovery of dinosaurs) that is not so. When, later, the first bones are found and you claim that *these* were what you were talking about, why should we believe you? How can we take your reference as to *these* creatures exactly? In some early films, cinematically enlarged monitor lizards, with 'costumes' of dorsal sails and the like, played the role of dinosaurs. These are clearly not dinosaurs (nor representations of dinosaurs), despite the film-makers best intentions. But why are they ruled-out as the objects of your earlier comments? Indeed, how can they be, until the concept *dinosaur* acquires a more specific content? (Now, if you had reasons to believe in the creatures. . . but then, of course, you would have already introduced the concepts.) So, while there may be no absolute divide here, the cases are far less alike than Stecker credits.

Were there *obviously* dinosaurs before the discovery of the first bones (and the introduction of the concept)? Or is it *obviously* true that "dinosaurs were dinosaurs in prehistoric times" (Stecker, 2003: 144)? In one way, this is right—the right thing for us, now, to say. But that is simply the practitioners' stance on this issue, as opposed to the philosophers'. Indeed, if TV shows are to be believed, some paleontologists dispute whether to 'lump' together all the large saurians as *dinosaurs*, or whether to regard some differently, in contrast to *true dinosaurs* (as Dummett [1978: 429] discussed, in respect of the terms "acid", "gold"). If paleontologists settled on, say, two kinds of reptilians here, how would this bear on the concept *dinosaur*? On one version, some giant saurians have then been *mistaken* for dinosaurs for a long while: that is, the term "dinosaur" might be reserved for only some of what

are presently called *dinosaurs* (There were later occurring; although, of course, this might instead be done for either class of what had, previously, been *thought* dinosaurs). Equally, the term "dinosaur" might be kept for *all* these saurians, inventing two new terms. But now the resolution bears on whether there were *dinosaurs* at a certain point in prehistory: on one version, there were not (but only a different saurian) while, on the other, there were (although of a certain type). Without knowing in which of these two 'worlds' we will find ourselves, we cannot answer briefly the question, "Were there dinosaurs at such-and-such a time in prehistory?". And deciding between these worlds is re-writing paleontology. If we can answer that question *now*, it is because we have the concepts *now*.

Again, the comparison with dinosaurs makes the thesis of the historical character *of art* seem especially powerful, by linking to conceptual innovation of the kinds typical of *art*: the concepts there *come into being* in ways that might be doubted for, say, animals. For a connection here is to human action, and to the history, traditions and institutions that surround it—as one might say, to an *artworld*.

5.7 Making Sense of the Past

A different objection (deployed by Sharpe, 1994) is that acknowledging the historical character of art cannot (consistently) *stop short* of granting the 'anything goes' of subjectivism: hence that forwards retroactivism generates a package of subjectivism and (destructive) relativism. Such a position, if correct, would deny the arts the importance that, with Sharpe, I take them to have.

This worry might derive from my connecting change of meaning with change of critical analysis, such that "ascriptions are only meaningful within a critical practice, and this changes over time. Hence meaning also changes" (Stecker, 2003: 151 note 23). Thus, my (supposed) view "relativizes the meaningful application of concepts to practices" (Stecker, 2003: 151 note 23): this might be thought a species of relativism.

The primary danger lies in permitting *any* 'interpretation' of a particular artwork equal weight with all others, as Sharpe rightly sees. Like him, I would reject that suggestion explicitly for, as Wölfflin noted (quoted earlier: see Section 5.1 above), not everything is possible at every time. The constraints here arise from practices of discussion, argument, and so on, which those who engage in discussion of these matters learn, and become masters of—all pretty harmless! For instance, given *hypothetical intentionalism* (see Section 4.1), discussion of a literary work here concerns what *could have been* meant by those words at that time, not what *was* meant—as though we postulate direct access to the thoughts of playwright or poet (other than through their words)! Then what is meant by the words in poems and plays "depends an the usage of the context of utterance, not the usage several centuries later" (Sharpe, 1994: 173)—a position sitting easily with the occasion-sensitivity of meaning. Managing such hypothetical intentionalism realistically will not always be straightforward. It implies that 'standards' of relevance, and so on,

might change. So that judgements here are not unconstrained, but are constrained roughly as legal matters are; through debate about what past cases imply—although, of course, that is the theorists' perspective: the practitioners will claim the change as improvement. Nor should we expect it *always* to offer an uncontentious result as to the boundaries of meaning for a particular work. Indeed, there is no reason to hope for, or to expect, a once-and-for-all answer. Even on so small a topic, critical difference seems more to be expected than its opposite. But each version generates a clear sense to the term "misreading".

Sharpe (1994: 172) urges that "[s]ecuring the meaning of a work of art is, in this respect, a form of securing the meaning of a historical document". Yet artworks differ crucially from other past artefacts: works of the art from the past are typically taken as, and treated as, artworks. They are not just historical artefacts, since our interest in them may be *artistic interest*; and that interest is answerable to the artwork's features. What is and what is not a feature of the artwork itself may well be debatable; but, once that debate concludes, the object of artistic interest is identified. For critical scrutiny concerns *the artwork itself* and not, for example, its impact on its audience or the society (insofar as such contrasts make sense): doing otherwise would be turning away from the work. So the understanding of artworks is closely tied-in with the nature of those works. Of course, "[t]here is a major difference between those responses to a work of art which are peculiar to me or even to my culture and those which are controlled by the meaning of the work, in so far as that is recoverable" (Sharpe, 1994: 172). For Sharpe, both seem suitable topics for a critic acting in the centre of his/her role. Yet any critical remark not "controlled by the meaning of the work" must either be reading something into that work, or supplementing it: neither of these is licensed by forward retroactivism.

5.8 *Oeuvre*, Action and Understanding

Might one have stopped at the mild historicism sketched above (see Section 5.2)? Well, the *artist's oeuvre* is one organizing interpretive category for artworks. At one time, Levinson (1990: 198 note) thought that "[w]hat the artist is saying ... in early work does not change when the later work emerges, it just becomes ... more clearly evident".[11] Even without the "probably"s, "possibly"s and "typically"s (which I have omitted) restored, surely an artist's later efforts can sometimes make us think differently of his/her early work, and rightly so: only once Rothko's later works had invented a particular concern with colour do we see that concern in his early works!

Suppose the artist had never produced those later works. Now, *ex hypothesi*, the early work would not be seen in that revised way. Will that miss something? Something lying forever 'buried' in those (as I shall keep calling them) early works? The temptation to answer "yes" has two sources: first, the case implies that a different 'take' on that early work is possible—then we see how it *could* present (say) that distinctive concern with colour. But now imagine the case 'from scratch'. Just looking at that early work, in context, gives no (particular) reason to think, or hope, that

it might be seen differently, nor reason to look for 'reading' of it other than that then made, beyond pious reflection on variety within criticism (The situation parallels that where sceptics ask us to consider *all* the possibilities that might upset some epistemological apple-cart: we need, instead, to consider all the *genuine* possibilities). Certainly, we have no basis for *this specific* new reading.

Second, it might seem that a perceptive critic could find this different 'reading' of the early work. But that is not our case. At the least, this new critic's judgement (in finding such-and-such in early Rothko) is explained in ways different from those other critics who talk in terms of the whole *oeuvre*. For explaining why he sees *that* in these works cannot, as later critics could, draw on the later works. So it is problematic to guarantee that the same judgement is being made by both 'earlier' and 'later' critics, in finding this particular concern with colour in those early works. That the same words are used is no guarantee (see Sections 2.3 and 2.4). Putting aside this possibility, together with that rejected above, what reason could one have for insisting on a 'buried' meaning? But rejecting the unavailable meaning here is conceding the forward-retroactivist point: this is *not* a case of recognizing what was already there in the work, such that it 'might' (in principle) have been recognized at the earlier time.

So what is the effect of considering of the *entire corpus* (which T. S. Eliot remarked would be a good title for a detective thriller)? Interestingly, Levinson (1996: 272) has changed his mind: in "a limited concession", he grants that "the position McFee favours has been embraced intraoeuvrally, if nowhere else". If the artist's later work can affect how his early work is rightly understood, then surely— without those later works—the revised understanding would be impossible: the meaning in question would be lost. But this is not *lost* in the sense in which the word "lost" implies, at the least, the possibility of finding: those 'meanings' *would* be forever unavailable. Rather, a correct interpretation of an artwork, given the way that the particular *oeuvre* actually developed, would not *be* correct had the artist, say, died before producing the later works. So a work's location within a particular artist's *oeuvre* can play a role in how the work is (appropriately) understood. Thus *later* events alter the meaning of a particular artwork. So this *seems* an example supporting the general plausibility of forward retroactivism.

Nevertheless, Levinson (1996: 272) urges that this *seeming* is an illusion: the rather special relationship between work and *oeuvre* cannot suggest any general forward retroactivist argument. For Levinson, the artist's *oeuvre* as a whole constitutes one *action* of the artist: we should ground our understanding of individual works (as part of his *oeuvre*) by seeing them as "part of a larger work in which the artist is engaged" (Levinson, 1996: 252). This discussion already grants some latitude in the idea of "same action", if one action can be constituted by, for instance, writing poems at wildly different times. As Levinson (1996: 245) summarizes his position, "the totality of an artist's pieces—the oeuvre—constitutes his or her *work*, and this work can ... be seen as ... *a single artistic act*". As a result, understanding later pieces in that *oeuvre* offers concepts (etc.) useful for the understanding of earlier works in that *oeuvre*. Indeed, these early works could not be appropriately

regarded except in the light of what that artist *went on* to do. And this can alter our (appropriate) understanding, because:

> ... it is possible to understand the items in an oeuvre ... to be the utterance of a single individual or mind ... [with] ... the meaning of early installments of such an enterprise ... only definitely assessable once all the installments were in. (Levinson, 1996: 245–246)

Thus, the principle Levinson concedes is that, where earlier and later works (W1 and W2) should be seen as *part of* the same action (as Levinson, 1996: 245 puts it), the understanding (the 'meaning') of W1 may be inflected by the existence (and understanding) of W2. This view is distinguished from *forward retroactivism* by its *principled* emphasis that W1 and W2 must be part of *the same action* before one can proceed in this way.[12]

Of course, *were* Levinson's principle generalisable, a wide variety of cases might be treated similarly: it would extend as far as the generalisability. So, for Levinson, later actions *of this artist* count towards our understanding of earlier 'works': the thought that later events might change the meaning of earlier works is my *forward retroactivism*, here *only* applied within an *oeuvre*. By his own lights, can Levinson stop there? Can he show that other interpretive categories such as *genre* or *school* (or indeed *category* in Walton's sense) should be treated differently?

5.9 Genre and Artistic Intention

Levinson (1996: 265) recognizes this as "an interesting challenge" to his position, suggesting other cases in which "we seem compelled to construe a work in terms of works, by other artists, which succeed it". It does so most sharply in respect of a work which is *pioneering* and hence:

> ... the genre or style category to which it belongs arguably does not fully exist until other works are subsequently created that serve to stake out the boundaries of the category involved. (Levinson, 1996: 265)

This seems to bring with it forward retroactivism. But Levinson (1996: 266) treats a particular, pioneering work as within the genre "*as it had been constituted up to that point*", rather as *within an incomplete* genre or category. Then the importance (for the understanding of artworks) of ascription to genre or category can be accepted *without* treating such acceptance as importing forward retroactivism.

Has Levinson thereby demonstrated that discussion of *oeuvre* amounts to treating (say) separate paintings as part of one 'work' or action? Or that factors parallel to those which (on his version) produce a "retroactive reconstrual" (Levinson, 1996: 250) of meaning in respect of *oeuvre* do not do so for *genre* or *category*? I urge that he has not.

First, what counts as *one* work of art? It can, for example, comprise a number of canvasses: the five canvasses which together make up Magritte's *The Eternal Evidence* (1930) are clearly (parts of) one artwork.[13] What about the canvasses in

Picasso's *Las Meninas* series (1957)? Are these a number of *separate* works of art, or parts of a single work? In reality, no definitive answer here is necessary: we *associate* works with one another for purposes of discussion, criticism and the like without asking whether they are ('really') parts of the same work or not. So how can Levinson make out his position? What would convince us absolutely that what *we* took for a series of artworks were in fact parts "of a larger artistic endeavour"? What considerations would *compel* us to treat the example in one way rather than the other?

Taken *generally*, any feature compelling here would, surely, also be a reason for treating, say, the second canvas as part of *the same artwork* as the first: that is, not merely elements of the same *oeuvre* but parts of the very same work. At least, we would treat them like Picasso's *Las Meninas* series—as a series! But *oeuvre*-ascription works differently. Indeed those film critics who emphasize the idea of *oeuvre* (for example, Sarris, 1968, 1973) would be scandalized at the suggestion that therefore their preferred directors had each made only *one* artwork in their (cinematic) lives. So we have *prima facie* cases in the direction opposite to Levinson's: these are standardly treated (for example in criticism) as separate, individual works. In the absence of compelling reasons to do otherwise, we should (continue to) treat them as separate artworks within an artist's *oeuvre*, at least in standard cases.

Has Levinson provided a basis for *differential* treatment of *oeuvre* and of *category* or *genre*? The importance of the idea of a *category of art* lies broadly in connecting *misperception* and *improper (category) construal*: that, say, a Cubist painting or a piece of atonal music will be mis-perceived if one does not *perceive* it (that is, experience it) as in that category. Now Levinson's answer to questions of category-ascription—in terms of the genre "*as it had been constituted up to that point*" (Levinson, 1996: 266)—is not compelling. There seems no reason (other than an *apriori* rejection of forward retroactivism) not to bring to bear that genre *as it has been constituted up to the time of my judgement*. Indeed, it will be difficult to imagine my failing to do so once we view this case in terms of the concepts which I *mobilize in my experience* (see Section 4.8). Of course, to employ inappropriate concepts will (typically) be to misperceive the work. But there is no reason to suppose that we can always specify *in the abstract* what are and what are not appropriate concepts; in particular, no reason to suppose that the concepts available to the artist at the time of creation must *always* be selected. Indeed, doing so would have important implications for the extent to which what we have subsequently learned—say, in psychology—can be attributed (as insight?) to artists. Yet this is regularly done in discussions of Shakespeare or Jane Austen.

Moreover, a pre-theoretical treatment of the topic of *critical relevance* of this sort would emphasize that no reason is definite here: what is and what is not *appropriate* is an art-critical matter—and hence may be expected to change. Further, appeal to currently-validated theory (for example, from psychology) is a traditional part of a critic's armoury. Perhaps neither course of action is warranted: but surely, taken together, they constitute a *prima facie* case in favour of the *forward retroactivist* reading of critical practice. For they pick-up the need for critics to actually *make* judgements: a certain amount of 'waiting on posterity' is justified—but only a

limited amount. If this were right, Levinson's *principle* (articulated earlier) should apply to any case where understanding an earlier work requires essential reference[14] to a later work (for example, in the idea of a 'precursor')—this precisely *is* forward retroactivism as I read it.

One vexed question here will be, "What counts as a later act *of the artist?*". Levinson (1996: 250–251) invites us to treat that artist's *oeuvre* as "one big action". Yet actions are internally related to intentions: for Levinson (1996: 188), there are two intentions 'in the offing'—semantic intentions and categorial intentions. Here, a different (overall) intention should mean that we confront a different *action*. Levinson's focus, in characterizing the relation of work to *oeuvre*, is on the semantic intentions[15]: that is, those we might readily ascribe to our artist, in saying what the artwork *meant*. By contrast, our attention will include the categorial intentions. For, were Levinson right about *oeuvre*, changes in *both* semantic and categorial intentions are relevant to meaning, and to meaning-change or modification; and that, with both semantic and categorial intentions *being* relevant, more than just *oeuvre*-judgements are affected.

As Levinson (1996: 188) puts it, the primary role of categorial intentions concerns how the work is to be *taken*:

> Categorial intentions involve the maker's framing and positioning of his project vis-à-vis his projected audience; they involve the maker's conception of what he has produced and what it is for . . .

Yet such framing bears not merely on the *classification* of the object before us, but on its appropriate *appreciation*: taking it as an artwork at all permits application to it of a *critical discourse* (at least in typical cases); relatedly, as the idea of *categories of art* stressed, seeing a work in such-and-such a category is seeing some features as standard, some contra-standard, and some variable, for works of that sort—we cannot easily prise its ontology from its appreciation.

Levinson (1996: 190) certainly recognizes that "categorial intentions are inherently part of art-making". Yet these are not the sorts of 'intention' over which the artist himself/herself exercises a direct control—say, by willing, choosing or the like. Indeed, this seems to be Levinson's point:

> . . . not all intentions relevant to the appreciation of a work of literature can be effectively located internal to the work or to its process of production. (Levinson, 1996: 190)

The upshot (for Levinson) must be intentions, first, *relevant* to appreciation of the literary work (with similar things said for other artforms) and, second, *not* located within those processes over which the artist has (direct) control. Still, these are intentions *embodied* in the artwork: as intentions, they are crucial to the act of art-making (as Levinson concedes). But these are just the sorts of features which bear on what *action* the artist performs in creating this particular artwork. Now, earlier, Levinson conceded that later works in an artist's *oeuvre* can alter how the earlier work is (appropriately) understood. Yet, in fact, this artist's *oeuvre* can always be affected by changes in his/her categorial intentions (in how such intentions are appropriately understood): further, such intentions are not entirely within the artist's gift, since

they reflect the state of the contemporary artworld and the narrative of art appropriate to that artform. Other changes in *category*, and hence in (relevant) categorial intention, can be brought about *other than* by the explicit planning of the artist, the meaning of the artwork changing with such categorial changes.

By way of counter-blast, Levinson claims that such a view (if accepted) would make us take *all* of a period as one object, since changes are to *category*, rather than specifically to work—but in fact the view only requires that the impact here be treated work-by-work: changes in categorial intention affect work **a** through *oeuvre* A, and work **b** through *oeuvre* B, etc.: each work is (typically) part of *some oeuvre* and each may be affected. So any work may be affected. But not *because* "part of a larger work" (Levinson, 1996: 252) or "larger act" (Levinson, 1996: 250). Instead, the role of categorial intentions in work-identity means that the restriction to *oeuvre* is unsupportable—thus Levinson's "concession" generates *forward retroactivism*.

When such a shift in understanding such-and-such a work has taken place and we consider our previous understanding of that work (the previous categorial intentions), what will we say? Our reply again contrasts the practitioner's perspective with the philosopher's. Our (contemporary) practitioners' perspective will take the *category* to be previously misunderstood. So that, asked about that category *after* the 'category-shift', we will (appropriately) say that, having misunderstood the category, we had misunderstood (to some degree) all the works embodying *categorial intentions* in respect of that category. Then, for any work in that category, the *oeuvre* of which it is a part is (subtly) transformed: hence, its meaning too is changed—that produces (at least) *backward retroactivism* (which Levinson [1990: 196] endorses). But this fact applies to works 'in place' prior to the reorientation of the category: that yields *forward retroactivism*.

Thus, Levinson has not supplied a reason to contrast the treatment of *oeuvre* with that of *genre* (or *category*). Since his account of *oeuvral* judgements is in line with forward retroactivism (as he concedes), similar accounts should apply more widely. Moreover, the connection of categorial intention to work-identity, and thence to the avoidance of misperception of artworks, offers a relatively independent reason so to do. The discussion of *oeuvre* shows *one* way in which this might be explained, for changes in *categorial* intention might apply outside (just) *oeuvres*, yet bring about changes in (relevant) understanding *similar to* (or the same as) those contributed within an artist's *oeuvre* by (Levinson-style) *semantic* intentions.

Can my key case ("precursor") and Levinson's specimen case ("pioneering") can be accommodated short of forward retroactivism? For instance, might a particular artwork indeed be pioneering—so that "pioneering" was true of the work—but not intrinsically so: that this was not true *of it* (in itself) but only in its relations to other works? (As it might be put, that *pioneering* was, at best, a *relational* property: Section 5.4 above.) This reply is not open to Levinson: first, properties positioning a work in its *oeuvre* will be genuine properties of that work. So, if they are not intrinsic, still they are *of the work* in the relevant sense—as Levinson's use of them in this discussion illustrates. Second, *this* version of what is intrinsic conflicts with our having adopted the *categories of art* idea: this too is relational in just the same way. So, since its *category* is a genuine property of an artwork, the realm of properties *of artworks* is granted to include some that are relational in that sense.

This example highlights an omission: not much has been said about what *are* the candidate properties (or meaning-facts). Indeed, I have drawn heavily on Levinson's account partly to not contest these matters here, by not contesting them *with him*. For no exhaustive specification of what could or could not *count* is possible, not least because the issue concerns what properties might have a bearing on how a work is appropriately understood—that is an art-critical matter. Clearly there are some truths about a particular work that are not relevant to the *meaning* of that work (not all truths are *critically relevant*: UD: 139).

Yet *one* consequence of putting the matter that way—stressing what bears on the relevant *categorial intention*—reveals that the factors here need not, themselves, be centrally art-related. General principles cannot be offered but, roughly, a category could be reshaped, at least, by changes *within* art (including those in art-theory); by changes in theory *outside* art, for example, by changes in psychological theory; and by changes in historical circumstance. These can be diagnoses of what is lacking in some critical judgement: "She has misperceived the work by locating it in the wrong category"—and therefore needs more insight into art; "He is appealing to a mistaken account of personal understanding, or of the sensuous"—and therefore needs to consider modern psychology; "His view still takes such-and-such as the norm of women's behaviour". *Oeuvral* changes exemplify the first: the second might come about with, say, a psychoanalytic 'reading' of a certain artwork—here, while critics claim that the theory makes the work clearer, aestheticians should recognize this as identifying a new *meaning-fact* (following Levinson). The third case might invoke the inflection from fictional to real—an earlier example: that Nixon's later Watergate scandal gave a new nuance to the remark, in Woody Allen's film *Sleeper*, that he was a President of the USA who had done something *terrible* (supposing the chronology to put the film before the events). There is no logical bar to such changes in meaning for artworks, or to our understanding how they might come about.

5.10 An Argument Against Any Historicism

In attempting preclude any kind of 'retroactivism', Stecker (2003: 125) offers a dilemma for what he calls "historical constuctivism", and we have termed "mild historicism" or "backwards retroactivism": the dilemma asks whether or not "interpretations [of artworks] make statements that are truth valued (true or false)" (Stecker, 2003: 126[16]). Here is the first horn:

If they do, then, when they are true, their objects already have the properties attributed to them; while, if they are false, their objects do not have these properties and will not acquire them in virtue of such false ascription. (Stecker, 2003: 126)

On this view, such 'interpretations' (if truth ascriptions) cannot be involved in changes in their objects: that is, the artworks. Rather, they report the 'facts' about those works. The dilemma's second horn comes from denying that the 'interpretations' are truth-valued. Then they could be regarded, not as fact-stating, but rather on a parallel with "issuing a command, recommendation, or by imagining something"—again, these will not bring about changes in the object: rather, "[t]he

best I can do is to bring about a change in myself or another human being, by doing these things" (Stecker, 2003: 126).

Faced with critics at a later date offering accounts differing from earlier critics, Stecker (2003: 148) utilizes the first horn, writing of "[t]he *right* thing to say about such cases"—well, of course that is what a later critic *should* say (again, in line with Feyerabend's practitioner). Yet it will be hard to imagine some set of "properties the work always possessed" when *ex hypothesi* those properties could never be known or recognized by anyone (in the absence of the later event). Certainly, such a claim makes no sense applied to a property which is the product of human activity, as artistic properties must be. Recognizing such properties is surely granting the possibility of their recognition by humans—for meaning-related properties, this is the possibility of humans understanding them. Of course, given the later event, there might be some 'right thing to say'—and I would want to say it too, of course, because that is what a practitioner should say once the later event (say, the publication of the later poems) has taken place. Does this position relativize artistic concepts to human powers and capacities? But where else could they go? Clearly artworks do derive from human activities and interests; and, as we have seen (Section 4.6), artistic properties depend on beings with the capacities to recognize them. Perhaps, in the future, the powers and capacities of extra-terrestrials should be considered. But, even then, *art* must surely be available to humans. Still, a similar situation occurs, without *too* much modification, for colour-properties, about which I am a realist (as I am for artistic properties: see Section 5.11 below). So there is no *threatening* relativism here.

Here, Stecker's critique exposes the timeless conception of truth (and relatedly of meaning) which he assumes. This is visible in the form the dilemma argument takes—for that argument, both the interpretation's being truth valued and the value itself (true or false) is fixed: otherwise there could be no object *for interpretation*. But if there *is* one work, will it have properties (at least *core* properties) independently of how it is 'taken' by, say, critics? For Stecker, this core must be unchanging, and unchangeable, or the work would have no identity-conditions. Then, for these properties at least, the historicist (of any stripe) is wrong: and these core properties do not depend on the rest of the artist's *oeuvre*.

Our response makes two points. First, it is unclear what (if anything) is always *crucial* to numerical identity claims for artworks—although we are pretty clear that, say, chipping Michelangelo's *David* into small pieces destroys the artwork, even though one would still have the marble that composed it, and so on: similarly, a painting has properties not shared by the canvas-and-pigment that compose it (as redistributing that pigment typically shows). But this identity-formulation is unhelpful here, given no context for the issue; just as there seems little practical point in fussing about whether there is one word "bank" with two meanings—relating to money and to rivers—or two orthographically indistinguishable words. For any responses here will be occasion-sensitive: on different occasions, either reply may be appropriate. Moreover, changes in *core* properties are compatible with continuity, although the situation is complex just because the critic's (or practitioner's) perspective will treat such a case as having initially missed the work's meaning.

Second, Stecker's commitment to the determinacy of (artistic) properties is explicit here.[17] Without such an assumption of a finite totality of properties for artworks, talking in these ways about "*the* meaning of a work" makes no sense, even with the caveats Stecker (2003: 58) introduces.[18] On his view, a work lacking such determinacy would resemble the unbounded 'field' which Frege (1960: 159; see SRV: 67) urges is not *really* a field at all. Denying this is (he assumes) denying that the work might be individuated. But Stecker (2003: 64) had begun by urging, as an individuating feature of artworks, that "they are produced in a particular historical context". Scrutinizing the view that:

> [t]o the extent that contextual variables enter into the individuation of works, only interpretations that respect all of these variables are acceptable interpretations of works.

Stecker (2003: 65) comments:

> A lot depends on how we are to interpret the vague idea of respecting "contextual variables", that is, essential facts about the origin of a work.

So, for Stecker, a loose 'reading' here undermines the (necessary) individuative character of an artwork's properties. In fact, the difficulty is more fundamental: for no sense can be given to the "all" in the passage—there cannot be a finite totality of 'contextual variables' here, such that one might know that *all* were dealt with in such-and-such a case. Of course, finding one 'variable' not included in a particular interpretation shows that *all* are not dealt with. But then adding that one won't get us to *all*—or, indeed, move one *closer* to *all*, since the close/far metaphor is without substance.

5.11 Historical Character and Understanding—Some Realism

Aspects of our forward retroactivism are explained by referring to our cultivation of a *robust sense of constructivity* (Section 5.1 above) and yet others defended by drawing on our commitment to artistic properties and artistic values as *of the artwork*: that is, to artistic realism (see Section 4.9). But these might seem antithetical. Does the historical character of art, the central idea of this chapter, conflict either with our robust sense of constructivity or with our avowed realism about artistic properties? We cultivate that robust sense of constructivity by refusing to extend our claims about artistic meaning or value beyond the scope of (possible) human powers and capacities. This 'robust sense' operates as a *slogan* for us, directing our attention to properties amenable to (human) recognition. And this seems unproblematic for *art*—which is, after all, made by and for human 'consumption' in just this way.

It is less obvious that there is no conflict with our artistic realism: how can artistic properties be *genuine* properties of artworks if they are *mutable* in the ways articulated earlier? Surely what can be changed in these ways is just our *understanding*, rather than meaning. But recall—once again—the relation between artistic properties and values on the one hand and, on the other, human powers to recognize and

acknowledge such properties and values: for example, the response-reliant character of (some) artistic properties. For them (at least), acknowledging the reality of the property is acknowledging that the property could (in principle) be recognized by humans—and that is to reinforce the *robustly constructive* nature of our position. It connects the *facts of the* (artistic) *matter* to our powers (in principle) to grasp such facts. Yet we should not expect some particular property to be exceptionlessly ascribed in any particular utterance of an artistic judgement (see Section 2.5). At any particular time (and perhaps place), the properties of a particular artwork will turn on those an audience of *competent judges* (for art of that category) can recognize (And it will be *can* here since such an audience will, *ex hypothesi*, recognize all that is there to be recognized). When the understanding available to such an audience changes, as it might with the introduction of new concepts (see Section 5.3 above), the features of the work itself should be seen as changing: for these are *meaning-features*. So a change in them is a change in meaning, and vice versa. Yet such properties *can* change—as suggested—because the concepts that *must* be mobilized in their (artistic) perception can change (or be changed); and the properties themselves are intimately connected, in ways we have seen, to their *understandability*.

This does not make the properties of a particular artwork *arbitrary*: for, at any time, we (or, anyway, art critics) can *argue* about what are, and what are not, the properties of a particular artwork, disputing how our idealized audience *can* appropriately 'read' the artwork—and recognizing that there may be more than one plausible way. Nor does the position make those properties of artworks *subjective*: they can be seen by other members of that audience, and disputed (at least within that audience). So the various views (or 'readings') offered of a particular artwork are not untrammeled. Rather, they are amenable to debate among the knowledgeable; and hence to (possible) resolution. And the terms of the debate are set, roughly, by contemporary art criticism (in the relevant genre, and so on). This picture—which again gives due weight to the *logical* role of *competent judges*—suggests an institutionalism about art, to be explored (and exploited) in the next chapter.

Notes

1. The word "historicity" is used in a bewildering variety of ways. Hence I prefer to speak of art having an historical character.
2. The example, from McFee (1980), was actually supplied by a journal's reader.
3. Thus Kuhn (2000: 189):

 In applying the term "incommensurability" to theories, I'd intended only to insist that there was no common language within which both could be fully expressed and which could therefore be used in a point-by-point comparison between them.

4. Levinson (1990: 199–200) is explicitly critical of this example; but eminent critics 'read' the Velasquez as though the Picasso work(s) influence how the Velasquez should be understood.

Now, such critics may have made methodological mistakes but, as I describe it, their practice conforms to my theory: its purpose here is as such an example.

5. Of course, one's respondent might be browbeaten into silence: see Cavell (1969: 92).

6. See Stecker (2003: 151 note 23); Sharpe (1994). My special thanks to Bob Stecker for sending drafts versions of some of the material discussed here (to which I replied by e-mail).

7. Both Levinson and Stecker draw on Tolhurst (1979) here [see note 15 below]. My more radical 'utterance' account of meaning here permits me to deny the 'speakers meaning' view—all meaning has a contextual element (see Sections 2.3, 2.4, 2.5 and 2.6).

8. Having raised a similar objection, Sharpe (in correspondence) accepted that to separate judgement from reasons, in the way he once urged, was a mistake (especially in aesthetics).

9. This is, of course, a standard assumption in evidential investigation: compare Carnap (1950: 211–212).

10. An attempted formalisation here must recognize the "paradox of precisification" (Gordon Baker "The Logic of Vagueness" unpublished DPhil thesis, University of Oxford, 1970 [cited as LoV]: 293), recognizing "the trivial sense that indefinite 'precisification' is possible by transforming one language into another". Thus "no vagueness is ineliminable within a given language, any vagueness can be eliminated by a change to another system" (LoV: 295). As a result, "any putative improvement is merely a change to a new language incomparable with the original one" (LoV: 296). At the least, there cannot be direct comparison here in terms of greater exactness or accuracy (see PI §71). This is better understood occasion-sensitively.

11. In McFee (2005b), I discussed another case, urging Levinson's *determination* to avoid the forward retroactivist solution: he prefers, to one even *suggestive* of forward retroactivism, a solution where the same piece of celluloid amounts to two different artworks!

12. What (in general) counts as *the same action* is often both contentious and resolved in ways forward retroactivism would approve: we do not know what he was *really* doing—as opposed, say, to what he was *trying* to do—until we know what happened later (for example, he was aiming to assassinate the President and thereby to achieve détente. But it turns out that this was a blow to détente: so his action wasn't ...) As a result, whether his doing is part of the same action as some other doing is often contentious: were two people *both* acting to aid détente when both were seeking to kill the President?

13. See Ades (1978: 214 [exhibition catalogue]).

14. The term "essential" is crucial—the criterial (not symptomatic: PI §354) is fundamental.

15. Levinson (1996: 188) explains these by the appropriation of some ideas from Tolhurst (1979) on *utterance* meaning, as "the author's intention to mean something in or by a text ...". [Stecker, 2003: 59: for literary art, "the meaning of a work ... is identical to its utterance meaning".]

16. NB a version of Wollheim's dilemma: see Section 6.6.

17. Also contrast his comments on *disambiguation* (Stecker, 2003: 49 and note) with Section 2.3.

18. And despite his protestations to the contrary (Stecker, 2003: 56): his procedures assume that any interpretative remark (once appropriately framed) has a determinate truth-value, independent of whether it is uttered.

Chapter 6
The Republic of Art: A Plausible Institutional Account of Art?

6.1 The Idea of an Institutional Concept

The artistic/aesthetic contrast offers clear demarcation of artworks (as intentional, meaning-bearing, history-involving) from natural objects—resulting from causal forces only. But any plausible account of art draws on the context or background of specific artmaking and art-understanding. It assumes a body of people interested in art, and also in practices which (while not themselves artmaking) bear on it—practices of *learning* artmaking, and practicing skills that might then be used in art-making, as well as concerns with displaying, restoring and discussing artworks. At least for performing arts, there is also training in performance: as we might say (UD: 104–105), in *art-instantiating*! Moreover, there are traditions of performance (McFee, 2003b: 137–140); and venues (of various sorts) for its presentation. So there is *institutionalism* of a weak kind here: a certain sort of context provides the background, minimally, for artmaking to occur. Further, artistic judgements typically draw on extant *categories*, having a 'life' independent of particular artists and performers.

However, the insight of institutionalism may be best located through recognizing that artistically-relevant properties of artworks reflect this human dimension: they are "fruits of human contrivance", in an evocative expression (Quinton, 1982: 98). Thus something fundamental (if smaller-scale than is sometimes hoped) can be learned by taking very seriously the contours of an *institutional account* of art, as playing a role in art-status. Hence, on some *occasions*, institutional answers will be revealing.

Appeal to *institutional concepts* has another place, already well-established within the philosophical literature, in moral philosophy. For instance, both Anscombe (1981: 24) and Searle (1969: 50–52) have urged that, say, *promising* is an institutional concept. Distinguishing my case from theirs highlights a key difference between genuinely institutional matters and (other) rule-governed ones—for instance, *language* (Baker and Hacker, 1984: 272–273 esp. note). For *language* is the province of all native speakers (give or take a few qualifications); and typified by Mr. or Ms. Everyone, the person on the Clapham omnibus (as we say in the UK). By contrast, institutional concepts in my sense require an *authoritative body*, although perhaps of an unstructured kind, that pronounces on institutional activities (see also

Section 6.7 below). For example, since language is simply rule-governed, the normativity of language is directly embodied in language-using behaviour: hence *all* such behaviour is potentially relevant. By contrast, the normativity of an established institutional concept (like *art*) requires that some, but not others, can pronounce on its normativity. The activity of this 'institution' marks out the concept as institutional. There is a close parallel with the concept *machine*; not every Tom, Dick or Harriette is competent to judge on matters mechanical.[1] So there is no community of native 'art-speakers' in this sense; or rather, there is—but they comprise what, following Terry Diffey (1991: 45–48; UD: 72–79), I call "the Republic of Art".

6.2 Sketch of an Institutional Account of Art

On any general characterization of institutionalism,[2] institutional concepts pick-out objects or practices themselves explained in terms of human behaviour or human decision, where the correctness (or otherwise) of the concepts' application is itself a matter of human decision: applied to our case, this connects art-making, art-understanding and social forces. So institutionalism about art amounts roughly to urging that something is art if the right people say it is, at least once a convincing story is told. And such a 'story' may just explain the object's being treated as art: say, exhibited in an art gallery.

Even at this rudimentary level of articulation, such a view clearly stands common-sense on its head. We assume works are exhibited *because* they are art, rather than that they are art because they are exhibited as such. But unless we postulate, say, real essences of some kind, which explain why those things which *are* exhibited would be art even were they not exhibited, or taken as art, it is hard to see any alternative to an account of art-status in terms of what persons see and regard as art: that is, broadly institutionally.

Of course, *that* a particular artwork is in the gallery or whatever is not irrelevant. That work is displayed precisely because people see it (or at least saw it) as art. A particular community, with the concepts, values, etc. of that community, made sense of this object as art: in particular, as art of a certain type, in a certain form, with a certain (non-monetary) value. To speak figuratively, it has proved itself on the pulses (or, if relics prove themselves on the pulses of antiquarians, proved itself on the artistic pulses).

What might be thought the worst outcomes for any account of art—hence the worst for any plausible institutional account? Two are of most importance:

- The case where 'wishing makes it so': where such-and-such is an artwork, or of artistic value, *just* because I say it is—where, for example, my wanting to be an artist is all there is to it.
- The case where work made in a society with no concept of art is taken as art—the case of the 'unintended artist': this case is disastrous because it breaks the tie between *wanting* or *trying* to make art (and hence being responsible if you succeed) and the resultant artworks.

Although institutional theories are supposed (by their critics) to have just these features, once these cases are recognized as constraints on *any* account of art, an institutional account might avoid them: and be rendered more plausible in the bargain!

So the basic thought of institutionalism (roughly, that something is art if the right people say it is) must be further complicated: the process of objects being or becoming art is best identified in two stages. In the first stage, "self-election", an object is put forward or offered as art. This permits the rejection (from art) of any objects which could not *possibly* be art—hence it allows ruling-out the 'unintended artist' above. The second stage, "other-acclamation", amounts (roughly) to that work being accepted by others; that is, by the Republic of Art. That group of 'others' will be fairly wide, including other artists, critics, performers (where relevant), gallery owners or theatre managers—as well as historians and philosophers of the arts. The need for other-acclamation deals with the pretensions of 'wishing makes it so'.

Thus the Republic of Dance (say) will be composed of choreographers, producers, dance theatre owners and so on; and, in particular, (other) dance-critics and dance-theorists. Any movement sequence put forward as dance (self-election) and accepted by others (other-acclamation by the Republic) is indeed an artwork: in this case, a dance. If it does not receive this 'other-acclamation', one may simply accept that the sequence is not (art-)dance after all, and let it sink into obscurity. Otherwise, two courses of action are open to those putting the work forward: they may wait for the judgement of posterity—assuming that they are right and waiting to be *proved* right, when later dance-theorists, dance-critics, etc., regard the work as art. That is, when the judgement of the Republic changes. As reflection on the history of the artform suggests, this is a doubtful path to success.

The other, more enlightened course of action attempts to *shape taste,* so that one's work is accepted as art, receiving the necessary other-acclamation. This public relations job can be undertaken for oneself, as T. S. Eliot's criticism did "throw light on [his] own verse" (Introduction to Eliot, 1993: 19), thereby creating the taste by which his poetry was admired. Thus, if Eliot formulated "a major theory of metaphysical poetry during his first decade as poet and critic in London" (Introduction to Eliot, 1993: 1), that theory should be given importance for understanding Eliot's poetry—as well, of course, as his critical writing. Suppose Eliot's critical writing of the time highlighted "three metaphysical moments—Dante in Florence in the thirteenth century; Donne in London in the seventeenth century; Laforgue in Paris in the nineteenth century" (Introduction to Eliot, 1993: 3). Then certainly "there was a fourth moment at hand—Eliot in London in the twentieth century" (Introduction to Eliot, 1993: 3).

Alternatively, others can be recruited to undertake that public relations task: Clive Bell created a climate of criticism appropriate for the appreciation of Cézanne. For dance, the reviews and articles of critic XXX in the *Journal des Debats* from 1828 to 1832 brought about changes in artistic values, and hence in how dance was thought about (Chapman, 1984). Other critics of the time emphasized the narrative, literal and dramatic elements of the ballet. In contrast, since XXX enjoyed the non-literal appeal of dance, his writing stressed the expressive quality of the dancing itself. His

sustained polemic for that view can explain the subsequent shift in critical interest from pantomime-type effects in ballet to a (pure) dance. Such a shift in taste resulted in the other-acclamation of works previously not seen as art. In such cases, the public relations exercise involved the *validation* of certain critical concepts: the vocabulary of criticism is changed in these events and, with it, the sorts of things which count as *reasons* for artistic judgement.

On this institutional picture, a 'decision' of the Republic of Art might downgrade an artist's work (as happens periodically with Sibelius) or simply eject it from the canon of artworks. Again, the Republic may admit (as art) works not previously seen that way, reflecting the re-shapings of taste achieved by Ruskin, Bell, etc. So *artistic value* and *art-status* are both in the Republic's gift. Consider a concrete example. In 1969, burglars who took the masterpieces by his friends from the walls of Lawrence Durrell's house left behind his own "daubings" (MacNiven, 1998: 567). Should one conclude that the burglars were, perhaps, art-critics or connoisseurs? Or did they simply take the *familiar* works (or works by *familiar* artists)? Our institutionalism explains why these might come to the same thing—why the familiar works are uncontentiously artworks: they are *known* to have received other-acclamation by the Republic of Painting. Yet that very familiarity explains the art-status of these works being uncontentious; hence, of the kind that might explain the art-status of other works: that is, function as our *temporary paradigms* for art-status. While that other-acclamation ensures the (non-monetary) value of these works, their established connection to the artworld explains their monetary worth in terms well-prepared burglars might have appreciated. Here sociological questions about what objects are valued (including economically) as *artworks* intersects with philosophical issues of the nature of art and artistic values. Still, our point is to recognize how the *force* of the institutional action is manifest in the relative valuings of these works. Then a further reason for insisting that the concept *art* is institutional (in the relevant sense) is that points such as these, concerning the practical workings of the concept, are thereby parts of the *philosophy* of art, not (merely) its sociology.[3]

6.3 A More Plausible (than Dickie's) Account of Art

How might this version of institutionalism for art be developed? Unfortunately, the prospects for an institutional account of art have become entangled with the fortunes of George Dickie's (putative) institutional definition of art. The literature on institutional accounts of art typically accepts the features of Dickie's version as identifying all (or anyway most) of what institutionalism about art requires. But institutionalism about art leaves indeterminate some features of the account of art[4]: Dickie's definition resolves some of those indeterminacies in a characteristic way. In a nutshell, my strategy draws on criticisms of Dickie's institutional definition, or areas where it might realistically be criticized, to sketch an institutional account of art more plausible than Dickie's—with a plausibility of its own, once we understand it aright. My critique concentrates on the version from *Art and the Aesthetic* (Dickie,

1974) as both simpler and more suitable for my purposes[5], although considering other versions (especially that from *The Art Circle*: Dickie, 1984).

There are (at least) three issues on which institutional theory as a whole is indeterminate:

- whether institutional theories or accounts offer a *definition* of art (Dickie's, below, does);
- whether they employ a classificatory/evaluative contrast (as Dickie's does);
- whether they are one-stage or two-stage theories.

Dickie (1974: 34) brings together his first account of art, as an attempt to define the term "art" in its "primary or classificatory sense", in the following way:

> A work of art in the classificatory sense is (1) an artifact (2) a set of the aspects of which has had conferred upon it the status of candidate for appreciation by some person or persons acting on behalf of a certain social institution (the artworld).

Two matters of drafting arise immediately. First, this definition says that the artefact has had "conferred upon it" the status of candidate for appreciation: the notion of *conferring* is misleading (as Dickie recognized later). For the theory can stress objects becoming art through institutional action without requiring specific acts of conferral, contrary to what some critics (for example, Beardsley, 1976; Hanfling, 1999: 190–191) seemed to suppose. So, although talk of 'conferring' *can be* useful, as a short-hand or for simplicity's sake, nothing crucial turns on this formulation.

Notice here a difference between models of (acknowledged) institutional action, such as the conferring of University degrees (one of Dickie's examples). In the UK, there is sometimes a specific act of conferral, with degrees conferred at the precise moment during a ceremony at which the University's Chancellor utters a certain formula. On the other, more prevalent version, degrees are awarded at a meeting of the Academic Board (the ceremony just displays the graduates). Since this committee enacts the institutional action, one cannot distinguish precisely when, during its meeting, Jane Smith acquired her BA. But the meeting *does it*: and this is genuine (as opposed to metaphorical) conferring. Hence many objections to institutionalism on the question of conferring are beside the point. The language of conferral is informative when, say, the conferring of degrees takes place at a particular time and place. Dropping that implication moves us forward here, for it is unusual for anyone, ever, to locate times and places when objects become transfigured into art. (Of all the topics discussed in relation to Dickie's account(s) of art, this has generated the most heat and the least light.)

A second 'drafting' feature relates to artefactuality: here Dickie too recognized his earlier view to be insufficiently sharp. But any discussion is rendered murky by difficulties in determining what is and what is not an artefact for these purposes. At the very least this is a topic for criticism or discussion: there, in general, Dickie's comments correctly identify the variety of cases for consideration. For the key thought is surely that artworks require authorship in this sense (see Section 4.1).

6.4 Topics for Criticism

So, how should *we* treat the institutional accounts of art's dimensions of inde-
terminacy, noted above? First, many objections to Dickie's account (summarized
Hanfling, 1992: 24–32; Davies, 1991: 109–114) turn on his insistence that he is
presenting necessary and sufficient conditions for art-hood. When his opponents
deny that these conditions are individually necessary and jointly sufficient, they
take themselves to be denying the applicability of institutional ideas. But do insti-
tutional accounts require definitions? This issue revolves around what precisely
the term "definition" means here. Assuming, as usual in philosophy, that a defi-
nition is a concise yet comprehensive characterization—that is, something logically
equivalent—our answer is "no"! Dickie (1974: 43–44) wished to insist on the neces-
sity within philosophy for the provision of definitions. Yet, at first blush, his account
seems obviously circular, explaining *art* in terms of properties of *the artworld*. In
response, Dickie (1984: 77) insisted that this definition, although circular, was not
viciously so, "because the circle it ran was large and contained a lot of information
about the art world".

Later, Dickie was no longer willing to concede that circularity *even of this sort*
is a topic for criticism, however mild. Now, "the circularity involved in the theory
is to be flaunted" (Dickie, 1984: 12). His point here is methodological: "[t]here is
a philosophical ideal which underlies the non-circular norm of definition" (Dickie,
1984: 77). Since, as Dickie accepts, such non-circular definitions are in principle
impossible (at least for non-technical terms of sufficient complexity to be interest-
ing), he regards his new definition as doing all that may reasonable be required. But
the natural home of the idea of *definition* is just those technical definitions where
non-circularity *is* a possibility, with which the 'definition' of art would normally be
contrasted.

One possible response would emphasize the usefulness of definitions, such that
any theory or account of art not offering a definition of art is inherently uninfor-
mative. But this misconceives both the power of definitions and the effectiveness of
explanations of a non-definitional kind. The apparent explanatory content of defini-
tions is largely illusory (see McFee, 2003a). The term in question (say, "art") must
be previously understood in order to decide whether or not the proposed definition
is in fact correct. Moreover, our understanding can be expanded greatly by offering
something less than a definition—by offering some 'helpful hints and reminders'.
If, therefore, institutional accounts do not *need* to offer a definition of art, our insti-
tutional account (in *not* offering one) becomes determinate on this question, but in
a way radically different from Dickie's avowed direction.

The second dimension concerns what the institutional 'action' achieves: it makes
the object *art*, but does it make the object valuable? Pre-theoretically (or pre-
philosophically), "yes" seems the right answer; that *at least* the object is an
artwork—that the object is regarded *as art* because of some merit seen in it, in
contrast to other objects. This seems a default condition here. But there can also be
bad art: yet how can that be, if art-status is minimally (positively) evaluative? This
question arises because Dickie (1974: 34) insists that his account refers to art "in the

classificatory sense", distinguishing the classificatory from the evaluative. Dickie's recent strategy to show that "art" could not be *defined* in an evaluative way involves raising obvious counterexamples based around *bad art*. Nor can "work-of-art" (as evaluative) be contrasted with "work-of-art-falsely-so-called" (non-evaluative), since they pretty much shared a definition of "work of art" (see Dickie, 2000a, b). For Dickie, the success of *this* strategy presupposes the appropriateness of his search for definitions of *art*. But since that search is both pointless (one cannot be found) and futile (philosophy cannot need one), there is no argument left here.

Views opposing Dickie's might seem to treat *art* as evaluative *rather than* descriptive. But theorists disagreeing with Dickie *should* contend that the whole distinction is misconceived: that the terms "evaluative" and "descriptive" refer to large realms within thought and experience, which may significantly overlap. In the moral case, for example, an increasingly traditional view is that concepts such as *murder* are not quite what Dickie calls "classificatory" (descriptive), nor what he calls "evaluative". Rather, its location within a certain set of social practices mean that the description "murder" brings with it certain moral evaluations: that murder (rather than, say manslaughter) has taken place. Without broaching these vexed questions, notice that, at the least, Dickie's view offers only one possible elaboration vis-à-vis 'classificatory or evaluative?'.

The idea of art-status as minimally evaluative may strike many, as it strikes Dickie, as counter-intuitive. "How can we think about the *good* in art," they ask, "before we know whether such-and-such *is* art?". That is, they expect to specify independently what counts as an instance, and then (here) invoke standards of valuation. They therefore see classification as logically prior to evaluation. But connecting classification and evaluation becomes more intuitively plausible when one recognizes that *good art* is actually logically prior to art. For exposition begins from cases of *acknowledged* art, and then asks whether other objects are art, even though they are not *as* worthwhile as those from which one started—just as thinking about reasoning begins from cases of sound reasoning: the rest counts as reasoning (when it does) only to the degree that it approximates sound reasoning (Grice, 2001: 35). Then a consistent account which did not takes Dickie's line would be preferable to one that did: Dickie must shoulder the burden of proof.

How should we proceed? We seem drawn to two apparently contradictory ideas: that calling something "art" is, at least in some minimal sense, commending it; *and* that an object can be an artwork without necessarily being worthy of appreciation. Aestheticians at least should grant the first of these (apparently) contradictory intuitions: that "works of art are per se valuable" (Wieand, 1981: 332). Nevertheless, on *some* occasions, the mere fact of **X** being a work of art does not guarantee it any artistic value. Many artworks are, in Wieand's phrase, "routine, forgettable, dispensable" (Wieand, 1981: 330). And some works of art are simply bad: my choice here would be sentimental paintings, for example by Holman Hunt, but readers can supply their own. The expression "bad work of art" is not self-contradictory—yet it ought to be, if *all* art works are worthy of appreciation. That is the second intuition. Moreover, it is enshrined in the 'charter' of some art galleries. For example, the Tate Modern in London is required to buy works *representative* of periods of history: in

effect, a command to buy art without regard to its (artistic) value, suggesting that some works might lack it.

This 'contradiction' comes about because, once art's value lies in its *nature*, elaborating the connection between art-status and (artistic) value seems to require reference to some kind of *necessity* (a view some philosophy encourages). But, as counter-cases show, this connection cannot be of a once-and-for-all, 'always' or 'never' kind: in short, it cannot be entailment. Even one work which, although art, is not (or no longer) worthy of appreciation, in reality or in imagination, proves that there is no entailment between art-status and artistic value. Yet, for one tradition in philosophy, *only* connections of that exceptionless kind are genuinely 'necessary' or 'logical' connections. Then Wieand (1981: 332) puts the point clearly: "The logical point then is this: 'X is a work of art' does not imply 'X is worthy of appreciation'". So, were entailment the basic *logical* relation, art-status could not be logically or necessarily connected with artistic value.

In spite of this absence of any implication, "given that X is a work of art it is *rational* to believe that it is worthy of appreciation" (Wieand, 1981: 332: my italics). Then a weaker relation, stopping short of entailment, might explain the rationality of moving from art-status to artistic value. Here Wieand (1981: 31) offers "the Appreciation Maxim" (AM): "Put forward something as a work of art only if you believe that it is worthy of appreciation and does not waste the time and effort of its audience". On his view, this maxim is central to art-making and, once understood, to art appreciation. That it is appropriate, in the first instance, for artists is obvious; but it also works for critics. For if my column of art-criticism discusses, say, so-and-so's action of electrocuting fish *as* an artwork, I am effectively putting it forward as art. So the Appreciation Maxim (AM) has purchase on my practice.

But suppose the AM were integral to the functioning of the Republic of Art, without being *logically* related to an object's art-status: could the Republic then fulfill its assigned task? Surely that task involves answering questions such as "Why is X art?"; that is to say, it describes the *logic* of an object's being art, or what *makes* it art, or the *nature* of art. Expressions of that sort seem better suited to characterize logical or internal relations than mere implicatures (compare Grice, 1989: 26–31). So treating the AM simply as a *maxim* will not explain the evaluative force of art within the Republic, since it cannot bear on the *nature* of art.

Suppose something like AM instantiated an internal relation, if a defeasible one, modelled on legal *contract* (see Section 2.2). A defeasible connection, although *not* an entailment, represents an almost universal generalization. But it is not simply a kind of inductive confirmation, which merely makes outcomes *probable*. Rather, when A and B are defeasibly connected, and there is no defeat, A guarantees B with certainty. On such a picture, an object's being an artwork does not entail its being worthy of appreciation; but there is nonetheless a strong inference from "X is a work of art" to "X is worthy of appreciation". One might describe this by saying that defeasible connections are *weaker than* entailment; but this suggests (falsely) that they might be strengthened. Rather, these connections are *of a different sort*. Moreover, defeasibility places the onus of proof on those wishing to dispute the claim that there is such a connection (given the satisfaction of the initial conditions).

If X is a work of art then it *will* be worthy of appreciation just in all cases except those where some recognized head of exception is brought to bear *in this specific case* (thus without importing general scepticism). Seeing the AM as a feature of a defeasible connection to an object's being an artwork revises it, until it is no longer a maxim. Still, I shall speak of "the AM (revised version)".

The AM (revised version) fits neatly into an institutional account of art. Artists might be modelled as operating *directly* under its 'influence' (that is, putting forward only those objects they considered worthy of appreciation and not time-wasting); indeed this just *was* putting one's work forward as art. Further, such a 'maxim' might structure the experience of the audience. Suppose the work was:

- made under the revised AM (unless some head of exception is raised);
- accepted by the Republic under that revised AM (with the same proviso); and
- with this fact now internal to the concept "art".

Now it would make perfectly good sense for the audience to connect art-status and artistic value—as indeed they do in practice! But the connection would not be exceptionless. Thus the perplexing relationship between the 'evaluative' matter of artistic value and the 'descriptive' matter of art-status is resolved once-and-for-all, in a neat and powerful way.

The third dimension in which institutional theories are indeterminate concerns the workings of the institutions: do they operate in one stage or two? Just one stage may be sufficient: that the work is put forward in a certain way—other-acclamation may not be necessary. Or *only* other-acclamation might be required for art-status. On my reading of his 1974 text, Dickie is not very specific on this topic, although is remarks about "acting on behalf of ... the artworld" (Dickie, 1974: 34) might suggest an emphasis on (at least) other-acclamation. But his later work is quite explicit: "I certainly did not intend to claim that artworld acceptance is required for making art" (Dickie, 1984: 9). This is surely peculiar. For institutional theories, objects are art as a result of institutional action—and not merely on the part of self-styled artists, but rather of accredited artists: this seems the force of Dickie's requirement that artists participate "with understanding" (Dickie, 1984: 80). To reinforce this point, simply consider any object which one views as self-indulgence rather than art: efforts to electrocute fish (say), or Kurt Schwitter's spittle, perhaps cannot be art—whatever the artist's commitments. At the least, the artist's say-so alone cannot be sufficient. Therefore, as above (Section 6.2), a two-stage theory was required: in the self-election stage, an artist puts forward his work as art; then, in the other-acclamation stage, the work is or is not accepted by the institution.

This model of a two-stage process is not simply abstract or theoretical, but closely approximates some actual practice. For example, faced with a blank response from the Republic of Art to a self-elective offering of her work, an artist might, of course, grant that the work was not art; or she might (perhaps unprofitably) await the verdict of posterity. But, most likely, she would engage in public relations efforts on behalf of her work (either personally or through some agent). This is what the theoretical model predicts; and (as above) just such activity recognizably takes place in the real

world of art—Ruskin creates the taste which leads to general acceptance of Turner's work; or Clive Bell (and Roger Fry) create the taste which leads to widespread appreciation of Cézannes's paintings; or the critical work of T. S. Eliot forges the taste by which his own poems are accepted.

My prospective account has been contrasted with Dickie's in three dimensions within which institutional theories are essentially indeterminate, suggesting why his answers are neither compulsory nor compelling. On each occasion, the alternative direction is at least as plausible as the one Dickie takes. So standard objections to Dickie provide, indirectly, support for my position: if Dickie is wrong, an account not so different from mine must have appeal on any occasions where a broadly institutional approach is attractive.

6.5 Does Dickie's Later Theory Fare Better?

Dickie (2000b: 108 note 14) claims that "the best single account of the institutional theory of art" is the "revised version" (Dickie, 1984: 7) from *The Art Circle*. Yet the fundamental indeterminacies of institutional accounts are clarified there in roughly the same way as previously. For instance, Dickie (1984: 80–82) still deploys definitions, although now a sequence of five linked ones:

(I) An artist is a person who participates with understanding in the making of art.

(II) A work of art is an artefact of a kind created to be presented to an artworld public.

(III) A public is a set of persons the members of which are prepared in some degree to understand an object which is presented to them.

(IV) The artworld is the totality of all artworld systems.

(V) An artworld system is a framework for the presentation of a work of art by an artist to an artworld public.

But he comments on the idea of a definition: "I never intended or pretended to give a real (noncircular) definition" (Dickie, 2000b: 103). Instead, the key terms ("artist", "work of art", "public", "artworld", "artworld system") from the sequence of definitions "are not technical notions generated by theory and in need of theoretical explanation" (Dickie, 2000b: 101). Yet what is the *force* of offering a definition unless it avoids circularities?

Moreover, the classificatory understanding of art still has primacy, offering "a basic, non-evaluative sense of the expression . . . a value-neutral sense of art" (Dickie, 2000b: 97). The reason for this insistence remains the same: Dickie cannot see how anything else would permit the possibility of bad works of art. And *bad art* is taken for granted. Similarly, the theory operates in one-stage. For Dickie (2000b: 96), "[t]here is absolutely no element in any of these five definitions that gives the slightest impression that anyone other than artists . . . create art". Certainly the artist makes the artefact or object (at least in typical cases), but under what conditions is it an *artwork*? To require the artist just *intend* that it is would scarcely

be institutional: on such an account can 'wishing make it so'? Nor can the artist give the work features appropriate to being an artwork: again, this suggests just the kind of "exhibited characteristics" of which Dickie (2000b: 103) expressly disapproves.

What is the precise role of the institution? Much here turns on the artefact being "created to be presented". Can "an artworld public, . . . prepared . . . to understand an object which is presented to them", fail to see it as the kind of thing that is "created to be presented" to such a public? As Dickie (2000b: 99) comments, this new account "leaves open the possibility that artworks can be created that are *never* presented to anyone". Then the object is merely of the *kind* that *might* be presented to such a public. Both qualifications weaken the theory. How am I, as an artist, to know whether my artefact is of the kind that might be presented, unless I begin from real cases of actually *being* presented to such a public? That, after all, might be required in order that I count as an artist!

Now consider the artworld public. Dickie (2000b: 100) recognizes a "basketball public" which knows the rules (roughly), can recognize basketball, perhaps understand leagues, and certainly has a grasp on basketball fandom. But, seen another way, there is nothing to understand, since basketball is not *understandable* in the sense of meaning-bearing. By contrast, a public concerned with poetry would need *more* than that concerned with basketball, in precisely this dimension. Of course, like the basketball public, the poetry public is aware of the external features of poetry—its publication in small magazines as well as books, its readings public and semi-public, its prizes perhaps. But such a public must also understand *poetry*. And here there is something to understand (since, say, more than an understanding of French is required to make sense of French poetry). That means treating one set of verbal inscriptions (poems) as importantly different from another (say, lists) on the basis of that understanding. And Dickie offers no convincing strategy here. In any case, the earlier critique is still in place. Thus, nothing in this later theory requires us to modify our account of the Republic of Art.

6.6 Wollheim's Criticism

While discussing institutional *definitions* of art, Wollheim (1980: 157–166; also Wollheim, 1987: 13–16) produces an elegant argument, by dilemma, to show that institutional accounts of art are impossible. Institutionalism traditionally involves art-status being *conferred* on the object by some group of people "whose roles are social facts" (Wollheim, 1980: 157), where such "conferring" *is* (or at least *models*) the institutional action—even though (as above: Section 6.3) the term "conferring" puts it badly! Wollheim's dilemma (if successful) strikes at the heart of institutional accounts, squarely undercutting such a model. The argument is simple. Wollheim (1980: 160) asks:

> Is it to be presumed that those who confer status on some artifact do so for good reasons, or is there no such presumption? Might they have no reason, or bad reasons, and yet their action be efficacious given they themselves have the right status—that is, they represent the art world?

This question generates an apparent dilemma for any institutional account. As the first horn, if the 'conferrers' have good reasons for taking the work to be art—reasons, that is, which antedate the object's acquiring art-status—they only *confirm* by their action that the object enjoys art-status prior to that action. Hence something other than their action makes the object art. As Wollheim notes, this argument has little bite if the reasons are to be reasons for *conferring* status on the work as art rather than reasons for taking it to be art. As he says, "good reasons for marrying two people are not good reasons for thinking them married" (Wollheim, 1980: 161). Yet there is a deep plausibility in arguing that a reason for *making* an artefact a work of art is better construed as a reason for *its being* a work of art. To take this option would be, Wollheim thinks, to acknowledge that artworks are not, after all, *institutional objects,* for their art-status antedates their 'conferring'.

The other horn of the dilemma comes from denying that any reason is required: all that is required is that the 'conferrers' have the appropriate status. This reply violates "two powerful intuitions that we have" (Wollheim, 1980: 163): first, that there is an interesting connection between being a work of art and being a *good* work of art and, second, that there is something *important to* the status of being a work of art. Aestheticians must surely acknowledge both of these. Really, they come to the same thing in this context: that art-status minimally implies a commendation and categorially allows for commendation. But if art-status can be conferred for no good reasons "the importance of that status is placed in serious doubt" (Wollheim, 1980: 164). For what can be conferred for no good reason cannot be of any great importance; yet we do not doubt the importance of art-status—that such-and-such is an artwork typically grants it some value. So choosing the first horn of this dilemma endangers the account's claim to be *institutional;* choosing the second endangers its relation to *art*, at least as traditionally understood, by making the *value* of art-status arbitrary.

If foisted on any institutional account of art, this dilemma will succeed in making that account at least very implausible. And while institutionalism may need to grasp some nettles of implausibility, too many destroy the account. Here, I urge that a member of the Republic of Art conferring status—or, better, taking an object to be an artwork—both allows that nothing other than his/her so taking it makes it a work of art (apart from others in the Republic so taking it, thus accepting the claim) *and* that he/she can still offer reasons, give explanations etc., in justification of that work's art-status. In short, what I have called the *story* is related to the conferring. For the two intuitions Wollheim mentions in developing the second horn of his dilemma are not violated if one can speak at length, giving reasons and such like (as critics are wont to do), about works which are art for no prior reason than one's institutional action.

At first blush, this option seems impossible, for surely any reasons or explanations offered could support the art-status of the work *prior* to the institutional action, in line with Wollheim's conclusion. But the transfigurative nature of art-status provides a crucial categorial difference, as we argued (following Danto:

see Section 1.1): that the object is an artwork *brings with it* sets of reasons or explanations otherwise unavailable. Hence a neck-tie 'decorated' with blue paint by a child differs from an indistinguishable tie painted by Picasso (Danto, 1981: 40). Given the categorial difference, the reasons employed in interpreting Picasso's blue tie (say, in respect of its absence of visible brushstrokes) are simply not available as comment on the child's effort. So that an artefact's being an artwork *creates* many ways of explaining this object's value, and hence the importance of its art-status. Thus institutional action with respect to some particular works not merely confers art-status on those works but also creates *categories of art*, bringing with them a 'universe' of discourse.

For instance, someone puzzled by one of Rothko's *Four Seasons* canvases might find, in the following brief remarks, a way of making sense of that painting:

> The greatness of Rothko's painting lies ultimately . . . in its expressive quality, and if one wanted to characterize this quality—it would be crude characterization—we would talk of a form of suffering and of sorrow, and somehow barely or fragilely contained. We would talk perhaps of sentiment akin to that expressed in Shakespeare's *The Tempest*—I don't mean, expressed in any one character, but in the play itself (Wollheim, 1973: 128).

These comments might offer a way of finding the Rothko intelligible: and hence coming to regard it as art, rather than daub! This is true even for someone whose "other-acclamation" would, on an institutional account, make this a work of art. Indeed, when self-proclaimed artists conduct a public relations exercise on behalf of their work—an idea central to the institutional model—such 'conversion' is exactly what is predicted. The person's coming to regard the Rothko in this way allows something to be said in its defence. Here we see the connection between art-status and aesthetic value, subjects of Wollheim's "two powerful intuitions".

Further, these reasons apply specifically to the Rothko. This painting's greatness may reside in its expressiveness, but other works whose expressiveness could be crudely characterized in the same way will not necessarily themselves be art. This fact might *seem* to derive from the crudeness of the characterization; actually, it explains why any characterization will always be open to a charge of crudeness. With no finite totality of properties of the Rothko, relevant to this judgement, one cannot consider them *all*; and so no characterization of the painting is *more subtle* absolutely (that is, non-occasion-sensitively).

In addition to directly characterizing the Rothko's expressiveness, Wollheim (1973: 128–129) draws the comparison with *The Tempest*, speaking of "a formal counterpart" for this expressive quality which:

> . . . lies in the uncertainty that the painting is calculated to produce, whether we are to see the painting as containing an image within it or whether we are to see the painting as itself an image.

Again, these remarks simultaneously treat the work as art and give a critical vocabulary for discussion of it, in just the ways discussed earlier (see Section 1.1). That vocabulary locates this discussion in a particular narrative since, for example, at one time informed criticism of *The Tempest* might see a parallel not merely for the

barely contained suffering of the Rothko, but also for the formal ambiguities which, for example, might be brought out by considering who is the hero of the play. As informed criticism of *The Tempest* changed, the force of the comparison between it and the Rothko would change. At some other time, informed criticism of the Rothko might even find that comparison ludicrous. Were this to happen, one reason for the art-status of the Rothko, and one set of critical tools for its discussion, would have been removed; and both removed at a stroke, as it were. For the categorial difference allows purchase to the critical tools, and *vice versa*.

This option does not require that there be *no reason* why certain objects are art. Rather, there is no such reason *antecedently* of their being so considered. Once the objects are taken as art, a wealth of analytical tools becomes available. And our taking the objects as art may be no more than our taking these tools to be appropriate for the analysis and discussion of those objects. So these works are taken as valuable for certain reasons expressible with reference to these analytical tools.

Given that this significance *can* be ascribed to the categorial difference, why should the resultant position be preferred to Wollheim's view of the matter? What, apart from an attachment to the institutional, drives one in that direction? Replying requires consideration of the presuppositions of Wollheim's argument.

The comparison with marriage, offered by Wollheim, is revealing: someone has new or additional reasons for acting in a certain way as a result of marriage (say, with respect to the distribution of property); and these reasons are generated by the fact of becoming married. Is the conferring of marriage-status done for some reason or not? It is hard to see what non-purposive reasons *within* the institution of marriage can be offered here. Rather, the major reason is that the partners *want* this status. Thus it too is a matter of what humans want, of the things they consider important. In Western societies, our situation is almost exactly analogous to that in the Republic of Art; namely, people self-elect themselves to the status of marriage, and are taken to be married if others accept them as such. None of this means that reasons cannot be given for the different treatment of those persons as result of the marriage, nor that one's status as married is not important.

Wollheim rightly distinguishes a judgement made for a reason from a judgement made for no reason; but he assumes that the second of these is equivalent to a judgement for which no explanation or 'story' can be given. This is mistaken, since the comments required here are from *the artistic*. Hence, the 'stories' usually told about this artwork, referring to its formal features, its expressiveness, and so on, are only possible vis-à-vis artworks. So the judgement cannot depend on some antecedently extant reason; the reason can be operative only if art-status is granted. Hence Wollheim's argument can be defused by rejecting the view of reasons it presupposes (see also McFee, 1985).

6.7 Critical Reflections

Still, a great many difficulties and unclarities remain.[6] For instance, "how . . . does one know whether one's chosen occupation or activity is the right one?" (Beardsley, 1976: 200). Setting up as a member of the Republic—and in particular, as an

artist-member—requires some grasp on what artists make and do not make: that is, on the sorts of things that might successfully be offered to the Republic. Yet is this really a problem? There is a huge historical background to which to appeal. Becoming the Republic's major fire-eater may prove more difficult than being accepted for a couple of sonnets or watercolours. Even though *saying* just what sorts of thing one's trade might be could prove problematic, there is nothing very mysterious about how it might be learned: by looking to other practitioners, among other things. Indeed, a *mild* institutionalism (or *quasi*-institutionalism) seems attractive here, stressing the social background required to *permit* art.

Related worries concerns the nature of *institutional action*: who 'does' it, and what constitutes it? Our Republic of Art functions as the *authoritative body* (Baker and Hacker, 1984: 273) that earlier was claimed as logically fundamental to the operation of genuine institutional concepts (see Section 6.1 above). So this provides our answer to one such question—this Republic is the fount of institutional action. Yet in what sense is it a *body*?; and in what ways is it *authoritative*?

The members of our Republic are all the persons interested in the arts, such as artists, critics, readers, performers, spectators. Although philosophers and historians were traditionally included in the Republic, we can follow Diffey (1991: 45) in ignoring them. Of course, there is not *one* body here; not one *Republic of Art* at all, but a series of overlapping Republics, for different artforms (and perhaps within artforms): critic **A**, knowlegeable about poetry, has (yet) no place speaking for the Republic of Dance; while critic **B** (or, better, the work of critic **B**) sits happily in both. Nor for the purpose of the model need the work of art be distinguished from its creator; both 'roles' will be treated in terms of the Republic—that is, institutionally. Following our two-stage model, membership of the Republic is by self-election in the first instance (Diffey, 1991: 45); that generally takes the form of setting-up in business as a writer, reader, painter, producer of plays or whatever. Although membership begins from self-election, not all who declare themselves members are recognized as such: the functioning of the Republic must preclude 'wishing makes it so'. Then, standard cases of institutional action involve exhibiting another's work, writing criticism of it, discussing it in certain ways. These represent ways of 'taking seriously' that work. And it is *another's work* that is important because this is a sign of acclamation; a sign of acceptance by the Republic of Art—not mere self-election. Doing this *just is* treating the artefacts as artworks. And being a work of art *just is* being treated as an artwork by the Republic.

The psychology here is complex. At any time not all works function for the Republic of Art as temporary paradigms of art-hood, to be used in explaining the art-status of other works; moreover, such paradigms are not constantly called on to be *vivid* for every member of the Republic. As Cavell (1969: 193) comments:

> The list of figures whose art Tolstoy dismisses as fraudulent or irrelevant or bad is, of course, unacceptably crazy … But the sanity of his procedure is this: it confronts the fact that we often do not find, and have never found, works we would include in the canon of works of art to be of importance or relevance for us.

Further, the weight of our judgement here is not straightforward. Consider "a reliable and trustworthy friend who has proved a good judge of what to do in hard cases"—Dancy (2004: 103) has moral cases in mind where the example offers two important points. First, I expect this friend to do the right thing, faced with a hard case: so, if he advises me not to do something, that is action is probably wrong. This person's conclusions coincide, at least typically, with what one ought (or ought not) to do; or with how one ought (or ought not) to judge or appreciate. But then, second, "it is not wrong . . . *because* my friend has advised me not to do it, nor *because* my friend thinks it to be wrong" (Dancy, 2004: 103: my emphasis). Roughly, what makes the action wrong may turn out—and we expect will turn out—to be my friend's reason for taking it to be wrong: but his having pronounced against it is *not* part of what makes the action wrong.

We can imagine a similar example of a sound judge for artistic judgement. But we must recognize two cases: roughly, those Wittgenstein (PI §354) highlighted in contrasting symptoms with criteria, or where commenting on the length of a particular bar (which is the standard metre) is contrasted with treating that bar as an exemplar—these second remarks are therefore not bipolar (PI §50; SRV: 43–44). Our reliable friend might simply be reporting her own conclusion to us (as in Dancy's example). Even here, her judgements typically coincide with those of the Republic of Art—and hence may be evidence of the Republic's judgements. Yet, on occasion, she might act as a representative of that Republic: in that case, she is making clear the art-status or artistic value of the work. And this contrast is all the more confusing since, as occasion-sensitivity warns us, both cases may appear in exactly the same form of words.

So the body is merely *logically* authoritative: it comprises (or includes) our *competent judges* (see Section 2.6) in respect of particular artforms, and artworks. In this sense, it encompasses what *we* mean by "interpretive communities" (Fish, 1980: 167–173). As Diffey (1991: 46) says, "when the metaphor was live, it was the republic of letters, not the monarchy of letters or the autocracy of letters." Such a model allows us to characterize the 'objectivity' of artistic judgements as (broadly) institutional. The 'conferring' of the status of *work of art* on something is, then, a matter for the Republic and not for the mere exercise of personal judgement. Hence artistic concepts are in some way 'universal'. Artistic judgements are made on the basis of the judgements of the Republic—defeasibly, and as variously filtered through our 'stories' and values. The force here is not towards 'one right answer', and especially not a timeless one; the Republic's judgements may be overturned (say, by posterity). Rather, it is to provide a "space of reasons" (McDowell, 1994: 3–11) for debate.

But, within this account of institutional action, must artworks be exhibited or, at least, submitted to the public? For it seems plausible, first, that works can be exhibited and yet not be art; and, second, that works can be art and yet not exhibited. So institutional action might not *seem* necessary for art-status.

Let us consider the cases in that order. Diffey (1991: 62) puts the first problem clearly:

I forgot that, besides works of art, museums also exhibit objects of other kinds, and I gave no way of distinguishing works of art from their companions on display.

Without offering a way to make this distinction, we have suggested that visitors to galleries, etc. can distinguish artworks from "their companions on display". No general account of what is and what is not art can be offered—at least, if this means an account in terms of necessary and sufficient conditions. But a rudimentary contrast is between works exhibited purely or primarily for their historical interest, which are put in museums, and those exhibited purely or primarily for their artistic interest. The first category also includes other non-aesthetic interests in works; for example, an economic interest. We cannot *describe* what allows us to distinguish artworks from other exhibited objects, for this may be something learned, a recognitional ability. But it comes out in the 'stories' told in explanation of decisions to exhibit the object in question, or in justification of similar decisions by others. That there are problematic borderline cases is not in dispute. But any account of art would leave us with a difficulty in deciding if certain exhibited works are of artistic interest or only of antiquarian interest: for example, certain Greek amphora. Thus the objection that objects other than art can be exhibited can be put aside.

But what of the second case, works *not* exhibited? Surely there are various paintings, musical scores and literary manuscripts hidden in various places: it *seems* implausible that they are not works of art until that far future day when they are discovered. And this consideration seems strengthened by reflecting on cases where such scores, poems, or paintings have been found: for instance, discovery of the poems of Emily Dickinson (Diffey, 1991: 67).

One red herring here will be works not exhibited but made (and known to be made) by acknowledged members of the Republic: for example, those of his paintings that Francis Bacon destroyed without exhibiting. These are works made under the general notion *art* by an accredited member of the Republic. While Bacon's sincerity may, of course, raise problems in taking these creations as art, such problems can, after all, occur even with exhibited works. These Bacon works, and similar ones, lack an audience, but only in the sense of being hidden from that audience by a reputable member of the Republic—one whose actions confers art-status on the works. We can be fairly sure that the works in question would be accredited by the Republic. Also they are known to have existed at one time. The institutional theory can handle such works without undue difficulty. But what can be said of other, undiscovered and unknown works?

On an institutional account of art, works not available to the institution are, in a clear sense, not art. Yet the 'sting' of implausibility can be removed from this response. Consider certain paintings that are, say, hidden: are these paintings art? For not all paintings are artworks. So the default case must conclude that the hidden paintings are *not* art. Whether or not these hidden paintings are works of art depends on their features or properties—and *ex hypothesi* these are not available to us. No analyses can be given of their 'meaning'; no 'stories' told which are answerable to their features. And what are these features, given their response-reliance? So in

whose eyes are these undiscovered works art? Certainly not in the eyes of those who do not see them. If they are not art in the eyes of some member of the artworld, and if they were not in the past, then one cannot be sure that they are art—although this does not pre-empt the position of posterity: by today's judgement, they are not art. Thus works *ex hypothesi* not available to scrutiny by the Republic of Art can neither gain nor fail to gain art-status. But, since most objects are *not* artworks, objects which do not *gain* art-status are best regarded as not artworks.

In the cases which initially generate hesitancy here, such as the discovery of the poems of Emily Dickinson, we *have* the objects, and can scrutinize them. So the judgement of them is based on their features. Then we are asked to imagine just those poems, but undiscovered. But this is a trick! It invites us to postulate artistic properties presently unavailable to humans, and hence to go beyond our robust sense of constructivity (see Section 5.1); and appears to offer a genuine reason for doing so—but does not. The illusion is generated by consideration of cases where the artistic properties are (now) apparent. Of course institutional action can offer a kind of 'back-dating' here, especially when taking the practitioner's view (in contrast to the aesthetician's: see Section 2.6). One simply has no position at all about works completely undiscovered, unknown, and so on. Talking about *lost* works of Picasso, or Bacon, offers slightly firmer ground—just as institutionalism predicts! But, even here, one might be unhappy to discuss the art-status of, say, a work Picasso *might have* produced (but did not): we suspect it will turn out to be art, but . . .

6.8 Can the Institution Be Wrong?

Can an institutional account of art accommodate the place of reason; and, in particular, the normative force of the reasoning? For instance, Tiffany Sutton (2000: 4) claims that an institutional account of art "can only explain why Warhol's *Brillo Box* was taken up into the canon of art history, not whether it should have been". Even putting aside Sutton's reference to a "canon of art history" (as picking up those temporary paradigms a particular narrative tradition employs), her remark is mistaken in urging that institutionalism does not have, among its resources, a place for rational engagement on the normative issues. For taking some object as an artwork imports a critical vocabulary for works in that category, as my defence of the artistic/aesthetic contrast illustrates (Chapter 1 and elsewhere).

Consider the suggestion (roughly) that Carl André's collection of fire bricks, *Equivalent VIII*, does for texture (as embodied, in this case, in the fire bricks) what Turner did for colour (see Fuller, 1980: 115). And, in the same radio programme in the UK, André's commented that his work was "in the line of Bernini, Rodin, Brancusi, and then I would put my name at the end of that line" (reported in Fuller, 1980: 115). At the centre of each discussion are features or factors rightly considered of importance in respect of *other* artworks—in particular, of wholly traditional ones, from the centre of the artistic canon. As Fuller (1980: 117) continues, "the *Venus de Milo* would just be a stone woman if nobody knew about sculpture". Or sometimes an unexpected comparison reveals critical possibilities: for instance that

one the Tracy Emin *Unmade Bed* be taken as though a *painting* of a bed in order to see it as an artwork—this is really a three-dimensional *depiction* of a bed (or so one might think). This in turn is one way to see it as *other than* a 'real thing', consonant with ideas from Danto (1981: 1). Moreover, we are familiar with the depiction of everyday objects from the artist's life (say, from Van Gogh's boots)—familiar, that is, with seeing artistic resonance, such that our discussion might soon be conducted in terms of, say, the revelation (or embodiment) of aspects of the artist's personality. And that just integrates these comments with others concerning artworks. So, faced with opponents who insist on general scepticism about the rationality of artistic judgement, I cannot here demonstrate that these procedures are rational. But I have sketched how they embody some of the same rational structures as other discussions in aesthetic appreciation. Hence, institutionalism has, among its resources, a place for rational engagement. And, as such cases illuminate, our discussion does not rely on selecting examples that are odd or unusual or problematic in some way[7]— although some can seem problematic (the better to put pressure on philosophical claims).

Then (*pace* Sutton) it *can* explain why Warhol's *Brillo Box* had a place in the artworld. For, asked whether the object should have been recognized as art *after* it has been acknowledged ("taken up"), one has—in principle—(artistic) reasons why *Brillo Box* should indeed have been taken as an artwork: one has the critical vocabulary its acknowledgement generates. Using that vocabulary, it becomes possible to explain why the Republic did 'the right thing'. In this case, then, Sutton is wrong; and the required perspective here is, roughly, that of Feyerabend's practitioners, rather than that of philosophers. Further, the practitioners rightly make their judgements from the contemporary viewpoint.

If, on the other hand, one asks *before* the object has been "taken up" (and on the assumption that its "taking up" is problematic), the question itself has no clear sense, for two related reasons. First, the properties of *Brillo Box* are differentially inflected by its being or not being an artwork: more and different things can (truly) be said of that case in each situation. This is just a moral from Danto's gallery of indiscernibles: that artworks and 'real things' may have different properties, even when each might be mistaken for the other (Danto, 1981: 1–2; McFee, 2005a: 372). Indeed, the concepts by which one understands *art* are different *after* the "taking up" of such problematic examples (or "disputable cases", for short) from those concepts before the art-status of that "disputable case" is acknowledged, if only subtly so. So the question of whether it *should* be an artwork cannot (in the imagined, disputable case) be resolved simply by, say, reference to the properties of the object since the precise nature of these properties is simultaneously up for grabs. Second, the 'dispute' (however brief) in respect of our "disputable case" is a clash of views of what art *is*; of what counts as art. It is rather like the disputes among scientists during periods of *revolutionary* science,[8] when no single paradigm for scientificity is in place. Once a resolution is reached, then the question is clear—but so is the answer! Before, one can only repeat that these are disputable cases, and join in the dispute (which will be centrally a dispute in art-criticism). A philosopher of art, viewing this process from some imaginary 'outside', might conclude that the

two positions were actually incommensurable, passing one another by (compare Feyerabend, 1987: 272, for a parallel case: and see Section 2.6). But this is one limit on abstract modelling; for this case *is* resolved in practice—and it would be foolish to dismiss the resolution as somehow *irrational* when this is all the rationality there is here! A parallel with legal cases is informative: they arrive at resolutions but the conclusion is not compelled in the manner imagined by some scientists and some logicians.[9]

So *can* the judgements of the Republic of Art possibly be wrong? This question about institutional judgements fits into our more general picture. First, avoiding the 'unintended artist' required that being an artist involves *self-election* to the Republic of Art; or, if this is different, a *self-election* process of one's work as an artwork. Second, our strategy to avoid 'wishing makes it so' stressed institutional activity— that putative artworks must be *other-acclaimed* by the Republic. Now, questions about the Republic's being wrong, in this context, will not usually arise for self-election: there, something is *presented* to the Republic. But what of the other kind of case? And especially in its strongest form, one denying art-status? Well, a particular judgement of the Republic of Art—say, one which fails to other-acclaim work **Y**— can indeed by taken by art critics, at some later time, to be wrong; and correctly. For 'public relations' work on behalf of work **Y** might have brought about a change in taste since its original condemnation. This is as we expect from the practitioners' perspective on works. Similarly, philosophers of art will recognize that, at the earlier time, the judgement on work **Y** was right—it was the judgement of the Republic of Art on that work. If later events, or changes in artistic concepts or artistic sensibility, reverse the conclusion *later*, that is formally irrelevant *now*. For, now, one only has the reasons, concepts, insights, traditions, and so on of *now*.

6.9 The Friends of Jones

To expand this case a little, let us sketch a simplified example in more detail. For the Republic of Art is not *unitary*: although most of the Republic's judgements are never (seriously) challenged in practice, at a particular time, some candidates might be waiting for posterity's reconsideration of their artworks, and others actively engaged in the public relations exercise to change taste. So there are lots of voices here, not necessarily in agreement, even though such cases will be the exception, rather than the rule.

Imagine, therefore, a revolutionary style of easel painting, which is self-elected by a particular painter, Jones, and her colleagues, but rejected by the Republic of Painting. Jones' work is turned down by all the major galleries. It is even rejected from the Radicals Exhibition of that year; and, when seen in a small gallery, roundly panned by art critics. Jones herself is aggrieved at this treatment. What galls her especially is that, being a keen historian of art, Jones knows that similar fates have befallen Monet, Van Gogh, and so on. Further, Jones knows of judgements of the Republic of Painting—especially its positive judgements on some of her peers— which have been bizarre; and eventually exposed as such. She is convinced that

the Republic of Painting is wrong about her work. But she decides to wait for the judgement of posterity.

Now, Jones is here a member of the Republic of Painting under one heading—as an art historian—but not (presently) as a artist. So her case already recognizes diversity within the Republic of Painting. Then, Jones thinks that the 'final' judgement is mistaken; that the specific judgements are wrong. And that really means what reflection on Monet, Van Gogh, and so on has taught her (from a practitioner's perspective): that even great art—which theirs undoubtedly is, and she takes hers to be—can remain unacclaimed. So she waits for posterity to right (as she sees it) the wrong, as it did in these other cases! Her position here grants force to the judgements of the Republic of Painting in *other* cases: in particular, in respect of Monet and Van Gogh. So she is not here disputing the *mechanism*, but thinking that it operated in a faulty way in her case. Perhaps, thinking of legal parallels, she takes this to be a travesty of justice.

However, the Friends of Jones (her official support group) take a more aggressive line: they are the ones who, in the model, argued *for* the art-status of Jones' easel paintings, but lost the argument. And, like many cases in law (compare Wisdom, 1965: 102; Hampshire, 2000: 13–14), the substance of the conclusion then was a *fact*—that so-and-so did the murder, or that Jones's painting is not an artwork. But the Friends of Jones regard this case as a miscarriage of justice. They think that the Republic of Painting is presently dominated by a bunch of fogies, with no real artistic sensibility. So they set out to change the taste of the Republic of Painting—or, what may come to the same thing, to change its contemporary membership. They use their influence to get Jones's work seen (speaking privately to friendly gallery-owners, just before Jones arrives with her work, and so on). They write articles for learned journals praising Jones's virtuosity, creativity, mastery of the brush-stroke . . . While many of these articles are turned down (most editors are consenting members of the Republic of Painting), enough are published to cause a bit of a stir. The Friends of Jones even manage to get a painting by Jones a 'product placement' in the background in a major motion picture; and, as a result, a small arts television programme is made about Jones' painting.

If the Friends of Jones achieve that much, it seems right to say that the Republic of Painting is now in conflict about the status of Jones' work: that work can no longer simply be shrugged off. So this is now a version of the Republic of Art 'coming to a conclusion': here, two conclusions, with (as yet) no resolution. For one can also imagine articles, television programmes, and the like mounted to show that Jones is no artist at all—but, perhaps, just a jumped-up graphic designer. Still, at this stage it seems more likely that a 'new vote' in the Republic of Painting might acknowledge Jones as a minor artist. At the least, such a case is arguable, in ways the Friends of Jones know how to deploy.

As a third voice, consider the perspective from another Republic: in particular, from the Republic of Film. Suppose Smith, the director who (ultimately) chose—or agreed—to put Jones' painting in his movie, decides to write about the case, extolling the virtues of (at least) that one work. Now this is another kind of conflict. Smith has a voice all right, but not in the Republic of Painting. (He is not, as Derek

Jarman was, a member of both Republics.) His ideas are taken up vociferously by film fans but, in the nature of the beast, only a few of those primarily interested in painting read the learned journal to which Smith contributes. So there is another kind of conflict here, still within the (greater) Republic of Art, but—as it were—between constituent Republics, with the Republic of Film clashing with that of Painting. Again, perhaps this intervention leads yet more people to look at paintings by Jones; and, guided by the writings of the Friends of Jones and of Smith (the film director), some learn both to see and to value her works. That is, they come to see her works as valuable—at least, as minimally valuable in ways required for art-status (see Section 6.4 above). For they now see how her work is both put forward as art worthy of appreciation, and not time-wasting for that audience for art and how it has been self-elected by Jones and other-acclaimed by members of the Republic of Painting (such as the Friends of Jones) and by members of other Republics, such as the Republic of Film. Some of these, of course, now say that Jones' work, while art, is *bad* art. But, in that eventuality, they do so by drawing on the other published articles—they give reasons why the normal presumption of artistic *value* fails in this case. Yet others, realizing that the Republic of Painting is in conflict, deny that Jones' work is art since (as they point out) it fails the crucial test here, by lacking the appropriate institutional action. As this last group might put it, all the institutional activity described so far is still not sufficient.

Now one could begin to describe (say) the *tone* of the critical articles written about Jones. Perhaps it was because the negative ones were so hugely negative while the positive ones were only lukewarm that the last group mentioned were able to deny the art-status of Jones' work. But further elaboration is unnecessary: the plurality of voices has been illustrated, together with *one* way (among many) in which they might be resolved.

The philosophers' perspective on this story differs from the practitioners' perspective deployed so far. From the philosophers' perspective, the first judgement of Jones' work accurately reflected the detail of the artistic concepts then available within the Republic of Painting, and the contemporary narrative of easel painting. In this sense, it was correct: there was no travesty of justice. But then the activities of the Friends of Jones, and of Smith (the film director), modify some of the relevant conceptual connections, and re-draft some of that art-historical narrative. As a result of these conceptual changes, the early judgements of the Republic on Jones' work are incommensurable (recognized from the philosopher's perspective) with the later judgement where (let us suppose) Jones' work is eventually recognized as art: the two sets of judgements pass one another by. But now the revised judgement of the Republic is correct!

As this extended example shows, the resolution here is one for rational debate: but the outcome is unclear—thus *institutional action* should not be seen as an unproblematic notion. In particular, whether or not the Republic of Art has other-acclaimed a particular work may sometimes be difficult to resolve in practice (although less often than its critics assume)—as it was for Jones' work by the end of the example. This does not impugn the *logical* model of institutionalism. The structure of the argument here reflects the contours of the logical role of *competent*

judges (see Section 2.6; compare McFee, 2001: 104–108), without requiring an 'all-or-nothing' compliance.

First, changes of the sort for which Jones waited (patiently?) and the Friends of Jones initiated should be seen as (small) changes in artistic sensibility—which is one reason they are contentious. For they suggest, roughly, a re-writing of the history of easel painting as the original fogies had it, so as to find a place—however humble—for Jones. This is best understood as modifying (however slightly) the connections between key concepts: now Bloggs can be seen as a precursor of Jones; and, perhaps, that will even allow something different to be said about the work of Bloggs. As that view of the history of easel painting becomes more widespread (to the extent it does), others readily or immediately see Jones' works a certain way (in line with that history) and as art—although that will be *one* realization, not two!

Moreover, something about the state of the artworld prior to the case of Jones could be inferred if only enough of the detail were known; that is, "the lay of the artworld" (Carroll, 2001: 91). For, to the degree that the arguments for Jones succeeded in changing taste, there was a 'state of the artworld' which permitted it. Indeed, this is unsurprising. Sociological congruences here are to be expected: we might reflect on the factors which led Jones to paint as she did and the factors in the artworld that led her work to be (ultimately) acknowledged, first by the Friends and then more generally. And that will allow others to locate her work within traditions of craftsmanship, of restoration, of presentation, and so on: that is, within the institutional panoply of the Republic of Art.

But what of cases where the artworld gives whole-hearted support to work that *turns out* to be trivial? Cases where, on balance, the *later* judgement of posterity is that works are less interesting than was formerly thought (Holman Hunt, perhaps) should be distinguished both from those where, on balance, a work is no longer regarded as art at all and from those where the Republic of Art was actually *deceived* in some particular—where the work was by a child or a chimpanzee, say. The first two types follow broadly the pattern described here: posterity revises the judgement, the difference being how substantial the revision. And both practitioners' and philosophers' viewpoints on these events are recognized.

The third type of case offers a different moral to institutional theories: namely, the operation of a 'principle of total evidence', such that one presently has all the relevant evidence. For the deceptive judgement follows from just such a failure. By contrast, there seems an answer to the question of whether (say) King Lear loves Cordelia, if only an uncorrupted text and the right interpretation were located. Now suppose we have the text we have, by and large: that we are not about to find another folio or quarto edition of Shakespeare—and that any hand-written scripts of complete plays are now lost. Then our current texts can be used to 'substantiate' exactly and precisely those 'readings' for which reasons compelling on some part of the Republic can be given. All such interpretations are equally 'right'. But if an interpretation is not held (in at least the attenuated sense of being considered) by some member of this Republic—or perhaps some other—we cannot be offering it: we would not even *know* of it.

Nor are we just *assuming* that no further textual material—other folios, quartos, or manuscripts—will become available. Rather, since any critical judgement depends on the 'total evidence' condition (Carnap, 1950: 211), suggesting that our evidence was incomplete (say, by producing another quarto) raises a 'head of exception' to this condition (as noted earlier: see Section 2.5): failure of the principle of total evidence generates a defeating condition for one's artistic judgements. Suppose (again) you lead me to mistake one artwork item from Danto's gallery of indistinguishable objects for another (see Section 1.5): deploying concepts or categories inappropriate to that artwork, I misperceive it. If this were accidental, then obviously the artworld *should* have judged a certain way just because (*ex hypothesi*) that *would* have happened, had the correct categorial content been mobilized. But were the misperception deliberately arranged, it would be a kind of fraud.

Then we can explain the susceptibility of the Republic of Art to trickery, to the pranks of those who offer the work of the child or the chimp, for instance. *Of course*, the Republic can be deceived in these ways; what happens here is only what happens when a con-artist (note!) sells a fake Rolex watch: *we did not know* (failure of 'total evidence'). If it is a *good* fake, and presented in a 'good' context, with a 'good' story, we can sympathize with the person tricked into buying it. We *should* feel exactly the same about similar frauds against the Republic. Unfortunately, art critics, connoisseurs, etc., having *set themselves up* as possessing a higher sensibility (or being thought to have done so), do not generate sympathy when they are tricked while employing what is typically only, after all, something *learned*. More importantly, here the artistic is confused with the merely sensuous. For the accusation seems directed especially at *artistic* judgement. If it were generally understood that the eye *can* (under suitable circumstances) be tricked here, there would be less likelihood of artistic judgement *as such* being thought flawed: outside philosophy, we do not distrust perception quite generally because *sometimes* psychologists can trick us!

6.10 What the Account Offers

Since art-status (typically) implies a value, it becomes important to see to which objects this value could accrue, and to which it could not. But one cannot hope either to answer exceptionlessly the question, "What is art?" (or, "When are objects X, Y art?") or to have an exceptionless explanation of why/when no such answer is needed. But any comments here import assumptions, which (although not exceptionless) are underpinnings important for our claims. Even someone whose judgements of art rest exclusively on his immediate preferences—who therefore might deny having such a theory—is in fact presupposing the 'theory' that no reliable standards of what is worthwhile in art can be formulated. Or someone aiming to become a neutral observer is employing some more general view (or 'theory'), however implicitly, of what sorts of work (and what sorts of features) are worth noticing. And even someone who disregards art entirely, or considers it of no value,

is presupposing a criterion for the value of art, and giving vent to some general view of art—namely, that it fails to satisfy the criterion. Then:

> [t]he only real choice ... is whether to adopt a theory uncritically or to try to arrive at a theory on the basis of critical reflection about art. To choose the latter course is to engage in the philosophy of fine art. (Karelis, 1979: xi)

To choose the former course is to sacrifice rigour entirely. So the institutional account represents one answer (or one kind of answer) to a question which needs answering, filling a valuable spot in our aesthetic—one which needs filling!

Could my institutional account of art actually meet this need? One might think not—it does not circumscribe the class of artworks. Rather, a very general, minimal sense of the term "institution" is exploited. No 'complete analysis' of the 'artistic object' via the artworld is attempted, just as it does not attempt to define the term "art". So it plays a limited role in my picture of philosophical aesthetics. But a number of insights it contributes to the overall framework have been highlighted:

- the place of self-election;
- a context/background of practices;
- the role of the authoritative body;
- 'open-ness' of the objects that are (or could be) art;
- the dependence of art on human beings (especially on their powers and capacities and their interests).

At least some of these features speak to *negative* cases: that is, to determine that work **X** is *not* art, at least defeasibly. And each reflects both characteristics of our art-critical practice (or our more traditional view of art) otherwise under-rated *and* aspects of our institutionalism: so, recognizing an institutional account of art will serve to explain the importance we see them to have.

Although our institutional account does *not* offer a definition of art, it explains the *force* of some of the comments made about art—it shows that this is more than *mere* contingency. For instance, our institutionalism explains the longevity of other supposed 'criteria' of arthood, such as the test of time (see also Levinson, 2006: 355–385). Although not themselves logically forceful, these reflect features of institutionalism as logically compelling, if defeasibly: in particular, its 'principle of permanence' (Bambrough, 1973: 42; McFee, 1980: 315a). Further, it recognizes (in one plausible way) the force of self-election: that one cannot make artworks *by accident* (except where this is a compositional tool!). Hence, there is a place here for some kind of intentionalism.

But it also explains the logical relevance of other features of the institution, features otherwise plausibly thought irrelevant to art-status—that, say, a performance-tradition is crucial to the performing arts, or that traditions of restoration are fundamental to (some kinds of) easel painting. So these are conceptual connections, the practices not mere *adjuncts*: rather, if we restore a particular painting for artistic reasons, we restore those we think *worthy* of restoration, with art-based criteria of success—and these are art-critical or art-historical judgements,

in the gift of the Republic of Art. But, in reality, there are only particular persons—especially art critics—making particular judgements of particular artworks. In part, the recognition is that these can have an overall direction, as the Republic's judgement.

This view sustains our authoritative body. So, not 'anything goes': artistic judgement is not unconstrained, and, as a consequence, not in the gift of everyone. Further, such judgement is not constrained in ways easily described in the abstract: hence, there cannot be a guaranteed recipe here—although, of course one can also explain why joining the Republic as an easel painter is easier than as a fish-electrocuter; and the answer will be an institutional one! Moreover, artistic properties are a species of institutional property, in the strong sense in which an *authoritative body* is implied. Putting the point that way focuses attention away from the nature of the institution (our concern is not the sociology of artistic institutions) and away from unanswerable questions about the character of institutional action (which initiated the great "conferring" debate).

Yet is the concept *art* institutional in this sense? Well, our point is, in effect, just that institutional answers can be revealing in answer to occasion-sensitive questions or issues. Further, it will be difficult to decide when exactly a hypothetical model is *true*: without giving a knock-down response, something must be said, when the credentials of a broadly institutional account are advanced. First, the model reveals features noticed in reality: as Diffey[10] concludes, "[t]his Republic is not entirely a fictitious model". For instance, it correctly predicts that, faced with a failure to receive other-acclamation, (putative) artists might seek to change the taste of the Republic. Second, the model offers an explanation of how objects putatively art become (regarded as) art, and hence can explain the transfiguration of such objects—though it has little to say about objects which are *never* other-acclaimed. Third, it offers new or revealing questions. In stressing the connection to "fruits of human contrivance" (Quinton, 1982: 98), institutionalism can explain why artworks are valuable; namely, that art-status is regarded as minimally evaluative (at least defeasibly). In stressing the human dimension here, the institutional account makes it easier to claim that—*qua* artistic property—these are valuable properties since, in characterizing them, they are already treated as valued; and in a context where such valuing (by the Republic, rather than by individuals) is really all *having value* could come to. Finally, in admitting *institutional concepts*, this account illustrates how some issues otherwise dismissed as sociological might be recognized as philosophical.

Notes

1. For example, Storer (1962: 151–152) argues that a penny with "Yes" written on paper glued to one face and "No" on paper on the other is an electronic computer.
2. Institutional *accounts* of art should be distinguished from institutional *definitions* of art. Attempts to *define* "art" offering *functional* definitions (where "what makes a thing an X is its functional efficacy" [Davies, 1991: 27], with "poison" is a good example) are fashionably distinguished from those offering *procedural* definitions, where "the evolution of a procedure

leads to the use of those procedures in ways that go so far as to conflict with the point of the concept" (Davies, 1991: 36). Then institutional definitions of *art*, such as Dickie's, would be one kind of procedural definition. [NB Davies (1991: 28–29) clearly distinguishes concepts *having* a function from those *defined* in terms of that function.]

3. A similar conception of institutional concepts grants that Kuhn's work on paradigms is philosophy of science (not merely its sociology): see Kuhn (1977: 321–325; EKT: 96).

4. Is this what Matravers (2000: 242) means by "protean"?

5. However, Dickie takes most discussion of that 1974 version to be misconceived, arguing (in four papers: Dickie, 1993a; b; Dickie, 1998; 2000b) that his views have been misunderstood in the literature, in ways the presentation here perpetuates.

 I cannot address all the issues. But, first, Dickie did not say *clearly* what he now claims was his point; second, this 'clarification' of his view makes it less interesting (a two-stage account is needed): third, Wollheim was therefore justified in treating Dickie's account the way he did; further, a careful study of the chronology shows that some of Dickie's specific complaints against Wollheim are misplaced, and many are disingenuous, given the (acknowledged) unclarities in what he (Dickie) wrote; finally, the revised version (Dickie, 1984) does not fare appreciably better when confronted with the major lines of criticism (see also McFee, 1986).

6. One, concerning so-called first art, is not discussed here: see McFee (2008).

7. In contrast, Carroll (2001: 83) urged that Dickie's account is primarily explanatory only of a certain class of problem cases, requiring "something like the presupposition that Dada is the central form of artistic practice in order for its intuition pumps . . . to work."

8. Kuhn (1970: 65–68, 201–204). Also Kuhn (1970: 84) quotes Wolfgang Pauli:

 At the moment, physics is again terribly confused. At any rate, it is too difficult for me, and I wish I had been a movie comedian . . . and had never heard of physics.

 This is, of course, before Pauli had in place a "time-tested and group-licenced way of seeing" (Kuhn, 1970: 189)—that is, a paradigm. Later, though, Pauli came to some framework: "Heisenberg's type of mechanics has again given me hope and joy in life" (Kuhn, 1970: 84).

9. Interestingly, the impact of the *principle of total evidence* (Carnap, 1950: 211) is to make us content with what we have, if defeasibly.

10. T. J. Diffey *Aesthetic Judgements and Works of Art*, PhD Thesis, University of Bristol, 1966: 290–291 (My thanks to Terry for making this available to me).

Chapter 7
Conclusion

7.1 The Framework: A Summary

The framework for philosophical aesthetics developed throughout this work rests on four main pillars: outlining them here offers a global overview of the direction this text has taken. The first 'pillar' is, of course, the distinction between artistic interest and judgement and (mere) aesthetic interest and judgement, a contrast central to our articulation of the distinctiveness of the concept *art*. As elaborated in Chapter 1, the drawing of this distinction had three important corollaries: first, that terms in their *artistic uses* (or the properties thereby ascribed) amounted to something different from that in the *aesthetic uses* of those same terms (or, again, the properties thereby ascribed). For instance, what counted as *beauty* or *gaudiness* amounted to something different when the beautiful object, or gaudy object, was an artwork than when it was some other object of aesthetic interest or judgement. To modify a claim from Danto (quoted Section 1.1): *the artistic difference presupposed the ontological difference*. And, since artistic judgement draws on categories of art, one should more exactly have spoken of *gaudy for a Fauve*, and so on.

Second, taking an artwork for a (merely) aesthetic object was *mis*taking it, misperceiving it. So the contrast clarified the argumentative centrality of the idea of misperception: misperception must be avoided if one's experience is to be *of art*. Classic modes of misperception involved both taking an artwork for a (mere) aesthetic object, or vice versa; and mobilizing an inappropriate *category of art* in one's appreciation of an artwork. So the object must be seen aright. Then, as a third corollary, the value of artworks—a value of a non-monetary kind not (in principle) shareable with (mere) aesthetic objects—was best characterized in terms of a kind of *meaning* appropriate to artworks. Here, too, the emphasis was on not 'getting it wrong' in trying to make sense of an artwork. And only an account of art sharing these corollaries would draw the contrast on which I have insisted. So they might be seen as at the heart of our account of art.

But how are these corollaries, and especially the first, to be explained? Replying raised the second pillar of my framework: the occasion-sensitive account of meaning and understanding. In fact, this feature is really yet more fundamental—a kind of foundation for much of the other work, resting on an occasion-sensitive picture

of philosophy in general (and hence of philosophical aesthetics). On it, as Austin (1970: 130) noted, "[t]he statements fit the facts always more or less loosely, in different ways on different occasions for different intents and purposes". So our claims, reflecting the features which make them true or false, should always be seen here as answers to specific questions, importing a concern with those features. Then some other answer would be likely were a different question raised, since the same concern could not be assumed.

Accepting the occasion-sensitivity of understanding is key both in rejecting some assumptions about exceptionlessness in philosophy and in suggesting how to deal with exceptions; say, in the form of (putative) counter-examples. When Wisdom (1953: 222) first wrote of the *dullness* or *dreariness* of aesthetics, he complained that general or abstract books about art had no role: that they offered nothing but platitudes. At the heart of this complaint was the need to treat artistic value case-by-case. And Wisdom compared that position with the ways in which, for instance, novels could reveal facets of human life without producing exceptionless general-izations about human flourishing. Our commitment to occasion-sensitivity explains this effect. For, in approaching the other key topics, our discussions must answer specific questions as they might arise—hence, any demand that our account of art be exceptionless can be put aside. Thus, explaining the connection of art to the rest of our lives (the 'life-issues' connection) only requires sketching an account in broad brush-strokes, and then showing how apparent counter-cases might be met. Further, when a model for an account of art's connection to the (humanly) valu-able is required, aspects of Martha Nussbaum's work can be offered, conceding its role as meeting occasion-sensitive questions about artworks rather than claim-ing (or imagining) that it dealt with *every* case. Further, the meanings of artworks are thereby tied to the judgements offered of the meanings of those works. For, as a slogan, *meaning in art is what is explained by explanations of the meanings of artworks*. In thus connecting artistic meaning to explanation, this picture per-mits that an artwork's meaning be mutable in the light of changes in how it should (appropriately) be explained: that is, in terms of current *narratives* of art-making and art-understanding.

That leads to the third pillar. For, on an appropriate occasion, the meaning-features of an artwork can, in certain circumstances, be changed by later conceptual events, since those features can then be differently explained: changes in how the *narrative* of art is to be written at some later time can amount to changes in what properties can (truly) be ascribed; and hence in how those works should be under-stood. So the framework grants a *foreword retroactivist* picture of the historical character of art. This results partly from recognizing that artistic properties are necessarily available to humans (in principle). And, if the interrogation of artis-tic practice by philosophical aesthetics is occasion-sensitive, later generations may also be asking different questions: hence, at least sometimes, different answers (reflecting conceptual changes) will be appropriate.

Finally, the fourth pillar of our framework is our institutional account of art, connecting the reality of our experience of art with the preconditions for an audience for art. For the possibility of art requires, not only that people be able to recognize

artistic properties, but also that they be inclined to do so. In this way, it requires traditions of art-making and art-understanding. Such institutionalism also offers a reply to specific questions about the limitations of candidate artworks (putting aside 'wishing makes it so' and 'the unintended artist'): for it posits an *authoritative body* ("the Republic of Art"), employing phases of self-election and other-acclamation.

One way to see aspects of the whole framework in practice would return us to, for instance, the case of Marla Olmstead, the 4-year-old whose paintings were taken as significant works of Abstract Expressionism (see Section 1.7). Ways of explaining why people might, say, want to hang these large paintings on their walls were noted implicitly, but without granting that these were artworks. For instance, their interest might be broadly sentimental: that she was then four would be crucial (and what can one say as she gets older?). This resembles hanging one's children's paintings on the fridge: no-one would mistake that for artistic appreciation. Going down this route would exploit the problematic connection of Marla's canvases to the relevant *categories of art* or narratives of art history. But, equally, our artistic/aesthetic contrast permits the works being aesthetically-pleasing, without any inference to the art-status of the canvases. Further, one can say exactly why there is no implication from the beauty of these works (if that is granted) to their artistic appreciation, in a world where "beauty" *is* a term of artistic value. For, even then, what the beauty amounts to here, as aesthetic beauty, differs from what it would amount to, were the beauty artistic.

Of course, the judgements offered of Marla's work might be challenged: seen one way, that could reflect the changing taste of the Republic of Painting, whereby "the lay of the artworld" (Carroll, 2001: 91) at some time speaks against these works—but where this changes, perhaps as a result of the public-relations activity of her support group, the Friends of Marla. Or it could reflect changes in the concepts by which the works are understood: perhaps they are not after all, works from the tail-end of Abstract Expressionism, but part of an emergent new movement (Post-Abstract Expressionism?). Then our *forward retroactivism* might lead aestheticians to conclude that the meaning of Marla's work had changed, although contemporary critics will still reflect the traditional 'practitioner' perspective, by claiming to have found something new in these works. In either of these ways, the works might now find a place in the Republic of Art; and that fact could be both explicable and justifiable.

Indeed, the changing fate of Marla's works might be regarded as raising different sets of issues at different times. Perhaps the audience first confronting them is struck by her youth, and the category of art best suited to her output *seems* "Abstract Expressionism". Then the question is, roughly: "What should one make of a 4-year-old Abstract Expressionist manqué, given that she is not a prodigy?". Our answer, for the reasons given in Chapter 1, was that her works were not art, therefore having at best aesthetic interest. (And perhaps with the slight suggestion that much of the interest was actually sentimental.) But with the (imagined) new movement in full swing, offering a clear place in the history of art and a clearly developed narrative of art history of its own, the question might become: "What should be made of the pre-pubescent works of this important artist, given their similarities to major works

of the School of which she is an established part?". Now, as granted initially, any answers sketched here would reflect the case-by-case consideration of critics. And no one answer is *always* given in such cases: the writings of a youthful T. S. Eliot are treated as a minor fragment of his *oeuvre*, while those of Lawrence Durrell are put aside as juvenilia. Still, this second question above might easily be answered differently to the first, with that difference reflecting occasion-sensitivity. In this case, then, one sees how questions raised about the nature of artworks might find a response which draws on the features of our framework.

Further, this is just a *framework* for debate. To illustrate, consider objects made in a society without the concept *art*: following my view of anthropologists' understanding, I shall assume that the Lascaux cave paintings fit this bill—that they were hunting magic of some kind, expressed in a decorative form, and hence not art; and that the society which produced them lacked the concept *art*. Then, someone claiming that these painters just lacked *our* concept of art would be mistaken. For that is where comparisons must be drawn to determine whether the society had a concept of art; and our evidence includes the fact that such decorative objects have clear non-art purposes, uses or intentions. Now suppose a similar comment is made about, say, the North Indian dance form, Kathak: although insisting that Kathak is art, its advocates claim that the makers of these dances lacked *our* concept of art. Clearly, this issue is important: the framework prioritizes the artistic/aesthetic contrast, as we have drawn it. Could there be some *other* concept of art? To enter the debate here, one needs first to show that a concept of *art* was indeed at work in the society that produced Kathak—and a part of this might involve recognizing its differences from its ancestor-form, Bharata Natyum. For Kathak was no longer an act of worship, was performed for an audience, was sharply distinguished from other kinds of physical activities: these would be first steps in acknowledging Kathak as art. That it was, say, non-purposive, observed and regarded as meaningful would be the beginnings of an argument for its art-status, just because these are features of *art*. If it was insisted that the meaning-bearing character of Kathak operated differently from meaning-bearing in, say, ballet, both the truth and the significance of this 'fact' could be discussed. Does it show that, after all, works in Kathak are not art (perhaps by highlighting a purposiveness)? Or does it show that the range of meaning-bearing within art is greater than we first thought? Again, a contrast with *our* concept of art makes no sense. Debate here is within the concept *art*, exploring its features; and could include kinds of public relations exercise to reshape that concept. But these resemble the debates around detail among evolutionary biologists: yes, there are places for contestation, but within a shared framework. And that is the situation here.

7.2 The Aesthetic Reconsidered

Since the first chapter of this text concerns the artistic *and the aesthetic*, it may seem odd that so little space has been allotted to consideration of the (merely) aesthetic—especially since I have stressed on many occasions that this view does not denigrate

the aesthetic (say, in speaking of "merely"). Rather, our interest in this text has been in the artistic. But, once said, that really does all that is needed here. For, if we are concerned primarily with artistic judgements, or artistic properties, it will be enough to offer (as a default) a conception of the aesthetic as *not this*.

Actually, four other key themes here can be sketched briefly: they would be crucial were one to turn, at some later time, to a more detailed discussion of the aesthetic. For the (merely) aesthetic has been discussed here in terms of its *appearance* (or *mutatis mutandis*, for other sensory modalities) and its *sensuousness*. These suggest two related characteristics, returning us to the Greek origins of the term "aesthetic", in sense-perception. The third factor here might be put by recognizing the *limited cognitivism* in our relation to the aesthetic: some conceptual mastery is needed to see the *redness* of the red object—but clearly a far greater mastery of concepts (and, in particular, of *categories of art*) is required to make sense of artistic experience, where this means making sense of it *in our experience*, or via concepts *mobilized* in that experience.

These three features stress the unity within the aesthetic, by stressing is connection to perceptual confrontation ('only'). The fourth feature recognizes the diversity within the broad category of *the aesthetic*. So, importantly, some objects of aesthetic appraisal will be *naturally occurring* (such as landscapes) and yet others will be *designed* objects, such as the Ferrari. And the diversity within each of these classes is recognized immediately. So any account offered, even occasion-sensitively, must typically contrast the naturally-occurring with cases where aesthetic experience is *managed* (where this is a designed objects—even if from naturally-occurring materials, as perhaps in landscape gardening). Here it will often be crucial to stress that the designed differs from the merely man-made, although (of course) both will be *aesthetic* rather than *artistic*, on our account.

7.3 Envoi: *The Muscular Aesthetic*

Our framework for philosophical aesthetics provides materials for answering a large number of the questions arising in respect of artworks. Our occasion-sensitive picture illuminates the framework's intellectual resources both in responding to a number of questions about artworks and their appreciation and in its explanation of why certain questions cannot be addressed in the abstract. For these, one must turn to "the lay of the artworld" (Carroll, 2001: 91) at a particular time, and hence to the contingent details within our institutional picture.

But this is—and is designed to be—just a *framework* for philosophical aesthetics: and, in particular, for that part of philosophical aesthetics dealing with artworks or art-forms. Two related lacunae within that project concern, first, the *logical* role of particular cases and, second, the questions or issues that flow from the peculiarities of specific artworks or art-forms. Let us consider then in that order.

First, as Wisdom (1965: 102) informs us, "at the bar of reason, always the final appeal is to cases": such an idea is naturally of a piece with occasion-sensitivity—that this specific case can differ from that one, and so the topic only be treatable

case-by-case. For philosophical aesthetics, this means that exceptions may *always* arise to any philosophical theses, even mine. For that reason, such *theses* are better considered *slogans* (McFee, 2001: 110–113). To elaborate one's account, therefore, often involves considering the details of some cases apparently problematic for any theses (or slogans) one adopts.

But the second version, although pointing in the same direction, is more fundamental: that features of specific artforms, or even specific artworks, will require the modification (or augmentation) of the framework. Given my interest in dance, I am keen to explore what issues it might raise, both as a performing (and multiple) artform, and in terms of other peculiarities of danceworks—both general peculiarities shared by typical danceworks and the atypical deviances. For instance, the dancework itself is a multiple, which might be treated in a type-token fashion, as with novels. Yet the very same ('numerically identical') work is encountered through different performances: numerical identity of artwork makes sense here in a way different than that for novels. Then, the notated score could obviously have some practical role in respect of such numerical-identity judgements. But, in reality, today's choreographers rarely use such notation in the creation of danceworks; and, even for reconstruction, dances are rarely realized from notated scores directly— most dancers cannot readily perform from scores, the very opposite situation to that in music. So, in these ways, applying our framework to dance requires elaborating it. Further, performing arts (but not others) presuppose practices of performance, an aspect of the institution for dance (McFee, 2003b: 138–141).

Hence a fuller version of our framework, one suitable to deal with danceworks, requires augmentation of this sort, considering in detail what such features would mean for a philosophical aesthetics of dance. This will, I hope, be my next large-scale project in aesthetics. In this sense, the resultant text would be a second volume of the project of which this framework volume is the first. That conceptualization would treat the passage from one volume to the next as moving laterally across the artforms. But this projected work might also be viewed as a second volume for *Understanding Dance*: that is, UD might be seen as a sketch for relative beginners of the philosophical aesthetics of dance, and the projected new text as an opportunity to take the issues, or anyway similar ones, to a deeper level.

So this would be an philosophical aesthetics for a physical activity, a physical art-form. Moreover, its dependence on the framework elaborated here would mean that such a text could be developed rigorously from our more general picture of the arts. In this way, it should offer the possibility to deal firmly with the issues raised, thereby justifying (in two ways) my wife's suggested title for it: *the muscular aesthetic*.

References

Adams, T. (2003) "Saatchi's Open House", *The Observer Review*, 23rd March: 1–2.

Ades, D. (1978) *Dada & Surrealism Reviewed*. London: Art Council of Great Britain.

Adorno, T. (2002) *Essays on Music* (Selected by Richard Leppart). Berkeley: University of California Press.

Alvarez, A. (1963) *The Shaping Spirit*. London: Arrow Books.

Alvarez, A. (1971) *The Savage God*. London: Heinemann.

Anderson, J. C. & Dean, J. T. (1998) "Moderate Autonomism", *British Journal of Aesthetics*, 38, 2, April: 150–167.

Anscombe, G. E. M. (1981) "On Brute Facts" in G. E. M. Anscombe (ed.) *Metaphysics and the Philosophy of Mind* (Collected Papers Volume III). Oxford: Blackwell: 22–25.

Austin, J. L. (1962) *Sense and Sensibilia*. Oxford: Clarendon Press.

Austin, J. L. (1970) *Philosophical Papers* (Second Edition). Oxford: Clarendon Press.

Baker, G. (1977) "Defeasibility and Meaning" in P. Hacker & J. Raz (eds.) *Law, Morality and Society*. Oxford: Clarendon: 26–57.

Baker, G. (1981) "Following Wittgenstein: Some Signposts from *Philosophical Investigations* §§143–242" in S. Holtzman & C. Leich (eds.) *Wittgenstein: To Follow a Rule*. London: Routledge: 31–71.

Baker, G. (ed.) (2003) *The Voices of Wittgenstein: The Vienna Circle*. London: Routledge.

Baker, G. (2004) *Wittgenstein's Method: Neglected Aspects*. Oxford: Blackwell.

Baker, G. & Hacker, P. (1980) *Wittgenstein: Understanding and Meaning* (An Analytical Commentary on the *Philosophical Investigations*, Volume 1). Oxford: Blackwell.

Baker, G. & Hacker, P. (1984) *Language, Sense and Nonsense*. Oxford: Blackwell.

Baker, G. & Morris, K. (1996) *Descartes' Dualism*. London: Routledge.

Bambrough, R. (1962) "Plato's Modern Friends and Enemies", *Philosophy*, XXXVII: 97–113.

Bambrough, R. (1969) *Reason, Truth and God*. London: Methuen.

Bambrough, R. (1973) "To Reason is to Generalise", *The Listener*, 89, 11th January: 43.

Beardsley, M. (1958) *Aesthetics: Problems in the Philosophy of Criticism*. New York, NY: Harcourt, Brace.

Beardsley, M. (1970) *The Possibility of Criticism*. Detroit: Wayne State University Press.

Beardsley, M. (1976) "Is Art Essentially Institutional?" in L. Aagaard-Mogensen (ed.) *Culture and Art*. Atlantic Highlands, NJ: Humanities Press: 194–209.

Beardsmore, M. (1971) *Art and Morality*. London: Macmillan.

Beardsmore, R. W. (1973a) "Learning from a Novel" in G. Vesey (ed.) *Philosophy and the Arts: Royal Institute of Philosophy Lectures* (Volume 6, 1971/72). London: Macmillan: 23–46.

Beardsmore, R. W. (1973b) "Two Trends in Contemporary Aesthetics", *British Journal of Aesthetics*, 13, 4: 346–366.

Bennett, T. (1979) *Formalism and Marxism*. London: Methuen.

Berg, A. [1924] (1965) "Why is Schoenberg's Music so Difficult to Understand?" in reprinted in W. Reich (ed.) *The Life and Work of Alban Berg*. London: Thames & Hudson: 189–204.

Best, D. (1978) *Philosophy and Human Movement*. London: George Allen & Unwin.

Best, D. (1985) *Feeling and Reason in the Arts*. London: George Allen & Unwin.

Best, D. (1992) *The Rationality of Feeling*. London: Falmer Press.

Borges, J. L. (1962) "Pierre Menard, Author of Don Quixote" in J. L. Borges (ed.) *Fictions*. [trans. A. Kerrigan]. New York, NY: Grove Press: 42–51.

Borges, J. L. (1970) *Labyrinths*. [trans. D. A. Yates & J. E. Irby]. London: Penguin.

Bradley, F. H. (1934) "On the Treatment of Sexual Detail in Literature" in F. H. Bradley (ed.) *Collected Essays* (Volume II). Oxford: Clarendon Press: 618–627.

Bradley, F. H. [1893] (1969) *Appearance and Reality*. Oxford: Clarendon.

Brady, E. (2003) *Aesthetics of the Natural Environment*. Eninburgh: Edinburgh University Press.

Brand, P. Z. (2000) "Glaring Omissions in Traditional Theories of Art" in C. Noël (ed.) *Theories of Art Today*. Madison, WI: University of Wisconsin Press: 175–198.

Braxton, G. (2004) "Controversy Reborn", *LA Times*, Calendar, Saturday, 7th August: E1, E4.

Carnap, R. (1950) *Logical Foundations of Probability*. London: Routledge & Kegan Paul.

Carrier, D. (1991) *Principles of Art History Writing*. University Park, PN: Pennsylvania University Press.

Carroll, L. [1894] (1973) "What the Tortoise Said to Achilles" in *The Complete Works*. London: Nonesuch Press: 1104–1108.

Carroll, N. (1998a) "Moderate Moralism Versus Moderate Autonomism", *British Journal of Aesthetics*, 38, 4, October: 419–425.

Carroll, N. (1998b) "The End of Art?", *History and Theory*, 37, 4: 17–29.

Carroll, N. (2001) *Beyond Aesthetics*. Cambridge: Cambridge University Press.

Carroll, N. (2009) *On Criticism*. London: Routledge.

Cavell, S. (1969) *Must We Mean What We Say?* New York, NY: Scribners.

Cavell, S. (1979a) *The World Viewed*. [Enlarged Edition]. Harvard, MA: Harvard University Press.

Cavell, S. (1979b) *The Claim of Reason*. Cambridge, MA: Harvard University Press.

Cavell, S. (1981) *Pursuits of Happiness*. Cambridge, MA: Harvard University Press.

Cavell, S. (2004) *Cities of Words*. Cambridge, MA: Harvard University Press.

Chapman, J. (1984) "XXX and the Changing Ballet Aesthetic", *Dance Research*, 2, 1: 35–47.

Cioffi, F. (1965) "Intention and Interpretation in Criticism" in C. Barrett (ed.) *Collected Papers on Aesthetics*. Oxford: Blackwell: 161–183.

Cumming, L. (2003a) "Hardly a Home Fit for Heroes", *The Observer Review*, 13th April: 12.

Cumming, L. (2003b) "Natal Attraction", *The Observer Review*, 23rd March: 10.

Cunningham, M. (1984) *The Dancer and the Dance: Merce Cunningham in Conversation with Jacqueline Lesschaeve*. New York, NY: Scribners.

Dancy, J. (2004) *Ethics Without Principles*. Oxford: Clarendon Press.

Danto, A. (1977) "The Art World" in G., Dickie & R. Sclafani (eds.) *Aesthetics: A Critical Anthology*. New York, NY: St. Martins Press: 22–35.

Danto, A. (1981) *The Transfiguration of the Commonplace*. Cambridge, MA: Harvard University Press.

Danto, A. (1986) *The Philosophical Disenfranchisement of Art*. New York, NY: Columbia University Press.

Danto, A. (1987) "Approaching the End of Art" in A. Danto (ed.) *The State of the Art*. New York, NY: Prentice-Hall: 202–218.

Danto, A. (1992) *Beyond the Brillo Box*. New York, NY: Farrar, Strauss, Giroux.

Danto, A. (1993) "Responses and Replies" in M. Rollins (ed.) *Danto and His Critics*. Oxford: Blackwell: 193–216.

Danto, A. (1994) *Embodied Meanings: Critical Essays and Aesthetic Meditations*. New York, NY: Farrar, Straus and Giroux.

Danto, A. (1997) *After the End of Art: Contemporary Art and the Pale of History*. Princeton, NJ: Princeton University Press.

Danto, A. (1999) "Indiscernibility and Perception: A Reply to Margolis", *British Journal of Aesthetics*, 39, 4: 321–329.

Danto, A. (2000) "Art and Meaning" in N. Carroll (ed.) *Theories of Art Today*. Madison, WI: University of Wisconsin Press: 130–140.

Davies, S. (1991) *Definitions of Art*. Ithaca, NY: Cornell University Press.

Davies, S. (2000) "Definitions of Art" in B. Gaut & D. Lopes (eds.) *The Routledge Companion to Aesthetics*. London: Routledge: 169–179.

Davies, S. (2007) *Philosophical Perspectives on Art*. Oxford: Oxford University Press.

Dickie, G. (1974) *Art and the Aesthetic: An Institutional Analysis*. Ithaca, NY: Cornell University Press.

Dickie, G. (1984) *The Art Circle*. New York, NY: Haven Publications.

Dickie, G. (1993a) "A Tale of Two Artworlds" in M. Rollins (ed.) *Danto and His Critics*. Oxford: Blackwell: 73–78.

Dickie, G. (1993b) "An Artistic Misunderstanding", *Journal of Aesthetics and Art Criticism*, 51, 1: 69–70.

Dickie, G. (1998) "Wollheim's Dilemma", *British Journal of Aesthetics*, 38, 2: 127–135.

Dickie, G. (2000a) "Art and Value", *British Journal of Aesthetics*, 40, 2: 228–241.

Dickie, G. (2000b) "The Institutional Theory of Art" in N. Carroll (ed.) *Theories of Art Today*. Madison, WI: University of Wisconsin Press: 93–108.

Diffey, T. J. (1991) *The Republic of Art and Other Essays*. New York, NY: Peter Lang.

Dummett, M. (1978) *Truth and Other Enigmas*. London: Duckworth.

Dummett, M. (2006) *Thought and Reality*. Oxford: Clarendon Press.

Durrell, L. (1952) *A Key to Modern Poetry*. London: Peter Nevill: [American edition: (1952) *A Key to Modern British Poetry*. Norman: University of Oklahoma Press].

Dworkin, R. (1986) *Law's Empire*. Cambridge, MA: Belknap/Harvard University Press.

Dworkin, R. (1996) *Freedom's Law: The Moral Reading of the American Constitution*. Cambridge, MA: Harvard University Press.

Eaton, M. (2001) *Merit, Aesthetic and Ethical*. Oxford: Oxford University Press.

Eddy, T. (2001) "The Red Dust", *British Journal of Aesthetics*, 41, 2: 205–221.

Eliot, T. S. (1993) *The Varieties of Metaphysical Poetry* (Edited & Introduced by R. Schuchard). New York, NY: Harcourt Brace.

Empson, W. (1935) *Some Versions of Pastoral*. London: Chatto & Windus.

Feyerabend, P. K. (1987) *Farewell to Reason*. London: New Left Books.

Fish, S. (1980) *Is There a Text in This Class? The Authority of Interpretive Communities*. Cambridge, MA: Harvard University Press.

Foot, P. (2002) *Moral Dilemmas*. Oxford: Clarendon Press.

Foster, S. L. (1986) *Reading Dancing*. Berkley: University of California Press.

Foucault, M. (1970) *The Order of Things*. London: Tavistock.

Franger, W. (1951) *The Millennium of Hieronymous Bosch*. New York, NY: Hacker Art Books.

Frege, G. (1960) *Philosophical Writings of Gottlob Frege*. [trans. P. Geach & M. Black] (Second Edition). Oxford: Blackwell.

Fuller, P. (1980) *Beyond the Crisis in Art*. London: Readers & Writers Publishing Co-operative.

Fuller, P. (1988) *Theoria; Art and the Absence of Grace*. London: Chatto & Windus.

Gardner, J. (1978) *On Moral Fiction*. New York, NY: Basic Books.

Gaut, B. (1998) "The Ethical Criticism of Art" in J. Levinson (ed.) *Aesthetics and Ethics: Essays at the Intersection*. Cambridge: Cambridge University Press: 182–203.

Gaut, B. (2000a) "Art and Ethics" in B. Gaut & D. Lopes (eds.) *The Routledge Companion to Aesthetics*. London: Routledge: 341–352.

Gaut, B. (2000b) "'Art' as a Cluster Concept" in N. Carroll (ed.) *Theories of Art Today*. Madison, WI: University of Wisconsin Press: 25–44.

Gaut, B. (2007) *Art, Emotion and Ethics*. Oxford: Clarendon.

Goodman, N. (1968) *Languages of Art*. Indianapolis, NY: Bobbs-Merrill.

Greenberg, C. (1999) *Homemade Esthetics: Observations on Art and Taste*. Oxford: Oxford University Press.

Greeves, S. (2003) "Ron Mueck: A Redefinition of Realism." in *Ron Mueck*. London: National Gallery: 43–62.

Grice, P. (1989) *Studies in the Ways of Words*. Cambridge, MA: Harvard University Press.

Grice, P. (2001) *Aspects of Reason*. Oxford: Clarendon Press.

Ground, I. (1989) *Art or Bunk?* Bristol: Bristol Classical Press.

Hampshire, S. (2000) *Justice is Conflict*. Princeton, NJ: Princeton University Press.

Hanfling, O. (ed.) (1992) *Philosophical Aesthetics: An Introduction*. Oxford: Blackwell.

Hanfling, O. (1999) "The Institutional Theory: A Candidate for Appreciation?", *British Journal of Aesthetics*, 39, 2: 189–194.

Hanfling, O. (2004) "Wittgenstein on Music and Language" in P. Lewis (ed.) *Wittgenstein, Aesthetics and Philosophy*. Aldershot: Ashgate: 151–162.

Hess, H. (1975) *Pictures as Arguments*. Falmer: University of Sussex Press.

Hirsch, E. D. (1966) *Validity in Interpretation*. New Haven: Yale University Press.

Kamber, R. (1998) "Weitz Reconsidered: A Clearer View of Why Theories of Art Fail", *British Journal of Aesthetics*, 38, 1: 33–46.

Kant, I. [1790] (1987) *Critique of Judgement*. [trans. W. Pluhar]. Indianapolis: Hackett.

Karelis, C. (1979) *Hegel's Introduction to Aesthetics*. Oxford: Clarendon Press.

Kivy, P. (1975) "What Makes Aesthetic Terms *Aesthetic?*" *Philosophy and Phenomenological Research*, 36: 197–211.

Korsmeyer, C. (1977) "On Distinguishing 'Aesthetic' from 'Artistic'". *Journal of Aesthetic Education*, 11, 4: 45–57.

Kristeller, P. O. (1965) "The Modern System of the Arts" in P. O. Kristeller (ed.) *Renaissance Thought II: Papers on Humanism and the Arts*. New York, NY: Harper and Row: 163–227.

Kuhn, T. (1970) *The Structure of Scientific Revolutions* (Second Edition). Chicago, IL: University of Chicago Press.

Kuhn, T. (1977) *The Essential Tension: Selected Studies in Scientific Tradition and Change*. Chicago, IL: University of Chicago Press.

Kuhn, T. (2000) *The Road Since Structure: Philosophical Essays 1970–1993*. Chicago, IL: University of Chicago Press.

Lamarque, P. (1996) *Fictional Points of View*. Ithaca, NY: Cornell University Press.

Lamarque, P. & Olsen, S. (1994) *Truth, Fiction and Literature: A Philosophical Perspective*. Oxford: Clarendon.

Lear, J. (1998) *Open Minded: Working Out the Logic of the Soul*. Cambridge, MA: Harvard University Press.

Leavis, F. R. (1950) *New Bearings in English Poetry*. London: Chatto & Windus.

Levinson, J. (1990) *Music, Art and Music: Essays in Philosophical Aesthetics*. Ithaca, NY: Cornell University Press.

Levinson, J. (1996) *The Pleasures of Aesthetics: Philosophical Essays*. Ithaca, NY: Cornell University Press.

Levinson, J. (2002) "Hypothetical Intentionalism: Statement, Objections and Replies" in M. Krausz (ed.) *Is There a Single Right Interpretation?* University Park, PN: University of Pennsylvania Press: 309–318.

Levinson, J. (2006) *Contemplating Art*. Oxford: Clarendon.

Levinson, J. (2010) "Defending Hypothetical Intentionalism", *British Journal of Aesthetics*, 50, 2: 139–150.

Lyas, C. (1992) "Criticism and Interpretation" in O. Hanfling (ed.) *Philosophical Aesthetics: An Introduction*. Oxford: Blackwel/Open University: 381–403.

Lyas, C. (1997) *Aesthetics*. London: UCL Press.

Lyas, C. (2000) "Sibley" in B. Gaut & D. Lopes (eds.) *The Routledge Companion to Aesthetics*. London: Routledge: 131–141.

Lynton, N. (1989) *The Story of Modern Art* (Second Edition). London: Phaidon.

Mackie, J. (1977) *Ethics—Inventing Right and Wrong*. Harmondsworth: Penguin.

Mackrell, J. (1997) *Reading Dance*. London: Michael Joseph.

MacNiven, I. (1998) *Lawrence Durrell: A Biography*. London: Faber.

Matravers, D. (2000) "The Institutional Theory: A Protean Creature", *British Journal of Aesthetics*, 40, 2: 242–250.

McAdoo, N. (2002) "Kant and the Problem of Dependent Beauty", *Kant-Studien*, 93, 4: 444–452.

McDowell, J. (1994) *Mind and World*. Cambridge, MA: Harvard University Press.

McDowell, J. (1998) *Mind, Value and Reality*. Cambridge, MA: Harvard University Press.

McFee, G. (1978) *Much of Jackson Pollock is Vivid Wallpaper*. New York, NY: University Press of America.

McFee, G. (1980) "The Historicity of Art", *Journal of Aesthetics and Art Criticism*, 38, 3: 307–324.

McFee, G. (1985) "Wollheim and the Institutional Theory of Art", *Philosophical Quarterly*, 35, 139: 179–185.

McFee, G. (1986) Review of Dickie, the Art Circle, *British Journal of Aesthetics*, 36: 72–74.

McFee, G. (1989) "The Logic of Appreciation in the Republic of Art", *British Journal of Aesthetics*, 29: 230–238.

McFee, G. (1990) "Davies' Replies: A Response", *Grazer Philosophische Studien*, 38: 177–184.

McFee, G. (1992a) *Understanding Dance*. London: Routledge.

McFee, G. (1992b) "The Historical Character of Art: A Re-Appraisal", *British Journal of Aesthetics*, 32, 4: 307–319.

McFee, G. (1994) "Pictorial Representation in Art", *British Journal of Aesthetics*, 34, 1: 35–47.

McFee, G. (1995) "Back to the Future: A Reply to Sharpe", *British Journal of Aesthetics*, 35, 3: 278–283.

McFee, G. (1997) "Meaning and the Art-Status of *Music Alone*", *British Journal of Aesthetics*, 37, 1: 31–46.

McFee, G. (1998) "Truth, Arts Education and the 'Postmodern Condition'" in D. Carr (ed.) *Education, Knowledge and Truth: Beyond the Postmodern Impasse*. London: Routledge: 80–95.

McFee, G. (1999) "Wittgenstein on Art and Aspects", *Philosophical Investigations*, 22, 3, July: 262–284.

McFee, G. (2000) *Free Will*. Teddington: Acumen.

McFee, G. (2001) "Wittgenstein, Performing Art and Action" in R. Allen & M. Turvey (eds.) *Wittgenstein, Theory and the Arts*. London: Routledge: 92–116.

McFee, G. (2003a) "Art, Essence and Wittgenstein" in S. Davies (ed.) *Art and Essence*. Westport, CT: Praeger: 17–38.

McFee, G. (2003b) "Cognitivism and the Experience of Dance" in A. C. Sukla (ed.) *Art and Experience*. Westport, CT: Praeger: 121–143.

McFee, G. (2004a) *Sport, Rules and Values*. London: Routledge.

McFee, G. (2004b) *The Concept of Dance Education* (Expanded Edition). Eastbourne: Pageantry Press.

McFee, G. (2004c) "Wittgenstein and the Arts: Understanding and Performing" in P. Lewis (ed.) *Wittgenstein, Aesthetics and Philosophy*. Aldershot: Ashgate: 109–136.

McFee, G. (2005a) "The Artistic and the Aesthetic", *British Journal of Aesthetics*, 45, 4: 368–387.

McFee, G. (2005b) "Art, Understanding and Historical Character: A Contribution to Analytic Aesthetics" in K. Mey (ed.) *Art in the Making: Aesthetics, Historicity and Practice*. New York, NY: Peter Lang: 71–93.

McFee, G. (2008) "The Friends of Jones' Paintings: A Case of Explanation in the Republic of Art", *Contemporary Aesthetics*, 6.

McFee, G. (2010a) *Ethics, Knowledge and Truth in Sports Research: An Epistemology of Sport*. London: Routledge.

McFee, G. (2010b) "Defending 'the Artist's Theory': Wollheim's Lost Idea Regained?", *Estetika*, XLVII , New Series III, 1: 3–26.

McFee, G. & Tomlinson, A. (1999) "Riefenstahl's Olympia: Ideology and Aesthetics in the Shaping of the Aryan Athletic Body" in J. A. Mangan (ed.) *Shaping the Superman: Fascist Body as Political Icon—Aryan Fascism*. London: Frank Cass: 86–106.

Mothersill, M. (1984) *Beauty Restored*. Oxford: Clarendon Press.

Murdoch, I. (1997) *Existentialists and Mystics: Writings on Philosophy and Literature*. Harmondsworth: Penguin.

Nussbaum, M. (1990) *Love's Knowledge: Essays on Philosophy and Literature*. Oxford: Oxford University Press.

Orwell, G. [1945] (1968) "Revenge is Sour" in *The Collected Essays, Journalism and Letters of George Orwell* (Volume 4). New York, NY: Harcourt, Brace & World: 3–6.

Pichler, A. (1991) *Ludwig Wittgenstein, Vermischte Bermerkungen: Liste der Manuskriptquellen*, Schriften des Wittgenstein Archivs, University of Bergen, Norway, Nr 1.

Podro, M. (1982) *The Critical Historians of Art*. New Haven: Yale University Press.

Quinton, A. (1982) "Tragedy" in A. Quinton (ed.) *Thoughts and Thinkers*. New York, NY: Holmes & Meier: 94–107.

Raine, C. (1998) "To the Life", *Modern Painters*, 11, 3, Autumn: 20–23.

Reid, T. [1785] (1997) *An Inquiry into the Human Mind on the Principles of Common Sense* (Fourth Edition). D. R. Brookes (ed.). Edinburgh: University of Edinburgh Press.

Reid, T. [1815] (2002) *Essays on the Intellectual Powers of Man*. D. R. Brookes (ed.). Edinburgh: University of Edinburgh Press.

Rhees, R. (1969) *Without Answers*. London: Routledge & Kegan Paul.

Richards, I. A. (1924) *Principles of Literary Criticism*. London: Routledge & Kegan Paul.

Robinson, I. (1973) *The Survival of English*. Cambridge: Cambridge University Press.

Russell, B. (1919) *Introduction to Mathematical Philosophy*. London: George Allen & Unwin.

Sarris, A. (1968) *The American Cinema*. New York, NY: Dutton.

Sarris, A. (1973) *The Primal Screen*. New York, NY: Simon & Schusters.

Savile, A. (1982) *The Test of Time*. Oxford: Clarendon Press.

Schapiro, M. (1995) *Mondrian: On the Humanity of Abstract Painting*. New York, NY: George Braziller.

Scruton, R. (1983) *The Aesthetic Understanding*. Manchester: Carcanet Press.

Scruton, R. (1990) *The Philosopher on Dover Beach*. Manchester: Carcanet Press.

Scruton, R. (1997) *The Aesthetics of Music*. Oxford: Clarendon Press.

Scruton, R. (1998/2000) *An Intelligent Person's Guide to Modern Culture*. South Bend, Indiana: St Augustine's Press.

Searle, J. (1969) *Speech Acts*. Cambridge: Cambridge University Press.

Sharpe, R. A. (1994) "Making the Past: McFee's Forward Retroactivism", *British Journal of Aesthetics*, 34, 2: 170–173.

Sharpe, R. A. (2000) *Music and Humanism: An Essay in the Aesthetics of Music*. Oxford: Clarendon.

Shusterman, R. (1984) *The Object of Literary Criticism*. Amsterdam: Rodopi.

Shusterman, R. (1992) *Pragmatist Aesthetics*. Oxford: Blackwell.

Sibley, F. (2001) *Approaches to Aesthetics: Collected Papers on Philosophical Aesthetics*. Oxford: Clarendon.

Smith, C. S. (2003) "Forward" *to Ron Mueck*. London: National Gallery: 9.

Sparshott, F. (1963) *The Structure of Aesthetics*. Toronto, ON: University of Toronto Press.

Sparshott, F. (1982) *The Theory of the Arts*. Princeton, NJ: Princeton University Press.

Spencer, P. (ed.) (1985) *Society and the Dance*. Cambridge: Cambridge University Press.

Stecker, R. (2003) *Interpretation and Construction: Art, Speech and the Law*. Oxford: Blackwell.

Storer, T. (1962) "Miniac: World's Smallest Electronic Brain", *Analysis*, 22: 151–152.

Strawson, P. (1974) *Freedom and Resentment*. London: Methuen.

Stroud, B. (2000) *Understanding Human Knowledge*. Oxford: Oxford University Press.

Suits, B. (1978) *The Grasshopper: Games, Life and Utopia*. Edinburgh: Scottish Academy Press.

Sutton, T. (2000) *The Classification of Visual Art: A Philosophical Myth and Its History*. Cambridge: Cambridge University Press.

Tanner, M. (1976/7) "Sentimentality", *Proceedings of the Aristotelian Society*, LXXVII: 127–147.

Tolhurst, W. (1979) "On What a Text is and How It Means", *British Journal of Aesthetics*, 19: 3–19.

Travis, C. (1989) *The Uses of Sense*. Oxford: Clarendon Press.

Travis, C. (1997) "Reply to Simmons", *Mind*, 106: 119–120.

Travis, C. (2004a) "The Limits of Empiricism", *Proceedings of the Aristotelian Society*, CIV: 245–270.

Travis, C. (2004b) "The Silence of the Senses", *Mind*, 113: 57–94.

Travis, C. (2006) *Thought's Footing*. Oxford: Clarendon Press.

Travis, C. (2008) *Occasion-Sensitivity: Selected Essays*. Oxford: Clarendon Press.

Urmson, J. O. (1976) "The Performing Arts" in H. D. Lewis (ed.) *Contemporary British Philosophy* (Fourth Series). London: Allen & Unwin: 239–252.

Van Gerwen, R. (2004) "Ethical Autonomism: The Work of Art as Moral Agent", *Contemporary Aesthetics*, 2.

Waismann, F. (1968) "Verfiability" in F. Waismann (ed.) *How I See Philosophy*. London: Macmillan: 39–66.

Walton, K. (2008) "Categories of Art" reprinted in K. Walton (ed.) *Marvelous Images: On Values and the Arts*. Oxford: Oxford University Press: 195–219.

Warberton, N. (2003) *The Art Question*. London: Routledge.

Weitz, M. (1977) *The Opening Mind: A Philosophical Study of Humanistic Concepts*. Chicago, IL: University of Chicago Press.

Wieand, J. (1981) "Quality in Art", *British Journal of Aesthetics*, 21, 3: 330–335.

Wieand, J. (1994) "Perceptually Indistinguishable Objects" in R. J. Yanal (eds.) *Institutions of Art: Reconsiderations of George Dickie's Philosophy*. University Park, PN: Pennsylvania State University Press: 39–49.

Wiggins, C. (2003) "Ron Mueck at the National Gallery" in *Ron Mueck*. London: National Gallery: 19–41.

Wilde, O. (1966a) "The Decay of Lying" in *The Complete Works of Oscar Wilde*. London: Collins: 970–992.

Wilde, O. (1966b) "De Profundis" in *The Complete Works of Oscar Wilde*. London: Collins: 873–957.

Wimsatt, W. K. & Beardsley, M. (1962) "The Intentional Fallacy" in J. Margolis (ed.) *Philosophy Looks at the Arts*. New York, NY: Scribners: 91–105.

Winch, P. (1972) *Ethics and Action*. London: Routledge & Kegan Paul.

Wisdom, J. (1953) *Philosophy and Psycho-Analysis*. Oxford: Blackwell.

Wisdom, J. (1965) *Paradox and Discovery*. Oxford: Blackwell.

Wisdom, J. (1991) *Proof and Explanation* (The Virginia Lectures). S. Barker (ed.). Washington, DC: University Press of America.

Wittgenstein, L. (1953) *Philosophical Investigations* (trans. G. E. M. Anscombe). [50th Anniversary Edition, 2001 (new pagination)]. Oxford: Basil Blackwell.

Wittgenstein, L. (1958) *The Blue & Brown Books*. Oxford: Blackwell.

Wittgenstein, L. (1967) *Zettel*. Oxford: Blackwell.

Wittgenstein, L. (1975) *Philosophical Remarks* (trans. R. Hargreaves & R. White). Oxford: Blackwell.

Wittgenstein, L. (1979) *Wittgenstein and the Vienna Circle*. Oxford: Blackwell.

Wittgenstein, L. (1980) *Culture and Value* (trans. P. Winch) [Second Edition: 1998]. Oxford: Basil Blackwell.

Wittgenstein, L. (1993) *Philosophical Occasions 1912–1951*. J. Klagge & A. Nordmann (eds.). Indianapolis: Hackett Publishing Company.

Wittgenstein, L. (2005) *The Big Typescript: Ts 213*. (trans. C. G. Luckhardt & M. A. E. Aue). Oxford: Blackwell.

Wittgenstein, L. (2009) *Philosophical Investigations* (trans. G. E. M. Anscombe, P. M. S. Hacker, & J. Schulte) [Fourth Edition]. Oxford: Basil Blackwell.

Wollheim, R. (1969) *A Family Romance*. London: Jonathan Cape.

Wollheim, R. (1973) *On Art and the Mind*. Harmondsworth: Allen Lane.

Wollheim, R. (1978) "Are the Criteria of Identity that Hold for a Work of Art in the Different Arts Aesthetically Relevant?", *Ratio*, 20, 1, June: 29–48.

Wollheim, R. (1980) *Art and Its Objects* (Second Edition). Cambridge: Cambridge University Press.

Wollheim, R. (1986) "Imagination and Pictorial Understanding", *Proceedings of the Aristotelian Society Supplementary Volume*, 40: 45–60.

Wollheim, R. (1987) *Painting as an Art*. London: Thames and Hudson.

Wollheim, R. (1993a) *The Mind and Its Depths*. Cambridge, MA: Harvard University Press.

Wollheim, R. (1993b) "Danto's Gallery of Indiscernibles" in M. Rollins (ed.) *Danto and His Critics*. Oxford: Blackwell: 28–38.

Wollheim, R. (2001) "On Pictorial Representation" in R. Van Gerwen (ed.) *Richard Wollheim on the Art of Painting*. Cambridge: Cambridge University Press: 13–27.

Wood, G. (2004) "What I Did Today", *The Observer Review*, 24th October: 1–2.

Wright, A. H. (1953) *Jane Austen's Novels*. London: Chatto & Windus.

Wright, C. (1992) *Truth and Objectivity*. Cambridge, MA: Harvard University Press.

Wright, C. (2003) *Saving the Differences*. Cambridge, MA: Harvard University Press.

Wölfflin, H. [1929] (1950) *Principles of Art History*. New York, NY: Dover.

Zangwill, N. (2001) *The Metaphysics of Beauty*. Ithaca, NY: Cornell University Press.

Ziff, P. (1972) *Understanding Understanding*. Ithaca, NY: Cornell University Press.

Ziff, P. (1984) *Antiaesthetics: An Apprectiation of the Cow with the Subtile Nose*. Dordrecht: D. Reidel Publishing.

Index